OXFORD WOR[

STUDIES IN TH
THE REN

WALTER HORATIO PATER was born in south-east London in 1839, the son of a surgeon. He attended King's School, Canterbury, then studied Classics at Queen's College, Oxford. After graduating, he failed to become ordained, not least because of the intercession of a former friend, who denounced him to the Bishop of London as an apostate; he failed too to acquire a clerical fellowship in Oxford. In 1864, however, Pater was appointed as a non-clerical Fellow in Classics at Brasenose College, Oxford, where he tutored Gerard Manley Hopkins among other undergraduates. He travelled to Italy in 1865, accompanied by his young friend and colleague, the diaphanous C. L. Shadwell, and there amassed impressions that he subsequently put to use in the intensely passionate prose of his book on the Renaissance. From the second half of the 1860s, he published a number of articles on literary and art-historical topics for the periodical press, in particular the *Westminster* and *Fortnightly Reviews*. He collected several of these, including an article on Winckelmann, in *Studies in the History of the Renaissance* (1873), to which he added a controversial 'Conclusion' taken from a review of various poems by William Morris. Even at the time, it was read by a number of people as a hedonistic defence not simply of aestheticism or Hellenism but of homoeroticism too. The faint aroma of scandal became more noisome in 1874, when Pater was reprimanded by Benjamin Jowett for his intimate correspondence with an openly homosexual undergraduate. In the second edition of *The Renaissance*, as he retitled it, Pater therefore removed the offending 'Conclusion'. His identity was however already indissolubly associated with what came to be called the decadent movement. Oscar Wilde, for example, at once the most rapturous and the least socially acceptable of Pater's numerous champions at the *fin de siècle*, later referred to *The Renaissance* as his 'golden book'. In the 1880s, Pater published his extraordinary anti-realist novel *Marius the Epicurean* (1885), an attempt in part to assimilate aspects of Christianity to his aesthetic; he also published *Imaginary Portraits* (1887) and a collection of essays largely on English literature entitled *Appreciations* (1889). His lectures on Plato appeared in 1893 as *Plato and Platonism*. He died in Oxford in 1894.

MATTHEW BEAUMONT is a Senior Lecturer in English Literature at University College London. He is the author of *Utopia Ltd.: Ideologies of Social Dreaming in England 1870–1900* (2005) and the editor of *Adventures in Realism* (2007). He has also edited *Looking Backward*, by Edward Bellamy, for Oxford World's Classics.

OXFORD WORLD'S CLASSICS

*For over 100 years Oxford World's Classics have brought
readers closer to the world's great literature. Now with over 700
titles—from the 4,000-year-old myths of Mesopotamia to the
twentieth century's greatest novels—the series makes available
lesser-known as well as celebrated writing.*

*The pocket-sized hardbacks of the early years contained
introductions by Virginia Woolf, T. S. Eliot, Graham Greene,
and other literary figures which enriched the experience of reading.
Today the series is recognized for its fine scholarship and
reliability in texts that span world literature, drama and poetry,
religion, philosophy, and politics. Each edition includes perceptive
commentary and essential background information to meet the
changing needs of readers.*

OXFORD WORLD'S CLASSICS

WALTER PATER

Studies in the History of the Renaissance

Edited with an Introduction and Notes by
MATTHEW BEAUMONT

OXFORD
UNIVERSITY PRESS

OXFORD
UNIVERSITY PRESS

Great Clarendon Street, Oxford OX2 6DP

Oxford University Press is a department of the University of Oxford.
It furthers the University's objective of excellence in research, scholarship,
and education by publishing worldwide in

Oxford New York

Auckland Cape Town Dar es Salaam Hong Kong Karachi
Kuala Lumpur Madrid Melbourne Mexico City Nairobi
New Delhi Shanghai Taipei Toronto

With offices in

Argentina Austria Brazil Chile Czech Republic France Greece
Guatemala Hungary Italy Japan Poland Portugal Singapore
South Korea Switzerland Thailand Turkey Ukraine Vietnam

Oxford is a registered trade mark of Oxford University Press
in the UK and in certain other countries

Published in the United States
by Oxford University Press Inc., New York

Editorial material © Matthew Beaumont 2010

The moral rights of the author have been asserted
Database right Oxford University Press (maker)

First published as an Oxford World's Classics paperback 1986
New edition 2010

British Library Cataloguing in Publication Data

Data available

Library of Congress Cataloging-in-Publication Data

Data available

Typeset by Glyph International Ltd., Bangalore, India
Printed in Great Britain
on acid-free paper by
Clays Ltd., Elcograf S.p.A

ISBN 978–0–19–953507–1

16

CONTENTS

ACKNOWLEDGEMENTS

A NUMBER of people have helped me in the course of producing this edition. For responding to my requests for information or for providing me with translations I'd like to record my gratitude to Caroline Arscott, Laurel Brake, Eleanor Chiari, Paul Davis, Steve Edwards, Jane Gilbert, Philip Horne, Fabian Macpherson, Federica Mazzara, Kathy Metzenthin, and René Weis. I am especially grateful to Rachel Bowlby, who kindly read my Introduction and offered characteristically insightful comments; and Henry Woudhuysen, who advised me on editorial matters and generously lent me his copy of the first edition. Thanks too to Judith Luna at Oxford University Press. Finally, I should like to dedicate this edition to the memory of Philip Glazebrook, who gave me a copy of Adam Phillips's edition of *The Renaissance*, which this one respectfully replaces, when I was 15.

INTRODUCTION

IN *Marius the Epicurean* (1885), one of the oddest and most seductive novels of the nineteenth century, Pater includes an extended meditation on the passionate intensity that can, on rare occasions, character- ize a reader's relationship to a particular book. 'A book, like a person, has its fortunes with one,' his narrator announces; 'is lucky or unlucky in the precise moment of its falling in our way, and often by some happy accident counts with us for something more than its independent value.'[1] The book to which Pater's narrator refers, explicitly at least, is the *Metamorphoses* by the second-century Roman author Apuleius. This is the 'golden book' that has an incandescent effect on the adolescent imagination of Marius, the eponymous hero of Pater's novel, as he matures in the fertile philosophical climate fostered by the Roman emperor Marcus Aurelius. Full of 'stories with the sudden, unlooked-for changes of dreams', its effect on his imagination is hallucinogenic.[2] Marius is especially deeply affected by the tale of Cupid and Psyche, because it emblematizes 'the ideal of a perfect imaginative love, centred upon a type of beauty entirely flawless and clean'. The narrator clarifies this in a cool tone that can- not fully conceal his inflamed emotions:

The human body in its beauty, as the highest potency of all the beauty of material objects, seemed to him just then to be matter no longer, but, hav- ing taken celestial fire, to assert itself as indeed the true, though visible, soul or spirit in things.[3]

The tale of Cupid and Psyche represents an epiphany for Marius, at once intellectual and sexual. It is like a code, disclosed almost acci- dentally, which unlocks the secrets of his identity. Pater's narrator emphasizes that the book's potent effect on Marius cannot in the end be separated from the experience of 'truant reading'—a surreptitious form of reading that takes place outside institutional structures.[4] The *Metamorphoses*, he concludes, 'occupied always a peculiar place in his

[1] Walter Pater, *Marius the Epicurean*, ed. Michael Levey (Harmondsworth: Penguin, 1985), pp. 87–8.

[2] Ibid. p. 68.

[3] Ibid. p. 87.

[4] Ibid. p. 66.

remembrance, never quite losing its power in frequent return to it for the revival of that first glowing impression'.[5]

This description of the intoxicating effect of Apuleius' book on an acutely sensitive adolescent in the second century is at the same time an attempt—part repentant, part defiant—to think through the extraordinary impact of the first book that Pater himself had published: *Studies in the History of the Renaissance*. For from the moment of its publication, in February 1873, *Studies* acquired the kind of cult value reserved for especially controversial books. Its effect on both its supporters and its detractors proved sensational. People took it personally. George Eliot, for example, after reading Margaret Oliphant's coolly hostile review for *Blackwood's*, was prompted to dismiss it hot-temperedly as 'quite poisonous in its false principles of criticism and false conceptions of life'.[6] Felicitous or infelicitous in the precise moment of its appearance, it seemed by some accident to count for something not more than its independent value so much as almost irrespective of it. The book caused consternation among the more conservative representatives of Victorian culture in particular (even though several of its chapters had already appeared as articles in the periodical press).[7] These commissars of acceptable taste thought above all that its 'Conclusion', taken from the final paragraphs of an unsigned review of the poems of William Morris that had been printed in the *Westminster Review* in 1868, might contaminate the morals of an entire generation of undergraduates. And in a sense their fears proved prophetic, since in the 1890s, so the legend has it, 'students at Oxford were often heard chanting its melodious passages in unison'.[8] Decadent undergraduates, their enthusiasm sharpened by the older generation's indignation, sloganized its statements on aesthetics and used them as a rough guide to ethics.

So if the descriptions of the *Metamorphoses* in *Marius the Epicurean* are an account of an adolescent falling in love with a book, it could be said that at the *fin de siècle* thousands of male youths conducted a romance with Pater's *Studies*. Its patient, subtly probing attempt to reconstruct the history of the Renaissance as a hidden Hellenic

[5] Pater, *Marius the Epicurean*, p. 88.

[6] R. M. Seiler, ed., *Walter Pater: The Critical Heritage* (London: Routledge & Kegan Paul, 1980), p. 92.

[7] On Pater and the periodical press, see Laurel Brake, *Print in Transition, 1850–1910: Studies in Media and Book History* (Basingstoke: Palgrave, 2001), pp. 183–96.

[8] Gerald Monsman, *Walter Pater* (Boston: Twayne, 1977), pp. 54–5.

tradition, running from the twelfth to the eighteenth century, that celebrated 'the free play of human intelligence' and, almost more importantly, the free play of the human body, proved profoundly persuasive in the time in which Pater lived, an epoch of industrial capitalism shaped by utilitarian values that had effectively rendered even the idea of 'free play' unacceptable (p. 10). For Pater, as he defined it in a section added to the second edition of the book, the Renaissance is 'that movement in which, in various ways, the human mind wins for itself a new kingdom of feeling and sensation and thought, not opposed to but only beyond and independent of the spiritual system then actually realized'.[9] The aesthetics of the Renaissance thus have momentous, and potentially redemptive, ethical implications for the second half of the nineteenth century. Pater's exquisite prose, which participates in or re-enacts the movement that it evaluates, itself creating a distinctive realm of feeling and sensation and thought, intensified the almost talismanic effect that the book's claims had on some of its readers. As Kenneth Clark remarked, 'its slow-moving sentences produced an unconscious revolution in the minds of thousands of young men'.[10] In the contemporary bourgeois imagination, if not in Oxford itself, it thus acted as the literary equivalent of Zuleika Dobson, the *femme fatale* whose lethal attractiveness drives so many students to suicide in Max Beerbohm's celebrated novel of that name.

Formation

Studies in the History of the Renaissance, which made truant readers of all its admirers, thus acquired an incendiary reputation that did not diminish as the nineteenth century reached its end. It was as if the book had on its publication instantaneously constituted a secret society of readers for whom 'the human body in its beauty', specifically the male human body, 'as the highest potency of all the beauty of material objects', enshrined the deepest spiritual truths. If Pater had been conscious of the polemical implications of the book, parts of which had after all appeared anonymously, he was nonetheless

[9] See Walter Pater, *The Renaissance: Studies in Art and Poetry: The 1893 Text*, ed. Donald L. Hill (Berkeley and Los Angeles: University of California Press, 1980), p. 5.

[10] Kenneth Clark, ed., *The Renaissance: Studies in Art and Poetry, to which is added the essay on Raphael from Miscellaneous Studies* (London: Collins, 1961), p. 26.

unprepared for its explosive impact. A private, recessive man, though at the same time a quietly audacious one, who liked for instance 'to show off his irreligious character as a token of his modernity', he appears to have been disconcerted by the reactions it elicited.[11] His sense of dismay was scarcely misplaced. The notoriety of *Studies*—the title page of which, to the nervous contempt of its critics, referred to him as 'Walter H. Pater, Fellow of Brasenose College, Oxford'—confirmed and reinforced its author's marginal status at this most prestigious of universities. Pater, who became an academic because he could not afford to write articles and books unless paid to teach, lacked the indomitable sense of entitlement that typified the attitude of contemporaries who had been brought up expecting to attend Oxford as a student and to adopt an academic post if it suited them to do so. This sapped the sense of authority with which, in spite of his institutional location, he intervened in contemporary cultural debates. His homosexuality also undermined it. As Laurel Brake has observed, 'although he was writing from "inside" a culturally dominant institution, he wrote from the endangered position of a homosexual in such an institution, writing primarily for other men open to such homosocial readings'.[12] His contradictory situation on the outside of the inside helps explain both the iconoclastic content of *Studies* and the encoded form that it assumed. For if Pater's book is a manifesto for aestheticism, as a number of his contemporaries understood it to be, it is a paradoxically cryptic one.

Pater had been born in Stepney, in the east end of London—not one of the most traditional points of departure, in the mid-nineteenth century, for someone destined to spend almost his entire adult life as an Oxford don. His father, who died when he was only two and a half, had moreover been a 'surgeon', which in the nineteenth century meant a general practitioner of medicine among the poor rather than a distinguished specialist. His social credentials were thus already compromised by Oxford standards when, thanks in part to the financial support of a friend's family, he became an undergraduate at the university in 1858. Prior to that date he had attended the King's

[11] Denis Donoghue, *Walter Pater: Lover of Strange Souls* (New York: Knopf, 1995), p. 31

[12] Laurel Brake, 'Degrees of Darkness: Ruskin, Pater and Modernism', in Giovanni Cianci and Peter Nicholls, eds., *Ruskin and Modernism* (Basingstoke: Palgrave Macmillan, 2001), p. 56.

School in Canterbury, where he acquired a reputation both for intel-
lectual promise and a pious commitment to High Anglicanism. This
reputation counted for little by the time he graduated from Oxford,
though, for to the disappointment of his tutors he failed to take a
first-class degree in Classics and, more carelessly still, lost his reli-
gious faith too. In consequence, it proved difficult to attain an aca-
demic appointment, especially after the spiteful interference of John
Rainier McQueen, a former school-friend to whom he had been
exceptionally close, whose letter to the Bishop of London made it
impossible for him to become ordained. In 1864 he was however
eventually elected to a non-clerical fellowship in Classics at Brasenose.
Thereafter, except for a stint in London, where he moved briefly
after the publication of *Marius the Epicurean*, and the occasional trip
to the continent, Pater's life centred on his scattered scholarly pur-
suits in Oxford. His encounters with the most important intellectuals
of the time, even ones keen to act as his disciples, were mostly missed
opportunities; and his intimate friendships, too, tended to peter out.
He reminded his acquaintance Henry James, who made a number of
catty comments about Pater, 'of one of those lucent matchboxes
which you place, on going to bed, near the candle, to show you, in
the darkness, where you can strike a light: he shines in the uneasy
gloom—vaguely, and has a phosphorescence, not a flame'.[13]

Almost uniquely among nineteenth-century intellectuals, even
Pater's correspondence offers not the slightest glimpse of an inner
life, and his relatively uneventful outer life in consequence seems
oddly characterless. The literature that he left, flame-like rather than
phosphorescent, is in contrast positively steeped in his elusive tem-
perament. In his essay on Pascal, which appeared in the *Contemporary
Review* after his death, Pater claimed that, like volcanic fires beneath
the 'green undulations' of the philosopher's homeland, passion
bubbles up beneath his theological abstractions.[14] The intricate
surface of Pater's prose, too, seems to be shaped by a sometimes
perceptible, sometimes imperceptible passion. 'Within its severe
limits', as he himself writes of the eighteenth-century German clas-
sicist Johann Joachim Winckelmann in *Studies*, 'his enthusiasm burns

[13] See Henry James, *Henry James: A Life in Letters*, ed. Philip Horne (Harmondsworth:
Penguin, 2000), pp. 292–3.

[14] Walter Pater, *Miscellaneous Studies: A Series of Essays* (London: Macmillan, 1920),
p. 77.

like lava' (p. 90). That emotional affectiveness can first be glimpsed
in 'Diaphaneitè', the piece that he composed for the Old Mortality,
a society of young, mostly agnostic intellectuals at Oxford, in 1864
(see Appendix B). This attempt to identify 'a type of life that might
serve as a basement type' is in fact far closer to a manifesto, in terms
both of form and content, than *Studies* (a book that repeatedly echoes
and paraphrases it). 'Diaphaneitè' posits nothing less than the proto-
type of a utopian society: 'the type must be one discontented with
society as it is', Pater declares; and the mass proliferation of this man
of the future, he adds, 'would be the regeneration of the world'. This
is no activist, though, not even of an ascetic, transcendental kind. 'The
philosopher, the saint, the artist, neither of them can be this type'
(p. 139). No, Pater's 'revolutionist', to use his ascription, is the 'diaph-
anous' type. The diaphanous character—innocent, transparent—
incarnates 'the human body in its beauty', to appropriate the
language of *Marius the Epicurean*, and so incorporates 'the true,
though visible, soul or spirit in things'. It effects a perfect commu-
nion of body and spirit. 'Like all the higher forms of inward life this
character is a subtle blending and interpenetration of intellectual,
moral and spiritual elements,' Pater announces in 'Diaphaneitè'; 'it
is a mind of taste lighted up by some spiritual ray within' (p. 136). In
this, and in its perfect simplicity, it represents an almost statuesque
critique of the desiccated, spiritually dissociated conditions of life in
industrial society. In contrast to the saint, the artist, or the philoso-
pher, who is so often 'confused, jarred, disintegrated in the world',
the diaphanous character is 'like a relic from the classical age, laid
open by accident to our alien modern atmosphere' (p. 137).

The diaphanous type embodies the youthful Pater's utopian
dreams of a homosocial society that reinstates the ethics and aesthet-
ics associated with the spirit of Hellenism, and in particular 'the care
for physical beauty, the worship of the body' that he celebrates in the
Preface to *Studies* (p. 5). His description in 'Diaphaneitè', it is evi-
dent, like his characterization of Marius, is on one level an attempt
to sublimate the painful, sometimes exquisite sensitivity that, as a
man who loves other men, he feels as he confronts life in 'the adulter-
ated atmosphere of the world' (p. 138). More concretely, though, it
is thought to have been inspired by Charles Lancelot Shadwell, a
friend and former student famed for his handsomeness. 'Often the
presence of this nature,' Pater intones in a calm, controlled voice that

nonetheless seems to tremble with erotic excitement, 'is felt like a sweet aroma in early manhood' (p. 138). Pater dedicated *Studies in the History of the Renaissance* to Shadwell, who had in the summer of 1865 accompanied him on the trip to Italy during which he soaked up many of the impressions that permeate the book.[15] Its chapters, especially the one on Winckelmann, which lifts some of its sentences directly from 'Diaphaneitè', read like a sustained effort to recover the diaphanous character, this time however by excavating the past. At one point in 'Diaphaneitè', he characterizes diaphanousness as 'a thread of pure white light that one might disentwine from the tumultuary richness of Goethe's nature' (p. 138).[16] *Studies* traces the thread of light that runs through the richness of the Renaissance; and having unpicked this thread, as the 'Conclusion' reveals, it also attempts, in a far more violent movement, to weave it deep into the nineteenth century in the hope that, like a late form of Romanticism, it might eventually redeem the dispiriting realities of life in an industrial society. Like Romanticism, it thus constitutes a critique of the present and, at least potentially, a utopian alternative to it (one critic has pointed out that 'Pater's volume might have been titled *Studies in the History of Romanticism*').[17] Romanticism, too, is for Pater an 'outbreak of the human spirit', as he puts it in the Preface to *Studies* (p. 5). The book thus constructs an antinomian tradition—openly aesthetic, covertly both homoerotic and atheistic—that it uses to recruit readers to a sort of invisible college of the future concealed among the visible colleges of Oxford.

The 'Renaissance' is for Pater an ontological rather than a historical phenomenon: it is a trope for 'any moment of intense feeling encountered in a world that scientific enquiry, rational thought, "analysis" itself have reduced to a state of enervation and entropy'.[18] Pater clarifies his concept of the Renaissance in the opening paragraphs of the first chapter of *Studies*, 'Aucassin and Nicolette', an account of the French romance of that name composed in the

[15] For the little that is known about this visit to Italy see Michael Levey, *The Case of Walter Pater* (London: Thames and Hudson, 1978), pp. 104–5.

[16] Note that in the chapter on Winckelmann Pater adapts this to 'the tumultuous richness of Goethe's culture' (see p. 90).

[17] John J. Conlon, *Walter Pater and the French Tradition* (London: Bucknell University Press, 1982), p. 65.

[18] Jonathan Freedman, *Professions of Taste: Henry James, British Aestheticism, and Commodity Culture* (Stanford, Calif.: Stanford University Press, 1990), pp. 64–5.

thirteenth century. The poem is important to Pater because it is symptomatic of 'a Renaissance within the limits of the middle age itself, a brilliant but in part abortive attempt to do for human life and the human mind what was afterwards done in the fifteenth' (p. 9). It testifies to the reappearance of a subterranean spiritual tradition, buried since the decline of Hellenism, in which intellectual and physical life are revelled in for themselves:

For us the Renaissance is the name of a many-sided but yet united move-ment, in which the love of the things of the intellect and the imagination for their own sake, the desire for a more liberal and comely way of conceiv-ing life, make themselves felt, prompting those who experience this desire to seek first one and then another means of intellectual or imaginative enjoyment, and directing them not merely to the discovery of old and forgotten sources of this enjoyment, but to divine new sources of it, new experiences, new subjects of poetry, new forms of art. (p. 9)

Studies in the History of the Renaissance does not purport to be a com-prehensive chronological narrative of a carefully delimited cultural phenomenon. Instead, it unearths old and sometimes forgotten embodiments of its spirit and identifies some of its more recent incarnations. The 'love of art for art's sake' that, influenced by the French literature of the mid-nineteenth century, he recklessly celebrates in the final sentence of the book, is in fact only the latest manifestation of 'the love of the things of the intellect and the im-agination for their own sake' that he has discovered in previous centuries (p. 9). Pater's notion of the Renaissance, as a pulse of free-dom connecting up the past, present, and future, is ostentatiously anti-antiquarian.

The apparently scattered topics addressed in *Studies* comprise a secret history of European culture. Pater finds the Renaissance, as he conceptualizes it, in the philosophy of the humanist scholar Pico della Mirandola, the paintings of Botticelli and Leonardo, the sculp-tures of Luca della Robbia, the poems of Michelangelo and Joachim du Bellay, and, finally, in the life and scholarship of Winckelmann. He esteems Botticelli's use of colour, for example, because of the delicacy with which it displays residues of 'the Hellenic spirit', a spirit that heals the rupture of body and mind that is characteristic of Enlightenment thought. In Botticelli's picture of Venus rising from the sea, 'you have a record of the first impression made by it on minds turned back towards it in almost painful aspiration from a

world in which it had been ignored so long' (p. 33). Pater implies that, in the philistine conditions of the nineteenth century, he too suffers from this painful sense of aspiration. It is therefore at once consoling and inspiriting for him to perceive in the paganistic impulses of the past the temperament that he believes can redeem the present. He praises Pico's philosophy because it appears to surge up from 'deep and passionate emotion'—and implicitly from physical desire (p. 27). He admires Michelangelo's poetry, conversely, because he 'is always pressing forward from the outward beauty . . . to apprehend the unseen beauty' (p. 49). The spirit of the Renaissance, symptomatically materialized in the poems and paintings that Pater evokes, promises to fuse physical and intellectual life, as in the time of Plato.

The apparently anomalous chapter on Winckelmann, originally published unsigned in the *Westminster Review* in 1867, is incorporated in the book, in spite of 'coming in the eighteenth century', because 'he is the last fruit of the Renaissance, and explains in a striking way its motive and tendencies'. He is the apotheosis of the occult tradition reconstructed by Pater. 'By his enthusiasm for the things of the intellect and the imagination for their own sake, by his Hellenism, his life-long struggle to attain to the Greek spirit, he is in sympathy with the humanists of an earlier century,' Pater insists (p. 6). 'Hellenism', in this sentence, is a euphemistic allusion to Winckelmann's homosexuality as well as a reference to his philosophical humanism. As the ruminative, dreamily reflective chapter devoted to him reveals, Winckelmann transmits the essence of the Renaissance to Pater in a form comparable to some physical charge like an electrical current. 'Betraying his temperament, even in appearance, by his olive complexion, his deep-seated, piercing eyes, his rapid movements,' he informs the reader, Winckelmann 'apprehended the subtlest principles of the Hellenic manner not through the understanding, but by instinct or touch' (p. 95). At times, the chapter reads like the transcript of an erotic dream about Winckelmann rather than a biographical introduction to him. The German classicist seems to channel the spirit of the Renaissance like a medium.

Perhaps the most dramatic invocation of the spirit of the Renaissance in Pater's *Studies* is his aching, ecstatic description of the 'Mona Lisa' (which the poet W. B. Yeats, in a celebrated act of

appropriation, transposed into free verse in 1936).[19] Leonardo 'fascinates, or perhaps half repels' Pater because of the occult secrets that the mysterious surfaces of his paintings offer to disclose to those prepared to become initiates (p. 56). His paintings are imbued with 'the fascination of corruption' and, in their incomplete perfection, they seem stained by death as much as life (p. 60). The artist is like 'the sorcerer or the magician, possessed of curious secrets and a hidden knowledge, living in a world of which he alone possessed the key'; his art is like 'a strange variation of the alchemist's dream' (pp. 60–61). Pater's hope, as a 'lover of strange souls', and of the androgynous bodies that encase them too, is that he himself might act in an almost priestly capacity as Leonardo's interpreter: he proposes to 'analyse for himself the impression made on him' by his paintings and so to reach 'a definition of the chief elements of Leonardo's genius'—to crack the Da Vinci code (p. 57). It is therefore as the acolyte of a cult that is at once sacred and profane, spiritual and almost animal, that Pater mediates the troubling beauty of the portrait of Mona Lisa. Her face is etched with 'all the thoughts and experience of the world—'the animalism of Greece, the lust of Rome, the reverie of the middle age with its spiritual ambition and imaginative loves, the return of the Pagan world, the sins of the Borgias'—and so she sums up the idea of the Renaissance like a sacred emblem (p. 70). 'She is older than the rocks among which she sits,' Pater declares; 'like the vampire, she has been dead many times, and learned the secrets of the grave; and has been a diver in deep seas' (p. 70). It is as if invisible spiritual forces have been inscribed on her flesh and made visible for an instant. 'Nervous, electric, faint always with some inexplicable faintness', Pater writes of Leonardo's 'clairvoyants', these strange figures seem 'to feel powers at work in the common air unfelt by others, to become, as it were, receptacles of them, and pass them on to us in a chain of secret influences' (p. 66). The Mona Lisa, it might therefore be said, is for Pater the goddess or patron saint of diaphanousness.

In *Studies*, as the chapter on Leonardo implicitly demonstrates, Pater mediates the concept of diaphanousness, which he does not refer to explicitly, through the idea of the 'impression'. Impressionism, as a form of criticism that commences from the effects of a specific artefact on the critic's consciousness, is first adumbrated in the Preface.

[19] See W. B. Yeats, ed., *The Oxford Book of Modern Verse, 1892–1935* (Oxford: Clarendon, 1936).

Pater's statements of method in the Preface constitute an understated but decisive refusal of the influence of the most authoritative cultural critics of the mid-nineteenth century, John Ruskin and Matthew Arnold, who are in symbolic terms Pater's paters. Pater was from the late 1850s profoundly shaped by the example of these men, but it became increasingly intellectually stifling to him in the second half of the 1860s—in part because both men, in spite of their differences, promoted the moral vocation of art, in part perhaps because both employed a prophetic voice that, in its assertive masculinism, alienated him. In Oxford their sphere of influence was especially inescapable, for Arnold was Professor of Poetry there from 1857 and Ruskin the Slade Professor of Art from 1870 (Pater unsuccessfully applied for both of these posts after they had vacated them). It is in opposition to Arnold and Ruskin that, in the opening paragraphs of the Preface to *Studies*, Pater sets out the tenets of an impressionist criticism, though neither of them are named. In the first paragraph, Pater takes on Ruskin, whose fulminations against the rampant sensualism of the Renaissance in *The Stones of Venice* (1851–3) and other influential publications are in effect refuted throughout the book. Pater's insistence that 'beauty, like all other qualities presented to human experience, is relative', and that abstract, fleshless definitions of it are consequently 'useless', is an insouciant rejection of the lessons he had learned from Ruskin (p. 3). The impression is central to Pater's deviant attempt 'to define beauty not in the most abstract, but in the most concrete terms possible', in terms of the sensations it elicits from the individual rather than its moral consequences for the collective (p. 3).

In the second paragraph, Pater takes on Arnold. There he makes a methodological statement of enormous importance for debates about aesthetics in Europe in the late nineteenth and early twentieth century, one that is echoed in the fiction of many of the most influential modernists, including Ford, Joyce, Proust, and Woolf.[20] It starts from the critical axiom that Arnold had made famous in 'The Function of Criticism at the Present Time' (1864):

'To see the object as in itself it really is,' has been justly said to be the aim of all true criticism whatever; and in aesthetic criticism the first step towards seeing one's object as it really is, is to know one's own impression as it really is, to discriminate it, to realise it distinctly. The objects with which aesthetic criticism deals, music, poetry, artistic and accomplished

[20] On Pater in relation to modernism see Donoghue, *Walter Pater*, pp. 271–329.

forms of human life, are indeed receptacles of so many powers or forces; they possess, like natural elements, so many virtues or qualities. What is this song or picture, this engaging personality presented in a life or in a book, to *me*? What effect does it really produce on me? Does it give me pleasure? and if so, what sort or degree of pleasure? How is my nature modified by its presence and under its influence? (p. 3)

An objectivist criticism is overturned, almost at a stroke, by a subjectivist one. Seeing is for Pater not so much an act of intellectual apprehension as an expression of what in another context he called the 'lust of the eye'.[21] This is an unassuming but at the same time shocking critique of Arnoldian aesthetics. Pater takes Arnold's celebrated dictum and comprehensively deconstructs it, in the spirit of Humean scepticism, by softly insisting that the subject's impression of the object effectively creates it. The impression itself is not 'simply sensuous', as critics of Pater's book instantly assumed; 'it is a third term born out of a refusal of a long-standing alienation of intellect and sense'.[22] In this respect, it has the synthetic function of the diaphanous character, which blends the 'intellectual, moral and spiritual elements'. In an impressionist criticism, for Pater, the critic's temperament acts on the artefact alchemically, creating 'a special, unique, impression of pleasure'; and it is the critic's task to probe this impression, like a scientist carefully testing a compound deposit left by an experiment on some 'natural element' (p. 4). This experimental process is equivalent, then, to the 'disentwining' of which Pater spoke in 'Diaphaneitè'. For the impressionist critic must sift the work of artistic geniuses like Goethe, setting aside the 'debris' so as to find 'only what the heat of their imagination has wholly fused and transformed' (p. 4). In the case of Wordsworth, for instance, 'the heat of his genius, entering into the substance of his work, has crystallised a part, but only a part, of it; and in that great mass of verse there is much which might well be forgotten'. The critic must 'trace the action of his unique incommunicable faculty' in the deposits that it leaves scattered, 'as if at random', like 'fine crystal[s]' (pp. 4–5). 'The function of the critic of Wordsworth', Pater concludes in a further Oedipal stab at Arnold, 'is to trace that active principle, to disengage it, to mark the degree in which it penetrates his verse' (p. 5).

[21] Walter Pater, 'The Child in the House', in *Imaginary Portraits, with The Child in the House and Gaston de la Tour*, ed. Bill Beckley (New York: Allworth Press, 1997), p. 8.

[22] Jesse Matz, *Literary Impressionism and Modernist Aesthetics* (Cambridge: Cambridge University Press, 2001), p. 61.

The same is the case for the critic of Luca della Robbia or Joachim du Bellay as he examines the former's sculptures or the latter's poems.

In the impression, the subject is for a moment completely immersed in the object, the critic in the artist, Pater in the poet or painter he happens to examine. This process precipitates a sense of the diaphanous that, like some combustible residue of Hellenism 'laid open by accident to our alien modern atmosphere', sparks a flame that instantaneously fuses past and present, in the name of the future. The 'Renaissance', it can be repeated, is for Pater not a chronological phenomenon, a sequence of events that the historian tells, in Walter Benjamin's phrase, 'like the beads of a rosary'. It is instead a dialectical relationship between past and present. So in *Studies in the History of the Renaissance* Pater 'grasps the constellation which his own era has formed with a definite earlier one'.[23] Pater's 'impression', rooted in a criticism that is simultaneously idealist and materialist, desperately attempts to mediate between 'abstract questioning and immediate experience'.[24] As the metaphors he uses in the Preface indicate, Paterian impressionism can thus be characterized, on the one hand, as like a scientific experiment. On the other hand, it can be characterized as a kind of séance. For Pater 'all great art was a kind of haunting, a spiritual and sensory presence that had been caught in the image, but which was nonetheless a thing in time and subject to the flow of past, present and future'.[25] Finally, impressionism can also be depicted as the scene of an erotic encounter, one that fuses and transforms the relations of present to past, subject to object, even writer to reader. It is above all this homoerotic aspect of his aesthetic that upset Pater's contemporaries. And in the 'Conclusion' to *Studies* its ethical implications—which acquire more and more force in the chapters on Leonardo, Michelangelo, and Winckelmann in particular—became all too apparent to them:

While all melts under our feet, we may well grasp at any exquisite passion, or any contribution to knowledge that seems, by a lifted horizon, to set the spirit free for a moment, or any stirring of the senses, strange dyes, strange flowers, and curious odours, or work of the artist's hands, or the face of one's friend. (p. 119)

[23] Walter Benjamin, 'Theses on the Philosophy of History', in *Illuminations*, trans. Harry Zohn, ed. Hannah Arendt (London: Fontana, 1992), p. 255.

[24] Matz, *Literary Impressionism*, p. 58.

[25] Lynda Nead, *The Haunted Gallery: Painting, Photography, Film, c.1900* (New Haven: Yale University Press, 2007), p. 53.

Pater's closing reference to 'the face of one's friend', in spite of its gently fading cadence, which is superficially, so to speak, self-effacing, gathers up into itself all the other instances of an ephemeral freedom of the spirit that this sentence cites, the passion, the knowledge, the stirred senses, the dyes, the flowers, the odours, and the hands. The friend's face is thus embodied—the sight of it unfolds to include the sense of touch, the sense of smell, indeed all the senses that can be stirred—and eroticized. This sentence, in its synaesthetic effects, is perhaps the closest that Pater comes in his prose to a description of the sexual act itself. It beautifully, subtly elaborates the celebrated sentence with which the paragraph opens: 'To burn always with this hard gem-like flame, to maintain this ecstasy, is success in life' (p. 119). 'Success', in this final clause, is like a softly slurred homophone of 'sex'. Shockingly, Pater not only posited the aesthetic as the secret of his ethics, he posited the erotic as the secret of his aesthetics.

Reception

In the conditions of modernity, Pater attempted to reclaim, and redeem, the moment. He confronted the sense of instantaneousness characteristic of life in an industrial society through passionate attention to the instant itself—as in some homoeopathic solution. He advocated living life, 'this short day of frost and sun', as a constant deferment of death (p. 119): 'For our one chance is in expanding that interval, in getting as many pulsations as possible into the given time' (p. 119). This idea, the epicurean doctrine of 'Cyrenaicism' outlined in the 'Conclusion', proved unacceptable even to relatively sympathetic critics. So the unsigned review in the *Examiner*—which carefully underlined the fact 'that Pater is an industrious, energetic, self-sacrificing College tutor, and that his theories about life are the relaxation of a life sternly devoted to duty'—compared the author's 'pulsation philosophy', all the same, to the unconscious convictions of housemaids addicted to sensation fiction.[26] It is to these critics that Pater responded, almost explicitly, in *Marius the Epicurean*:

The blood, the heart, of Marius were still pure. He knew that his carefully considered theory of practice braced him, with the effect of a moral

[26] Seiler, ed., *Walter Pater*, pp. 76–7.

principle duly recurring to mind every morning, towards the work of a student, for which he might seem intended. Yet there were some among his acquaintance who jumped to the conclusion that, with the 'Epicurean style', he was making pleasure—pleasure, as they so poorly conceived it—the sole motive of life.[27]

There were some among his acquaintance, Pater implies, who simply jumped to the 'Conclusion'.

Marius the Epicurean is therefore among other things a sustained, self-conscious reflection on the ideas and sensations that had infused *Studies*. More specifically, the chapters that relate to the attractions of Apuleius' book, half repentant in tone, half triumphant, are an elliptical meditation on its cult appeal. Wilde adverted to this aspect of Pater's autobiographical novel when, in a review of Pater's *Appreciations* (1889) for the *Speaker*, he made an impassioned reference to *Studies in the History of the Renaissance*: 'Mr Pater's essays became to me "the golden book of spirit and sense, the holy writ of beauty". They are still this to me.'[28] The revealing allusion to the 'golden book' is in fact taken from A. C. Swinburne's 'Sonnet (With a Copy of *Mademoiselle de Maupin*)', a poem about Théophile Gautier's infamous novel of 1835. This reference surreptitiously pointed to Swinburne's importance to Pater, especially as an art critic, and hinted too, slightly more specifically, at the closet relationship between the poet's sonnet, first published in 1873, and Pater's 'Conclusion', which in the same year reprinted the final paragraphs of the article from 1868 about Morris's poems. For one thing, both of them were influenced by Gautier's aestheticist claim, in his 'Preface', that 'the only things that are really beautiful are those which have no use'; for another thing, Swinburne's evocation of man feeling 'his soul burn as an altar-fire | To the unknown God of unachieved desire' manifestly recalls Pater's notorious injunction to the reader of *Studies* to 'burn always with this hard, gem-like flame'.[29] Wilde—who in the 1870s 'adopted "flame-like" as one of his favourite adjectives'—must have been conscious of these connections.[30]

[27] Pater, *Marius the Epicurean*, p. 119.

[28] Seiler, ed., *Walter Pater*, p. 233.

[29] See Théophile Gautier, *Mademoiselle Maupin*, trans. and ed. Helen Constantine (Harmondsworth: Penguin, 2005), p. 23; and Algernon Charles Swinburne, *Major Poems and Selected Prose*, ed. Jerome McGann and Charles L. Sligh (New Haven: Yale University Press, 2004), p. 170.

[30] Richard Ellmann, *Oscar Wilde* (Harmondsworth: Penguin, 1987), p. 46.

And there can be no doubt that he is also echoing Pater's character-
ization of the *Metamorphoses*, insofar as it stands in for *Studies in the
History of the Renaissance*, in *Marius the Epicurean*.

It was in his first term as an undergraduate in 1874 that Wilde was
seduced by *Studies*. Thereafter, he did not lose opportunities to
praise it, both in conversation and in print. Its influence on him ran
deep. His lecture on 'The English Renaissance of Art', for instance,
delivered in New York in 1882, is indebted to it throughout. More
sensationally, the description of the 'poisonous book' that Dorian is
fated to read in *The Picture of Dorian Gray* (1891), though it evokes
J.-K. Huysmans' *À rebours* (1884), also voices Wilde's continued
fascination for Pater's *Studies*. Indeed, the account of its 'curious
jewelled style, vivid and obscure at once, full of argot and of archa-
isms', and of the mysterious musical effects of its sentences, which
induce 'a form of reverie, a malady of dreaming', seem directly to
recall Pater's descriptions of the *Metamorphoses in Marius*.[31] Finally,
in *De Profundis*, the testament that he composed from his prison cell
in a state of spiritual fever in 1897, Wilde still referred to it, melan-
cholically enough, as 'that book which has had such a strange influ-
ence on my life'.[32] In a sense, then, and in a characteristically
theatrical mode, Wilde incarnated the ideal reader that *Studies* had
secretly constructed. For precisely that reason, however, he was also
the reader that it most forcefully denied. The Wildean reader was the
one whose name Pater's *Studies* dared not speak. It is perhaps for this
reason that the friendship between the two men, which had been
relatively intimate in the late 1870s, became increasingly complicated
in the course of the 1880s. It appears that, as the drama of the
decadent movement unfolded at the *fin de siècle*, Wilde never fully
forgave Pater for failing to act as John the Baptist to his Christ. For
his part, Pater probably had Wilde in mind when, comparing
Heraclitus and Aristippus in the chapter on Cyrenaicism in *Marius
the Epicurean*, he emphasized 'the difference between the mystic in
his cell, or the prophet in the desert, and the expert, cosmopolitan,
administrator of his dark sayings'.[33]

[31] Oscar Wilde, *The Picture of Dorian Gray*, in *Oscar Wilde: The Oxford Authors*, ed.
Isobel Murray (Oxford: Oxford University Press, 1989), p. 141.

[32] Oscar Wilde, *De Profundis and Other Writings*, ed. Hesketh Pearson
(Harmondsworth: Penguin, 1986), p. 158.

[33] Pater, *Marius the Epicurean*, p. 111.

Other admirers of *Studies* also testified to its talismanic force when it first appeared, if in more conflicted language than Wilde's florid admiration afforded. For the poet and critic J. A. Symonds, to take a significant example, the book's fortunes seem to have been lucky and unlucky at the same time. 'The Style', he wrote to Swinburne in a slightly slippery compliment to the book's potency of effect, 'has an indescribable perfume & charm.'[34] Symonds's review of *Studies* in the *Academy* of March 1873 was broadly positive, but it failed to conceal a dislike of Pater that had increased on both sides since their first, relatively friendly encounters in the early 1860s. This mutual suspicion, reinforced by the fact that in the course of that decade both became specialists in the Italian Renaissance, was probably further compounded by the fact that, although Pater had liberally quoted Symonds's translations of Michelangelo's sonnets in *Studies*, he failed to cite him by name. Symonds was distinctly relieved that, in spite of its calculatedly ambivalent quality, the review had not displeased Pater. In private, though, he was rather less polite about *Studies*, which he evidently viewed with contradictory emotions no doubt related to his own attempt at this time to come to terms with his homosexuality. In a letter of February 1873, he attacked it for having the 'wormy hollow-voiced seductiveness of a fiend': 'There is a kind of Death clinging to the man,' he told this correspondent, 'wh[ich] makes his music (but heavens! how sweet it is!) a little faint and sickly.'[35] This admixture of beauty and death, one of the persistent thematic obsessions of *Studies* (as the chapter on Leonardo indicates), is an aspect of its form too that is at once appalling and insidiously appealing to Symonds. In *Marius*, again referring to the tale of Cupid and Psyche, Pater characterizes it as 'the fatality which seems to haunt any signal beauty, whether moral or physical, as if it were in itself something illicit and isolating'.[36] For Symonds, the peculiar aura of *Studies* was itself illicit and oddly isolating, perhaps because he could not accept that he too was in practice one of its ideal readers.

The openly adverse responses to *Studies*, which in spite of some highly positive reviews tended to dominate its reception, reacted far more violently to this elusive scent that, in its savour both of beauty

[34] Seiler, ed., *Walter Pater*, p. 55.

[35] Ibid. p. 55.

[36] Pater, *Marius the Epicurean*, p. 87.

and fatality, seemed to cling to the book's pages. But these attacks are themselves too deeply emotive to seem unambivalent. For instance, the chaplain of the college at which Pater himself taught, John Wordsworth, the poet's great-nephew, sent an outraged letter of complaint to his colleague that at the same time testified to the fiendish seductiveness of the book's use of language:

No one can admire more than I do the beauty of style and the felicity of thought by which it is distinguished, but I must add that no one can be more grieved at the conclusions at which you represent yourself as having arrived. I owe so much to you in time past, and have so much to thank you for as a colleague more recently, that I am very much pained in making this avowal. But after a perusal of the book I cannot disguise from myself that the concluding pages adequately sum up the philosophy of the whole.[37]

Wordsworth's efforts to divorce the book's philosophy from its literary style are finally unconvincing: the 'felicity of thought' that he confesses to admiring seems to collapse the difference between them, mediating as it does between form and content. He is in fact troubled precisely because Pater's serpentine sentences are absolutely inseparable from his poisonous ideas. This is the concealed logic of Pater's ceaseless, almost utopian pursuit, in the language of prose in particular, to find 'the unique word, phrase, sentence, paragraph, essay, or song, absolutely proper to the single mental presentation or vision within', as he put it in 'Style' (1888).[38] Wordsworth had himself been privately taught by Pater as an undergraduate, so it is as if in retrospect this respectable chaplain suddenly comprehends the temptations to which, as a student, he had been exposed in his relationship with Pater. 'Could you indeed have known the dangers into which you were likely to lead minds weaker than your own,' he writes plaintively, 'you would, I believe, have paused.'[39]

This fear of the book's potentially egregious effect on the young is characteristic of most of the negative responses to it. So in a rather desperate sermon preached at Christ Church Cathedral in 1875, the Bishop of Oxford, John Fielder Mackarness, decried the fact that, 'when they cross the threshold of their lecture-rooms', students are

[37] Seiler, ed., *Walter Pater*, pp. 61–2.

[38] Walter Pater, *Appreciations, With an Essay on Style* (London: Macmillan, 1924), p. 29.

[39] Seiler, ed., *Walter Pater*, p. 62.

expected by their tutors to refuse the authority of Christianity and to capitulate instead to philosophical scepticism. He then recited several supposedly inflammatory sentences from Pater's 'Conclusion' in order to underline his claim that 'learners in the school of unbelief have been taught that it is folly to disturb themselves for the sake of others'. 'They have lost all motive for serious action,' he continued, 'self-restraint and self-sacrifice are discovered to be "mere moral babble".' The dystopian future that the Bishop fears is foremost one in which a generation of ruling-class youths, like fallen angels, casually laugh in the face of Christian authority: 'Can you wonder that some who played an honourable part in Oxford life a generation since,' he asked, 'refuse to let their sons imbibe lessons so alien from the lore they learned?'[40] He also probably fears a future in which, far from taking up their political responsibilities, these spiritually enfeebled adolescents simply loaf about, like lotus-eaters, in an effete, if not openly homoerotic state of euphoria. This is after all the outset of an epoch of imperialism, and in the succeeding decades opinions like this will harden into a rigidly ideological discourse on the dangers of 'degeneration'.

After the publication of the 'Conclusion' to *Studies* in 1873, Pater reacted nervously to the letters, reviews, and sermons attacking it for its 'hedonism' and 'Cyrenaicism', as *Marius the Epicurean* testifies. In the second edition, which came out in 1877, the first to be retitled *The Renaissance: Studies in Art and Poetry*, he silently retracted it, to the disappointment of acolytes like Wilde. He reinstated it in the third edition, of 1888, and added a footnote to explain his actions (one retained in the fourth edition of 1893):

This brief 'Conclusion' was omitted in the second edition of this book, as I conceived it might possibly mislead some young men into whose hands it might fall. On the whole, I have thought it best to reprint it here, with some slight changes which bring it close to my original meaning. I have dealt more fully in *Marius the Epicurean* with the thoughts expressed by it.[41]

Disingenuously enough, Pater claims in this footnote to have been afraid that *Studies* was in danger of falling into the hands of those to whom he had effectively directed it in the first place. No doubt from

[40] Ibid. pp. 95–6.
[41] Pater, *The Renaissance*, ed. Hill, p. 186.

the outset Pater had been sensitive to complaints that threatened to shine a spotlight on his tutorial practice, or even on the iniquitous environment in which, according to the insinuations of Mackarness, he lectured. There is, though, a sequence of more immediate reasons for his decision to excise the 'Conclusion' from the second edition. The first of these was the scandal caused by an openly homosexual undergraduate called William Money Hardinge, with whom Pater had corresponded in ill-advised terms. It is probably because of this episode, in which Benjamin Jowett became involved, that John Wordsworth (of all people) was appointed to a university proctorship instead of Pater.[42] Then in 1875 the Bishop of Oxford delivered his damning sermon on Paterian aestheticism, as if to retrain the attention of Pater's critics. Thereafter, from the summer of 1876, W. H. Mallock's *The New Republic*, which contained a spiteful satirical portrait of Pater in the shape of the Pre-Raphaelite Mr Rose, kept his name circulating in the public sphere. Finally, in 1877 itself, after applying for the professorship of poetry at Oxford, both Pater and Symonds were forced to withdraw their names because of coded homophobic attacks on their candidacy. In addition to these events, and the perpetual gossip of petty-minded tutors and undergraduates in Oxford, there was throughout the mid-1870s a steady stream of innuendo in the periodical press that associated aestheticism with homosexuality. The term 'aestheticism', by this time, signified not so much a cultural impulse as a cluster of neurotic symptoms.

The fears dramatized by *Studies*, and then played out in the editorial changes made to *The Renaissance*, ultimately focus what might be called its prophylactic effect—its capacity, to put it simply, for interfering with the ability of the ruling class to reproduce itself, both socially and sexually. The book's assertion that 'no fixed principles either of religion or morality can be regarded as certain', as Wordsworth had phrased it, patently represents an ideological threat. Its cryptic celebration of male friendship, furthermore, represents an almost biological threat, for it silently refuses the 'compulsory heterosexuality' characteristic of late nineteenth-century Oxford in particular.[43] In this respect, the polemics aimed at Pater recall the

[42] See Billie Andrew Inman, 'Estrangement and Connection: Walter Pater, Benjamin Jowett, and William M. Hardinge', in Laurel Brake and Ian Small, eds., *Pater in the 1990s* (Greensboro, NC: ELT Press, 1991), pp. 1–20.

[43] Richard Dellamora, *Masculine Desire: The Sexual Politics of Victorian Aestheticism* (Chapel Hill: University of North Carolina Press, 1990), p. 193.

attack on Tennyson and Browning by Walter Bagehot, the economist and critic, in an essay published in the conservative *National Review* in 1864. Bagehot's concluding paragraph points to the moral failures of Tennyson's and Browning's verse, identified with 'ornate art' and 'grotesque art' respectively. In the absence of a 'pure art' like that of William Wordsworth, he argues, young men are vulnerable to a poetry that replicates and so reinforces the most demoralizing aspects of contemporary culture:

Without guidance young men, and tired men, are thrown amongst a mass of books; they have to choose which they like; many of them would much like to improve their culture, to chasten their taste, if they knew how. But left to themselves they take, not pure art, but showy art; not that which permanently relieves the eye and makes it happy whenever it looks, and as long as it looks, but *glaring* art which catches and arrests the eye for a moment, but which in the end fatigues it. But before the wholesome remedy of nature—the fatigue—arrives, the hasty reader has passed on to some new excitement, which in its turn stimulates for an instant, and then is passed by for ever.[44]

In a largely complimentary review of *Studies* in the *Fortnightly Review*, John Morley complained that Pater's extraordinary prose style 'may easily degenerate into vulgarity or weedy rankness or the grotesque'.[45] Pater's hymn to the impression in *Studies*, in locating aesthetics in the pulsations of an eroticized, apparently effeminate body, and in installing the instant, the moment, at the centre of an entire ethics, seems to realize Bagehot's deepest fears. In its emphasis on excitement—on 'the race of the midstream, a drift of momentary acts of sight and passion and thought', as the 'Conclusion' frames it (p. 208)—it makes explicit the qualities that are only implicit, according to Bagehot, in Tennyson and Browning.

In some respects, Pater's attitude to the rise of mass culture is probably closer to Bagehot's than this implies. Both are made uncomfortable by what Pater identifies as 'our alien modern atmosphere'; both are effectively in retreat from the characteristic product of this atmosphere that Bagehot calls the '*glaring* art which catches

[44] Walter Bagehot, 'Wordsworth, Tennyson, and Browning; or, Pure, Ornate, and Grotesque Art in English Poetry', in *The Collected Works of Walter Bagehot*, ed. Norman St John-Stevas, vol. ii (London: The Economist, 1965), pp. 365–6.

[45] Seiler, ed., *Walter Pater*, p. 64.

and arrests the eye for a moment'. But where Bagehot prescribes 'the wholesome remedy of nature', Pater promotes a solution that is irreducibly urban. Meditating on the ascetic, and therefore morally acceptable, aspects of epicureanism in *Marius the Epicurean*, which he typifies in terms of a priestly commitment to the 'contemplation of what is beautiful', Pater reflects that even 'life in modern London' offers an environment that might satisfy an aesthete: 'and the very sense and enjoyment of an experience in which all is new, are but enhanced . . . by the thought of its brevity, giving him something of a gambler's zest, in the apprehension, by dexterous act or diligently appreciative thought, of the highly coloured moments which are to pass away so quickly.'[46] These 'highly coloured moments' self-consciously allude to the 'Conclusion' of *Studies*, and makes it apparent, in retrospect, that Pater had used the paragraphs that he took from his assessment of Morris's poems to shape a specifically urban aesthetic. Paterian aestheticism is not simply an escape from the conditions of everyday life in industrial capitalist society, it is an attempt to redeem them—and in this respect it is like the Baudelairean aestheticism that Swinburne had mediated for him. Pater's poetic account of consciousness in the 'Conclusion'—in which experience 'is ringed round for each one of us by that thick wall of personality through which no real voice has ever pierced on its way to us' (p. 118)—implicitly situates the alienated subject that he hopes to emancipate in 'modern London'. His insistence that 'our failure is to form habits' is an indictment of the mechanization and routinization of urban life. His claim that, in a 'stereotyped world', 'it is only the roughness of the eye that makes any two persons, things, situations, seem alike', evokes a human sensorium that has been fatally eroded by the social conditions of the city (pp. 119–120). In this situation, though, the impressionist aesthetic passes through modernity rather than around it. Pater takes the moment that has been emptied out and promises to fill it up—as metropolitan modernists like Joyce did when, learning from Pater's example, they secularized the concept of the epiphany in the early twentieth century. If the 'impression of the individual in his isolation to which, for each one of us, experience dwindles down' has left the individual in a state of spiritual attenuation, then it is in reclaiming and replenishing these impressions, according to Pater, that salvation can be found (p. 118).

[46] Pater, *Marius the Epicurean*, p. 183.

Studies is thus an attempt to educate the senses so that they transcend as opposed to simply escape the demands of modernity. It is not a series of studies in the history of the Renaissance so much as a sequence of paradigmatic encounters with the idea of the Renaissance as Pater understood it. It takes repeated leaps into the past. Each chapter is an experimental attempt to use the impressionist aesthetic to redeem experience in spite of its alienation in the late nineteenth century. These encounters—at once scientific, necromantic, and erotic—self-consciously seek to restore a sense of aura to the work of art in the age of its technological reproduction. Faced with what Benjamin called 'the disintegration of the aura' in industrial society, Pater tried to imbue the paintings, poems, and sculptures that he explored with a sense of their unique spiritual presence.[47] In *Studies* each of the artefacts that he examines acts as an icon that testifies to the ritual function of the aesthetic, its cult appeal, in an epoch in which it threatens to become no more than an especially ornamental commodity. It therefore seems appropriate that, almost a century and a half after its publication, the book's mesmerizing prose still radiates an extraordinary intensity of affect. Pater's *Studies in the History of the Renaissance*, to paraphrase his description of the *Metamorphoses* in *Marius the Epicurean*, has never lost its power to revive the impressions that it occasioned when it shocked and seduced its first readers in 1873. Like Leonardo's paintings, it induces 'strange thoughts and fantastic reveries and exquisite passions' (p. 70).

[47] Benjamin, 'On Some Motifs in Baudelaire', in *Illuminations*, p. 185.

NOTE ON THE TEXT

In the chapter on Winckelmann, Pater reports that, at the precise moment that his murderer entered the room in order to kill him, the famous art historian was 'writing "memoranda for the future editor of the 'History of Art,'"' still seeking the perfection of his great work'. It is unfortunate that Pater himself, who had recently been preparing a manuscript on Pascal, was not compiling memoranda for the future editor of his book on the Renaissance when he died, suddenly enough, in 1894. For no manuscripts or proof copies of it remain. In a sense, though, Pater was still seeking the perfection of his great work, and as recently as 1893 he had corrected the fourth and final edition of it to appear in his lifetime.

The first edition, which consisted of ten chapters, half of which were revised versions of articles previously printed in periodicals, was published as *Studies in the History of the Renaissance* in 1873. A second, revised edition, from which Pater removed the controversial 'Conclusion', was published in 1877. Like the editions that succeeded it, this one was retitled *The Renaissance: Studies in Art and Poetry*—no doubt because Francis Pattison had opened her unsigned review of the first edition, printed in the *Westminster Review* in April 1873, with the forcefully articulated complaint that 'the title is misleading', since 'the historical element is precisely that which is wanting, and its absence makes the weak place of the whole book'. A third edition of *The Renaissance*, again substantially altered, not least because Pater added the chapter on 'The School of Giorgione', came out in 1888. It is however the fourth edition that, because it incorporates Pater's latest corrections, has generally been interpreted as the most authoritative text. Donald L. Hill, for instance, in the most definitive scholarly edition of *The Renaissance* to date, announces that he has chosen to reproduce it because it is 'the latest text that Pater saw through the press', and 'the one which thus embodies his own maturest judgements in matters of form, style, and meaning'. It is not perhaps quite as simple a matter as Hill implies, though. In an article on 'Editing and Annotating Pater', collected in *Pater in the 1990s* (1991), Ian Small has helpfully pointed out that the changes Pater made both to the individual chapters that comprise *The Renaissance* and to the

book as a whole make prescriptive solutions to its editorial problems seem positively irrelevant. 'At what point these different "editions" can be said to be different works is not easy to determine,' he concludes.

In the present edition, I have elected to reproduce the text of *Studies in the History of the Renaissance*, the book which appeared in 1873. I have taken this decision principally because it is this work that had the most controversial impact on contemporary debates about aesthetics and ethics. This is the edition, to put it simply, that scandalized the middle classes. Perhaps because of its mode of consumption as much as its mode of composition, it thus seems closest to being a manifesto for nineteenth-century English aestheticism. The most striking defect of this text for a modern reader, though, is that (like the second edition) it does not include 'The School of Giorgione'; so I have incorporated this crucially important chapter, which it is imperative not to excise altogether, as an Appendix. The names of Lionardo da Vinci and Pico della Mirandula, spelt thus in the first edition but not in subsequent editions, have been modernized. I have used the Explanatory Notes to explain, and on a number of occasions reproduce, the most significant changes, as I perceive them, that Pater made in the second, third, and fourth editions; I have in addition used them to record the publication details of those chapters that had already appeared in the periodical press. In preparing these Notes I have made extensive use of Hill's incomparable edition of the 1893 text, like all academics to have worked on Pater in the last three decades, and I would consequently like to record my gratitude for his formidable scholarship. The annotations I have made to the first edition, although not as comprehensive as Hill's to the fourth edition, nor I hope as intimidating to most readers, are nonetheless relatively detailed, and also contain material that he does not include. This has been necessary because Pater's richly textured prose is replete with allusions and intertextual resonances that are inaccessible to all but specialist readers today. Furthermore, 'Pater is particularly artful in quoting others without acknowledgement of the source, or indeed, quotation, at all', as Laurel Brake, the foremost Paterian scholar in the UK, has pointed out. I hope, however, that these Explanatory Notes, and the Glossary of Names that I have also included, will ultimately concentrate rather than dilute the often intoxicating pleasure of reading Pater.

All footnotes in the text are by Pater; asterisks refer to the Explanatory Notes at the back of the book.

SELECT BIBLIOGRAPHY

Editions of The Renaissance

The Renaissance: Studies in Art and Poetry, to which is added the essay on Raphael from Miscellaneous Studies, ed. Kenneth Clark (London: Collins, 1961).

The Renaissance: Studies in Art and Poetry: The 1893 Text, ed. Donald L. Hill (Berkeley and Los Angeles: University of California Press, 1980).

Works by Walter Pater

New Library Edition of the Works of Walter Pater, 10 vols. (London: Macmillan, 1910).

Walter Pater: Essays on Literature and Art, ed. Jennifer Uglow (London: Dent, 1973).

Marius the Epicurean, ed. Michael Levey (Harmondsworth: Penguin, 1985).

Imaginary Portraits, with The Child in the House and Gaston de la Tour, ed. Bill Beckley (New York: Allworth Press, 1997).

Bibliography

Franklin E. Court, *Water Pater: An Annotated Bibliography of Writings about Him* (De Kalb, Ill.: Northern Illinois Press, 1980).

Billie Andrew Inman, *Walter Pater and his Reading 1874–1877, with a Bibliography of his Literary Borrowings, 1878–1894* (New York: Garland, 1990).

Biography and Letters

Laurel Brake, 'Pater, Walter Horatio (1839–1894), Author and Aesthete', *Oxford Dictionary of National Biography*.

Michael Levey, *The Case of Walter Pater* (London: Thames & Hudson, 1978).

Walter Pater, *Letters of Walter Pater*, ed. Lawrence Evans (Oxford: Clarendon Press, 1970).

Robert M. Seiler, *The Book Beautiful: Walter Pater and the House of Macmillan* (London: Athlone Press, 1999).

Studies of Walter Pater

Stephen Bann, ed., *The Reception of Walter Pater in Europe* (Bristol: Thoemmes Press, 2004).

Paul Barolsky, *Walter Pater's Renaissance* (Pennsylvania: Pennsylvania State University Press, 1987).

Harold Bloom, ed., *Walter Pater: Modern Critical Views* (New York: Chelsea House, 1985).

Laurel Brake, *Walter Pater* (Plymouth: Northcote House, 1994).

Laurel Brake and Ian Small, eds., *Pater in the 1990s* (Greensboro, NC: ELT Press, 1991).

Laurel Brake, Lesley Higgins, and Carolyn Williams, eds., *Walter Pater: Transparencies of Desire* (Greensboro, NC: ELT Press, 2002).

William Earl Buckler, *Walter Pater: The Critic as Artist of Ideas* (New York: New York University Press, 1987).

Elicia Clements and Lesley Higgins, eds., *Victorian Aesthetic Conditions: Pater across the Arts* (Basingstoke: Palgrave, 2009).

John J. Conlon, *Walter Pater and the French Tradition* (London: Bucknell University Press, 1982).

Kenneth Daley, *The Rescue of Romanticism: Walter Pater and John Ruskin* (Athens, Oh.: Ohio University Press, 2001).

Denis Donoghue, *Walter Pater: Lover of Strange Souls* (New York: Knopf, 1995).

Stefano-Maria Evangelista, 'Walter Pater's Romantic Hellenism', unpublished D.Phil. thesis (Oxford: University of Oxford, 2003).

Jay Fellows, *Tombs Despoiled and Haunted: 'Under-Textures' and 'After-Thoughts' in Walter Pater* (Stanford, Calif.: Stanford University Press, 1991).

Wolfgang Iser, *Walter Pater: The Aesthetic Moment*, trans. David Henry Wilson (Cambridge: Cambridge University Press, 1987).

Robert Keefe and Janice A. Keefe, *Walter Pater and the Gods of Disorder* (Athens, Oh.: Ohio University Press, 1988).

Jonathan Loesberg, *Aestheticism and Deconstruction: Pater, Derrida, and de Man* (Princeton: Princeton University Press, 1991).

F. C. McGrath, *The Sensible Spirit: Walter Pater and the Modernist Paradigm* (Tampa, Fla.: University of Florida Press, 1986).

Perry Meisel, *The Absent Father: Virginia Woolf and Walter Pater* (New Haven: Yale University Press, 1980).

Gerald Monsman, *Walter Pater* (Boston: Twayne, 1977).

——, *Walter Pater's Art of Autobiography* (New Haven: Yale University Press, 1980).

R. M. Seiler, ed., *Walter Pater: The Critical Heritage* (London: Routledge & Kegan Paul, 1980).

William F. Shuter, *Rereading Walter Pater* (Cambridge: Cambridge University Press, 1997).

Anthony Ward, *Walter Pater: The Idea in Nature* (London: MacGibbon & Kee, 1966).

Carolyn Williams, *Transfigured World: Walter Pater's Aesthetic Historicism* (Ithaca, NY: Cornell University Press, 1989).

More General Studies

James Eli Adams, *Dandies and Desert Saints: Styles of Victorian Masculinity* (Ithaca, NY: Cornell University Press, 1995).

Chris Baldick, *The Social Mission of English Criticism* (Oxford: Oxford University Press, 1983).

Laurel Brake, *Print in Transition, 1850–1910: Studies in Media and Book History* (Basingstoke: Palgrave, 2001).

David J. DeLaura, *Hebrew and Hellene in Victorian England: Newman, Arnold, and Pater* (Austin, Tex.: University of Texas Press, 1969).

Richard Dellamora, *Masculine Desire: The Sexual Politics of Victorian Aestheticism* (Chapel Hill, NC: University of North Carolina Press, 1990).

Linda Dowling, *Hellenism and Homosexuality in Victorian Oxford* (Ithaca, NY: Cornell University Press, 1994).

Jonathan Freedman, *Professions of Taste: Henry James, British Aestheticism, and Commodity Culture* (Stanford, Calif.: Stanford University Press, 1990).

Warwick Gould and Marjorie Reeves, *Joachime of Fiore and the Myth of the Eternal Evangel in the Nineteenth and Twentieth Centuries*, rev. edn. (Oxford: Oxford University Press, 2001).

Josephine M. Guy, *The British Avant-Garde: The Theory and Politics of Tradition* (London: Harvester Wheatsheaf, 1991).

Graham Hough, *The Last Romantics* (London: Duckworth, 1949).

Frank Kermode, *Romantic Image* (London: Routledge & Kegan Paul, 1957).

U. C. Knoepflmacher, *Religious Humanism and the Victorian Novel: George Eliot, Walter Pater, and Samuel Butler* (Princeton: Princeton University Press, 1970).

Caroline Levine, *The Serious Pleasures of Suspense: Victorian Realism and Narrative Doubt* (Charlottesville, Va.: University of Virginia Press, 2003).

Jesse Matz, *Literary Impressionism and Modernist Aesthetics* (Cambridge: Cambridge University Press, 2001).

Catherine Maxwell, *Second Sight: The Visionary Imagination in Late Victorian Literature* (Manchester: Manchester University Press, 2008).

Ian Small, *Conditions for Criticism: Authority, Knowledge, and Literature in the Late Nineteenth Century* (Oxford: Clarendon Press, 1991).

Herbert Sussman, *Victorian Masculinities* (Cambridge: Cambridge University Press, 1995).

Further Reading in Oxford World's Classics

Michelangelo, *Life, Letters, and Poetry*, trans. George Bull and Peter Porter.

John Ruskin, *Selected Writings*, ed. Dinah Birch.

Giorgio Vasari, *The Lives of the Artists*, trans. Julia Conaway Bondanella and Peter Bondanella.

A CHRONOLOGY OF WALTER PATER

1839 Pater is born on 4 August at 1 Honduras Terrace, Commercial Road, Stepney, in London, the third child of Richard Glode Pater (1797?–1842), a surgeon, and Maria Hill (1803?–54); the other children are William (1835–87), Hester (1837–1922), and Clara (1841–1910).

1842 Father dies of an 'affection of the brain', and the family move, first to Grove Street, Hackney, then to Chase Side, Enfield, where Pater attends the local grammar school.

1853 After the family's move to Harbledown, Kent, Pater attends the King's School, Canterbury, as a day boy.

1854 Mother dies.

1855 Forms the 'Triumvirate' with close school-friends Henry Dombrain and John Rainier McQueen (it is dissolved in 1858, in part perhaps because of his increasing alienation from Christianity).

1856 Writes several poems, including 'St. Elizabeth of Hungary' and 'The Chant of the Celestial Sailors' (he destroys most of his poems in 1864 or 1865).

1857 Matthew Arnold is elected Professor of Poetry at Oxford.

1858 Leaves the King's School with prizes in Latin and Ecclesiastical History, and enters Queen's College, Oxford, to read Classics; Pater's sisters move to Heidelberg with their aunt.

1860 Estrangement from McQueen.

1861 Benjamin Jowett, a contributor to *Essays and Reviews* (1860) and subsequently the Master of Balliol, tutors Pater and his friend Ingram Bywater.

1862 Takes a second-class degree in Literae Humaniores; rents rooms in the High Street, Oxford, where he privately teaches students (including, from 1863, Charles Shadwell); fails to obtain a curacy, no doubt partly because McQueen denounces him to the Bishop of London as an apostate; after the death of his aunt, travels to Dresden and accompanies his sisters back to London.

1863 Elected, like Bywater, to the Old Mortality, a university essay society; fails to obtain clerical fellowships at Trinity College and Brasenose College.

1864 Appointed, on a probationary basis, to a non-clerical fellowship in Classics at Brasenose; presents two essays, 'Subjective Immortality'

Chronology

and 'Diaphaneitè', to Old Mortality (the former, on Fichte, is lost); visits Paris with his sisters.

1865 Travels to Florence, Pisa, and Ravenna with Shadwell.

1866 Publishes 'Coleridge's Writings', unsigned, in the *Westminster Review*; teaches Gerard Manley Hopkins.

1867 Publishes 'Winckelmann', unsigned, in the *Westminster Review*; lectures as well as tutors at Brasenose.

1868 Publishes 'Poems by William Morris', unsigned, in the *Westminster Review*.

1869 Moves to Bradmore Road, Oxford, with his sisters; publishes 'Notes on Leonardo da Vinci', the first article that he signs, in the *Fortnightly Review*.

1870 Publishes 'A Fragment on Sandro Botticelli' in the *Fortnightly Review*; John Ruskin is elected Slade Professor of Art at Oxford.

1871 Publishes both 'Pico della Mirandola' and 'The Poetry of Michelangelo' in the *Fortnightly Review*.

1872 Publishes a review of Sidney Colvin's *Children in Italian and English Design* (1872) in the *Academy*; writes 'Aucassin and Nicolette', 'Luca della Robbia', 'Joachim du Bellay', and the 'Preface' to *Studies in the History of the Renaissance*; visits Arezzo.

1873 Publishes *Studies in the History of the Renaissance* (Macmillan); Pater's friend the painter Simeon Solomon is imprisoned on a charge of gross indecency.

1874 Publishes 'On Wordsworth' and 'A Fragment on *Measure for Measure*' in the *Fortnightly Review*; is reprimanded by Jowett, who has seen intimate letters sent from Pater to William Money Hardinge, an undergraduate at Balliol; is passed over for the university proctorship.

1875 Publishes a review of J. A. Symonds's *Renaissance in Italy: The Age of the Despots* (1875) in the *Academy*; Pater's friend Oscar Browning is sacked from his teaching post at Eton College.

1876 Publishes 'Romanticism' in *Macmillan's Magazine* and 'A Study of Dionysus' in the *Fortnightly Review*; lectures on 'Demeter and Persephone' at the Birmingham and Midland Institute; is satirized as Mr Rose in W. H. Mallock's *The New Republic*, serialized in *Belgravia*.

1877 Publishes the second edition of *Studies in the History of the Renaissance*, omitting its 'Conclusion' and retitling it *The Renaissance: Studies in Art and Poetry*; publishes 'The School of Giorgione' in

the *Fortnightly Review*; is proposed as a candidate for the professor-ship of poetry, but removes his name prior to the election (as does Symonds); meets Oscar Wilde; Whistler vs. Ruskin libel trial.

1878 Publishes 'The Child in the House', his first 'Imaginary Portrait', in *Macmillan's Magazine*, and 'The Character of the Humourist: Charles Lamb' in the *Fortnightly Review*; cancels a book for Macmillan entitled ' "Dionysus" and Other Studies'.

1880 Publishes two articles on 'The Beginnings of Greek Scuplture' and a further piece on 'The Marbles of Aegina' in the *Fortnightly Review*; also publishes 'Samuel Taylor Coleridge' in *The English Poets*, edited by T. H. Ward.

1881 Meets Vernon Lee.

1882 Visits Rome and other Italian cities.

1883 Publishes 'Dante Gabriel Rossetti' in *The English Poets*, edited by T. H. Ward; resigns his tutorship at Brasenose in order to concen-trate on his novel.

1885 Publishes his novel *Marius the Epicurean* (Macmillan); moves to Kensington, London, with his sisters (though he resides at Brasenose during the academic term); becomes Curator of the University Galleries; stands unsuccessfully for the Slade Professorship of Fine Art; meets George Moore.

1886 Publishes 'Sebastian van Storck' and two other 'Imaginary Portraits' in *Macmillan's Magazine*, and a number of reviews for daily, weekly, and monthly publications.

1887 Publishes *Imaginary Portraits* (Macmillan); Pater's elder brother William dies.

1888 The third edition of *The Renaissance*, to which the 'Conclusion' is restored, appears; publishes *Gaston de la Tour* in five parts in *Macmillan's Magazine*, though it remains unfinished, and the essay on 'Style' in the *Fortnightly Review*; meets Arthur Symons.

1889 Publishes *Appreciations: With an Essay on Style* (Macmillan); travels to Bergamo, Brescia, and Milan.

1890 Publishes 'Art Notes in North Italy' in the *New Review*; lectures on Prosper Mérimée in Oxford and William Wordsworth in London.

1891 Reviews Wilde's *The Picture of Dorian Gray* (1891) in the *Bookman*.

1892 Publishes 'Emerald Uthwart' in the *New Review*; also publishes pieces on Plato in *Macmillan's Magazine* and the *Contemporary Review*, and on Raphael in the *Fortnightly Review*.

1893 Publishes *Plato and Platonism* (Macmillan); also publishes 'The Age of Athletic Prizemen' in the *Contemporary Review* and 'Apollo in Picardy' in *Harper's New Monthly Magazine*; fourth edition of *The Renaissance* appears; moves back to Oxford with his sisters.

1894 Publishes two articles on 'Some Great Churches in France' in the *Nineteenth Century*; dies of a heart attack on 30 July in Oxford, after an attack of rheumatic fever and pleurisy, and is buried in Holywell Cemetery.

1895 *Greek Studies* (Macmillan) and *Miscellaneous Studies* (Macmillan), both edited by Shadwell, are published; 'Pascal', an unfinished article prepared for publication by Edmund Gosse, appears in the *Contemporary Review*.

1896 An expanded though still unfinished edition of *Gaston de la Tour*, edited by Shadwell, is published.

1910 The New Library Edition of *The Works of Walter Pater* (Macmillan), in ten volumes, is published.

STUDIES IN THE HISTORY OF
THE RENAISSANCE

PREFACE

MANY attempts have been made by writers on art and poetry to define beauty in the abstract, to express it in the most general terms, to find a universal formula for it. The value of such attempts has most often been in the suggestive and penetrating things said by the way. Such discussions help us very little to enjoy what has been well done in art or poetry, to discriminate between what is more and what is less excellent in them, or to use words like beauty, excellence, art, poetry, with more meaning than they would otherwise have. Beauty, like all other qualities presented to human experience, is relative; and the definition of it becomes unmeaning and useless in proportion to its abstractness. To define beauty not in the most abstract, but in the most concrete terms possible, not to find a universal formula for it, but the formula which expresses most adequately this or that special manifestation of it, is the aim of the true student of æsthetics.

'To see the object as in itself it really is,'* has been justly said to be the aim of all true criticism whatever; and in æsthetic criticism the first step towards seeing one's object as it really is, is to know one's own impression as it really is, to discriminate it, to realise it distinctly. The objects with which æsthetic criticism deals, music, poetry, artistic and accomplished forms of human life, are indeed receptacles of so many powers or forces; they possess, like natural elements, so many virtues or qualities. What is this song or picture, this engaging personality presented in life or in a book, to *me*? What effect does it really produce on me? Does it give me pleasure? and if so, what sort or degree of pleasure? How is my nature modified by its presence and under its influence? The answers to these questions are the original facts with which the æsthetic critic has to do; and, as in the study of light, of morals, of number, one must realise such primary data for oneself or not at all. And he who experiences these impressions strongly, and drives directly at the analysis and discrimination of them, need not trouble himself with the abstract question what beauty is in itself, or its exact relation to truth or experience,—metaphysical questions, as unprofitable as metaphysical questions elsewhere. He may pass them all by as being, answerable or not, of no interest to him.

The æsthetic critic, then, regards all the objects with which he has to do, all works of art and the fairer forms of nature and human life, as powers or forces, producing pleasurable sensations, each of a more or less peculiar and unique kind. This influence he feels and wishes to explain, analysing it, and reducing it to its elements. To him, the picture, the landscape, the engaging personality in life or in a book, La Gioconda, the hills of Carrara, Pico of Mirandola, are valuable for their virtues, as we say in speaking of a herb, a wine, a gem; for the property each has of affecting one with a special, unique impression of pleasure. Education grows in proportion as one's susceptibility to these impressions increases in depth and variety. And the function of the æsthetic critic is to distinguish, analyse, and separate from its adjuncts, the virtue by which a picture, a landscape, a fair personality in life or in a book, produces this special impression of beauty or pleasure, to indicate what the source of that impression is, and under what conditions it is experienced. His end is reached when he has disengaged that virtue, and noted it, as a chemist notes some natural element, for himself and others; and the rule for those who would reach this end is stated with great exactness in the words of a recent critic of Sainte-Beuve: 'De se borner à connaître de près les belles choses, et à s'en nourrir en exquis amateurs, en humanistes accomplis.'*

What is important, then, is not that the critic should possess a correct abstract definition of beauty for the intellect, but a certain kind of temperament, the power of being deeply moved by the presence of beautiful objects. He will remember always that beauty exists in many forms. To him all periods, types, schools of taste, are in themselves equal. In all ages there have been some excellent workmen and some excellent work done. The question he asks is always, In whom did the stir, the genius, the sentiment of the period find itself? who was the receptacle of its refinement, its elevation, its taste? 'The ages are all equal,' says William Blake, 'but genius is always above its age.'*

Often it will require great nicety to disengage this virtue from the commoner elements with which it may be found in combination. Few artists, not Goethe or Byron even, work quite cleanly, casting off all debris, and leaving us only what the heat of their imagination has wholly fused and transformed. Take for instance the writings of Wordsworth. The heat of his genius, entering into the substance of his work, has crystallised a part, but only a part, of it; and in that great mass of verse there is much which might well be forgotten. But scattered

up and down it, sometimes fusing and transforming entire composi-
tions, like the Stanzas on 'Resolution and Independence' and the
Ode on the 'Recollections of Childhood,' sometimes, as if at random,
turning a fine crystal here and there, in a matter it does not wholly
search through and transform, we trace the action of his unique
incommunicable faculty, that strange mystical sense of a life in nat-
ural things, and of man's life as a part of nature, drawing strength
and colour and character from local influences, from the hills and
streams and natural sights and sounds. Well! that is the *virtue*, the
active principle in Wordsworth's poetry; and then the function of the
critic of Wordsworth* is to trace that active principle, to disengage
it, to mark the degree in which it penetrates his verse.

The subjects of the following studies are taken from the history
of the Renaissance, and touch what I think the chief points in that
complex, many-sided movement. I have explained in the first of
them what I understand by the word, giving it a much wider scope
than was intended by those who originally used it to denote only that
revival of classical antiquity in the fifteenth century which was but
one of many results of a general stimulus and enlightening of the
human mind, and of which the great aim and achievements of what,
as Christian art, is often falsely opposed to the Renaissance, were
another result. This outbreak of the human spirit may be traced far
into the middle age itself, with its qualities already clearly pro-
nounced, the care for physical beauty, the worship of the body, the
breaking down of those limits which the religious system, of the
middle age imposed on the heart and the imagination. I have taken as
an example of this movement, this earlier Renaissance within the
middle age itself, and as an expression of its qualities, a little compo-
sition in early French; not because it is the best possible expression
of them, but because it helps the unity of my series, inasmuch as the
Renaissance ends also in France, in French poetry, in a phase of
which the writings of Joachim du Bellay are in many ways the most
perfect illustration; the Renaissance thus putting forth in France an
aftermath, a wonderful later growth, the products of which have to
the full the subtle and delicate sweetness which belong to a refined
and comely decadence; just as its earliest phases have the freshness
which belongs to all periods of growth in art, the charm of *ascesis*,* of
the austere and serious girding of the loins in youth.

But it is in Italy, in the fifteenth century, that the interest of the Renaissance mainly lies, in that solemn fifteenth century which can hardly be studied too much, not merely for its positive results in the things of the intellect and the imagination, its concrete works of art, its special and prominent personalities, with their profound æsthetic charm, but for its general spirit and character, for the ethical qualities of which it is a consummate type.

The various forms of intellectual activity which together make up the culture of an age, move for the most part from different starting points and by unconnected roads. As products of the same generation they partake indeed of a common character and unconsciously illustrate each other; but of the producers themselves, each group is solitary, gaining what advantage or disadvantage there may be in intellectual isolation. Art and poetry, philosophy and the religious life, and that other life of refined pleasure and action in the open places of the world, are each of them confined to its own circle of ideas, and those who prosecute either of them are generally little curious of the thoughts of others. There come however from time to time eras of more favourable conditions, in which the thoughts of men draw nearer together than is their wont, and the many interests of the intellectual world combine in one complete type of general culture. The fifteenth century in Italy is one of these happier eras; and what is sometimes said of the age of Pericles is true of that of Lorenzo—it is an age productive in personalities, many-sided, centralised, complete. Here, artists and philosophers and those whom the action of the world has elevated and made keen, do not live in isolation, but breathe a common air and catch light and heat from each other's thoughts. There is a spirit of general elevation and enlightenment in which all alike communicate. It is the unity of this spirit which gives unity to all the various products of the Renaissance, and it is to this intimate alliance with mind, this participation in the best thoughts which that age produced, that the art of Italy in the fifteenth century owes much of its grave dignity and influence.

I have added an essay on Winckelmann, as not incongruous with the studies which precede it, because Winckelmann, coming in the eighteenth century, really belongs in spirit to an earlier age. By his enthusiasm for the things of the intellect and the imagination for their own sake, by his Hellenism, his life-long struggle to attain to the Greek spirit, he is in sympathy with the humanists of an earlier century. He is the last fruit of the Renaissance, and explains in a striking way its motive and tendencies.

CONTENTS

AUCASSIN AND NICOLETTE[1]*

THE history of the Renaissance ends in France and carries us away from Italy to the beautiful cities of the country of the Loire. But it was in France also, in a very important sense, that the Renaissance had begun; and French writers, who are fond of connecting the creations of Italian genius with a French origin, who tell us how Saint Francis of Assisi took not his name only, but all those notions of chivalry and romantic love which so deeply penetrated his thoughts, from a French source, how Boccaccio borrowed the outlines of his stories from the old French *fabliaux*, and how Dante himself expressly connects the origin of the art of miniature painting with the city of Paris,* have often dwelt on this notion of a Renaissance in the end of the twelfth and beginning of the thirteenth century,—a Renaissance within the limits of the middle age itself, a brilliant but in part abortive effort to do for human life and the human mind what was afterwards done in the fifteenth. The word *Renaissance* indeed is now generally used to denote not merely that revival of classical antiquity which took place in the fifteenth century, and to which the word was first applied, but a whole complex movement, of which that revival of classical antiquity was but one element or symptom. For us the Renaissance is the name of a many-sided but yet united movement, in which the love of the things of the intellect and the imagination for their own sake, the desire for a more liberal and comely way of conceiving life, make themselves felt, prompting those who experience this desire to seek first one and then another means of intellectual or imaginative enjoyment, and directing them not merely to the discovery of old and forgotten sources of this enjoyment, but to divine new sources of it, new experiences, new subjects of poetry, new forms of art. Of this feeling there was a great outbreak in the end of the twelfth and the beginning of the following century. Here and there, under rare and happy conditions, in Pointed architecture, in the doctrines of romantic love, in the poetry of Provence, the rude strength of the middle age turns to sweetness; and the taste for sweetness generated there becomes the seed of the

[1] Aucassin et Nicolette. See Nouvelles Françoises du 13ᵉ siècle, a Paris, chez P. Jannet, libraire; M DCCC LVI.

classical revival in it, prompting it constantly to seek after the springs of perfect sweetness in the Hellenic world. And coming after a long period in which this instinct had been crushed, that true 'dark age,' in which so many sources of intellectual and imaginative enjoyment had actually disappeared, this outbreak is rightly called a Renaissance, a revival.

Theories which bring into connection with each other modes of thought and feeling, periods of taste, forms of art and poetry, which the narrowness of men's minds constantly tends to oppose to each other, have a great stimulus for the intellect and are almost always worth understanding. It is so with this theory of a Renaissance within the middle age, which seeks to establish a continuity between the most characteristic work of the middle age, the sculpture of Chartres and the windows of Lemans, and the work of the later Renaissance, the work of Jean Cousin and Germain Pilon, and thus heals that rupture between the middle age and the Renaissance which has so often been exaggerated. But it is not so much the ecclesiastical art of the middle age, its sculpture and painting,—work certainly done in a great measure for pleasure's sake, in which even a secular, a rebellious spirit often betrays itself,—but rather the profane poetry of the middle age, the poetry of Provence, and the magnificent aftergrowth of that poetry in Italy and France, which those French writers have in view when they speak of this Renaissance within the middle age. In that poetry, earthly passion, in its intimacy, its freedom, its variety—the liberty of the heart—makes itself felt; and the name of Abelard, the great clerk and the great lover, connects the expression of this liberty of heart with the free play of human intelligence round all subjects presented to it, with the liberty of the intellect, as that age understood it. Every one knows the legend of Abelard,* that legend hardly less passionate, certainly not less characteristic of the middle age, than the legend of Tannhäuser;* how the famous and comely clerk, in whom Wisdom, herself, self-possessed, pleasant, and discreet, seemed to sit enthroned, came to live in the house of a canon of the church of Notre-Dame, where dwelt a girl Héloïse, believed to be his orphan niece, his love for whom he had testified by giving her an education then unrivalled, so that rumour even asserted that, through the knowledge of languages, enabling her to penetrate into the mysteries of the older world, she had become a sorceress, like the Celtic druidesses; and how as they sat together in that shadowy

home, to refine a little further on the nature of abstract ideas, 'Love made himself of the party with them.'* You conceive the temptations of the scholar in that dreamy tranquillity, who, amid the bright and busy spectacle of 'the Island,'* lived in a world of something like shadows; and how for one who knew so well to assign its exact value to every abstract idea, those restraints which lie on the consciences of other men had been relaxed. It appears that he composed many verses in the vulgar tongue; already the young men sang them on the quay below the house. Those songs, says M. de Rémusat, were probably in the taste of the Trouvères,* of whom he was one of the first in date, or, so to speak, the predecessor; it is the same spirit which has moulded the famous 'letters' written in the quaint Latin of the middle age. At the foot of that early Gothic tower, which the next generation raised to grace the precincts of Abelard's school on the 'mountain' of Saint Genevieve, the historian Michelet* sees in thought 'a terrible assembly; not the hearers of Abelard alone, fifty bishops, twenty cardinals, two popes, the whole body of scholastic philosophy: not only the learned Héloïse, the teaching of languages and the Renaissance; but Arnold of Brescia,—that is to say, the revolution.'

And so from the rooms of that shadowy house by the Seine side we see that spirit going abroad, with its qualities already well-defined, its intimacy, its languid sweetness, its rebellion, its subtle skill in dividing the elements of human passion, its care for physical beauty, its worship of the body; which penetrated the early literature of Italy and finds an echo in Dante.*

The central love-poetry of Provence, the poetry of the *Tenson* and the *Aubade*, of Bernard de Ventadour and Pierre Vidal,* is poetry for the few, for the elect and peculiar people of the kingdom of sentiment. But below this intenser poetry there was probably a wide range of literature, less serious and elevated, reaching, by lightness of form and comparative homeliness of interest, an audience which the concentrated passion of those higher lyrics left untouched. This literature has long since perished, or lives only in later French or Italian versions. One such version, the only representative of its species, M. Fauriel thought he detected in the story of *Aucassin and Nicolette*, written in the French of the latter half of the thirteenth century, and preserved in a unique manuscript in the national library of Paris; and there were reasons which made him divine for it a still more ancient ancestry, traces in it of an Arabian origin, as in a leaf lost out of some

early Arabian Nights.* The little book loses none of its interest by the criticism which finds in it only a traditional subject, handed on from one people to another; for after passing thus from hand to hand, its outline is still clear and its surface untarnished; and, like many other stories, books, literary and artistic conceptions of the middle age, it has come to have in this way a sort of personal history almost as full of risk and adventure as that of its own heroes. The writer himself calls the piece a *cantefable*, a tale told in prose, but with its incidents and sentiment helped forward by songs, inserted at irregular intervals. In the junctions of the story itself there are signs of roughness and want of skill which make one suspect that the prose was only put together to connect a series of songs,—a series of songs so moving and attractive that people wished to heighten and dignify their effect by a regular framework or setting. Yet the songs themselves are of the simplest kind, not rhymed even, but only imperfectly assonant, stanzas of twenty or thirty lines apiece, all ending with a similar vowel sound. And here, as elsewhere in that early poetry, much of the interest is in the spectacle of the formation of a new artistic sense. A new music is arising, the music of rhymed poetry, and in the songs of Aucassin and Nicolette, which seem always on the point of passing into true rhyme, but which halt somehow, and can never quite take flight, you see people just growing aware of the elements of a new music in their possession, and anticipating how pleasant such music might become. The piece was probably intended to be recited by a company of trained performers, many of whom, at least for the lesser parts, were probably children. The songs are introduced by the rubric 'Or se cante'—ici on chante; and each division of prose by the rubric, 'Or dient et content et fabloient'—ici on conte.* The musical notes of part of the songs have been preserved; and some of the details are so descriptive that they suggested to M. Fauriel the notion that the words had been accompanied throughout by dramatic action. That mixture of simplicity and refinement which he was surprised to find in a composition of the thirteenth century is shown sometimes in the turn given to some passing expression or remark; thus, 'the Count de Garins, was old and frail, his time was over:—Li quens Garins de Beaucaire estoit vix et frales; si avoit son tans trespassè.' And then all is so realised! One still sees the ancient forest of Gastein, with its disused roads grown deep with grass, and the place where seven roads meet— 'u a forkeut

set cemin qui s'en vont par le païs'—we hear the lighthearted coun-
try people calling each other by their rustic names, and putting for-
ward as their spokesman one among them who is more eloquent and
ready than the rest—'li un qui plus fu enparlés des autres'; for the
little book has its burlesque too, so that one hears the faint far-off
laughter still. Rough as it is, the piece has certainly this high quality
of poetry that it aims at a purely artistic effect. Its subject is a great
sorrow, yet it claims to be a thing of joy and refreshment, to be enter-
tained not for its matter only, but chiefly for its manner; it is 'cortois,'
it tells us, 'et bien assis.'*

For the student of manners and of the old French language and
literature it has much interest of a purely antiquarian order. To say of
an ancient literary composition that it has an antiquarian interest,
often means that it has no distinct æsthetic interest for the reader of
to-day. Antiquarianism, by a purely historical effort, by putting its
object in perspective and setting the reader in a certain point of
view from which what gave pleasure to the past is pleasurable for him
also, may often add greatly to the charm we receive from ancient lit-
erature. But the first condition of such aid must be a real, direct,
æsthetic charm in the thing itself; unless it has that charm, unless
some purely artistic quality went to its original making, no merely
antiquarian effort can ever give it an æsthetic value or make it a proper
object of æsthetic criticism. These qualities, when they exist, it is
always pleasant to define, and discriminate from the sort of borrowed
interest which an old play, or an old story, may very likely acquire
through a true antiquarianism. The story of Aucassin and Nicolette
has some of these qualities. Aucassin, the only son of Count Garins of
Beaucaire, is passionately in love with Nicolette, a beautiful girl of
unknown parentage, bought of the Saracens, whom his father will not
permit him to marry. The story turns on the adventures of these two
lovers until at the end of the piece their mutual fidelity is rewarded.
These adventures are of the simplest sort, adventures which seem to
be chosen for the happy occasion they afford of keeping the eye of the
fancy, perhaps the outward eye, fixed on pleasant objects, a garden, a
ruined tower, the little hut of flowers which Nicolette constructs in
the forest as a token to Aucassin that she has passed that way. All the
charm of the piece is in its details, in a turn of peculiar lightness and
grace given to the situations and traits of sentiment, especially in its
quaint fragments of early French prose.

All through it one feels the influence of that faint air of overwrought delicacy, almost of wantonness, which was so strong a characteristic of the poetry of the Troubadours. The Troubadours themselves were often men of great rank; they wrote for an exclusive audience, people of much leisure and great refinement, and they came to value a type of personal beauty which has in it but little of the influence of the open air and sunshine. There is a faint Eastern delicacy in the very scenery of the story, the full-blown roses, the chamber painted in some mysterious manner where Nicolette is imprisoned, the cool brown marble, the almost nameless colours, the odour of plucked grass and flowers. Nicolette herself well becomes this scenery, and is the best illustration of the quality I mean, the beautiful weird foreign girl whom the shepherds take for a fay, who has the knowledge of simples, the healing and beautifying qualities of leaves and flowers, whose skilful touch heals Aucassin's sprained shoulder, so that he suddenly leaps from the ground; the mere sight of whose white flesh, as she passed the place where he lay, healed a pilgrim stricken with sore disease, so that he rose up and returned to his own country. With this girl Aucassin is so deeply in love that he forgets all knightly duties. At last Nicolette is shut up to get her out of his way, and perhaps the prettiest passage in the whole piece is the fragment of early prose which describes her escape from this place.

'Aucassin was put in prison, as you have heard, and Nicolette remained shut up in her chamber. It was summer-time, in the month of the May, when the days are warm and long and clear, and the nights coy and serene.

'One night Nicolette, lying on her bed, saw the moon shine clear through the little window and heard the nightingale sing in the garden, and then came the memory of Aucassin whom she so much loved. She thought of the Count Garins of Beaucaire, who so mortally hated her, and to be rid of her might at any moment cause her to be burned or drowned. She perceived that the old woman who kept her company was asleep; she rose and put on the fairest gown she had; she took the bed-clothes, and other pieces of stuff, and knotted them together like a cord as far as they would go. Then she tied the end to a pillar of the window and let herself slip down quite softly into the garden, and passed straight across it to reach the town.

'Her hair was fair, in small curls, her eyes smiling and of a greenish-blue colour, her face feat and clear, the little lips very red, the teeth

small and white; and the daisies which she crushed in passing, hold-
ing her skirt high behind and before, looked dark against her feet; the
girl was so white!

'She came to the garden-gate and opened it, and walked through
the streets of Beaucaire, keeping on the dark side of the street to
avoid the light of the moon which shone quietly in the sky. She
walked as fast as she could until she came to the tower where
Aucassin was. The tower was set about with pillars here and there.
She pressed herself against one of the pillars, wrapped herself close
in her mantle, and putting her face to a chink of the tower, which was
old and ruined, she heard Aucassin crying bitterly within, and when
she had listened a while she began to speak.'

But scattered up and down through this lighter matter, always tinged
with humour, and often passing into burlesque, which makes up the
general substance of the piece, there are morsels of a different qual-
ity, touches of some intenser sentiment, coming it would seem from
the profound and energetic spirit of the Provençal poetry itself, to
which the inspiration of the book has been referred. Let me gather
up these morsels of deeper colour, these expressions of the ideal
intensity of love, the motive which really unites together the frag-
ments of the little composition. Dante, the perfect flower of that ideal
love, has recorded how the tyranny of that 'Lord of terrible aspect'*
became actually physical, blinding his senses and suspending his
bodily forces. In this, Dante is but the central expression and type,
of experiences known well enough to the initiated, in that passionate
age. Aucassin represents this ideal intensity of passion—

> 'Aucassin, li biax, li blons,
> Li gentix, li amorous;—'*

the slim, tall, debonair figure, *dansellon,* as the singers call him, with
curled yellow hair and eyes of vair, who faints with love, as Dante
fainted, who rides all day through the forest in search of Nicolette,
while the thorns tear his flesh so that one might have traced him
by the blood upon the grass, and who weeps at evening because
he has not found her; who has the malady of his love so that he
neglects all knightly duties. Once he is induced to put himself at
the head of his people, that they, seeing him before them, might have
more heart to defend themselves; then a song relates how the sweet

grave figure goes forth to battle in dainty tight-laced armour. It is the very image of the Provençal love-god, no longer a child but grown to pensive youth, as Pierre Vidal* met him, riding on a white horse, fair as the morning, his vestment embroidered with flowers. He rode on through the gates into the open plain beyond. But as he went that strong malady of his love came upon him, so that the bridle fell from his hands; and like one who sleeps walking, he was carried on into the midst of the enemy, and heard them talking together how they might most conveniently kill him.

One of the strongest characteristics of that outbreak of the reason and the imagination, of that assertion of the liberty of the heart in the middle age, which I have termed a mediæval Renaissance, was its antinomianism,* its spirit of rebellion and revolt against the moral and religious ideas of the age. In their search after the pleasures of the senses and the imagination, in their care for beauty, in their worship of the body, people were impelled beyond the bounds of the primitive Christian ideal; and their love became a strange idolatry, a strange rival religion. It was the return of that ancient Venus, not dead, but only hidden for a time in the caves of the Venusberg, of those old pagan gods still going to and fro on the earth, under all sorts of disguises. The perfection of culture is not rebellion but peace; only when it has realised a deep moral stillness has it really reached its end. But often on the way to that end there is room for a noble antinomianism. This element in the middle age, so often ignored by those writers on it, who have said so much of the 'Ages of Faith,' this rebellious and antinomian element, the recognition of which has made the delineation of the middle age by the writers of the Romantic school in France, by Victor Hugo for instance, in 'Notre Dame de Paris,'* so suggestive and exciting, is found alike in the history of Abelard and the legend of Tannhäuser. More and more as we come to mark changes, and distinctions of temper, in what is often in one all-embracing confusion called the middle age, this rebellious element, this sinister claim for liberty of heart and thought, comes to the surface. The Albigensian movement,* connected so strangely with the history of Provençal poetry, is deeply tinged with it. A touch of it makes the Franciscan order, with its poetry, its mysticism, its *illumination*, from the point of view of religious authority, justly suspect. It influences the thoughts of those obscure prophetical writers, like Joachim of Flora,* strange dreamers in a world of flowery rhetoric of that third and final dispensation of a

spirit of freedom, in which law has passed away. Of this spirit
Aucassin and Nicolette contains perhaps the most famous expres-
sion; it is the answer Aucassin makes when he is threatened with the
pains of hell, if he makes Nicolette his mistress.*

'En paradis qu'ai-je à faire[1]? répondit Aucassin. Je ne me soucie
d'y aller, pourvu qui j'aie seulement Nicolette, ma douce mie, qui
j'aime tant. Qui va en paradis, sinon telles gens, comme je vous dirai
bien? Ces vieux prêtres y vont, ces vieux boiteux, ces vieux man-
chots, qui jour et nuit ae cramponnent aux autels, et aux chapelles.
Aussi y vont ces vieux moines en guenilles, qui marchent nu-pieds
ou en sandales rapiécetées, qui meurent de faim, de soif et de més-
aises. Voilà ceux qui vont en paradis; et avec telles gens n'ai je que
faire. Mais en enfer je veux bien aller; car en enfer vont les bons
clercs et les beaux chevaliers morts en bataille et en fortes guerres, les
braves sergents d'armes et les hommes de parage. Et avec tous ceux-
là veux-je bien aller. En enfer aussi vont les belles courtoises dames
qui, avec leurs maris, ont deux amis ou trois. L'or et l'argent y vont,
les belles fourrures, le vair et le gris. Les joueurs de harpe y vont, les
jongleurs et les rois du monde; et avec eux tous veux-je aller, pourvu
seulement qu'avec moi j'aie Nicolette, ma très-douce mie.'*

[1] I quote Fauriel's modernised version, in which he has retained however, some
archaic colour, *quelques légères teintes d'archäisme*.

PICO DELLA MIRANDOLA

No account of the Renaissance can be complete without some notice of the attempt made by certain Italian scholars of the fifteenth century to reconcile Christianity with the religion of ancient Greece. To reconcile forms of sentiment which at first sight seem incompatible, to adjust the various products of the human mind to each other in one many-sided type of intellectual culture, to give the human spirit for the heart and imagination to feed upon, as much as it could possibly receive, belonged to the generous instincts of that age. An earlier and simpler generation had seen in the gods of Greece so many malignant spirits, the defeated but still living centres of the religion of darkness, struggling, not always in vain, against the kingdom of light. Little by little, as the natural charm of pagan story reasserted itself over minds emerging out of barbarism, the religious significance which had once belonged to it was lost sight of, and it came to be regarded as the subject of a purely artistic or poetical treatment. But it was inevitable that from time to time minds should arise deeply enough impressed by its beauty and power to ask themselves whether the religion of Greece was indeed a rival of the religion of Christ; for the older gods had rehabilitated themselves, and men's allegiance was divided. And the fifteenth century was an impassioned age, so ardent and serious in its pursuit of art that it consecrated everything with which art had to do as a religious object. The restored Greek literature had made it familiar, at least in Plato, with a style of expression about the earlier gods, which had about it much of the warmth and unction of a Christian hymn. It was too familiar with such language to regard mythology as a mere story; and it was too serious to play with a religion.

'Let me briefly remind the reader,' says Heine, in the 'Gods in Exile,'* an essay full of that strange blending of sentiment which is characteristic of the traditions of the middle age concerning the pagan religions, 'how the gods of the older world at the time of the definite triumph of Christianity, that is, in the third century, fell into painful embarrassments which greatly resembled certain tragical situations of their earlier life. They now found themselves exposed to the same troublesome necessities to which they had once before

been exposed during the primitive ages, in that revolutionary epoch when the Titans broke out of the custody of Orcus, and piling Pelion on Ossa scaled Olympus. Unfortunate gods! They had then to take flight ignominiously, and hide themselves among us here on earth under all sorts of disguises. Most of them betook themselves to Egypt, where for greater security they assumed the forms of animals, as is generally known. Just in the same way they had to take flight again, and seek entertainment in remote hiding-places, when those icono-clastic zealots, the black brood of monks, broke down all the temples, and pursued the gods with fire and curses. Many of these unfortunate emigrants, entirely deprived of shelter and ambrosia, had now to take to vulgar handicrafts as a means of earning their bread. In these circumstances many whose sacred groves had been confiscated, let themselves out for hire as wood-cutters in Germany, and had to drink beer instead of nectar. Apollo seems to have been content to take service under graziers, and as he had once kept the cows of Admetus, so he lived now as a shepherd in Lower Austria. Here however, having become suspected on account of his beautiful singing, he was recognised by a learned monk as one of the old pagan gods, and handed over to the spiritual tribunal. On the rack he confessed that he was the god Apollo; and before his execution he begged that he might be suffered to play once more upon the lyre and to sing a song. And he played so touchingly, and sang with such magic, and was withal so beautiful in form and feature, that all the women wept, and many of them were so deeply impressed that they shortly afterwards fell sick. And some time afterwards the people wished to drag him from the grave again, that a stake might be driven through his body, in the belief that he had been a vampire, and that the sick women would by this means recover. But they found the grave empty.'

The Renaissance of the fifteenth century was in many things great rather by what it designed than by what it achieved. Much which it aspired to do, and did but imperfectly or mistakenly, was accom-plished in what is called the *éclaircissement* of the eighteenth century,* or in our own generation, and what really belongs to the revival of the fifteenth century is but the leading instinct, the curiosity, the initi-atory idea. It is so with this very question of the reconciliation of the religion of antiquity with the religion of Christ. A modern scholar* occupied by this problem might observe that all religions may be regarded as natural products, that at least in their origin, their

growth, and decay, they have common laws, and are not to be iso-
lated from the other movements of the human mind in the periods in
which they respectively prevailed; that they arise spontaneously out
of the human mind, as expressions of the varying phases of its senti-
ment concerning the unseen world; that every intellectual product
must be judged from the point of view of the age and people in which
it was produced. He might go on to observe that each has contributed
something to the development of the religious sense, and ranging
them as so many stages in the gradual education of the human mind,
justify the existence of each. The basis of the reconciliation of the
religions of the world would thus be the inexhaustible activity and
creativeness of the human mind itself, in which all religions alike
have their root, and in which all alike are laid to rest; just as the fan-
cies of childhood and the thoughts of old age meet and are reconciled
in the experience of an individual. Far different was the method fol-
lowed by the scholars of the fifteenth century. They lacked the very
rudiments of the historic sense, which by an imaginative act throws
itself back into a world unlike one's own, and judges each intellectual
product in connection with the age which produced it; they had no
idea of development, of the differences of ages, of the gradual educa-
tion of the human race.* In their attempts to reconcile the religions
of the world they were thus thrown back on the quicksand of alle-
gorical interpretation. The religions of the world were to be recon-
ciled, not as successive stages in a gradual development of the
religious sense, but as subsisting side by side, and substantially in
agreement with each other. And here the first necessity was to mis-
represent the language, the conceptions, the sentiments, it was pro-
posed to compare and reconcile. Plato and Homer must be made to
speak agreeably to Moses. Set side by side, the mere surfaces could
never unite in any harmony of design. Therefore one must go below
the surface, and bring up the supposed secondary or still more
remote meaning, that diviner signification held in reserve, *in recessu
divinius aliquid*, latent in some stray touch of Homer or figure of
speech in the books of Moses.

 And yet, as a curiosity of the human mind, a madhouse-cell,'* if
you will, into which we may peep for a moment and see it at work
weaving strange fancies, the allegorical interpretation of the fifteenth
century has its interest. With its strange web of imagery, its quaint
conceits, its unexpected combinations and subtle moralising, it is an

element in the local colour of a great age. It illustrates also the faith
of that age in all oracles, its desire to hear all voices, its generous
belief that nothing which had ever interested the human mind could
wholly lose its vitality. It is the counterpart, though certainly the
feebler counterpart, of that practical truce and reconciliation of the
gods of Greece with the Christian religion which is seen in the art of
the time; and it is for his share in this work, and because his own
story is a sort of analogue or visible equivalent to the expression of
this purpose in his writings, that something of a general interest still
belongs to the name of Pico della Mirandola, whose life, written by
his nephew Francis, seemed worthy, for some touch of sweetness in
it, to be translated out of the original Latin by Sir Thomas More,
that great lover of Italian culture, among whose works this life of
Pico, *Earl of Mirandola, and a great lord of Italy*, as he calls him, may
still be read, in its quaint, antiquated English.

Marsilio Ficino has told us how Pico came to Florence. It was the
very day—some day probably in the year 1482—on which Ficino
had finished his famous translation of Plato into Latin, the work to
which he had been dedicated from childhood by Cosmo de' Medici,
in furtherance of his desire to resuscitate the knowledge of Plato
among his fellow-citizens. Florence indeed, as M. Renan has pointed
out,* had always had an affinity for the mystic and dreamy philoso-
phy of Plato, while the colder and more practical philosophy of
Aristotle had flourished in Padua and other cities of the north; and
the Florentines, though they knew perhaps very little about him, had
had the name of the great idealist often on their lips. To increase this
knowledge Cosmo had founded the Platonic academy, with period-
ical discussions at the villa of Careggi. The fall of Constantinople in
1453 and the council in 1438 for the reconciliation of the Greek and
Latin Churches, had brought to Florence many a needy Greek
scholar. And now the work was completed, the door of the mystical
temple lay open to all who could construe Latin, and the scholar
rested from his labour; when there was introduced into his study,
where a lamp burned continually before the bust of Plato, as other
men burned lamps before their favourite saints, a young man fresh
from a journey, *of feature and shape seemly and beauteous, of stature
goodly and high, of flesh tender and soft, his visage lovely and fair, his colour
white, intermingled with comely reds, his eyes grey, and quick of look, his
teeth white and even, his hair yellow and abundant*, and trimmed with

more than the usual artifice of the time. It is thus that Sir Thomas More translates the words of the biographer of Pico, who even in outward form and appearance seems an image of that inward harmony and completeness of which he is so perfect an example. The word *mystic* has been usually derived from a Greek word which signifies *to shut*, as if one *shut one's lips*, brooding on what cannot be uttered; but the Platonists themselves derive it rather from the act of *shutting the eyes*, that one may see the more, inwardly. Perhaps the eyes of the mystic Ficino, now long past the midway of life, had come to be thus half-closed; but when a young man not unlike the archangel Raphael, as the Florentines of that age depicted him in his wonderful walk with Tobit,* or Mercury as he might have appeared in a painting by Sandro Botticelli or Piero di Cosimo, entered his chamber, he seems to have thought there was something not wholly earthly about him; at least, he ever afterwards believed that it was not without the cooperation of the stars that the stranger had arrived on that day. For it happened that they fell into a conversation, deeper and more intimate than men usually fall into at first sight. During that conversation Ficino formed the design of devoting his remaining years to the translation of Plotinus, that new Plato in whom the mystical element in the Platonic philosophy had been worked out to the utmost limit of vision and ecstasy; and it is in dedicating this translation to Lorenzo de' Medici that Ficino has recorded these incidents.

It was after many wanderings, wanderings of the intellect as well as physical journeys, that Pico came to rest at Florence. He was then about twenty years old, having been born in 1463. He was called Giovanni at baptism, Pico, like all his ancestors, from Picus, nephew of the Emperor Constantine, from whom they claimed to be descended, and Mirandola from the place of his birth, a little town afterwards part of the duchy of Modena, of which small territory his family had long been the feudal lords. Pico was the youngest of the family, and his mother, delighting in his wonderful memory, sent him at the age of fourteen to the famous school of law at Bologna. From the first indeed she seems to have had a presentiment of his future fame, for with a faith in omens characteristic of her time, she believed that a strange circumstance had happened at the time of Pico's birth—the appearance of a circular flame which suddenly vanished away, on the wall of the chamber where she lay. He remained two years at Bologna; and then, with an inexhaustible, unrivalled

thirst for knowledge, the strange, confused, uncritical learning of
that age, passed through the principal schools of Italy and France,
penetrating, as he thought, into the secrets of all ancient philosophies,
and many eastern languages. And with this flood of erudition came
the generous hope, so often disabused, of reconciling the philosophers
with each other, and all alike with the Church. At last he came to
Rome. There, like some knight-errant of philosophy, he offered to
defend nine hundred bold paradoxes drawn from the most opposite
sources, against all comers. But the Pontifical Court was led to suspect
the orthodoxy of some of these propositions, and even the reading of
the book which contained them was forbidden by the Pope. It was not
till 1493 that Pico was finally absolved by a brief of Alexander the
Sixth. Ten years before that date he had arrived at Florence; an early
instance of those who, after following the vain hope of an impossible
reconciliation from system to system, have at last fallen back
unsatisfied on the simplicities of their childhood's belief.

 The oration which Pico composed for the opening of this philo-
sophical tournament still remains;* its subject is the dignity of
human nature, the greatness of man. In common with nearly all
mediæval speculation, much of Pico's writing has this for its drift;
and in common also with it, Pico's theory of that dignity is founded
on a misconception of the place in nature both of the earth and of
man. For Pico the earth is the centre of the universe; and around it,
as a fixed and motionless point, the sun and moon and stars revolve
like diligent servants or ministers. And in the midst of all is placed
man, *nodus et vinculum mundi*, the bond or copula of the world, and
the 'interpreter of nature':* that famous expression of Bacon's really
belongs to Pico. 'Tritum est in scholis,' he says, 'esse hominem
minorem mundum, in quo mixtum ex elementis corpus et spiritus
coelestis et plantarum anima vegetalis et brutorum sensus et ratio et
angelica mens et Dei similitudo conspicitur.' '*It is a commonplace of
the schools that man is a little world, in which we may discern a body
mingled of earthy elements, and ethereal breath, and the vegetable life of
plants, and the senses of the lower animals, and reason, and the intelli-
gence of angels, and a likeness to God.*' A commonplace of the schools!
But perhaps it had some new significance and authority when men
heard one like Pico reiterate it; and false as its basis was, the theory
had its use. For this high dignity of man thus bringing the dust under
his feet into sensible communion with the thoughts and affections of

the angels was supposed to belong to him not as renewed by a religious system, but by his own natural right; and it was a counterpoise to the increasing tendency of mediæval religion to depreciate man's nature, to sacrifice this or that element in it, to make it ashamed of itself, to keep the degrading or painful accidents of it always in view. It helped man onward to that reassertion of himself, that rehabilitation of human nature, the body, the senses, the heart, the intelligence, which the Renaissance fulfils. And yet to read a page of one of Pico's forgotten books is like a glance into one of those ancient sepulchres, upon which the wanderer in classical lands has sometimes stumbled, with the old disused ornaments and furniture of a world wholly unlike ours still fresh in them. That whole conception of nature is so different from our own. For Pico the world is a limited place, bounded by actual crystal walls and a material firmament; it is like a painted toy, like that map or system of the world held as a great target or shield in the hands of the grey-headed father of all things, in one of the earlier frescoes of the Campo Santo at Pisa.* How different from this childish dream is our own conception of nature, with its unlimited space, its innumerable suns, and the earth but a mote in the beam;* how different the strange new awe and superstition with which it fills our minds! 'The silence of those infinite spaces,' says Pascal, contemplating a starlight night, 'the silence of those infinite spaces terrifies me.' *Le silence éternel de ces espaces infinis m'effraie.**

He was already almost wearied out when he came to Florence. He had loved much and been beloved by women, 'wandering over the crooked hills of delicious pleasure'; but their reign over him was over, and long before Savonarola's famous 'bonfire of vanities,'* he had destroyed those love-songs in the vulgar tongue which would have been such a relief to us after the scholastic prolixity of his Latin writings. It was in another spirit that he composed a Platonic commentary, the only work of his in Italian which has come down to us, on the 'Song of Divine Love,' *secondo la mente ed opinione dei Platonici*, 'according to the mind and opinion of the Platonists,' by his friend Hieronymo Beniveni, in which, with an ambitious array of every sort of learning, and a profusion of imagery borrowed indifferently from the astrologers, the Cabala,* and Homer, and Scripture, and Dionysius the Areopagite, he attempts to define the stages by which the soul passes from the earthly to the unseen beauty. A change indeed had passed over him, as if the chilling touch of

that abstract, disembodied beauty which the Platonists profess to long for, had already touched him; and perhaps it was a sense of this, coupled with that over-brightness of his, which in the popular imagination always betokens an early death, that made Camilla Rucellai, one of those prophetesses whom the preaching of Savonarola had raised up in Florence, prophesy, seeing him for the first time, that he would depart in the time of lilies—prematurely, that is, like the field flowers which are withered by the scorching sun almost as soon as they have sprung up. It was now that he wrote down those thoughts on the religious life which Sir Thomas More turned into English, and which another English translator thought worthy to be added to the books of the 'Imitation.'* 'It is not hard to know God, provided one will not force oneself to define him,' has been thought a great saying of Joubert's.* 'Love God,' Pico writes to Angelo Politian, 'we rather may, than either know him or by speech utter him. And yet had men liefer by knowledge never find that which they seek, than by love possess that thing, which also without love were in vain found.'

Yet he who had this fine touch for spiritual things did not—and in this is the enduring interest of his story—even after his conversion forget the old gods. He is one of the last who seriously and sincerely entertained the claims on men's faith of the pagan religions; he is anxious to ascertain the true significance of the obscurest legend, the lightest tradition concerning them. With many thoughts and many influences which led him in that direction, he did not become a monk, only he became gentle and patient in disputation; retaining 'somewhat of the old plenty, in dainty viand and silver vessel' he gave over the greater part of his property to his friend, the mystical poet Beniveni, to be spent by him in works of charity, chiefly in the sweet charity of providing marriage-dowries for the peasant girls of Florence. His end came in 1494, when, amid the prayers and sacraments of Savonarola, he died of fever on the very day on which Charles the Eighth entered Florence, the seventeenth of November, yet in the time of lilies, the lilies of the shield of France, as the people now said, remembering Camilla's prophecy. He was buried in the cloister at Saint Mark's, in the hood and white frock of the Dominican order.

It is because the life of Pico, thus lying down to rest in the Dominican habit, yet amid thoughts of the older gods, himself like one of those comely divinities, reconciled indeed to the new religion, but still with a tenderness for the earlier life, and desirous literally

to 'bind the ages each to each by natural piety'*—it is because this life is so perfect an analogue to the attempt made in his writings to reconcile Christianity with the ideas of Paganism, that Pico, in spite of the scholastic character of those writings, is really interesting. Thus in the 'Heptaplus, or Discourse on the Seven Days of the Creation,'* he endeavours to reconcile the accounts which pagan philosophy had given of the origin of the world with the account given in the books of Moses—the 'Timaeus' of Plato* with the book of 'Genesis.' The 'Heptaplus' is dedicated to Lorenzo the Magnificent, whose interest, the preface tells us, in the secret wisdom of Moses is well known. If Moses seems in his writings simple and even popular, rather than either a philosopher or a theologian, that is because it was an institution with the ancient philosophers either not to speak of divine things at all, or to speak of them dissemblingly; hence their doctrines were called mysteries. Taught by them, Pythagoras became so great a 'master of silence,' and wrote almost nothing, thus hiding the words of God in his heart, and speaking wisdom only among the perfect. In explaining the harmony between Plato and Moses, Pico lays hold on every sort of figure and analogy, on the double meanings of words, the symbols of the Jewish ritual, the secondary meanings of obscure stories in the later Greek mythologists. Everywhere there is an unbroken system of analogies. Every object in the material world is an analogue, a symbol or counterpart of some higher reality in the starry heavens, and this again of some law of the angelic life in the world beyond the stars. There is the element of fire in the material world; the sun is the fire of heaven; and there is in the super-celestial world the fire of the seraphic intelligence. 'But behold how they differ! The elementary fire burns, the heavenly fire vivifies, the super-celestial fire loves.' In this way every natural object, every combination of natural forces, every accident in the lives of men, is filled with higher meanings. Omens, prophecies, supernatural coincidences, accompany Pico himself all through life. There are oracles in every tree and mountain-top, and a significance in every accidental combination of the events of life.

This constant tendency to symbolism and imagery gives Pico's work a figured style by which it has some real resemblance to Plato's, and he differs from other mystical writers of his time by a real desire to know his authorities at first hand. He reads Plato in Greek, Moses in Hebrew, and by this his work really belongs to the higher culture.

Above all, there is a constant sense in reading him, that his thoughts, however little their positive value may be, are connected with springs beneath them of deep and passionate emotion; and when he explains the grades or steps by which the soul passes from the love of a physical object to the love of unseen beauty, and unfolds the analogies between this process and other movements upwards of human thought, there is a glow and vehemence in his words which remind one of the manner in which his own brief existence flamed itself away.

I said that the Renaissance of the fifteenth century was in many things great rather by what it designed or aspired to do than by what it actually achieved. It remained for a later age to conceive the true method of effecting a scientific reconciliation of Christian sentiment with the imagery, the legends, the theories about the world, of pagan poetry and philosophy. For that age the only possible reconciliation was an imaginative one, and resulted from the efforts of artists trained in Christian schools to handle pagan subjects; and of this artistic reconciliation work like Pico's was but the feebler counterpart. Whatever philosophers had to say on one side or the other, whether they were successful or not in their attempts to reconcile the old to the new, and to justify the expenditure of so much care and thought on the dreams of a dead religion, the imagery of the Greek religion, the direct charm of its story, were by artists valued and cultivated for their own sake. Hence a new sort of mythology with a tone and qualities of its own. When the ship-load of sacred earth from the soil of Jerusalem was mingled with the common clay in the Campo Santo of Pisa, a new flower grew up from it, unlike any flower men had seen before, the anemone with its concentric rings of strangely blended colour, still to be found by those who search long enough for it in the long grass of the Maremma.* Just such a strange flower was that mythology of the Italian Renaissance which grew up from the mixture of two traditions, two sentiments, the sacred and the profane. Classical story was regarded as a mere datum to be received and assimilated. It did not come into men's minds to ask curiously of science concerning its origin, its primary form and import, its meaning for those who projected it. It sank into their minds to issue forth again with all the tangle about it of mediæval sentiments and ideas. In the Doni Madonna in the Tribune of the Uffizii,* Michelangelo actually brings the pagan religion, and with it the unveiled human form, the sleepy-looking fauns of a Dionysiac

revel, into the presence of the Madonna, as simpler painters had introduced other products of the earth, birds or flowers, and he has given that Madonna herself much of the uncouth energy of the older and more primitive mighty Mother.

It is because this picturesque union of contrasts, belonging properly to the art of the close of the fifteenth century, pervades in Pico della Mirandola an actual person, that the figure of Pico is so attractive. He will not let one go; he wins one on in spite of oneself to turn again to the pages of his forgotten books, although we know already that the actual solution proposed in them will satisfy us as little as perhaps it satisfied him. It is said that in his eagerness for mysterious learning he once paid a great sum for a collection of cabalistic manuscripts which turned out to be forgeries; and the story might well stand as a parable of all he ever seemed to gain in the way of actual knowledge. He had sought knowledge, and passed from system to system, and hazarded much; but less for the sake of positive knowledge than because he believed there was a spirit of order and beauty in knowledge, which would come down and unite what men's ignorance had divided, and renew what time had made dim. And so while his actual work has passed away, yet his own qualities are still active, and he himself remains, as one alive in the grave, *caesiis et vigilibus oculis*,* as his biographer describes him, and with that sanguine clear skin, *decenti rubore interspersa*,* as with the light of morning upon it; and he has a true place in that group of great Italians who fill the end of the fifteenth century with their names, he is a true *humanist*. For the essence of humanism is that one belief of which he seems never to have doubted, that nothing which has ever interested living men and women can wholly lose its vitality—no language they have spoken, nor oracle by which they have hushed their voices, no dream which has once been entertained by actual human minds, nothing about which they have ever been passionate or expended time and zeal.

SANDRO BOTTICELLI

IN Leonardo's treatise on painting only one contemporary is mentioned by name—Sandro Botticelli. This pre-eminence may be due to chance only, but to some will rather appear a result of deliberate judgment; for people have begun to find out the charm of Botticelli's work, and his name, little known in the last century, is quietly becoming important. In the middle of the fifteenth century he had already anticipated much of that meditative subtlety which is sometimes supposed peculiar to the great imaginative workmen of its close. Leaving the simple religion which had occupied the followers of Giotto for a century, and the simple naturalism which had grown out of it, a thing of birds and flowers only, he sought inspiration in what to him were works of the modern world, the writings of Dante and Boccaccio, and in new readings of his own of classical stories; or if he painted religious subjects, painted them with an under-current of original sentiment which touches you as the real matter of the picture through the veil of its ostensible subject. What is the peculiar sensation, what is the peculiar quality of pleasure which his work has the property of exciting in us, and which we cannot get elsewhere? For this, especially when he has to speak of a comparatively unknown artist, is always the chief question which a critic has to answer.

In an age when the lives of artists were full of adventure, his life is almost colourless. Criticism indeed has cleared away much of the gossip which Vasari accumulated, has touched the legend of Lippo and Lucrezia,* and rehabilitated the character of Andrea del Castagno;* but in Botticelli's case there is no legend to dissipate. He did not even go by his true name: Sandro is a nickname, and his true name is Filipepi, Botticelli being only the name of the goldsmith who first taught him art. Only two things happened to him, two things which he shared with other artists—he was invited to Rome to paint in the Sistine Chapel, and he fell in later life under the influence of Savonarola, passing apparently almost out of men's sight in a sort of religious melancholy which lasted till his death in 1515, according to the received date. Vasari says that he plunged into the study of Dante, and even wrote a comment on the 'Divine Comedy.' But it seems strange that he should have lived on inactive

so long; and one almost wishes that some document might come to light which, fixing the date of his death earlier, might relieve one, in thinking of him, of his dejected old age.

He is before all things a poetical painter, blending the charm of story and sentiment, the medium of the art of poetry, with the charm of line and colour, the medium of abstract painting. So he becomes the illustrator of Dante.* In a few rare examples of the edition of 1481, the blank spaces left at the beginning of every canto for the hand of the illuminator have been filled, as far as the nineteenth canto of the 'Inferno,' with impressions of engraved plates, seemingly by way of experiment, for in the copy in the Bodleian Library, one of the three impressions it contains has been printed upside down and much awry in the midst of the luxurious printed page. Giotto, and the followers of Giotto, with their almost childish religious aim, had not learned to put that weight of meaning into outward things, light, colour, every-day gesture, which the poetry of the 'Divine Comedy' involves, and before the fifteenth century Dante could hardly have found an illustrator. Botticelli's illustrations are crowded with incident, blending with a naïve carelessness of pictorial propriety three phases of the same scene into one plate. The grotesques, so often a stumbling-block to painters who forget that the words of a poet, which only feebly present an image to the mind, must be lowered in key when translated into form, make one regret that he has not rather chosen for illustration the more subdued imagery of the 'Purgatorio.' Yet in the scene of those who 'go down quick into hell'* there is an invention about the fire taking hold on the up-turned soles of the feet, which proves that the design is no mere translation of Dante's words, but a true painter's vision; while the scene of the Centaurs wins one at once, for, forgetful of the actual circumstances of their appearance, Botticelli has gone off with delight on the thought of the Centaurs themselves, bright small creatures of the woodland, with arch baby faces and mignon forms, drawing tiny bows.*

Botticelli lived in a generation of naturalists, and he might have been a mere naturalist among them. There are traces enough in his work of that alert sense of outward things which, in the pictures of that period, fills the lawns with delicate living creatures, and the hillsides with pools of water, and the pools of water with flowering reeds. But this was not enough for him; he is a visionary painter, and

in his visionariness he resembles Dante. Giotto, the tried companion
of Dante, Masaccio, Ghirlandaio even, do but transcribe with more
or less refining the outward image; they are dramatic, not visionary,
painters; they are almost impassive spectators of the action before
them. But the genius of which Botticelli is the type usurps the data
before it as the exponents of ideas, moods, visions of its own; with
this interest it plays fast and loose with those data, rejecting some and
isolating others, and always combining them anew. To him, as to
Dante, the scene, the colour, the outward image or gesture, comes
with all its incisive and importunate reality; but awakes in him,
moreover, by some subtle structure of his own, a mood which it
awakes in no one else, of which it is the double or repetition, and
which it clothes, that all may share it, with sensuous circumstances.

But he is far enough from accepting the conventional orthodoxy of
Dante which, referring all human action to the easy formula of pur-
gatory heaven and hell, leaves an insoluble element of prose in the
depths of Dante's poetry. One picture of his, with the portrait of the
donor, Matteo Palmieri, below, had the credit or discredit of attract-
ing some shadow of ecclesiastical censure. This Matteo Palmieri—two
dim figures move under that name in contemporary history—was
the reputed author of a poem, still unedited, 'La Città Divina,'*
which represented the human race as an incarnation of those angels
who, in the revolt of Lucifer, were neither for God nor for his en-
emies, a fantasy of that earlier Alexandrian philosophy,* about which
the Florentine intellect in that century was so curious. Botticelli's
picture may have been only one of those familiar compositions in
which religious reverie has recorded its impressions of the various
forms of beatified existence—*Glorias*, as they were called, like that in
which Giotto painted the portrait of Dante*; but somehow it was
suspected of embodying in a picture the wayward dream of Palmieri,
and the chapel where it hung was closed. Artists so entire as Botticelli
are usually careless about philosophical theories, even when the
philosopher is a Florentine of the fifteenth century, and his work a
poem in *terza rima*. But Botticelli, who wrote a commentary on
Dante and became the disciple of Savonarola, may well have let such
theories come and go across him. True or false, the story interprets
much of the peculiar sentiment with which he infuses his profane
and sacred persons, comely, and in a certain sense like angels, but
with a sense of displacement or loss about them—the wistfulness of

exiles conscious of a passion and energy greater than any known issue of them explains, which runs through all his varied work with a sentiment of ineffable melancholy.

So just what Dante scorns as unworthy alike of heaven and hell, Botticelli accepts, that middle world in which men take no side in great conflicts, and decide no great causes, and make great refusals. He thus sets for himself the limits within which art, undisturbed by any moral ambition, does its most sincere and surest work. His interest is neither in the untempered goodness of Angelico's saints, nor the untempered evil of Orcagna's 'Inferno';* but with men and women, in their mixed and uncertain condition, always attractive, clothed sometimes by passion with a character of loveliness and energy, but saddened perpetually by the shadow upon them of the great things from which they shrink. His morality is all sympathy; and it is this sympathy, conveying into his work somewhat more than is usual of the true complexion of humanity, which makes him, visionary as he is, so forcible a realist.

It is this which gives to his Madonnas their unique expression and charm. He has worked out in them a distinct and peculiar type, definite enough in his own mind, for he has painted it over and over again, sometimes one might think almost mechanically, as a pastime during that dark period when his thoughts were so heavy upon him. Hardly any collection of note is without one of these circular pictures, into which the attendant angels depress their heads so naïvely. Perhaps you have sometimes wondered why those peevish-looking Madonnas, conformed to no acknowledged or obvious type of beauty, attract you more and more, and often come back to you when the Sistine Madonna* and the virgins of Fra Angelico are forgotten. At first, contrasting them with those, you may have thought that there was even something in them mean or abject, for the abstract lines of the face have little nobleness, and the colour is wan. For with Botticelli she too, though she holds in her hands the 'Desire of all nations,'* is one of those who are neither for God nor for his enemies; and her choice is on her face. The white light on it is cast up hard and cheerless from below, as when snow lies upon the ground, and the children look up with surprise at the strange whiteness of the ceiling. Her trouble is in the very caress of the mysterious child, whose gaze is always far from her, and who has already that sweet look of devotion which men have never been able altogether to love,

and which still makes the born saint an object almost of suspicion to his earthly brethren. Once, indeed, he guides her hand to transcribe in a book the words of her exaltation, the *Ave*, and the *Magnificat*, and the *Gaude Maria*, and the young angels, glad to rouse her for a moment from her dejection, are eager to hold the inkhorn and support the book;* but the pen almost drops from her hand, and the high cold words have no meaning for her, and her true children are those others, in the midst of whom, in her rude home, the intolerable honour came to her, with that look of wistful inquiry on their irregular faces which you see in startled animals—gipsy children, such as those who, in Apennine villages, still hold out their long brown arms to beg of you, but on Sundays become *enfants du chœur*,* with their thick black hair nicely combed and fair white linen on their sun-burnt throats.

What is strangest is that he carries this sentiment into classical subjects, its most complete expression being a picture in the Uffizii, of Venus rising from the sea, in which the grotesque emblems of the middle age, and a landscape full of its peculiar feeling, and even its strange draperies powdered all over in the Gothic manner with a quaint conceit of daisies, frame a figure that reminds you of the faultless nude studies of Ingres.* At first, perhaps, you are attracted only by a quaintness of design, which seems to recall all at once whatever you have read of Florence in the fifteenth century; afterwards you may think that this quaintness must be incongruous with the subject, and that the colour is cadaverous, or at least cold. And yet the more you come to understand what imaginative colouring really is, that all colour is no mere delightful quality of natural things, but a spirit upon them by which they become expressive to the spirit, the better you will like this peculiar quality of colour; and you will find that quaint design of Botticelli's a more direct inlet into the Greek temper than the works of the Greeks themselves even of the finest period. Of the Greeks as they really were, of their difference from ourselves, of the aspects of their outward life, we know far more than Botticelli, or his most learned contemporaries; but for us, long familiarity has taken off the edge of the lesson, and we are hardly conscious of what we owe to the Hellenic spirit. But in pictures like this of Botticelli's you have a record of the first impression made by it on minds turned back towards it in almost painful aspiration from a world in which it had been ignored so long; and in the passion, the

energy, the industry of realisation, with which Botticelli carries out
his intention, is the exact measure of the legitimate influence over the
human mind of the imaginative system of which this is the central
myth. The light is, indeed, cold—mere sunless dawn; but a later
painter would have cloyed you with sunshine; and you can see the
better for that quietness in the morning air each long promontory as
it slopes down to the water's edge. Men go forth to their labours until
the evening; but she is awake before them, and you might think that
the sorrow in her face was at the thought of the whole long day of
love yet to come. An emblematical figure of the wind blows hard across
the grey water, moving forward the dainty-lipped shell on which she
sails, the sea 'showing his teeth' as it moves in thin lines of foam, and
sucking in one by one the falling roses, each severe in outline, plucked
off short at the stalk, but embrowned a little, as Botticelli's flowers
always are. Botticelli meant all that imagery to be altogether pleasur-
able; and it was partly an incompleteness of resources, inseparable
from the art of that time, that subdued and chilled it; but his predilec-
tion for minor tones counts also; and what is unmistakeable is the
sadness with which he has conceived the goddess of pleasure as the
depositary of a great power over the lives of men.

I have said that the peculiar character of Botticelli is the result of
a blending in him of a sympathy for humanity in its uncertain condi-
tion, its attractiveness, its investiture at rarer moments in a character
of loveliness and energy, with his consciousness of the shadow
upon it of the great things from which it shrinks, and that this con-
veys into his work somewhat more than painting usually attains
of the true complexion of humanity. He paints the story of the god-
dess of pleasure in other episodes besides that of her birth from
the sea, but never without some shadow of death in the grey flesh and
wan flowers. He paints Madonnas, but they shrink from the pressure
of the divine child, and plead in unmistakeable undertones for a
warmer, lower humanity. The same figure—tradition connects it
with Simonetta, the mistress of Giuliano de' Medici—appears again
as Judith returning home across the hill country when the great deed
is over, and the moment of revulsion come, and the olive branch in
her hand is becoming a burthen; as Justice, sitting on a throne, but
with a fixed look of self-hatred which makes the sword in her hand
seem that of a suicide; and again as Veritas* in the allegorical picture
of Calumnia, where one may note in passing the suggestiveness of an

accident which identifies the image of Truth with the person of Venus. We might trace the same sentiment through his engravings; but his share in them is doubtful, and the object of this fragment has been attained if I have defined aright the temper in which he worked.

But, after all, it may be asked, is a painter like Botticelli, a second-rate painter, a proper subject for general criticism? There are a few great painters, like Michelangelo or Leonardo, whose work has become a force in general culture, partly for this very reason that they have absorbed into themselves all such workmen as Sandro Botticelli; and, over and above mere technical or antiquarian criticism, general criticism may be very well employed in that sort of interpretation which adjusts the position of these men to general culture, whereas smaller men can be the proper subjects only of technical or antiquarian treatment. But, besides those great men, there is a certain number of artists who have a distinct faculty of their own by which they convey to us a peculiar quality of pleasure which we cannot get elsewhere, and these, too, have their place in general culture, and have to be interpreted to it by those who have felt their charm strongly, and are often the objects of a special diligence and a consideration wholly affectionate, just because there is not about them the stress of a great name and authority. Of this select number Botticelli is one; he has the freshness, the uncertain and diffident promise which belongs to the earlier Renaissance itself, and makes it perhaps the most interesting period in the history of the mind; in studying his work one begins to understand to how great a place in human culture the art of Italy had been called.

LUCA DELLA ROBBIA

THE Italian sculptors of the earlier half of the fifteenth century are more than mere forerunners of the great masters of its close, and often reach perfection within the narrow limits which they chose to impose on their work. Their sculpture shares with the paintings of Botticelli and the churches of Brunelleschi that profound expressiveness, that intimate impress of an indwelling soul, which is the peculiar fascination of the art of Italy in that century. Their works have been much neglected and often almost hidden away amid the frippery of modern decoration, and we come with some surprise on the places where their fire still smoulders. One longs to penetrate into the lives of the men who have given expression to so much power and sweetness; but it is part of the reserve, the austere dignity and simplicity of their existence, that their histories are for the most part lost or told but briefly: from their lives as from their work all tumult of sound and colour has passed away. Mino, the Raffaelle of sculpture, Maso del Rodario, whose works add a new grace to the church of Como, Donatello even,—one asks in vain for more than a shadowy outline of their actual days.

Something more remains of Luca della Robbia; something more of a history of outward changes and fortunes is expressed through his work. I suppose nothing brings the real air of a Tuscan town so vividly to mind as those pieces of pale blue and white porcelain, by which he is best known, like fragments of the milky sky itself fallen into the cool streets and breaking into the darkened churches. And no work is less imitable: like Tuscan wine it loses its savour when moved from its birthplace, from the crumbling walls where it was first placed. Part of the charm of this work, its grace and purity and finish of expression, is common to all the Tuscan sculptors of the fifteenth century; for Luca was first of all a worker in marble, and his works in terra-cotta only transfer to a different material the principles of his sculpture.

These Tuscan sculptors of the fifteenth century worked for the most part in low relief, giving even to their monumental effigies something of its depression of surface, getting into them by this means a touching suggestion of the wasting and etherealisation of death.

They are haters of all heaviness and emphasis, of strongly opposed light and shade, and look for their means of expression among the last refinements of shadow, which are almost invisible except in a strong light, and which the finest pencil can hardly follow. The whole essence of their work is expression, the passing of a smile over the face of a child, the ripple of the air on a still day over the curtain of a window ajar.

What is the precise value of this system of sculpture, this low relief? Luca della Robbia, and the other sculptors of the school to which he belongs, have before them the universal problem of their art; and this system of low relief is the means by which they meet and overcome the special limitation of sculpture, a limitation which results from the essential conditions and material of all sculptured work, and which consists in the tendency of this work to a hard realism, a one-sided presentment of mere form, that solid material frame which only motion can relieve, a thing of heavy shadows and an individuality of expression pushed to caricature. Against this tendency to that hard presentment of mere form which tries vainly to compete with the reality of nature itself, all noble sculpture is constantly struggling; each great system of sculpture resisting it in its own way, etherealising, spiritualising, relieving its hardness, its heaviness and death. The use of colour in sculpture is but an unskilful contrivance to effect by borrowing from another art what the nobler sculpture effects by strictly appropriate means. To get not colour, but the equivalent of colour, to secure the expression and the play of life; to expand the too fixed individuality of pure unrelieved uncoloured form,—this is the problem which the three great styles in sculpture have solved in three different ways.

Allgemeinheit—breadth, generality, universality—is the word chosen by Winckelmann, and after him by Goethe and many German critics, to express that law of the most excellent Greek sculptors, of Phidias and his pupils, which prompted them constantly to seek the type in the individual, to purge from the individual all that belongs only to the individual, all the accidents, feelings, actions of a special moment, all that in its nature enduring for a moment looks like a frozen thing if you arrest it, to abstract and express only what is permanent, structural, abiding.

In this way their works came to be like some subtle extract or essence, or almost like pure thoughts or ideas; and hence that broad

humanity in them, that detachment from the conditions of a particular place or people, which has carried their influence far beyond the age which produced them, and insured them universal acceptance.

That was the Greek way of relieving the hardness and unspirituality of pure form. But it involved for the most part the sacrifice of what we call *expression*; and a system of abstraction which aimed always at the broad and general type, which purged away from the individual all that belonged only to him, all the accidents of a particular time and place, left the Greek sculptor only a narrow and passionless range of effects: and when Michelangelo came, with a genius spiritualised by the reverie of the middle age, penetrated by its spirit of inwardness and introspection, living not a mere outward life like the Greek, but a life full of inward experiences, sorrows, consolations, a system which sacrificed what was inward could not satisfy him. To him, lover and student of Greek sculpture as he was, work which did not bring what was inward to the surface, which was not concerned with individual expression, character, feeling, the special history of the special soul, was not worth doing at all.

And so, in a way quite personal and peculiar to himself, which often is, and always seems, the effect of accident, he secured for his work individuality and intensity of expression, while he avoided a too hard realism, that tendency which the representation of feeling in sculpture always has to harden into caricature. What time and accident, its centuries of darkness, under the furrows of the 'little Melian farm,' has done with a singular felicity of touch for the Venus of Melos,* fraying its surface and softening its lines, so that some spirit in the thing seems always on the point of breaking out of it, as if in it classical sculpture had advanced already one step into the mystical Christian age, so that of all ancient work its effect is most like that of Michelangelo's own sculpture;—this effect Michelangelo gains by leaving all his sculpture in a puzzling sort of incompleteness, which suggests rather than realises actual form. Something of the wasting of that snow-image which he moulded at the command of Piero de' Medici, when the snow lay one night in the court of the Pitti, lurks about all his sculpture, as if he had determined to make the quality of a task exacted from him half in derision the pride of all his work. Many have wondered at that incompleteness, suspecting however that Michelangelo himself loved and was loath to change it, feeling at the same time that they too would lose something, if that half-hewn

form ever quite emerged from the rough hewn stone: and they have wished to fathom the charm of this incompleteness. Well! that incompleteness is Michelangelo's equivalent for colour in sculpture; it is his way of etherealising pure form, relieving its hard realism, communicating to it breath, pulsation, the effect of life. It was a characteristic too which fell in with his peculiar temper and mode of life, his disappointments and hesitations. It was in reality perfect finish. In this way he combines the utmost amount of passion and intensity with the expression of a yielding and flexible life: he gets not vitality merely, but a wonderful force of expression.

Midway between these two systems—the system of the Greek sculptors and the system of Michelangelo—comes the system of Luca della Robbia and the other Tuscan sculptors of the fifteenth century, partaking both of the *Allgemeinheit* of the Greeks, their way of extracting certain select elements only in pure form and sacrificing all the others, and the studied incompleteness of Michelangelo, relieving that expression of intensity, passion, energy, which would otherwise have hardened into caricature. Like Michelangelo these sculptors fill their works with intense and individualised expression: their noblest works are the studied sepulchral portraits of particular individuals—the tomb of Conte Ugo in the Abbey of Florence, the tomb of the youthful Medea Colleoni,* with the wonderful long throat, in the chapel on the cool north side of the Church of Santa Maria Maggiore at Bergamo; and they unite the element of tranquillity, of repose, to this intense and individualised expression by a system of conventionalism as subtle and skilful as that of the Greeks, by subduing all the curves which indicate solid form, and throwing the whole into low relief.

The life of Luca, a life of labour and frugality, with no adventure and no excitement except what belongs to the trial of new artistic processes, the struggle with new artistic difficulties, the solution of purely artistic problems, fills the first seventy years of the fifteenth century. After producing many works in marble for the Duomo and the Campanile of Florence, which place him among the foremost sculptors of that age, he became desirous to realise the spirit, the manner, of that sculpture in a humbler material, to unite its science, its exquisite and expressive system of low relief, to the homely art of pottery, to introduce those high qualities into common things, to adorn and cultivate daily household life. In this he is profoundly

characteristic of the Florence of that century, of that in it which lay below its superficial vanity and caprice, a certain old-world modesty and seriousness and simplicity. People had not yet begun to think that what was good art for churches was not so good or less fitted for their own houses. Luca's new work was of plain white at first, a mere rough imitation of the costly, laboriously wrought marble, finished in a few hours. But on this humble path he found his way to a fresh success, to another artistic grace. The fame of oriental pottery, with its strange bright colours—colours of art, colours not to be attained in the natural stone—mingled with the tradition of the old Roman pottery of the neighbourhood. The little red coral-like jars of Arezzo dug up in that district from time to time are still famous. These colours haunted Luca's fancy. 'He still continued seeking something more,' his biographer says of him; 'and instead of making his terra-cotta figures simply white, he added the further invention of giving them colour, to the astonishment and delight of all who beheld them. Cosa singolare e molto utile per lo state!'—a curious thing and very useful for summer time, full of coolness and repose for hand and eye. Luca loved the forms of various fruits, and wrought them into all sorts of marvellous frames and garlands, giving them their natural colours, only subdued a little, a little paler than nature. But in his nobler terra-cottas, he never introduces colour into the flesh, keeping mostly to blue and white, the colours of the Virgin Mary.

I said that the work of Luca della Robbia possessed in an extreme degree that peculiar characteristic which belongs to all the workmen of his school, a characteristic which, even in the absence of much positive information about their actual history, seems to bring the workman himself very near to us, the impress of a personal quality, a profound expressiveness, what the French call *intimité*, by which is meant a subtler sense of originality, the seal on a man's work of what is most inward and peculiar in his moods and manner of apprehension: it is what we call expression carried to its highest intensity of degree. That characteristic is rare in poetry, rarer still in art, rarest of all in the abstract art of sculpture; yet at bottom perhaps it is the characteristic which alone makes works in the imaginative and moral order really worth having at all. It is because the works of the artists of the fifteenth century possess this quality in an unmistakeable degree that one is anxious to know all that can be known about them and explain to oneself the secret of their charm.

THE POETRY OF MICHELANGELO

CRITICS of Michelangelo have sometimes spoken as if the only characteristic of his genius were a wonderful strength, verging, as in the things of the imagination great strength always does, on what is singular or strange. A certain strangeness, something of the blossoming of the aloe,* is indeed an element in all true works of art; that they shall excite or surprise us is indispensable. But that they shall give pleasure and exert a charm over us is indispensable too; and this strangeness must be sweet also, a lovely strangeness. And to the true admirers of Michelangelo this is the true type of the Michelangelesque—sweetness and strength, pleasure with surprise, an energy of conception which seems at every moment about to break through all the conditions of comely form, recovering, touch by touch, a loveliness found usually only in the simplest natural things—*ex forti dulcedo.**

In this way he sums up for them the whole character of mediæval art itself in that which distinguishes it most clearly from classical work, the presence of a convulsive energy in it, becoming in lower hands merely monstrous or forbidding, but felt even in its most graceful products as a subdued quaintness or grotesque. Yet those who feel this grace or sweetness in Michelangelo might at the first moment be puzzled if they were asked wherein precisely the quality resided. Men of inventive temperament (Victor Hugo, for instance, in whom, as in Michelangelo, people have for the most part been attracted or repelled by the strength, while few have understood his sweetness) have sometimes relieved conceptions of merely moral or spiritual greatness, but with little æsthetic charm of their own, by lovely accidents or accessories, like the butterfly which alights on the blood-stained barricade in 'Les Miserablés'* or those sea-birds for whom the monstrous Gilliatt comes to be as some wild natural thing, so that they are no longer afraid of him, in 'Les Travailleurs de la Mer.'* But the austere genius of Michelangelo will not depend for its sweetness on any mere accessories like these. The world of natural things has almost no existence for him, 'When one speaks of him,' says Grimm,* 'woods, clouds, seas, and mountains disappear, and only what is formed by the spirit of man remains behind;' and he

quotes a few slight words from a letter of his to Vasari as the single expression in all he has left of a feeling for nature. He has traced no flowers like those with which Leonardo stars over his gloomiest rocks; nothing like the fretwork of wings and flames in which Blake frames his most startling conceptions; no forest-scenery like Titian's fills his backgrounds, but only blank ranges of rock and dim vegetable forms as blank as they, as in a world before the creation of the first five days.

Of the whole story of the creation he has painted only the creation of the first man and woman, and, for him at least, feebly, the creation of light. It belongs to the quality of his genius thus to concern itself almost exclusively with the creation of man. For him it is not, as in the story itself, the last and crowning act of a series of developments, but the first and unique act, the creation of life itself in its supreme form, off-hand and immediately, in the cold and lifeless stone. With him the beginning of life has all the characteristics of resurrection; it is like the recovery of suspended health or animation, with its gratitude, its effusion, and eloquence. Fair as the young men of the Elgin marbles,* the Adam of the Sistine Chapel is unlike them in a total absence of that balance and completeness which expresses so well the sentiment of a self-contained, independent life. In that languid figure there is something rough and satyr-like, something akin to the rough hill-side on which it lies. His whole form is gathered into an expression of mere expectation and reception; he has hardly strength enough to lift his finger to touch the finger of the creator; yet a touch of the finger-tips will suffice.

This creation of life, life coming always as relief or recovery, and always in strong contrast with the rough-hewn mass in which it is kindled, is in various ways the motive of all his work, whether its immediate subject be Pagan or Christian, legend or allegory; and this, although at least one half of his work was designed for the adornment of tombs—the tomb of Julius, the tombs of the Medici.* Not the Judgment but the Resurrection is the real subject of his last work in the Sistine; and his favourite Pagan subject is the legend of Leda,* the delight of the world breaking from the egg of a bird. He secures that ideality of expression, which in Greek sculpture depends on a delicate system of abstraction, and in early Italian sculpture on lowness of relief, by an incompleteness which is surely not always undesigned, and which I suppose no one regrets, and trusts to the

spectator to complete the half-emerged form. And as his persons have something of the unwrought stone about them, so as if to realise the expression by which the old Florentine records describe a sculptor, *master of live stone,** with him the very rocks seem to have life; they have but to cast away the dust and scurf to rise and stand on their feet. He loved the very quarries of Carrara, those strange grey peaks which even at midday convey into any scene from which they are visible something of the solemnity and stillness of evening, sometimes wandering among them month after month, till at last their pale ashen colours seem to have passed into his painting; and on the crown of the head of the David there still remains a morsel of unhewn stone, as if by one touch to maintain its connexion with the place from which it was hewn.

And it is in this penetrative suggestion of life that the secret of that sweetness of his is to be found. He gives us no lovely natural objects like Leonardo, but only blank ranges of rock, and dim vegetable forms as blank as they; no lovely draperies and comely gestures of life, but only the austere truths of human nature; 'simple persons'—as he replied in his rough way to the querulous criticism of Julius the Second that there was no gold on the figures of the Sistine Chapel—'simple persons, who wore no gold on their garments.'* But he penetrates us with a sense of that power which we associate with all the warmth and fulness of the world, and the sense of which brings into one's thoughts a swarm of birds and flowers and insects. The brooding spirit of life itself is there; and the summer may burst out in a moment.

He was born in an interval of a rapid midnight journey in March, at a place in the neighbourhood of Arezzo, the thin, clear air of which it was then thought was favourable to the birth of children of great parts. He came of a race of grave and dignified men, who, claiming kinship with the family of Canossa, and some colour of imperial blood in their veins, had, generation after generation, received honourable employment under the government of Florence. His mother, a girl of nineteen years, put him out to nurse at a country house among the hills of Settignano, where every other inhabitant is a worker in the marble quarries, and the child early became familiar with that strange first stage in the sculptor's art. To this succeeded the influence of the sweetest and most placid master Florence had yet seen, Domenico Ghirlandajo. At fifteen he was at work among the

curiosities of the garden of the Medici, copying and restoring antiques, winning the condescending notice of the great Lorenzo. He knew too how to excite strong hatreds; and it was at this time that in a quarrel with a fellow-student he received a blow in the face which deprived him for ever of the dignity of outward form. It was through an accident that he came to study those works of the early Italian sculptors which suggested much of his own grandest work and impressed it with so deep a sweetness. He believed in dreams and omens. A friend of his dreamed twice that Lorenzo, then lately dead, appeared to him in grey and dusty apparel. To Michelangelo this dream seemed to portend the troubles which afterwards really came, and with the suddenness which was characteristic of all his movements he left Florence. Having occasion to pass through Bologna he neglected to procure the little seal of red wax which the stranger entering Bologna must carry on the thumb of his right hand. He had no money to pay the fine, and would have been thrown into prison had not one of the magistrates interfered. He remained in this man's house a whole year, rewarding his hospitality by readings from the Italian poets whom he loved. Bologna, with its endless colonnades and fantastic leaning towers, can never have been one of the lovelier cities of Italy. But about the portals of its vast unfinished churches and dark shrines, half-hidden by votive flowers and candles, lie some of the sweetest works of the early Tuscan sculptors, Giovanni da Pisa and Jacopo della Quercia, things as soft as flowers; and the year which Michelangelo spent in copying these works was not a lost year. It was now, on returning to Florence, that he put forth that unique conception of Bacchus,* which expresses not the mirthfulness of the god of wine, but his sleepy seriousness, his enthusiasm, his capacity for profound dreaming. No one ever expressed more truly than Michelangelo the notion of inspired sleep, of faces charged with dreams. A vast fragment of marble had long lain below the Loggia of Orcagna, and many a sculptor had had his thoughts of a design which should just fill this famous block of stone, cutting the diamond, as it were, without loss. Under Michelangelo's hand it became the David which now stands on the steps of the Palazzo Vecchio. Michelangelo was now thirty years old, and his reputation was established. Three great works fill the remainder of his life; three works often interrupted, carried on through a thousand hesitations, a thousand disappointments, quarrels with his patrons, quarrels with

his family, quarrels perhaps most of all with himself—the Sistine Chapel, the Mausoleum of Julius the Second, and the sacristy of San Lorenzo.

In the story of Michelangelo's life, the strength often turning to bitterness is not far to seek; a discordant note sounds throughout it which almost spoils the music. He 'treats the Pope as the King of France himself would not dare to treat him;' he goes along the streets of Rome 'like an executioner,' Raffaelle says of him.* Once he seems to have shut himself up with the intention of starving himself to death. As one comes in reading his life on its harsh, untempered incidents, the thought again and again arises that he is one of those who incur the judgment of Dante, as having *wilfully lived in sadness.** Even his tenderness and pity are embittered by their strength. What passionate weeping in that mysterious figure which in the 'Creation of Adam' crouches below the image of the Almighty, as he comes with the forms of things to be, woman and her progeny, in the fold of his garment! What a sense of wrong in those two captive youths who feel the chains like scalding water on their proud and delicate flesh! The idealist who became a reformer with Savonarola, and a republican superintending the fortification of Florence—the nest where he was born, *il nido ove naqqu'io*, as he calls it once in a sudden throb of affection—in its last struggle for liberty, yet believed always that he had imperial blood in his veins and was of the kindred of the great Matilda, had within the depths of his nature some secret spring of indignation or sorrow. We know little of his youth, but all tends to make one believe in the vehemence of its passions. Beneath the Platonic calm of the sonnets there is latent a deep delight in carnal form and colour.* There, and still more in the madrigals, he often falls into the language of less tranquil affections; while some of them have the colour of penitence, as from a wanderer returning home. He who spoke so decisively of the supremacy in the imaginative world of the unveiled human form had not been always a mere Platonic lover. Vague and wayward his loves may have been; but they partook of the strength of his nature, and sometimes would by no means become music, so that the comely order of his days was quite put out; *par che amaro ogni mio dolce io senta.**

But his genius is in harmony with itself; and just as in the products of his art we find resources of sweetness within their exceeding strength, so in his own story also, bitter as the ordinary sense of it

may be, there are select pages shut in among the rest, pages one might easily turn over too lightly, but which yet sweeten the whole volume. The interest of Michelangelo's poems is that they make us spectators of this struggle; the struggle of a strong nature to adorn and attune itself; the struggle of a desolating passion, which yearns to be resigned and sweet and pensive, as Dante's was. It is a consequence of the occasional and informal character of his poetry that it brings us nearer to himself, his own mind and temper, than any work done merely to support a literary reputation could possibly do. His letters tell us little that is worth knowing about him, a few poor quarrels about money and commissions. But it is quite otherwise with these songs and sonnets, written down at odd moments, sometimes on the margins of his sketches, themselves often unfinished sketches, arresting some salient feeling or unpremeditated idea as it passed. And it happens that a true study of these has become within the last few years for the first time possible. A few of the sonnets circulated widely in manuscript, and became almost within Michelangelo's own lifetime a subject of academical discourses. But they were first collected in a volume in 1623 by the great-nephew of Michelangelo, Michelangelo Buonarroti the younger.* He omitted much, re-wrote the sonnets in part, and sometimes compressed two or more compositions into one, always losing something of the force and incisiveness of the original. So the book remained, neglected even by Italians themselves in the last century, through the influence of that French taste which despised all compositions of the kind, as it despised and neglected Dante. *Sa reputation s'affirmira toujours*, Voltaire says of Dante, *parce qu'on ne le lit guère*.* But in 1858 the last of the Buonarroti bequeathed to the municipality of Florence the curiosities of his family. Among them was a precious volume containing the autograph of the sonnets. A learned Italian, Signor Cesare Guasti, undertook to collate this autograph with other manuscripts at the Vatican and elsewhere, and in 1863 published a true version of Michelangelo's poems, with dissertations and a paraphrase.*

People have often spoken of these poems as if they were a mere cry of distress, a lover's complaint over the obduracy of Vittoria Colonna. But those who speak thus forget that though it is quite possible that Michelangelo had seen Vittoria, that somewhat shadowy figure, as early as 1537, yet their closer intimacy did not begin till about the year 1542, when Michelangelo was nearly seventy years old. Vittoria

herself, an ardent Neo-catholic, vowed to perpetual widowhood since the news had reached her, seventeen years before, that her husband, the youthful and princely Marquess of Pescara, lay dead of the wounds he had received in the battle of Pavia, was then no longer an object of great passion. In a dialogue written by the painter, Francesco d'Ollanda, we catch a glimpse of them together in an empty church at Rome, one Sunday afternoon, discussing indeed the characteristics of various schools of art, but still more the writings of Saint Paul, already following the ways and tasting the sunless pleasures of weary people, whose hold on outward things is slackening. In a letter still extant he regrets that when he visited her after death he had kissed her hands only. He made, or set to work to make, a crucifix for her use, and two drawings, perhaps in preparation for it, are now in Oxford. From allusions in the sonnets we may divine that when they first approached each other he had debated much with himself whether this last passion would be the most unsoftening, the most desolating of all—*un dolce amaro, un si e no mi muovi;** is it carnal affection, or *del suo prestino stato*—Plato's ante-natal state—*il raggio ardente?** The older conventional criticism, dealing with the text of 1623, had lightly assumed that all, or nearly all the sonnets were actually addressed to Vittoria herself; but Signor Guasti finds only four, or at most five, which can be so attributed on genuine authority. Still there are reasons which make him assign the majority of them to the period between 1542 and 1547, and we may regard the volume as a record of this resting-place in Michelangelo's story. We know how Goethe escaped from the stress of sentiments too strong for him by making a book about them;* and for Michelangelo to write down his passionate thoughts at all, to make sonnets about them, was already in some measure to command and have his way with them;—

> 'La vita del mia amor non è il cor mio,
> Ch'amor, di quel ch'io t'amo, è senza core.'*

It was just because Vittoria raised no great passion that the space in his life where she reigns has such peculiar suavity; and the spirit of the sonnets is lost if we once take them out of that dreamy atmosphere in which men have things as they will, because the hold of all outward things upon them is faint and thin. Their prevailing tone is a calm and meditative sweetness. The cry of distress is indeed there,

but as a mere residue, a trace of bracing chalybeate salt,* just discernible in the song which rises as a clear sweet spring from a charmed space in his life.

This charmed and temperate space in Michelangelo's life, without which its excessive strength would have been so imperfect, which saves him from the judgment of Dante on those who *wilfully lived in sadness*, is a well-defined period there, reaching from the year 1542 to the year 1547, the year of Vittoria's death. In it, the life-long effort to tranquillise his vehement emotions by withdrawing them into the region of ideal sentiment becomes successful; and the significance of Vittoria in it, is that she realises for him a type of affection which even in disappointment may charm and sweeten his spirit. In this effort to tranquillise and sweeten life by idealising its vehement sentiments there were two great traditional types, either of which an Italian of the sixteenth century might have followed. There was Dante, whose little book of the 'Vita Nuova' had early become a pattern of imaginative love, maintained somewhat feebly by the later Petrarchists; and since Plato had become something more than a name in Italy by the publication of the Latin translation of his works by Marsilio Ficino, there was the Platonic tradition also. Dante's belief in the resurrection of the body, through which even in heaven Beatrice loses for him no tinge of flesh-colour or fold of raiment even, and the Platonic dream of the passage of the soul through one form of life after another, with its passionate haste to escape from the burden of bodily form altogether, are, for all effects of art or poetry, principles diametrically opposite. And it is the Platonic tradition rather than Dante's that has moulded Michelangelo's verse. In many ways no sentiment could have been less like Dante's love for Beatrice than Michelangelo's for Vittoria Colonna. Dante's comes in early youth; Beatrice is a child, with the wistful ambiguous vision of a child, with a character still unaccentuated by the influence of outward circumstances, almost expressionless. Vittoria is a woman already weary, in advanced age, of grave intellectual qualities. Dante's story is a piece of figured work inlaid with lovely incidents. In Michelangelo's poems frost and fire are almost the only images—the refining fire of the goldsmith; once or twice the phœnix; ice melting at the fire; fire struck from the rock which it afterwards consumes. Except one doubtful allusion to a journey, there are almost no incidents. But there is much of the bright sharp unerring

skill with which in boyhood he gave the look of age to the head of a faun by chipping a tooth from its jaw with a single stroke of the hammer. For Dante, the amiable and devout materialism of the Middle Age sanctifies all that is presented by hand and eye. Michelangelo in always pressing forward from the outward beauty—*il bel del fuor che agli oochi piace*—to apprehend the unseen beauty; *trascenda nella forma universale**—that abstract form of beauty about which the Platonists reason. And this gives the impression in him of something flitting and unfixed, of the houseless and complaining spirit, almost clairvoyant through the frail and yielding flesh. He accounts for love at first sight by a previous state of existence—*la dove io t'amai prima.*[1]*

[1] The 'Contemporary Review' for September, 1872, contains translations of 'Twenty-three Sonnets from Michael Angelo,' executed with great taste and skill, from the original text as published by Guasti. I venture to quote the following:—

To Vittoria Colonna.

Bring back the time when blind desire ran free,
 With bit and rein too loose to curb his flight;
 Give back the buried face, once angel-bright,
That hides in earth all comely things from me;
Bring back those journeys ta'en so toilsomely,
 So toilsome slow to him whose hairs are white;
 Those tears and flames that in our breast unite;
If thou wilt once more take thy fill of me!

Yet, Love! suppose it true that thou dost thrive
Only on bitter honey-dews of tears,
Small profit hast thou of a weak old man.
My soul that toward the other shore doth strive,
Wards off thy darts with shafts of holier fears;
And fire feeds ill on brands no breath can fan.

To Tommaso Cavalieri.

Why should I seek to ease intense desire
 With still more tears and windy words of grief,
 When heaven, or late or soon, sends no relief
To souls whom love hath robed around with fire?
Why needs my aching heart to death aspire,
 When all must die? Nay death beyond belief
 Unto those eyes would be both sweet and brief,
Since in my sum of woes all joys expire!

Therefore because I cannot shun the blow
 I rather seek, say who must rule my breast,
Gliding between her gladness and her woe?
 If only chains and bonds can make me blest,
No marvel if alone and bare I go
 An armèd knight's captive and slave confessed.

[*note continues overleaf*]

And yet there are many points in which he is really like Dante, and comes very near to the original image over the later and feebler Petrarchists. He learns from Dante rather than from Plato, that for lovers, the surfeiting of desire—*ove gran desir gran copia affrend,** is a state less happy than misery full of hope—*una miseria di speranza piena*. He recalls him in the repetition of the words *gentile* and *cortesia*, in the personification of *Amor*, in the tendency to dwell minutely on the physical effects of the presence of a beloved object on the pulses and the heart. Above all he resembles Dante in the warmth and intensity of his political utterances, for the lady of one of his noblest sonnets was from the first understood to be the city of Florence; and he avers that all must be asleep in heaven if she who was created *d'angelica forma,** for a thousand lovers, is appropriated by one alone, some Piero or Alessandro de' Medici. Once and again he introduces Love and Death, who dispute concerning him; for, like Dante and all the nobler souls of Italy, he is much occupied with thoughts of the grave, and his true mistress is Death; death at first as the worst of all sorrows and disgraces, with a clod of the field for its brain; afterwards death in its high distinction, its detachment from vulgar needs, the angry stains of life and action escaping fast.

Some of those whom the gods love die young.* This man, because the gods loved him, lingered on to be of immense patriarchal age, till the sweetness it had taken so long to secrete in him was found at last. Out of the strong came forth sweetness, *ex forti dulcedo*. The world had changed around him. Neo-catholicism had taken the place of the Renaissance. The spirit of the Roman Church had changed; in the vast world's cathedral which his skill had helped to raise for it, it

To Night.

O night, O sweet though sombre span of time!
 All things find rest upon their journey's end—
 Whoso hath praised thee well doth apprehend;
And whoso honours thee hath wisdom's prime.
Our cares thou canst to quietude sublime,
 For dews and darkness are of peace the friend:
 Often by thee in dreams up-borne I wend
From earth to heaven where yet I hope to climb.

Thou shade of Death, through whom the soul at length
Shuns pain and sadness hostile to the heart,
 Whom mourners find their last and sure relief,
Thou dost restore our suffering flesh to strength,
Driest our tears, assuagest every smart,
 Purging the spirits of the pure from grief.

looked stronger than ever. Some of the first members of the Oratory*
were among his intimate associates. They were of a spirit as unlike as
possible from that of Lorenzo, or Savonarola even. The opposition
of the reform to art has been often enlarged upon; far greater was that
of the catholic revival. But in thus fixing itself in a frozen orthodoxy
the catholic church had passed beyond him, and he was a stranger to
it. In earlier days, when its beliefs had been in a fluid state, he too
might have been drawn into the controversy; he might have been for
spiritualising the papal sovereignty, like Savonarola; or for adjusting
the dreams of Plato and Homer with the words of Christ, like Pico of
Mirandola. But things had moved onward, and such adjustments
were no longer possible. For himself, he had long since fallen back
on that divine ideal which, above the wear and tear of creeds, has
been forming itself for ages as the possession of nobler souls. And
now he began to feel the soothing influence which since that time the
catholic church has often exerted over spirits too noble to be its sub-
jects, yet brought within the neighbourhood of its action; consoled
and tranquillised, as a traveller might be, resting for one evening in
a strange city, by its stately aspect and the sentiment of its many
fortunes, just because with those fortunes he has nothing to do. So
he lingers on; a *revenant*, as the French say, a ghost out of another
age, in a world too coarse to touch his faint sensibilities too closely;
dreaming in a worn-out society, theatrical in its life, theatrical in its
art, theatrical even in its devotion, on the morning of the world's
history, on the primitive form of man, on the images under which
that primitive world had conceived of spiritual forces.

I have dwelt on the thought of Michelangelo as thus lingering
beyond his time in a world not his own, because if one is to distin-
guish the peculiar savour of his work, he must be approached, not
through his followers, but through his predecessors; not through the
marbles of Saint Peter's, but through the work of the sculptors of the
fifteenth century over the tombs and altars of Tuscany. He is the last
of the Florentines, of those on whom the peculiar sentiment of the
Florence of Dante and Giotto descended; he is the consummate
representative of the form that sentiment took in the fifteenth cen-
tury with men like Luca Signorelli and Mino da Fiesole. Up to him
the tradition of sentiment is unbroken, the progress towards surer
and more mature methods of expressing that sentiment, continuous.

But his professed disciples did not share this temper, they are in love with his strength only, and seem not to feel his grave and temperate sweetness. Theatricality is their chief characteristic; and that is a quality as little attributable to Michelangelo as to Mino or Luca Signorelli. With him, as with them, all is passionate, serious, impulsive.

This discipleship of Michelangelo, this dependence of his on the tradition of the Florentine schools, is nowhere seen more clearly than in his treatment of the Creation. The Creation of Man had haunted the mind of the middle age like a dream; and weaving it into a hundred carved ornaments of capital or doorway, the Italian sculptors had early impressed upon it that pregnancy of expression which seems to give it many veiled meanings. As with other artistic conceptions of the middle age, its treatment became almost conventional, handed on from artist to artist, with slight changes, till it came to have almost an independent abstract existence of its own. It was characteristic of the mediæval mind thus to give an independent traditional existence to a special pictorial conception, or to a legend, like that of 'Tristram' or 'Tannhäuser,' or even to the very thoughts and substance of a book, like the 'Imitation,' so that no single workman could claim it as his own, and the book, the image, the legend, had itself a legend, and its fortunes, and a personal history; and it is a sign of the mediævalism of Michelangelo that he thus receives from tradition his central conception, and does but add the last touches in transferring it to the frescoes of the Sistine Chapel.

But there was another tradition of those earlier, more serious Florentines of which Michelangelo is the inheritor, to which he gives the final expression, and which centres in the sacristy of San Lorenzo, as the tradition of the Creation centres in the Sistine Chapel. It has been said that all the great Florentines were pre-occupied with death. *Outre-tombe! Outre-tombe!** is the burden of their thoughts, from Dante to Savonarola. Even the gay and licentious Boccaccio gives a keener edge to his stories by putting them in the mouths of a party of people who had taken refuge from the plague in a country-house. It was to this inherited sentiment, this practical decision that to be preoccupied with the thought of death was in itself dignifying, and a note of high quality, that the seriousness of the great Florentines of the fifteenth century was partly due; and it was reinforced in them by the actual sorrows of their times. How often, and in what various ways, had they seen life stricken down in their streets

and houses. La bella Simonetta dies in early youth, and is borne to the grave with uncovered face. The young Cardinal of Portugal dies on a visit to Florence—*insignis formâ fui et mirabili modesliâ*, his epitaph dares to say; Rossellino carved his tomb in the church of San Miniato,* with care for the shapely hands and feet and sacred attire; Luca della Robbia put his skyiest works there; and the tomb of the youthful and princely prelate became the strangest and most beautiful thing in that strange and beautiful place. After the execution of the Pazzi conspirators* Botticelli is employed to paint their portraits. This preoccupation with serious thoughts and sad images might easily have resulted, as it did, for instance, in the gloomy villages of the Rhine, or in the overcrowded parts of mediæval Paris, as it still does in many a village of the Alps, in something merely morbid or grotesque, in the *Danse Macabre** of many French and German painters, or the grim inventions of Dürer. From such a result the Florentine masters of the fifteenth century were saved by their high Italian dignity and culture, and still more by their tender pity for the thing itself. They must often have leaned over the lifeless body when all was at length quiet and smoothed out. After death, it is said, the traces of slighter and more superficial dispositions disappear; the lines become more simple and dignified; only the abstract lines remain, in a grand indifference. They came thus to see death in its distinction; and following it perhaps one stage further, and dwelling for a moment on the point where all that transitory dignity broke up, and discerning with no clearness a new body, they paused just in time, and abstained with a sentiment of profound pity.

Of all this sentiment Michelangelo is the achievement; and first of all of pity. *Pietà*, pity, the pity of the Virgin Mother over the dead body of Christ, expanded into the pity of all mothers over all dead sons, the entombment, with its cruel 'hard stones';—that is the subject of his predilection. He has left it in many forms, sketches, half-finished designs, finished and unfinished groups of sculpture, but always as a hopeless, rayless, almost heathen sorrow, no divine sorrow, but mere pity and awe at the stiff limbs and colourless lips. There is a drawing of his at Oxford* in which the dead body has sunk to the earth between his mother's feet with the arms extended over her knees. The tombs at San Lorenzo are memorials, not of any of the nobler and greater Medici, but of Giuliano and Lorenzo the younger, noticeable chiefly for their somewhat early

death. It is mere human nature therefore which has prompted the sentiment here. The titles assigned traditionally to the four symbolical figures, 'Night' and 'Day,' 'the Twilight' and 'the Dawn,' are far too definite for them; they come much nearer to the mind and spirit of their author, and are a more direct expression of his thoughts than any merely symbolical conceptions could possibly be. They concentrate and express, less by way of definite conceptions than by the touches, the promptings of a piece of music, all those vague fancies, misgivings, presentiments, which shift and mix and define themselves and fade again, whenever the thoughts try to fix themselves with sincerity on the conditions and surroundings of the disembodied spirit. I suppose no one would come here for consolation; for seriousness, for solemnity, for dignity of impression perhaps, but not for consolation. It is a place neither of terrible nor consoling thoughts, but of vague and wistful speculation. Here again Michelangelo is the disciple not so much of Dante as of the Platonists. Dante's belief in immortality is formal, precise, and firm, as much so almost as that of a child who thinks the dead will hear if you cry loud enough. But in Michelangelo you have maturity, the mind of the grown man, dealing cautiously and dispassionately with serious things; and what hope he has is based on the consciousness of ignorance—ignorance of man, ignorance of the nature of the mind, its origin and capacities. Michelangelo is so ignorant of the spiritual world, of the new body and its laws, that he does not surely know whether the consecrated host may not be the body of Christ. And of all that range of sentiment he is the poet, a poet still alive and in possession of our inmost thoughts—dumb inquiry, the relapse after death into the formlessness which preceded life, change, revolt from that change, then the correcting, hallowing, consoling rush of pity; at last, far off, thin and vague, yet not more vague than the most definite thoughts men have had through three centuries on a matter that has been so near their hearts—the new body; a passing light, a mere intangible, external effect over those too rigid or too formless faces; a dream that lingers a moment, retreating in the dawn, incomplete, aimless, helpless; a thing with faint hearing, faint memory, faint power of touch; a breath, a flame in the doorway, a feather in the wind.

The qualities of the great masters in art or literature, the combination of those qualities, the laws by which they moderate, support,

relieve each other, are not peculiar to them; but most often typical standards, revealing instances of the laws by which certain æsthetic effects are produced. The old masters indeed are simpler; their characteristics are written larger, and are easier to read, than their analogues in all the mixed confused productions of the modern mind. But when once one has succeeded in defining for oneself those characteristics and the law of their combination, one has acquired a standard or measure which helps us to put in its right place many a vagrant genius, many an unclassified talent, many precious though imperfect products. It is so with the components of the true character of Michelangelo. That strange interfusion of sweetness and strength is not to be found in those who claimed to be his followers; but it is found in many of those who worked before him, and in many others down to our own time, in William Blake, for instance, and Victor Hugo, who, though not of his school, and unaware, are his true sons, and help us to understand him, as he in turn interprets and justifies them. Perhaps this is the chief use in studying old masters.

LEONARDO DA VINCI

In Vasari's life of Leonardo da Vinci as we now read it there are some variations from the first edition.* There, the painter who has fixed the outward type of Christ for succeeding centuries was a bold speculator, holding lightly by other men's beliefs, setting philosophy above Christianity. Words of his, trenchant enough to justify this impression, are not recorded, and would have been out of keeping with a genius of which one characteristic is the tendency to lose itself in a refined and graceful mystery. The suspicion was but the time-honoured form in which the world stamps its appreciation of one who has thoughts for himself alone, his high indifferentism, his intolerance of the common forms of things; and in the second edition the image was changed into something fainter and more conventional. But it is still by a certain mystery in his work, and something enigmatical beyond the usual measure of great men, that he fascinates, or perhaps half repels. His life is one of sudden revolts, with intervals in which he works not at all, or apart from the main scope of his work. By a strange fortune the works on which his more popular fame rested disappeared early from the world, as the 'Battle of the Standard'; or are mixed obscurely with the work of meaner hands, as the 'Last Supper.' His type of beauty is so exotic that it fascinates a larger number than it delights, and seems more than that of any other artist to reflect ideas and views and some scheme of the world within; so that he seemed to his contemporaries to be the possessor of some unsanctified and secret wisdom; as to Michelet and others to have anticipated modern ideas.* He trifles with his genius, and crowds all his chief work into a few tormented years of later life; yet he is so possessed by his genius that he passes unmoved through the most tragic events, overwhelming his country and friends, like one who comes across them by chance on some secret errand.

His *legend*, as the French say, with the anecdotes which every one knows, is one of the most brilliant in Vasari. Later writers merely copied it, until, in 1804, Carlo Amoretti applied to it a criticism which left hardly a date fixed, and not one of those anecdotes untouched. And now a French writer, M. Arsène Houssaye,* gathering together

all that is known about Leonardo in an easily accessible form, has done for the third of the three great masters what Grimm has done for Michelangelo, and Passavant, long since, for Raffaelle.* Antiquarianism has no more to do. For others remain the editing of the thirteen books of his manuscripts, and the separation by technical criticism of what in his reputed works is really his, from what is only half his or the work of his pupils. But a lover of strange souls may still analyse for himself the impression made on him by those works, and try to reach through it a definition of the chief elements of Leonardo's genius. The *legend*, corrected and enlarged by its critics, may now and then intervene to support the results of this analysis.

His life has three divisions,—thirty years at Florence, nearly twenty years at Milan, then nineteen years of wandering, till he sinks to rest under the protection of Francis the First at the Château de Clou. The dishonour of illegitimacy hangs over his birth. Piero Antonio, his father, was of a noble Florentine house, of Vinci in the Val d'Arno, and Leonardo, brought up delicately among the true children of that house, was the love-child of his youth, with the keen puissant nature such children often have. We see him in his youth fascinating all men by his beauty, improvising music and songs, buying the caged birds and setting them free as he walked the streets of Florence, fond of odd bright dresses and spirited horses.

From his earliest years he designed many objects, and constructed models in relief, of which Vasari mentions some of women smiling. His father, pondering over this promise in the child, took him to the workshop of Andrea del Verrocchio, then the most famous artist in Florence. Beautiful objects lay about there,—reliquaries, pyxes, silver images for the pope's chapel at Rome, strange fancy work of the middle age keeping odd company with fragments of antiquity, then but lately discovered. Another student Leonardo may have seen there—a boy into whose soul the level light and aërial illusions of Italian sunsets had passed, in after days famous as Perugino. Verrocchio was an artist of the earlier Florentine type, carver, painter, and worker in metals in one; designer, not of pictures only, but of all things for sacred or household use, drinking-vessels, ambries, instruments of music, making them all fair to look upon, filling the common ways of life with the reflection of some far-off brightness; and years of patience had refined his hand till his work was now sought after from distant places.

It happened that Verrocchio was employed by the brethren of Vallombrosa to paint the Baptism of Christ, and Leonardo was allowed to finish an angel in the left-hand corner. It was one of those moments in which the progress of a great thing—here that of the art of Italy—presses hard and sharp on the happiness of an individual, through whose discouragement and decrease, humanity, in more fortunate persons, comes a step nearer to its final success.

For beneath the cheerful exterior of the mere well-paid craftsman, chasing brooches for the copes of Santa Maria Novella, or twisting metal screens for the tombs of the Medici, lay the ambitious desire of expanding the destiny of Italian art by a larger knowledge and insight into things, a purpose in art not unlike Leonardo's still unconscious purpose; and often, in the modelling of drapery, or of a lifted arm, or of hair cast back from the face, there came to him something of the freer manner and richer humanity of a later age. But in this 'Baptism' the pupil had surpassed the master; and Verrocchio turned away as one stunned, and as if his sweet earlier work must thereafter be distasteful to him, from the bright animated angel of Leonardo's hand.

The angel may still be seen in Florence, a space of sunlight in the cold, laboured old picture; but the legend is true only in sentiment, for painting had always been the art by which Verrocchio set least store. And as in a sense he anticipates Leonardo, so to the last Leonardo recalls the studio of Verrocchio, in the love of beautiful toys, such as the vessel of water for a mirror, and lovely needlework about the implicated hands in the 'Modesty and Vanity',* and of reliefs, like those cameos which in the 'Virgin of the Balances'* hang all round the girdle of Saint Michael, and of bright variegated stones, such as the agates in the 'Saint Anne', and in a hieratic preciseness and grace, as of a sanctuary swept and garnished. Amid all the cunning and intricacy of his Lombard manner this never left him. Much of it there must have been in that lost picture of 'Paradise', which he prepared as a cartoon for tapestry to be woven in the looms of Flanders. It was the perfection of the older Florentine style of miniature painting, with patient putting of each leaf upon the trees and each flower in the grass, where the first man and woman were standing.

And because it was the perfection of that style, it awoke in Leonardo some seed of discontent which lay in the secret places of his nature. For the way to perfection is through a series of disgusts;

and this picture—all that he had done so far in his life at Florence—was after all in the old slight manner. His art, if it was to be something in the world, must be weighted with more of the meaning of nature and purpose of humanity. Nature was 'the true mistress of higher intelligences.'* So he plunged into the study of nature. And in doing this he followed the manner of the older students; he brooded over the hidden virtues of plants and crystals, the lines traced by the stars as they moved in the sky, over the correspondences which exist between the different orders of living things, through which, to eyes opened, they interpret each other; and for years he seemed to those about him as one listening to a voice silent for other men.

He learned here the art of going deep, of tracking the sources of expression to their subtlest retreats, the power of an intimate presence in the things he handled. He did not at once or entirely desert his art; only he was no longer the cheerful objective painter, through whose soul, as through clear glass, the bright figures of Florentine life, only made a little mellower and more pensive by the transit, passed on to the white wall. He wasted many days in curious tricks of design, seeming to lose himself in the spinning of intricate devices of lines and colours. He was smitten with a love of the impossible—the perforation of mountains, changing the course of rivers, raising great buildings, such as the church of San Giovanni, in the air; all those feats for the performance of which natural magic* professes to have the key. Later writers, indeed, see in these efforts an anticipation of modern mechanics; in him they were rather dreams, thrown off by the overwrought and labouring brain. Two ideas were especially fixed in him, as reflexes of things that had touched his brain in childhood beyond the measure of other impressions—the smiling of women and the motion of great waters.

And in such studies some interfusion of the extremes of beauty and terror shaped itself, as an image that might be seen and touched, in the mind of this gracious youth, so fixed that for the rest of his life it never left him; and as catching glimpses of it in the strange eyes or hair of chance people, he would follow such about the streets of Florence till the sun went down, of whom many sketches of his remain. Some of these are full of a curious beauty, that remote beauty apprehended only by those who have sought it carefully; who, starting with acknowledged types of beauty, have refined as far upon these, as these refine upon the world of common forms. But mingled

inextricably with this there is an element of mockery also; so that, whether in sorrow or scorn, he caricatures Dante even. Legions of grotesques sweep under his hand; for has not nature too her grotesques—the rent rock, the distorting light of evening on lonely roads, the unveiled structure of man in the embryo or the skeleton?

All these swarming fancies unite in the 'Medusa' of the Uffizii.* Vasari's story of an earlier Medusa,* painted on a wooden shield, is perhaps an invention; and yet, properly told, has more of the air of truth about it than anything else in the whole legend. For its real subject is not the serious work of a man, but the experiment of a child. The lizards and glowworms and other strange small creatures which haunt an Italian vineyard bring before one the whole picture of a child's life in a Tuscan dwelling, half castle, half farm; and are as true to nature as the pretended astonishment of the father for whom the boy has prepared a surprise. It was not in play that he painted that other Medusa, the one great picture which he left behind him in Florence. The subject has been treated in various ways; Leonardo alone cuts to its centre; he alone realises it as the head of a corpse, exercising its powers through all the circumstances of death. What may be called the fascination of corruption penetrates in every touch its exquisitely finished beauty. About the dainty lines of the cheek the bat flits unheeded. The delicate snakes seem literally strangling each other in terrified struggle to escape from the Medusa brain. The hue which violent death always brings with it is in the features; features singularly massive and grand, as we catch them inverted, in a dexterous foreshortening, sloping upwards, almost sliding down upon us, crown foremost, like a great calm stone against which the wave of serpents breaks. But it is a subject that may well be left to the beautiful verses of Shelley.*

The science of that age was all divination, clairvoyance, unsubjected to our exact modern formulas, seeking in an instant of vision to concentrate a thousand experiences. Later writers, thinking only of the well-ordered treatise on painting which a Frenchman, Raffaelle du Fresne,* a hundred years afterwards, compiled from Leonardo's bewildered manuscripts, written strangely, as his manner was, from right to left, have imagined a rigid order in his inquiries. But this rigid order was little in accordance with the restlessness of his character; and if we think of him as the mere reasoner who subjects design to anatomy, and composition to mathematical rules,

we shall hardly have of him that impression, which those about him received from him. Poring over his crucibles, making experiments with colour, trying by a strange variation of the alchemist's dream to discover the secret, not of an elixir to make man's natural life immortal, but rather of giving immortality to the subtlest and most delicate effects of painting, he seemed to them rather the sorcerer or the magician, possessed of curious secrets and a hidden knowledge, living in a world of which he alone possessed the key. What his philosophy seems to have been most like is that of Paracelsus or Cardan; and much of the spirit of the older alchemy still hangs about it, with its confidence in short cuts and odd byways to knowledge. To him philosophy was to be something giving strange swiftness and double sight, divining the sources of springs beneath the earth or of expression beneath the human countenance, clairvoyant of occult gifts in common or uncommon things, in the reed at the brook-side or the star which draws near to us but once in a century. How in this way the clear purpose was overclouded, the fine chaser's hand perplexed, we but dimly see; the mystery which at no point quite lifts from Leonardo's life is deepest here. But it is certain that at one period of his life he had almost ceased to be an artist.

The year 1483—the year of the birth of Raffaelle and the thirty-first of Leonardo's life—is fixed as the date of his visit to Milan by the letter in which he recommends himself to Ludovico Sforza, and offers to tell him for a price strange secrets in the art of war. It was that Sforza who murdered his young nephew by slow poison, yet was so susceptible to religious impressions that he turned his worst passions into a kind of religious cultus, and who took for his device the mulberry tree—symbol, in its long delay and sudden yielding of flowers and fruit together, of a wisdom which economises all forces for an opportunity of sudden and sure effect. The fame of Leonardo had gone before him, and he was to model a colossal statue of Francesco, the first duke. As for Leonardo himself he came not as an artist at all, or careful of the fame of one; but as a player on the harp, a strange harp of silver of his own construction, shaped in some curious likeness to a horse's skull. The capricious spirit of Ludovico was susceptible to the charm of music, and Leonardo's nature had a kind of spell in it. Fascination is always the word descriptive of him. No portrait of his youth remains; but all tends to make us believe that up to this time some charm of voice and aspect, strong enough to balance

the disadvantage of his birth, had played about him. His physical strength was great; it was said that he could bend a horseshoe like a coil of lead.

The Duomo, the work of artists from beyond the Alps, so fantastic to a Florentine used to the mellow unbroken surfaces of Giotto and Arnolfo, was then in all its freshness; and below, in the streets of Milan, moved a people as fantastic, changeful, and dreamlike. To Leonardo least of all men could there be anything poisonous in the exotic flowers of sentiment which grew there. It was a life of exquisite amusements, (Leonardo became a celebrated designer of pageants,) and brilliant sins; and it suited the quality of his genius, composed in almost equal parts of curiosity and the desire of beauty, to take things as they came.

Curiosity and the desire of beauty*—these are the two elementary forces in Leonardo's genius; curiosity often in conflict with the desire of beauty, but generating, in union with it, a type of subtle and curious grace.

The movement of the fifteenth century was twofold: partly the Renaissance, partly also the coming of what is called the 'modern spirit,' with its realism, its appeal to experience; it comprehended a return to antiquity, and a return to nature. Raffaelle represents the return to antiquity, and Leonardo the return to nature. In this return to nature he was seeking to satisfy a boundless curiosity by her perpetual surprises, a microscopic sense of finish by her finesse, or delicacy of operation, that *subtilitas naturæ* which Bacon notices.* So we find him often in intimate relations with men of science, with Fra Luca Paccioli the mathematician, and the anatomist Marc Antonio della Torre. His observations and experiments fill thirteen volumes of manuscript; and those who can judge describe him as anticipating long before, by rapid intuition, the later ideas of science. He explained the obscure light of the unilluminated part of the moon, knew that the sea had once covered the mountains which contain shells, and the gathering of the equatorial waters above the polar.

He who thus penetrated into the most secret parts of nature preferred always the more to the less remote, what, seeming exceptional, was an instance of law more refined, the construction about things of a peculiar atmosphere and mixed lights. He paints flowers with such curious felicity that different writers have attributed to him a fondness for particular flowers, as Clement the cyclamen, and Rio*

the jasmine; while at Venice there is a stray leaf from his portfolio dotted all over with studies of violets and the wild rose. In him first, appears the taste for what is *bizarre* or *recherché* in landscape; hollow places full of the green shadow of bituminous rocks, ridged reefs of trap-rock which cut the water into quaint sheets of light—their exact antitype is in our own western seas; all solemn effects of moving water; you may follow it springing from its distant source among the rocks on the heath of the 'Madonna of the Balances,' passing as a little fall into the treacherous calm of the 'Madonna of the Lake,' next, as a goodly river below the cliffs of the 'Madonna of the Rocks,' washing the white walls of its distant villages, stealing out in a net-work of divided streams in 'La Gioconda' to the sea-shore of the 'Saint Anne'—that delicate place, where the wind passes like the hand of some fine etcher over the surface, and the untorn shells lie thick upon the sand, and the tops of the rooks, to which the waves never rise, are green with grass grown fine as hair. It is the landscape, not of dreams or of fancy, but of places far withdrawn; and hours selected from a thousand with a miracle of finesse. Through his strange veil of sight things reach him so; in no ordinary night or day, but as in faint light of eclipse, or in some brief interval of falling rain at daybreak, or through deep water.

And not into nature only; but he plunged also into human person-ality, and became above all a painter of portraits; faces of a modelling more skilful than has been seen before or since, embodied with a reality which almost amounts to illusion on dark air. To take a char-acter as it was, and delicately sound its stops, suited one so curious in observation, curious in invention. So he painted the portraits of Ludovico's mistresses, Lucretia Crivelli and Cecilia Galerani the poetess, of Ludovico himself, and the Duchess Beatrice.* The por-trait of Cecilia Galerani is lost, but that of Lucretia Crivelli has been identified with 'La Belle Feronière' of the Louvre, and Ludovico's pale, anxious face still remains in the Ambrosian. Opposite is the portrait of Beatrice d'Este, in whom Leonardo seems to have caught some presentiment of early death, painting her precise and grave, full of the refinement of the dead, in sad earth-coloured raiment, set with pale stones.

Sometimes this curiosity came in conflict with the desire of beauty; it tended to make him go too far below that outside of things in which art begins and ends. This struggle between the reason and

its ideas, and the senses, the desire of beauty, is the key to Leonardo's life at Milan—his restlessness, his endless retouchings, his odd experiments with colour. How much must he leave unfinished, how much recommence! His problem was the transmutation of ideas into images. What he had attained so far had been the mastery of that earlier Florentine style, with its naïve and limited sensuousness. Now he was to entertain in this narrow medium those divinations of a humanity too wide for it, that larger vision of the opening world which is only not too much for the great, irregular art of Shakespeare; and everywhere the effort is visible in the work of his hands. This agitation, this perpetual delay, give him an air of weariness and ennui. To others he seems to be aiming at an impossible effect, to do something that art, that painting, can never do. Often the expression of physical beauty at this or that point seems strained and marred in the effort, as in those heavy German foreheads—too heavy and German for perfect beauty.

For there was a touch of Germany in that genius which, as Goethe said, had 'müde sich gedacht,' *thought itself weary*.* What an anticipation of modern Germany, for instance, in that debate on the question whether sculpture or painting is the nobler art.[1] But there is this difference between him and the German, that, with all that curious science, the German would have thought nothing more was needed; and the name of Goethe himself reminds one how great for the artist may be the danger of over-much science; how Goethe, who, in the *Elective Affinities* and the first part of 'Faust,'* does transmute ideas into images, who wrought many such transmutations, did not invariably find the spell-word, and in the second part of 'Faust' presents us with a mass of science which has no artistic character at all. But Leonardo will never work till the happy moment comes—that moment of *bien-être*,* which to imaginative men is a moment of invention. On this moment he waits; other moments are but a preparation or after-taste of it. Few men distinguish between them as jealously as he did. Hence so many flaws even in the choicest work. But for Leonardo the distinction is absolute, and, in the moment of *bien-être*, the alchemy complete; the idea is stricken into colour and imagery; a cloudy mysticism is refined to a subdued and graceful mystery, and painting pleases the eye while it satisfies the soul.

[1] How princely, how characteristic of Leonardo, the answer, 'Quanto più, un' arte porta seco fatica di corpo, tanto più è vile!'*

This curious beauty is seen above all in his drawings, and in these chiefly in the abstract grace of the bounding lines. Let us take some of these drawings,* and pause over them awhile; and, first, one of those at Florence—the heads of a woman and a little child, set side by side, but each in its own separate frame. First of all, there is much pathos in the re-appearance in the fuller curves of the face of the child, of the sharper, more chastened lines of the worn and older face, which leaves no doubt that the heads are those of a little child and its mother. A feeling for maternity is indeed always characteristic of Leonardo; and this feeling is further indicated here by the half-humorous pathos of the diminutive rounded shoulders of the child. You may note a like pathetic power in drawings of a young man, seated in a stooping posture, his face in his hands, as in sorrow; of a slave sitting in an uneasy sitting attitude in some brief interval of rest; of a small Madonna and Child, peeping sideways in half-reassured terror, as a mighty griffin with bat-like wings, one of Leonardo's finest *inventions*, descends suddenly from the air to snatch up a lion wandering near them. But note in these, as that which especially belongs to art, the contour of the young man's hair, the poise of the slave's arm above his head, and the curves of the head of the child, following the little skull within, thin and fine as some sea-shell worn by the wind.

Take again another head, still more full of sentiment, but of a different kind, a little red chalk drawing which every one remembers who has seen the drawings at the Louvre. It is a face of doubtful sex, set in the shadow of its own hair, the cheek-line in high light against it, with something voluptuous and full in the eyelids and the lips. Another drawing might pass for the same face in childhood, with parched and feverish lips, but with much sweetness in the loose, short-waisted, childish dress, with necklace and bulla, and the daintily bound hair. We might take the thread of suggestion which these two drawings offer, thus set side by side, and, following it through the drawings at Florence, Venice, and Milan, construct a sort of series, illustrating better than anything else Leonardo's type of womanly beauty. Daughters of Herodias,* with their fantastic head-dresses knotted and folded so strangely, to leave the dainty oval of the face disengaged, they are not of the Christian family, or of Raffaelle's. They are the clairvoyants, through whom, as through delicate instruments, one becomes aware of the subtler forces of nature, and the

modes of their action, all that is magnetic in it, all those finer conditions wherein material things rise to that subtlety of operation which constitutes them spiritual, where only the finer nerve and the keener touch can follow; it is as if in certain revealing instances we actually saw them at their work on human flesh. Nervous, electric, faint always with some inexplicable faintness, they seem to be subject to exceptional conditions, to feel powers at work in the common air unfelt by others, to become, as it were, receptacles of them, and pass them on to us in a chain of secret influences.

But among the more youthful heads there is one at Florence which Love chooses for its own—the head of a young man, which may well be the likeness of Salaino,* beloved of Leonardo for his curled and waving hair—*belli capelli ricci e inanellati*—and afterwards his favourite pupil and servant. Of all the interests in living men and women which may have filled his life at Milan, this attachment alone is recorded; and in return, Salaino identified himself so entirely with Leonardo, that the picture of 'Saint Anne,' in the Louvre, has been attributed to him. It illustrates Leonardo's usual choice of pupils, men of some natural charm of person or intercourse like Salaino, or men of birth and princely habits of life like Francesco Melzi—men with just enough genius to be capable of initiation into his secret, for the sake of which they were ready to efface their own individuality. Among them, retiring often to the villa of the Melzi at Canonica al Vaprio, he worked at his fugitive manuscripts and sketches, working for the present hour, and for a few only, perhaps chiefly for himself. Other artists have been as careless of present or future applause, in self-forgetfulness, or because they set moral or political ends above the ends of art; but in him this solitary culture of beauty seems to have hung upon a kind of self-love, and a carelessness in the work of art of all but art itself. Out of the secret places of a unique temperament he brought strange blossoms and fruits hitherto unknown; and for him the novel impression conveyed, the exquisite effect woven, counted as an end in itself—a perfect end.

And these pupils of his acquired his manner so thoroughly, that though the number of Leonardo's authentic works is very small indeed, there is a multitude of other men's pictures, through which we undoubtedly see him, and come very near to his genius. Sometimes, as in the little picture of the 'Madonna of the Balances,' in which, from the bosom of his mother, Christ weighs the pebbles

of the brook against the sins of men, we have a hand, rough enough
by contrast, working on some fine hint or sketch of his. Sometimes,
as in the subjects of the Daughter of Herodias and the head of John
the Baptist, the lost originals have been re-echoed and varied upon
again and again by Luini and others. At other times the original
remains, but has been a mere theme or motive, a type of which the
accessories might be modified or changed; and these variations have
but brought out the more the purpose or expression of the original.
It is so with the so-called Saint John the Baptist of the Louvre*—one
of the few naked figures Leonardo painted—whose delicate brown
flesh and woman's hair no one would go out into the wilderness to
seek, and whose treacherous smile would have us understand some-
thing far beyond the outward gesture or circumstance. But the long
reed-like cross in the hand, which suggests Saint John the Baptist,
becomes faint in a copy at the Ambrosian Library, and disappears
altogether in another in the Palazzo Rosso at Genoa. Returning from
the last to the original, we are no longer surprised by Saint John's
strange likeness to the Bacchus, which hangs near it, which set
Gautier thinking of Heine's notion of decayed gods,* who, to main-
tain themselves after the fall of paganism, took employment in the
new religion. We recognise one of those symbolical inventions in
which the ostensible subject is used, not as matter for definite pictorial
realisation, but as the starting-point of a train of sentiment, as subtle
and vague as a piece of music. No one ever ruled over his subject more
entirely than Leonardo, or bent it more dexterously to purely artistic
ends. And so it comes to pass that though he handles sacred subjects
continually, he is the most profane of painters; the given person or
subject, Saint John in the Desert, or the Virgin on the knees of Saint
Anne, is often merely the pretext for a kind of work which carries one
quite out of the range of its conventional associations.

About the 'Last Supper,' its decay and restorations, a whole lit-
erature has risen up, Goethe's pensive sketch* of its sad fortunes
being far the best. The death in child-birth of the Duchess Beatrice,
was followed in Ludovico by one of those paroxysms of religious
feeling which in him were constitutional. The low, gloomy Dominican
church of Saint Mary of the Graces had been the favourite shrine of
Beatrice. She had spent her last days there, full of sinister presenti-
ments; at last it had been almost necessary to remove her from it by
force; and now it was here that mass was said a hundred times a day

for her repose. On the damp wall of the refectory, oozing with min-
eral salts, Leonardo painted the Last Supper. A hundred anecdotes
were told about it, his retouchings and delays. They show him refus-
ing to work except at the moment of invention, scornful of whoever
thought that art was a work of mere industry and rule, often coming
the whole length of Milan to give a single touch. He painted it, not
in fresco, where all must be *impromptu*, but in oils, the new method
which he had been one of the first to welcome, because it allowed of
so many after-thoughts, so refined a working out of perfection. It
turned out that on a plastered wall no process could have been less
durable. Within fifty years it had fallen into decay. And now we have
to turn back 'to Leonardo's own studies, above all, to one drawing of
the central head at the Brera,* which in a union of tenderness and
severity in the face-lines, reminds one of the monumental work of
Mino da Fiesole, to trace it as it was.

It was another effort to set a given subject out of the range of its
conventional associations. Strange, after all the misrepresentations of
the middle age, was the effort to see it, not as the pale host of the
altar, but as one taking leave of his friends. Five years afterwards, the
young Raffaelle, at Florence, painted it with sweet and solemn effect
in the refectory of Saint Onofrio; but still with all the mystical un-
reality of the school of Perugino. Vasari pretends that the central
head was never finished; but finished or unfinished, or owing part of
its effect to a mellowing decay, this central head does but consum-
mate the sentiment of the whole company—ghosts through which
you see the wall, faint as the shadows of the leaves upon the wall on
autumn afternoons, this figure is but the faintest, most spectral of
them all. It is the image of what the history it symbolises has been
more and more ever since, paler and paler as it recedes from us.
Criticism came with its appeal from mystical unrealities to originals,
and restored no life-like reality but these transparent shadows, spirits
which have not flesh and bones.

The 'Last Supper' was finished in 1497; in 1498 the French
entered Milan,* and whether or not the Gascon bowmen used it as a
mark for their arrows,[1] the model of Francesco Sforza certainly did
not survive. Ludovico became a prisoner, and the remaining years
of Leonardo's life are more or less years of wandering. From his

[1] M. Arsène Houssaye comes to save the credit of his countrymen.*

brilliant life at court he had saved nothing, and he returned to Florence a poor man. Perhaps necessity kept his spirit excited: the next four years are one prolonged rapture or ecstasy of invention. He painted the pictures of the Louvre, his most authentic works, which came there straight from the cabinet of Francis the First, at Fontainebleau. One picture of his, the Saint Anne—not the Saint Anne of the Louvre, but a mere cartoon now in London—revived for a moment a sort of appreciation more common in an earlier time, when good pictures had still seemed miraculous; and for two days a crowd of people of all qualities passed in naïve excitement, through the chamber where it hung, and gave Leonardo a taste of Cimabue's triumph.* But his work was less with the saints than with the living women of Florence; for he lived still in the polished society that he loved, and in the houses of Florence, left perhaps a little subject to light thoughts by the death of Savonarola (the latest gossip is of an undraped Monna Lisa, found in some out-of-the-way corner of the late Orleans collection), he saw Ginevra di Benci,* and Lisa, the young third wife of Francesco del Giocondo. As we have seen him using incidents of the sacred legend, not for their own sake, or as mere subjects for pictoral realisation, but as a symbolical language for fancies all his own, so now he found a vent for his thoughts in taking one of these languid women, and raising her as Leda or Pomona, Modesty or Vanity, to the seventh heaven of symbolical expression.

'La Gioconda' is, in the truest sense, Leonardo's masterpiece, the revealing instance of his mode of thought and work. In suggestiveness, only the Melancholia of Dürer* is comparable to it; and no crude symbolism disturbs the effect of its subdued and graceful mystery. We all know the face and hands of the figure, set in its marble chair, in that cirque of fantastic rocks, as in some faint light under sea. Perhaps of all ancient pictures time has chilled it least.[1] As often happens with works in which invention seems to reach its limit, there is an element in it given to, not invented by, the master. In that inestimable folio of drawings, once in the possession of Vasari, were certain designs by Verrocchio, faces of such impressive beauty that Leonardo in his boyhood copied them many times. It is hard not to connect with these designs of the elder by-past master, as with its germinal principle, the unfathomable smile, always with a touch of

[1] Yet for Vasari there was some further magic of crimson in the lips and cheeks, lost for us.

something sinister in it, which plays over all Leonardo's work. Besides, the picture is a portrait. From childhood we see this image defining itself on the fabric of his dreams; and but for express historical testimony, we might fancy that this was but his ideal lady, embodied and beheld at last. What was the relationship of a living Florentine to this creature of his thought? By what strange affinities had she and the dream grown thus apart, yet so closely together? Present from the first, incorporeal in Leonardo's thought, dimly traced in the designs of Verrocchio, she is found present at last in Il Giocondo's house. That there is much of mere portraiture in the picture is attested by the legend that by artificial means, the presence of mimes and flute-players, that subtle expression was protracted on the face. Again, was it in four years and by renewed labour never really completed, or in four months and as by stroke of magic, that the image was projected?

The presence that thus so strangely rose beside the waters is expressive of what in the ways of a thousand years man had come to desire. Hers is the head upon which all 'the ends of the world are come,'* and the eyelids are a little weary. It is a beauty wrought out from within upon the flesh, the deposit, little cell by cell, of strange thoughts and fantastic reveries and exquisite passions. Set it for a moment beside one of those white Greek goddesses or beautiful women of antiquity, and how would they be troubled by this beauty, into which the soul with all its maladies has passed! All the thoughts and experience of the world have etched and moulded there in that which they have of power to refine and make expressive the outward form, the animalism of Greece, the lust of Rome, the reverie of the middle age with its spiritual ambition and imaginative loves, the return of the Pagan world, the sins of the Borgias, She is older than the rocks among which she sits; like the vampire, she has been dead many times, and learned the secrets of the grave; and has been a diver in deep seas, and keeps their fallen day about her; and trafficked for strange webs with Eastern merchants; and, as Leda, was the mother of Helen of Troy, and, as Saint Anne, the mother of Mary; and all this has been to her but as the sound of lyres and flutes, and lives only in the delicacy with which it has moulded the changing lineaments and tinged the eyelids and the hands. The fancy of a perpetual life, sweeping together ten thousand experiences, is an old one; and modern thought has conceived the idea of humanity as

wrought upon by, and summing up in itself, all modes of thought and life. Certainly Lady Lisa might stand as the embodiment of the old fancy, the symbol of the modern idea.*

During these years at Florence Leonardo's history is the history of his art; he himself is lost in the bright cloud of it. The outward history begins again in 1502, with a wild journey through central Italy, which he makes as the chief engineer of Cæsar Borgia. The biographer, putting together the stray jottings of his manuscripts, may follow him through every day of it, up the strange tower of Siena, which looks towards Rome, elastic like a bent bow, down to the sea-shore at Piombino, each place appearing as fitfully as in a fever dream.

One other great work was left for him to do, a work all trace of which soon vanished, 'The Battle of the Standard,' in which he had Michelangelo for his rival. The citizens of Florence, desiring to decorate the walls of the great council chamber, had offered the work for competition, and any subject might be chosen from the Florentine wars of the fifteenth century. Michelangelo chose for his cartoon an incident of the war with Pisa, in which the Florentine soldiers, bathing in the Arno, are surprised by the sound of trumpets, and run to arms. His design has reached us only in an old engraving, which perhaps would help us less than what we remember of the background of his Holy Family in the Uffizii to imagine, in what superhuman form, such as might have beguiled the heart of an earlier world, those figures may have risen from the water. Leonardo chose an incident from the battle of Anghiari,* which two parties of soldiers fight for a standard. Like Michelangelo's, his cartoon is lost, and has come to us only in sketches and a fragment of Rubens.* Through the accounts given we may discern some lust of terrible things in it, so that even the horses tore each other with their teeth; and yet one fragment of it, in a drawing of his at Florence, is far different—a waving field of lovely armour, the chased edgings running like lines of sunlight from side to side. Michelangelo was twenty-seven years old; Leonardo more than fifty; and Raffaelle, then nineteen years old, visiting Florence for the first time, came and watched them as they worked.

We catch a glimpse of him again at Rome in 1514, surrounded by his mirrors and vials and furnaces, making strange toys that seemed alive of wax and quicksilver. The hesitation which had haunted him

all through life, and made him like one under a spell, was upon him now with double force. No one had ever carried political indifferentism farther; it had always been his philosophy to 'fly before the storm;'* he is for the Sforzas or against them, as the tide of their fortune turns. Yet now he was suspected by the anti-Gallican society at Rome,* of French tendencies. It paralysed him to find himself among enemies; and he turned wholly to France, which had long courted him.

France was about to become an Italy more Italian than Italy itself. Francis the First, like Lewis the Twelfth before him, was attracted by the finesse of Leonardo's work; La Gioconda was already in his cabinet, and he offered Leonardo the little Château de Clou, with its vineyards and meadows, in the soft valley of the Masse, and not too far from the great outer sea. M. Arsène Houssaye has succeeded in giving a pensive local colour to this part of his subject, with which, as a Frenchman, he could best deal. 'A Monsieur Lyonard, peintre du Roy pour Amboyse,'—so the letter of Francis the First is headed. It opens a prospect, one of the most attractive in the history of art, where, under a strange mixture of lights, Italian art dies away as a French exotic. M. Houssaye does but touch it lightly, and it would carry us beyond the present essay if we allowed ourselves to be attracted by its interest.

Two questions remain, after much busy antiquarianism, concerning Leonardo's death—the question of his religion, and the question whether Francis the First was present at the time. They are of about equally little importance in the estimate of Leonardo's genius. The directions in his will about the thirty masses and the great candles for the church of Saint Florentin are things of course, their real purpose being immediate and practical; and on no theory of religion could these hurried offices be of much consequence. We forget them in speculating how one who had been always so desirous of beauty, but desired it always in such precise and definite forms, as hands or flowers or hair, looked forward now into the vague land, and experienced the last curiosity.

JOACHIM DU BELLAY

IN the middle of the sixteenth century, when the spirit of the Renaissance was everywhere and people had begun to look back with distaste on the works of the middle age, the old Gothic manner had still one chance more in borrowing something from the rival which was about to supplant it. In this way there was produced, chiefly in France, a new and peculiar phase of taste with qualities and a charm of its own, blending the somewhat attenuated grace of Italian ornament with the general outlines of Northern design. It produced Château Gaillon—as you may still see it in the delicate engravings of Israel Silvestre, a Gothic donjon veiled faintly by a surface of delicate Italian traceries—Chenonceaux, Blois, Chambord and the church of Brou. In painting there came from Italy workmen like Maître Roux and the masters of the school of Fontainebleau,* to have their later Italian voluptuousness attempered by the naïve and silvery qualities of the native style; and it was characteristic of these painters that they were most successful in painting on glass, that art so essentially mediæval. Taking it up where the middle age had left it, they found their whole work among the last subtleties of colour and line; and keeping within the true limits of their material they got quite a new order of effects from it, and felt their way to refinements on colour never dreamed of by those older workmen, the glass-painters of Chartres or Lemans. What is called the Renaissance in France is thus not so much the introduction of a wholly new taste ready made from Italy, but rather the finest and subtlest phase of the middle age itself, its last fleeting splendour and temperate Saint Martin's summer.* In poetry, the Gothic spirit in France had produced a thousand songs; and in the Renaissance French poetry too did but borrow something to blend with a native growth, and the poems of Ronsard, with their ingenuity, their delicately figured surfaces, their slightness, their fanciful combinations of rhyme, are but the correlative of the traceries of the house of Jacques Cœur at Bourges or the 'Maison de Justice' at Rouen.*

There was indeed something in the native French taste naturally akin to that Italian *finesse*. The characteristic of French work had always been a certain nicety, *une netteté remarquable d'exécution*.*

In the paintings of François Clouet, for example, or rather of the Clouets, for there was a whole family of them, painters remarkable for their resistance to Italian influences, there is a silveriness of colour and a clearness of expression, which distinguish them very definitely from their Flemish neighbours, Hemling or the Van Eycks. And this nicety is not less characteristic of old French poetry. A light, aerial delicacy, a simple elegance, *une netteté remarquable d'exécution*—these are essential characteristics alike of Villon's poetry, and of the 'Hours of Anne of Brittany.'* They are characteristic too of a hundred French Gothic carvings and traceries. Alike in the old Gothic cathedrals and in their counterpart, the old Gothic *chansons de geste*,* the rough and ponderous mass becomes, as if by passing for a moment into happier conditions or through a more gracious stratum of air, graceful and refined, like the carved ferneries on the granite church at Folgoat, or the lines which describe the fair priestly hands of Archbishop Turpin in the song of Roland;* although below both alike there is a fund of mere Gothic strength or heaviness.*

And Villon's songs and Clouet's painting are like these. It is the higher touch making itself felt here and there, betraying itself, like nobler blood in a lower stock, by a fine line or gesture or expression, the turn of a wrist, the tapering of a finger. In Ronsard's time that rougher element seemed likely to predominate. No one can turn over the pages of Rabelais without feeling how much need there was of softening, of castigation. To effect this softening is the object of the revolution in poetry which is connected with Ronsard's name. Casting about for the means of thus refining upon and saving the character of French literature, he accepted that influx of Renaissance taste which, leaving the buildings, the language, the art, the poetry of France, at bottom, what they were, old French Gothic still, gilds their surfaces with a strange delightful foreign aspect, passing over all that Northern land neither deeper nor more permanent than a chance effect of light. He reinforces, he doubles the French *netteté* by Italian *finesse*. Thereupon nearly all the force and all the seriousness of French work disappear; only the elegance, the aerial touch, the perfect manner remain. But this elegance, this manner, this *netteté d'exécution* are consummate, and have an unmistakeable æsthetic value.

So the old French chanson, which, like the old Northern Gothic ornament, though it sometimes refined itself into a sort of weird

elegance was often at bottom something rude and formless, became in the hands of Ronsard a Pindaric ode.* He gave it structure, a sustained system, strophe and antistrophe, and taught it a changefulness and variety of metre which keeps the curiosity always excited, the very aspect of which as it lies written on the page carries the eye lightly onwards, and of which this is a good instance:—

> 'Avril, la grace, et le ris
> De Cypris,
> Le flair et la douce haleine;
> Avril, le parfum des dieux,
> Qui, des cieux,
> Sentent l'odeur de la plaine;
>
> C'est toy, courtois et gentil,
> Qui d'exil
> Retire ces passageres,
> Ces arondelles qui vont,
> Et qui sont
> Du printemps les messageres.'*

That is not by Ronsard, but by Remy Belleau, for Ronsard soon came to have a school. Six other poets threw in their lot with him in his literary revolution—this Remy Belleau, Antoine de Baif, Pontus de Tyard, Etienne Jodelle, Jean Daurat, and lastly Joachim du Bellay;* and with that strange love of emblems which is characteristic of the time, which covered all the works of Francis the First with the salamander, and all the works of Henry the Second with the double crescent, and all the works of Anne of Brittany with the knotted cord, and so on, they called themselves the *Pleiad*, seven in all, although as happens with the celestial Pleiad, if you scrutinise this constellation of poets more carefully you may find there a great number of minor stars.

The first note of this literary revolution was struck by Joachim du Bellay in a pamphlet written at the early age of twenty-four, which coming to us through three centuries seems of yesterday, so full is it of those delicate critical distinctions which are sometimes supposed peculiar to modern writers. The book has for its title *La Deffense et Illustration de la Langue Françoyse*; and its problem is how to illustrate or ennoble the French language, to give it lustre. We are accustomed to speak of the varied critical and creative movement of the fifteenth and sixteenth centuries as the *Renaissance*, and because we

have a single name for it we may sometimes fancy that there was more unity in the thing itself than there really was. Even the Reformation, that other great movement of the fifteenth and sixteenth centuries, had far less unity, far less of combined action, than is at first sight supposed; and the Renaissance was infinitely less united, less conscious of combined action, than the Reformation. But if anywhere the Renaissance became conscious, as a German philosopher might say, if ever it was understood as a systematic movement by those who took part in it, it is in this little book of Joachim du Bellay's, which it is impossible to read without feeling the excitement, the animation of change, of discovery. *La prose*, says M. Sainte-Beuve, *chose remarquable et à l'inverse des autres langues, a toujours en le pas chez nous, sur notre poésie*.* Du Bellay's prose is perfectly transparent, flexible and chaste. In many ways it is a more characteristic example of the culture of the *Pleiad* than any of its verse; and one who loves the whole movement of which the *Pleiad* is a part for a weird foreign grace in it, and may be looking about for a true specimen of it, cannot have a better than Joachim du Bellay and this little treatise of his.

Du Bellay's object is to adjust the existing French culture to the rediscovered classical culture; and in discussing this problem and developing the theories of the *Pleiad* he has lighted upon many principles of permanent truth and applicability. There were some who despaired of the French language altogether, who thought it naturally incapable of the fulness and elegance of Greek and Latin—*cette élégance et copie qui est en la langue Greque et Romaine*—that science could be adequately discussed and poetry nobly written only in the dead languages. 'Those who speak thus,' says Du Bellay,' make me think of those relics which one may only see through a little pane of glass and must not touch with one's hands. That is what these people do with all branches of culture, which they keep shut up in Greek and Latin books, not permitting one to see them otherwise, or transport them out of dead words into those which are alive, and wing their way daily through the mouths of men.' 'Languages,' he says again, 'are not born like plants and trees, some naturally feeble and sickly, others healthy and strong and apter to bear the weight of men's conceptions, but all their virtue is generated in the world of choice and men's free-will concerning them. Therefore, I cannot blame too strongly the rashness of some of our countrymen, who being anything rather than Greeks or Latins, depreciate and reject with more than stoical disdain

everything written in French, nor can I express my surprise at the odd opinion of some learned men who think that our vulgar tongue is wholly incapable of erudition and good literature.'

It was an age of translations. Du Bellay himself translated two books of the Æneid,* and other poetry old and new, and there were some who thought that the translation of classical literature was the true means of *ennobling* the French language—*nous favorisons toujours les étrangers.** Du Bellay moderates their expectations. 'I do not believe that one can learn the right use of them,'—he is speaking of figures and ornaments in language—'from, translations, because it is impossible to reproduce them with the same grace with which the original author used them. For each language has I know not what peculiarity of its own, and if you force yourself to express the naturalness, *le naïf*, of this in another language, observing the law of translation, which is not to expatiate beyond the limits of the author himself, your words will be constrained, cold and ungraceful;'—then he fixes the test of all good translation,—'To prove this read me Demosthenes and Homer in Latin, Cicero and Virgil in French, and see whether they produce in you the same affections which you experience in reading those authors in the original.'

In this effort to ennoble the French language, to give it grace, number, perfection, and as painters do to their pictures, *cette dernière main que nous désirons,** what Du Bellay is pleading for is his mother-tongue, the language, that is, in which one will have the utmost degree of what is moving and passionate. He recognised of what force the music and dignity of languages are, how they enter into the inmost part of things; and in pleading for the cultivation of the French language he is pleading for no merely scholastic interest, but for freedom, impulse, reality, not in literature merely, but in daily communion of speech. After all it was impossible to have this impulse in Greek and Latin, dead languages, *péris et mises en reliquaires de livres.** By aid of this poor *plante et vergette** of the French language, he must speak delicately, movingly, if he is ever to speak so at all; that, or none, must be for him the medium of what he calls, in one of his great phrases, *le discours fatal des choses mondaines;** and it is his patriotism not to despair of it; he sees it already, *parfait en toute élégance et venuste de paroles.**

Du Bellay was born in the disastrous year 1525, the year of the battle of Pavia and the captivity of Francis the First. His parents

died early, and to him, as the youngest of the family, his mother's little estate on the Loire side, *ce petit Lyrè*,* the beloved place of his birth descended. He was brought up by a brother only a little older than himself; and left to themselves the two boys passed their lives in day-dreams of military glory. Their education was neglected; 'the time of my youth,' says Du Bellay, 'was lost, like the flower which no shower waters, and no hand cultivates.' He was just twenty years old when this brother died, leaving Joachim to be the guardian of his child. It was with regret, with a shrinking feeling of incapacity, that he took upon him the burden of this responsibility. Hitherto he had looked forward to the profession of a soldier, hereditary in his family. But at this time a sickness attacked him which brought him cruel sufferings and seemed likely to be mortal. It was then for the first time that he read the Greek and Latin poets. These studies came too late to make him what he so much desired to be, a trifler in Greek and Latin verse, like so many others of his time now forgotten; instead, they made him a lover of his own homely native tongue, that poor *plante et vergette* of the French language. It was through this fortunate shortcoming in his education that he became national and modern, and he learned afterwards to look back on that wild garden of his youth with only half regret. A certain Cardinal du Bellay was the successful man of the family, a man often employed in high official affairs. It was to him that the thought of Joachim turned when it became necessary to choose a profession, and in 1552 he accompanied the Cardinal to Rome. He remained there nearly five years, burdened with the weight of affairs and languishing with homesickness. Yet it was under these circumstances that his genius yielded its best fruits. From Rome, which to most men of an imaginative temperament like his would have yielded so many pleasureable sensations, with all the curiosities of the Renaissance still fresh there, his thoughts went back painfully, longingly, to the country of the Loire, with its wide expanses of waving corn, its homely pointed roofs of grey slate, and its far-off scent of the sea. He reached home at last, but only to die there, quite suddenly, one wintry day, at the early age of thirty-five.

Much of Du Bellay's poetry illustrates rather the age and school to which he belonged than his own temper and genius. As with the writings of Ronsard and the other poets of the *Pleiad*, its interest depends not so much on the impress of individual genius upon it, as

on the circumstance that it was once poetry *à la mode*, that it is part of the manner of a time, a time which made much of manner, and carried it to a high degree of perfection. It is one of the decorations of an age which threw much of its energy into the work of decoration. We feel a pensive pleasure in seeing these faded decorations, and observing how a group of actual men and women pleased themselves long ago. Ronsard's poems are a kind of epitome of his age. Of one aide of that age, it is true, of the strenuous, the progressive, the serious movement, which was then going on, there is little; but of the catholic side, the losing side, the forlorn hope, hardly a figure is absent. The Queen of Scots, at whose desire Ronsard published his odes, reading him in her northern prison, felt that he was bringing back to her the true flavour of her early days in the court of Catherine at the Louvre, with its exotic Italian gaieties. Those who disliked that poetry, disliked it because they found that age itself distasteful. The poetry of Malherbe came, with its sustained style and weighty sentiment, but with nothing that set people singing; and the lovers of that poetry saw in the poetry of the *Pleiad* only the latest trumpery of the middle age. But the time came when the school of Malherbe too had had its day; and the Romanticists,* who in their eagerness for excitement, for strange music and imagery, went back to the works of the middle age, accepted the *Pleiad* too with the rest; and in that new middle age which their genius has evoked the poetry of the *Pleiad* has found its place. At first, with Malherbe, you may find it, like the architecture, the whole mode of life, the very dresses of that time,—fantastic, faded, *rococo*.* But if you look long enough to understand it, to conceive its sentiment, you will find that those wanton lines have a spirit guiding their caprices. For there is *style* there; one temper has shaped the whole; and everything that has style, that has been done as no other man or age could have done it, as it could never for all our trying, be done again, has its true value and interest. Let us dwell upon it for a moment, and try to gather from it that *fleur particulier*, that special flower, which Ronsard himself tells us every garden has.

It is poetry not for the people, but for a confined circle, for courtiers, great lords and erudite persons, people who desire to be humoured, to gratify a certain refined voluptuousness they have in them, like that of the Roman Emperor who would only eat fish far from the sea. Ronsard loves, or dreams that he loves, a rare and peculiar type of beauty,

la petite pucelle Angevine,* with blond hair and dark eyes. But he has
the ambition not only of being a courtier and a lover, but a great
scholar also; he is anxious about orthography, the letter *è Grecque*,
the true spelling of Latin names in French writing, and the restor-
ation of the *i voyelle en sa première liberté*.* His poetry is full of quaint
remote learning. He is just a little pedantic, true always to his own
express judgment that to be natural is not enough for one who in
poetry desires to produce work worthy of immortality. And there-
withal a certain number of Greek words, which charmed Ronsard
and his circle by their gayness and nicety, and a certain air of foreign
elegance about them, crept into the French language; and there were
other strange words which the poets of the *Pleiad* forged for them-
selves, and which had but an ephemeral existence.

With this was mixed the desire to taste a more exquisite and vari-
ous music than that of the older French verse, or of the classical
poets. The music of the measured scanned verse of Latin and Greek
poetry is one thing; the music of the rhymed, unscanned verse of
Villon and the old French poets, the *poésie chantée*, is another. To
unite together these two kinds of music in a new school of French
poetry, to make verse which would scan and rhyme as well, to search
out and harmonise the measure of every syllable and unite it to the
swift, flitting, swallow-like motion of rhyme, to penetrate their
poetry with a double music,—this was the ambition of the *Pleiad*.
They are insatiable of music, they cannot have enough of it; they
desire a music of greater compass perhaps than words can possibly
yield, to drain out the last drops of sweetness which a certain note or
accent contains.

This eagerness for music is almost the only serious thing in the
poetry of the *Pleiad*; and it was Goudimel,* the severe and protestant
Goudimel, who set Ronsard's songs to music. But except in this
these poets are never serious. Mythology, which with the great
Italians had been a motive so weighty and severe, becomes with them
a mere toy. That 'lord of terrible aspect,' *Amor*, has become the *petit
enfant Amour*.* They are full of fine railleries; they delight in diminu-
tives, *ondelette*, *fondelette*, *doucelette*, *Cassandrette*.* Their loves are
only half real, a vain effort to prolong the imaginative loves of the
middle age beyond their natural lifetime. They write love-poems for
hire. Like the people in Boccaccio's 'Decameron,' they form a party
who in an age of great troubles, losses, anxieties, amuse themselves

with art, poetry, intrigue; but they amuse themselves with wonderful elegance, and sometimes their gaiety becomes satiric, for as they play, real passions insinuate themselves, at least the reality of death; their dejection at the thought of leaving *le beau sejour du commun jour** is expressed by them with almost wearisome reiteration. But with this sentiment too they are able to trifle; the imagery of death serves for a delicate ornament, and they weave into the airy nothingness of their verses their trite reflections on the vanity of life; just as the grotesques of the charnel-house nest themselves together with birds and flowers and the fancies of the pagan mythology in the traceries of the architecture of that time, which wantons in its delicate arabesques with the images of old age and death.

Ronsard became deaf at sixteen, and it was this which finally determined him to be a man of letters instead of a diplomatist; and it was significant, one might fancy, of a certain premature agedness, and of the tranquil temperate sweetness appropriate to that, in the school of poetry which he founded. Its charm is that of a thing not vigorous or original, but full of the grace that comes of long study and reiterated refinements, and many steps repeated, and many angles worn down, with an exquisite faintness, a *fadeur exquise*, a certain tenuity and caducity, as for those who can bear nothing vehement or strong; for princes weary of love, like Francis the First, or of pleasure, like Henry the Third, or of action like Henry the Fourth. Its merits are those of the old, grace and finish, perfect in minute detail. For these people are a little jaded, and have a constant desire for a subdued and delicate excitement, to warm their creeping fancy a little. They love a constant change of rhyme in poetry, and in their houses that strange fantastic interweaving of thin reed-like lines, which are a kind of rhetoric in architecture.

But the poetry of the *Pleiad* is true not only to the physiognomy of its age, but also to its country, that *pays du Vendomois*, the names and scenery of which so often occur in it; the great Loire, with its spaces of white sand; the little river Loir; the heathy, upland country, *Le Bocage*, with its scattered pools of water and waste road-sides; *La Beauce*, the granary of France, where the vast rolling fields of corn seem to anticipate the great western sea itself. It is full of the traits of that country. We see Du Bellay and Ronsard gardening or hunting with their dogs, or watch the pastimes of a rainy day; and with this is connected a domesticity, a homeliness and simple goodness, by

which this Northern country gains upon the South. They have the love of the aged for warmth, and understand the poetry of winter; for they are not far from the Atlantic, and the west wind which comes up from it, turning the poplars white, spares not this new Italy in France. So the fireside often appears, with the pleasures of winter, about the vast emblazoned chimneys of the time, and a *bonhomie* as of little children or old people.

It is in Du Bellay's 'Olive,' a collection of sonnets in praise of a half-imaginary lady, *Sonnetz a la louange d'Olive*, that these characteristics are most abundant. Here is a perfectly crystallised specimen:—

> 'D'amour, de grace, et de haulte valeur
> Les feux divins estoient ceinctz et les cieulx
> S'estoient vestuz d'un manteau precieux
> A raiz ardens de diverse couleur:
> Tout estoit plein de beauté, de bonheur,
> La mer tranquille, et le vent gracieulx,
> Quand celle la nasquit en ces bas lieux
> Qui a pillé du monde tout l'honneur.
> Ell' prist son teint des beaux lyz blanchissans,
> Son chef de l'or, sea deus levres des rozes,
> Et du soleil ses yeux resplandissans:
> Le ciel usant de liberalité,
> Mist en l'esprit ses semences encloses,
> Son nom des Dieux prist l'immortalité.'*

That he is thus a characteristic specimen of the poetical taste of that age, is indeed Du Bellay's chief interest. But if his work is to have the highest sort of interest, if it is to do something more than satisfy curiosity, if it is to have an æsthetic as distinct from an historic value, it is not enough for a poet to have been the true child of his age, to have conformed to its æsthetic conditions, and by so conforming to have charmed and stimulated that age; it is necessary that there should be perceptible in his work something individual inventive, unique, the impress there of the writer's own temper and personality. This impress M. Sainte-Beuve thought he found in the 'Antiquités de Rome' and the 'Regrets,'* which he ranks as what has been called *poésie intime*,* that intensely modern sort of poetry in which the writer has for his aim the portrayal of his own most intimate moods, to take the reader into his confidence. That generation

had other instances of this intimacy of sentiment: Montaigne's Essays* are full of it, the carvings of the church of Brou are full of it. M. Sainte-Beuve has perhaps exaggerated the influence of this quality in Du Bellay's 'Regrets'; but the very name of the book has a touch of Rousseau about it, and reminds one of a whole generation of self-pitying poets in modern times. It was in the atmosphere of Rome, to him so strange and mournful, that these pale flowers grew up; for that journey to Italy, which he deplored as the greatest misfortune of his life, put him in full possession of his talent, and brought out all its originality. And in effect you do find *intimité*, intimacy, here. The trouble of his life is analysed, and the sentiment of it conveyed directly to our minds; not a great sorrow or passion, but only the sense of loss in passing days, the *ennui* of a dreamer who has to plunge into the world's affairs, the opposition between life and the ideal, a longing for rest, nostalgia, homesickness—that preeminently childish, but so suggestive sorrow, as significant of the final regret of all human creatures for the familiar earth and limited sky. The feeling for landscape is often described as a modern one; still more so is that for antiquity, the sentiment of ruins. Du Bellay has this sentiment. The duration of the hard sharp outlines of things is a grief to him, and passing his wearisome days among the ruins of ancient Rome, he is consoled by the thought that all must one day end, by the sentiment of the grandeur of nothingness, *la grandeur du rien*. With a strange touch of far-off mysticism, he thinks that *le grand tout** itself, into which all things pass, ought itself sometimes to perish and pass away. Nothing less can relieve his weariness. From the stately aspects of Rome his thoughts went back continually to France, to the smoking chimneys of his little village, the longer twilight of the North, *la douceur Angevine*; yet not so much to the real France, we may be sure, with its dark streets and roofs of rough-hewn slate, as to that other country with slenderer towers, and more winding rivers, and trees like flowers, and softer sunshine on more gracefully-proportioned fields and ways, which the fancy of the exile, and the pilgrim, and of the schoolboy far from home, and of those kept at home unwillingly, everywhere builds up before or behind them.

He came home at last through the Grisons, by slow journeys, and there in the cooler air of his own country, under its skies of milkier blue, the sweetest flower of his genius sprang up. There have been poets whose whole fame has rested on one poem, as Gray's on the

'Elegy in a Country Churchyard,'* or Ronsard's, as many critics have
thought, on the eighteen lines of one famous ode.* Du Bellay has
almost been the poet of one poem, and this one poem of his is an
Italian thing transplanted into that green country of Anjou; out of
the Latin verses of Naugerius, into French; but it is a thing in which
the matter is almost nothing, and the form almost everything;
and the form of the poem as it stands, written in old French, is all Du
Bellay's own. It is a song which the winnowers are supposed to sing
as they winnow the corn, and they invoke the winds to lie lightly on
the grain.

D'UN VANNEUR DE BLE AUX VENTS[1].

A vous trouppe legère
 Qui d'aile passagère
 Par le monde volez,
 Et d'un sifflant murmure
 L'ombrageuse verdure
 Doulcement esbranlez,

J'offre ces violettes,
 Ces lis & ces fleurettes,
 Et ces roses icy,
 Ces vermeillettes roses
 Sont freschement écloses,
 Et ces celliets aussi.

De vostre doulce haleine
 Eventez ceste plaine
 Eventez ce sejour:
 Ce pendant que j'ahanne
 A mon blé que je vanne
 A la chaleur du jour.*

That has in the highest degree the qualities, the value of the whole
Pleiad school of poetry, of the whole phase of taste from which that
school derives, a certain silvery grace of fancy, nearly all the pleasure
of which is in the surprise at the happy and dexterous way in which
a thing slight in itself is handled. The sweetness of it is by no means
to be got at by crushing, as you crush wild herbs to get at their per-
fume. One seems to hear the measured falling of the fans with a

[1] An excellent translation of this and some other poems of the *Pleiad* may be found in
'Ballads and Lyrics of Old France,' by A. Lang.

child's pleasure on coming across the incident for the first time in one of those great barns of Du Bellay's own country, *La Beauce*, the granary of France. A sudden light transfigures a trivial thing, a weather-vane, a wind-mill, a winnowing flail, the dust in the barn door; a moment,—and the thing has vanished, because it was pure effect; but it leaves a relish behind it, a longing that the accident may happen again.

WINCKELMANN[1]

GOETHE'S fragments of art criticism contain a few pages of strange pregnancy on the character of Winckelmann.* He speaks of the teacher who had made his career possible, but whom he had never seen, as of an abstract type of culture, consummate, tranquil, withdrawn already into the region of ideals, yet retaining colour from the incidents of a passionate intellectual life. He classes him with certain works of art possessing an inexhaustible gift of suggestion, to which criticism may return again and again with undiminished freshness. Hegel, in his Lectures on the Philosophy of Art,* estimating the work of his predecessors, has also passed a remarkable judgment on Winckelmann's writings. 'Winckelmann by contemplation of the ideal works of the ancients received a sort of inspiration through which he opened a new sense for the study of art. He is to be regarded as one of those who in the sphere of art have known how to initiate a new organ for the human spirit.' That it has given a new sense, that it has laid open a new organ, is the highest that can be said of any critical effort. It is interesting then to ask what kind of man it was who thus laid open a new organ? Under what conditions was that effected?

Johann Joachim Winckelmann was born at Stendal, in Brandenburg, in the year 1717. The child of a poor tradesman, he passed through many struggles in early youth, the memory of which ever remained in him as a fitful cause of dejection. In 1763, in the full emancipation of his spirit, looking over the beautiful Roman prospect, he writes, 'One gets spoiled here; but God owed me this; in my youth I suffered too much.' Destined to assert and interpret the charm of the Hellenic spirit, he served first a painful apprenticeship in the tarnished intellectual world of Germany in the earlier half of the eighteenth century. Passing out of that into the happy light of the antique he had a sense of exhilaration almost physical. We find him as a child in the dusky precincts of a German school hungrily feeding on a few colourless books. The master of this school grows blind; Winckelmann becomes his famulus.* The old man would have had him study theology. Winckelmann, free of the master's library, chooses rather to

[1] Reprinted from the 'Westminster Review,' for January, 1857.

become familiar with the Greek classics. Herodotus and Homer win, with their 'vowelled' Greek,* his warmest cult. Whole nights of fever are devoted to them; disturbing dreams of an Odyssey of his own come to him. 'Il se sentit attiré vers le Midi, avec ardeur,' Madame de Staël says of him; 'on retrouve encore souvent dans les imaginations Allemandes quelques traces de cet amour du soleil, de cette fatigue du Nord, qui entraîna les peuples septentrionaux dans les contrées méridionales. Un beau ciel fait naître des sentiments semblables à l'amour de la patrie.'*

To most of us, after all our steps towards it, the antique world, in spite of its intense outlines, its perfect self-expression, still remains faint and remote. To him, closely limited except on the side of the ideal, building for his dark poverty a house not made with hands,* it early came to seem more real than the present. In the fantastic plans of travel continually passing through his mind, to Egypt, for instance, and France, there seems always to be rather a wistful sense of something lost to be regained, than the desire of discovering anything new. Goethe has told us how, in his eagerness to handle the antique, he was interested in the insignificant vestiges of it which the neighbourhood of Strasburg contained. So we hear of Winckelmann's boyish antiquarian wanderings among the ugly Brandenburg sandhills. Such a conformity between himself and Winckelmann, Goethe would have gladly noted.

At twenty-one he enters the University of Halle, to study theology, as his friends desire; instead he becomes the enthusiastic translator of Herodotus. The condition of Greek learning in German schools and universities had fallen, and Halle had no professors who could satisfy his sharp, intellectual craving. Of his professional education he always speaks with scorn, claiming to have been his own teacher from first to last. His appointed teachers did not perceive that a new source of culture was within their hands. 'Homo vagus et inconstans,'* one of them pedantically reports of the future pilgrim to Rome, unaware on which side his irony was whetted. When professional education confers nothing but irritation on a Schiller,* no one ought to be surprised; for Schiller and such as he are primarily spiritual adventurers. But that Winckelmann, the votary of the gravest of intellectual traditions, should get nothing but an attempt at suppression from the professional guardians of learning, is what may well surprise us.

In 1743 he became master of a school at Seehausen. This was the most wearisome period of his life. Notwithstanding a success in dealing with children, which seems to testify to something simple and primeval in his nature, he found the work of teaching very depressing. Engaged in this work, he writes that he still has within a longing desire to attain to the knowledge of beauty; 'sehnlich wünschte zur Kenntniss des Schönen zu gelangen.' He had to shorten his nights, sleeping only four hours, to gain time for reading. And here Winckelmann made a step forward in culture. He multiplied his intellectual force by detaching from it all flaccid interests. He renounced mathematics and law, in which his reading had been considerable, all but the literature of the arts. Nothing was to enter into his life unpenetrated by its central enthusiasm. At this time he undergoes the charm of Voltaire. Voltaire belongs to that flimsier, more artificial, classical tradition, which Winckelmann was one day to supplant by the clear ring, the eternal outline of the genuine antique. But it proves the authority of such a gift as Voltaire's, that it allures and wins even those born to supplant it. Voltaire's impression on Winckelmann was never effaced; and it gave him a consideration for French literature which contrasts with his contempt for the literary products of Germany. German literature transformed, siderealised, as we see it in Goethe, reckons Winckelmann among its initiators. But Germany at that time presented nothing in which he could have anticipated 'Iphigenie'* and the formation of an effective classical tradition in German literature.

Under this purely literary influence, Winckelmann protests against Christian Wolf and the philosophers. Goethe, in speaking of this protest, alludes to his own obligations to Emmanuel Kant. Kant's influence over the culture of Goethe, which he tells us could not have been resisted by him without loss, consisted in a severe limitation to the concrete. But he adds, that in born antiquaries Eke Winckelmann, constant handling of the antique, with its eternal outline, maintains that limitation as effectually as a critical philosophy. Plato however, saved so often for his redeeming literary manner, is excepted from Winckelmann's proscription of the philosophers. The modern most often meets Plato on that side which seems to pass beyond Plato into a world no longer pagan, based on the conception of a spiritual life. But the element of affinity which he presents to Winckelmann is that which is wholly Greek, and alien from the

Christian world, represented by that group of brilliant youths in the Lysis,* still uninfected by any spiritual sickness, finding the end of all endeavour in the aspects of the human form, the continual stir and motion of a comely human life.

This new-found interest in Plato's writings could not fail to increase his desire to visit the countries of the classical tradition. 'It is my misfortune,' he writes, 'that I was not born to great place, wherein I might have had cultivation and the opportunity of following my instinct and forming myself.' Probably the purpose of visiting Rome was already formed, and he silently preparing for it. Count Bünau,* the author of an historical work then of note, had collected at Nöthenitz, near Dresden, a valuable library, now part of the library of Dresden. In 1784 Winckelmann wrote to Bünau in halting French: 'He is emboldened,' he says, 'by Bünau's indulgence for needy men of letters.' He desires only to devote himself to study, having never allowed himself to be dazzled by favourable prospects in the church. He hints at his doubtful position 'in a metaphysical age, when humane literature is trampled under foot. At present,' he goes on, 'little value is set on Greek literature, to which I have devoted myself so far as I could penetrate, when good books are so scarce and expensive.' Finally, he desires a place in some corner of Bünau's library. 'Perhaps at some future time I shall become more useful to the public, if, drawn from obscurity in whatever way, I can find means to maintain myself in the capital.'

Soon after we find Winckelmann in the library at Nöthenitz. Thence he made many visits to the collection of antiques at Dresden. He became acquainted with many artists, above all with Oeser, Goethe's future friend and master, who, uniting a high culture with a practical knowledge of art, was fitted to minister to Winckelmann's culture. And now there opened for him a new way of communion with the Greek life. Hitherto he had handled the words only of Greek poetry, stirred indeed and roused by them, yet divining beyond the words an unexpressed pulsation of sensuous life. Suddenly he is in contact with that life still fervent in the relics of plastic art. Filled as our culture is with the classical spirit, we can hardly imagine how deeply the human mind was moved when at the Renaissance, in the midst of a frozen world, the buried fire of ancient art rose up from under the soil. Winckelmann here reproduces for us the earlier sentiment of the Renaissance. On a sudden the imagination feels

itself free. How facile and direct, it seems to say, is this life of the
senses and the understanding* when once we have apprehended it!
That is the more liberal life we have been seeking so long, so near to
us all the while. How mistaken and roundabout have been our efforts
to reach it by mystic passion and religious reverie; how they have
deflowered the flesh; how little they have emancipated us! Hermione
melts from her stony posture,* and the lost proportions of life right
themselves. There, is an instance of Winckelmann's tendency to
escape from abstract theory to intuition, to the exercise of sight and
touch. Lessing, in the *Laocoon*,* has finely theorised on the relation
of poetry to sculpture; and philosophy can give us theoretical reasons
why not poetry but sculpture should be the most sincere and exact
expression of the Greek ideal By a happy, unperplexed dexterity,
Winckelmann solves the question in the concrete. It is what Goethe
calls his 'Gewahrwerden der griechischen Kunst,' his *finding* of
Greek art.

Through the tumultuous richness of Goethe's culture,* the influ-
ence of Winckelmann is always discernible as the strong regulative
under-current of a clear antique motive. 'One learns nothing from
him,' he says to Eckermann, 'but one becomes something.' If we ask
what the secret of this influence was, Goethe himself will tell us:
elasticity, wholeness, intellectual integrity. And yet these expres-
sions, because they fit Goethe, with his universal culture, so well,
seem hardly to describe the narrow, exclusive interest of Winckelmann.
Doubtless Winckelmann's perfection is a narrow perfection; his
feverish nursing of the one motive of his life is a contrast to Goethe's
various energy. But what affected Goethe, what instructed him
and ministered to his culture, was the integrity, the truth to its type
of the given force. The development of this force was the single
interest of Winckelmann, unembarrassed by anything else in him.
Other interests, religious, moral, political, those slighter talents and
motives not supreme, which in most men are the waste part of
nature, and drain away their vitality, he plucked out and cast from
him. The protracted longing of his youth is not a vague romantic
longing; he knows what he longs for, what he wills. Within its severe
limits his enthusiasm burns like lava. 'You know,' says Lavater,
speaking of Winckelmann's countenance, 'that I consider ardour and
indifference by no means incompatible in the same character. If ever
there was a striking instance of that union, it is in the countenance

before us.' 'A lowly childhood,' says Goethe, 'insufficient instruction in youth, broken, distracted studies in early manhood; the burden of school-keeping! He was thirty years old before he enjoyed a single favour of fortune, but as soon as he had attained to an adequate condition of freedom, he appears before us consummate and entire, complete in the ancient sense.'

But his hair is turning grey, and he has not yet reached the south. The Saxon court had become Roman Catholic, and the way to favour at Dresden was through Romish ecclesiastics. Probably the thought of a profession of the Romish religion was not new to Winckelmann. At one time he had thought of begging his way to Rome, from cloister to cloister, under the pretence of a disposition to change his faith. In 1751 the papal nuncio, Archinto, was one of the visitors at Nöthenitz. He suggested Rome as a stage for Winckelmann's attainments, and held out the hope of a place in the papal library. Cardinal Passionei, charmed with Winckelmann's beautiful Greek writing, was ready to play the part of Mæcenas, on condition that the necessary change should be made. Winckelmann accepted the bribe and visited the nuncio at Dresden. Unquiet still at the word 'profession,' not without a struggle, he joined the Romish Church, July the eleventh, 1754.

Goethe boldly pleads that Winckelmann was a pagan, that the landmarks of Christendom meant nothing to him. It is clear that he intended to deceive no one by his disguise; fears of the inquisition are sometimes visible during his life in Rome; he entered Rome notoriously with the works of Voltaire in his possession; the thought of what Bünau might be thinking of him seems to have been his greatest difficulty. On the other hand, he may have had a sense of something grand, primeval, pagan, in the Catholic religion. Casting the dust of Protestantism off his feet—Protestantism which at best had been one of the *ennuis* of his youth—he might reflect that while Rome had reconciled itself to the Renaissance, the Protestant principle in art had cut off Germany from the supreme tradition of beauty. And yet to that transparent nature, with its simplicity as of the earlier world, the loss of absolute sincerity must have been a real loss. Goethe understands that Winckelmann had made this sacrifice. He speaks of the doubtful charm of renegadism as something like that which belongs to a divorced woman, or to 'Wildbret mit einer kleinen Andeutung von Fäulniss.'* Certainly at the bar of the highest

criticism Winckelmann is more than absolved. The insincerity of his religious profession was only one incident of a culture in which the moral instinct, like the religious or political, was lost in the artistic. But then the artistic interest was that by desperate faithfulness to which Winckelmann was saved from the mediocrity which, breaking through no bounds, moves ever in a bloodless routine, and misses its one chance in the life of the spirit and the intellect. There have been instances of culture developed by every high motive in turn, and yet intense at every point; and the aim of our culture should be to attain not only as intense but as complete a life as possible. But often the higher life is only possible at all on condition of a selection of that in which one's motive is native and strong; and this selection involves the renunciation of a crown reserved for others. Which is better; to lay open a new sense, to initiate a new organ for the human spirit, or to cultivate many types of perfection up to a point which leaves us still beyond the range of their transforming power? Savonarola is one type of success; Winckelmann is another; criticism can reject neither, because each is true to itself. Winckelmann himself explains the motive of his life when he says, 'It will be my highest reward if posterity acknowledges that I have written worthily.'

For a time he remained at Dresden. There his first book appeared, 'Thoughts on the Imitation of Greek Works of Art in Painting and Sculpture.' Full of obscurities as it was, obscurities which baffled but did not offend Goethe when he first turned to art-criticism, its purpose was direct, an appeal from the artificial classicism of the day to the study of the antique. The book was well received, and a pension was supplied through the king's confessor. In September, 1755, he started for Rome, in the company of a young Jesuit. He was introduced to Raphael Mengs, a painter then of note, and found a home near him, in the artists' quarter, in a place where he could 'overlook far and wide the eternal city.' At first he was perplexed with the sense of being a stranger on what was to him native soil. 'Unhappily,' he cries in French, often selected by him as the vehicle of strong feeling, 'I am one of those whom the Greeks call ὀψιμαθεῖς.* I have come into the world and into Italy too late.' More than thirty years afterwards, Goethe also, after many aspirations and severe preparation of mind, visited Italy. In early manhood, just as he, too, was *finding* Greek art, the rumour of that high artist's life of Winckelmann in Italy had strongly moved him. At Rome, spending a whole year

drawing from the antique, in preparation for 'Iphigenie,' he finds the stimulus of Winckelmann's memory ever active. Winckelmann's Roman life was simple, primeval, Greek. His delicate constitution permitted him the use only of bread and wine. Condemned by many as a renegade, he had no desire for places of honour, but only to see his merits acknowledged and existence assured to him. He was simple, without being niggardly; he desired to be neither poor nor rich.

Winckelmann's first years in Rome present all the elements of an intellectual situation of the highest interest. The beating of the intellect against its bars, the sombre aspect, the alien traditions, the still barbarous literature of Germany, are far off; before him are adequate conditions of culture, the sacred soil itself, the first tokens of the advent of the new German literature, with its broad horizons, its boundless intellectual promise. Dante, passing from the darkness of the 'Inferno,' is filled with a sharp and joyful sense of light which makes him deal with it in the opening of the 'Purgatorio' in a wonderfully touching and penetrative way. Hellenism, which is preeminently intellectual light—modern culture may have more colour, the mediæval spirit greater heat and profundity, but Hellenism is pre-eminent for light—has always been most successfully handled by those who have crept into it out of an intellectual world in which the sombre elements predominate. So it had been in the ages of the Renaissance. This repression, removed at last, gave force and glow to Winckelmann's native affinity to the Hellenic spirit. 'There had been known before him,' says Madame de Stäel, 'learned men who might be consulted like books: but no one had, if I may say so, made himself a pagan for the purpose of penetrating antiquity.' '*On exécute mal ce qu'on n'a pas conçu soi-même*[1]'*—words spoken on so high an occasion—are true in their measure of every genuine enthusiasm. Enthusiasm—that, in the broad Platonic sense of the 'Phædrus,'* was the secret of his divinatory power over the Hellenic world. This enthusiasm, dependent as it is to a great degree on bodily temperament, gathering into itself the stress of the nerves and the heat of the blood, has a power of reinforcing the purer motions of the intellect with an almost physical excitement. That his affinity with Hellenism was not merely intellectual, that the subtler threads of temperament were inwoven in it, is proved by his romantic, fervid

[1] Words of Charlotte Corday before the *Convention*.

friendships with young men. He has known, he says, many young men more beautiful than Guido's archangel.* These friendships, bringing him in contact with the pride of human form, and staining his thoughts with its bloom, perfected his reconciliation with the spirit of Greek sculpture. A letter on taste, addressed from Rome to a young nobleman, Friedrich von Berg, is the record of such a friendship.

'I shall excuse my delay,' he begins, 'in fulfilling my promise of an essay on the taste for beauty in works of art, in the words of Pindar.* He says to Agesidamus, a youth of Locri, ἰδέᾳ τε καλὸν, ὥρᾳ τε κεκραμένον, whom he had kept waiting for an intended ode, that a debt paid with usury is the end of reproach. This may win your good-nature on behalf of my present essay, which has turned out far more detailed and circumstantial than I had at first intended.

'It is from yourself that the subject is taken. Our intercourse has been short, too short both for you and me; but the first time I saw you the affinity of our spirits was revealed to me. Your culture proved that my hope was not groundless, and I found in a beautiful body a soul created for nobleness, gifted with the sense of beauty. My parting from you was, therefore, one of the most painful in my life; and that this feeling continues our common friend is witness, for your separation from me leaves me no hope of seeing you again. Let this essay be a memorial of our friendship, which, on my side, is free from every selfish motive, and ever remains subject and dedicate to yourself alone.'

The following passage is characteristic:—

'As it is confessedly the beauty of *man* which is to be conceived under one general idea, so I have noticed that those who are observant of beauty only in women, and are moved little or not at all by the beauty of men, seldom have an impartial, vital, inborn instinct for beauty in art. To such persons the beauty of Greek art will ever seem wanting, because its supreme beauty is rather male than female. But the beauty of art demands a higher sensibility than the beauty of nature, because the beauty of art, like tears shed at a play, gives no pain, is without life, and must he awakened and repaired by culture. Now, as the spirit of culture is much more ardent in youth than in manhood, the instinct of which I am speaking must be exercised and directed to what is beautiful before that age is reached at which one would be afraid to confess that one had no taste for it.'

Certainly, of that beauty of living form which regulated Winckelmann's friendship, it could not be said that it gave no pain. One notable friendship, the fortune of which we may trace through his letters, begins with an antique, chivalrous letter in French, and ends noisily in a burst of angry fire. Far from reaching the quietism, the bland indifference of art, such attachments are nevertheless more susceptible than any others of equal strength of a purely intellectual culture. Of passion, of physical stir, they contain just so much as stimulates the eye to the last lurking delicacies of colour and form. These friendships, often the caprices of a moment, make Winckelmann's letters, with their troubled colouring, an instructive but bizarre addition to the 'History of Art,' that shrine of grave and mellow light for the mute Olympian family. Excitement, intuition, inspiration, rather than the contemplative evolution of general principles, was the impression which Winckelmann's literary life gave to those about him. The quick, susceptible enthusiast, betraying his temperament, even in appearance, by his olive complexion, his deep-seated, piercing eyes, his rapid movements, apprehended the subtlest principles of the Hellenic manner not through the understanding, but by instinct or touch. A German biographer of Winckelmann has compared him to Columbus.* That is not the happiest of comparisons; but it reminds one of a passage in which M. Edgar Quinet* describes Columbus's famous voyage. His science was often at fault; but he had a way of estimating at once the slightest indication of land in a floating weed or passing bird; he seemed actually to come nearer to nature than other men. And that world in which others had moved with so much embarrassment, seems to call out in Winckelmann new senses fitted to deal with it. He is *en rapport* with it; it penetrates him, and becomes part of his temperament. He remodels his writings with constant renewal of insight; he catches the thread of a whole sequence of laws in some hollowing of the hand, or dividing of the hair; he seems to realise that fancy of the reminiscence of a forgotten knowledge hidden for a time in the mind itself, as if the mind of one φιλοσοφήσας ποτὲ μετ' ἔρωτος, fallen into a new cycle, were beginning its intellectual culture over again, yet with a certain power of anticipating its results.* So comes the truth of Goethe's judgment on his works; they are *ein Lebendiges für die Lebendigen geschrieben, ein Leben selbst.**

In 1758, Cardinal Albani, who possessed in his Roman villa a precious collection of antiques, became Winckelmann's patron.

Pompeii had just opened its treasures; Winckelmann gathered its firstfruits. But his plan of a visit to Greece remained unfulfilled. From his first arrival in Rome he had kept the 'History of Ancient Art' ever in view. All his other writings were a preparation for it. It appeared, finally, in 1764; but even after its publication Winckelmann was still employed in perfecting it. It is since his time that many of the most significant examples of Greek art have been submitted to criticism. He had seen little or nothing of what we ascribe to the age of Phidias; and his conception of Greek art tends, therefore, to put the mere elegance of Imperial society in place of the severe and chastened grace of the palæstra.* For the most part he had to penetrate to Greek art through copies, imitations, and later Roman art itself; and it is not surprising that this turbid medium has left in Winckelmann's actual results much that a more privileged criticism can correct.

He had been twelve years in Rome. Admiring Germany had made many calls to him; at last, in 1768, he set out on a visit with the sculptor Cavaceppi. As he left Rome a strange inverted home-sickness came upon him. He reached Vienna; there he was loaded with honours and presents; other cities were awaiting him. Goethe, then nineteen years old, studying art at Leipsic, was expecting his coming with that wistful eagerness which marked his youth, when the news of Winckelmann's murder arrived. All that *fatigue du Nord* had revived with double force. He left Vienna, intending to hasten back to Rome. At Trieste a delay of a few days occurred. With characteristic openness Winckelmann had confided his plans to a fellow-traveller, a man named Arcangeli, and had shown him the gold medals which he had received at Vienna, Arcangeli's avarice was roused. One morning he entered Winckelmann's room under pretence of taking leave; Winckelmann was then writing 'memoranda for the future editor of the "History of Art,"' still seeking the perfection of his great work; Arcangeli begged to see the medals once more. As Winckelmann stooped down to take them from the chest, a cord was thrown round his neck. Some time after, a child whose friendship Winckelmann had made to beguile the delay, knocked at the door, and receiving no answer, gave an alarm. Winckelmann was found dangerously wounded, and died a few hours later, after receiving the sacraments of the Romish church. It seemed as if the gods, in reward for his devotion to them, had given him a death which, for its

swiftness and its opportunity, he might well have desired. 'He has,' says Goethe, 'the advantage of figuring in the memory of posterity as one eternally able and strong, for the image in which one leaves the world is that in which one moves among the shadows.' Yet, perhaps, it is not fanciful to regret that that meeting with Goethe did not take place. Goethe, then in all the pregnancy of his wonderful youth, still unruffled by the press and storm of his earlier manhood, was awaiting Winckelmann with a curiosity of the noblest kind. As it was, Winckelmann became to him something like what Virgil was to Dante. And Winckelmann, with his fiery friendships, had reached that age and that period of culture at which emotions, hitherto fitful, sometimes concentrate themselves in a vital unchangeable relationship. German literary history seems to have lost the chance of one of those famous friendships the very tradition of which becomes a stimulus to culture, and exercises an imperishable influence.

In one of the frescoes of the Vatican,* Raffaelle has commemorated the tradition of the Catholic religion. Against a strip of peaceful sky, broken in upon by the beatific vision, are ranged the great personages of Christian history, with the Sacrament in the midst. The companion fresco* presents a very different company, Dante alone appearing in both. Surrounded by the muses of Greek mythology, under a thicket of myrtles, sits Apollo, with the sources of Castalia at his feet. On either side are grouped those on whom the spirit of Apollo descended, the classical and Renaissance poets, to whom the waters of Castalia come down, a river making glad this other city of God.* In this fresco it is the classical tradition, the orthodoxy of taste, that Raffaelle commemorates. Winckelmann's intellectual history authenticates the claims of this tradition in human culture. In the countries where that tradition arose, where it still lurked about its own artistic relics, and changes of language had not broken its continuity, national pride might often light up anew an enthusiasm for it. Aliens might imitate that enthusiasm, and classicism become from time to time an intellectual fashion; but Winckelmann was not farther removed by language than by local aspects and associations from the vestiges of the classical spirit, and he lived at a time when, in Germany, classical studies were out of fashion. Yet, remote in time and place, he feels after the Hellenic world, divines the veins of ancient art, in which its life still circulates, and, like Scyles in the

beautiful story of Herodotus,* is irresistibly attracted by it. This testimony to the authority of the Hellenic tradition, its fitness to satisfy some vital requirement of the intellect, which Winckelmann contributes as a solitary man of genius, is offered also by the general history of culture. The spiritual forces of the past, which have prompted and informed the culture of a succeeding age, live, indeed, within that culture, but with an absorbed, underground life. The Hellenic element alone has not been so absorbed or content with this underground life; from time to time it has started to the surface; culture has been drawn back to its sources to be clarified and corrected. Hellenism is not merely an element in our intellectual life; it is a conscious tradition in it.

Again, individual genius works ever under conditions of time and place: its products are coloured by the varying aspects of nature and type of human form and outward manners of life. There is thus an element of change in art; criticism must never for a moment forget that 'the artist is the child of his time.' But besides these conditions of time and place, and independent of them, there is also an element of permanence, a standard of taste which genius confesses. This standard is maintained in a purely intellectual tradition; it acts upon the artist, not as one of the influences of his own age, but by means of the artistic products of the previous generation, which in youth have excited, and at the same time directed into a particular channel, his sense of beauty. The supreme artistic products of each generation thus form a series of elevated points, taking each from each the reflection of a strange light, the source of which is not in the atmosphere around and above them, but in a stage of society remote from ours. This standard takes its rise in Greece at a definite historical period. A tradition for all succeeding generations, it originates in a spontaneous growth out of the influences of Greek society. What were the conditions under which this ideal, this standard of artistic orthodoxy, was generated? How was Greece enabled to force its thought upon Europe?

Greek art, when we first catch sight of it, is entangled with Greek religion. We are accustomed to think of Greek religion as the religion of art and beauty, the religion of which the Olympian Zeus and the Athena Polias* are the idols, the poems of Homer the sacred books. Thus Dr. Newman speaks of 'the classical polytheism which was gay and graceful, as was natural in a civilised age.'* Yet such a view is

only a partial one; in it the eye is fixed on the sharp bright edge of high Hellenic culture, but loses sight of the sombre world across which it strikes. Greek religion, where we can observe it most distinctly, is at once a magnificent ritualistic system, and a cycle of poetical conceptions. Religions, as they grow by natural laws out of man's life, are modified by whatever modifies his life. They brighten under a bright sky, they become liberal as the social range widens, they grow intense and shrill in the clefts of human life, where the spirit is narrow and confined, and the stars are visible at noonday; and a fine analysis of these differences is one of the gravest functions of religious criticism. Still, the broad characteristic of all religions, as they exist for the greatest number, is a universal pagan sentiment, a paganism which existed before the Greek religion, and has lingered far onward into the Christian world, ineradicable, like some persistent vegetable growth, because its seed is an element of the very soil out of which it springs. This pagan sentiment measures the sadness with which the human mind is filled whenever its thoughts wander far from what is here, and now. It is beset by notions of irresistible natural powers, for the most part ranged against man, but the secret also of his luck, making the earth golden and the grape fiery for him. He makes wilful Gods in his own image'* gods smiling and drunken, or bleeding by a sad fatality, to console him by their wounds, never closed from generation to generation. It is with a rush of homesickness that the thought of death presents itself. He would remain at home for ever on the earth if he could: as it loses its colour, and the senses fail, he clings ever closer to it; but since the mouldering of bones and flesh must go on to the end, he is careful for charms and talismans that may chance to have some friendly power in them when the inevitable shipwreck comes. Such sentiment is the eternal stock of all religions, modified indeed by changes of time and place, but indestructible, because its root is so deep in the earth of man's nature. The breath of religious initiators passes over them; a few 'rise up with wings as eagles',* but the broad level of religious life is not permanently changed. Religious progress, like all purely spiritual progress, is confined to a few. This sentiment fixes itself in the earliest times to certain usages of patriarchal life, the kindling of fire, the washing of the body, the breaking of bread, the slaughter of the flock, the gathering of harvest, holidays and dances. Here are the beginnings of a ritual, at first as occasional and unfixed as the sentiment

which it expresses, but destined to become the permanent element of religious life. The usages of patriarchal life change; but this germ of ritual remains, developing, but always in a religious interest, losing its domestic character, and therefore becoming more and more inexplicable with each generation. This pagan cult, in spite of local colouring, essentially one, is the base of all religions. It is the anodyne which the religious principle, like one administering opiates to the incurable, has added to the law which makes life sombre for the vast majority of mankind.

More definite religious conceptions come from other sources, and fix themselves upon this cult in various ways, changing it and giving it new meanings. With the Hebrew people they came from individuals of genius, the authors of the prophetic literature. In Greece they were derived from mythology, itself not due to a religious source at all, but developing in the course of time into a body of anthropomorphic religious conceptions. To the unprogressive ritual element it brought these conceptions, itself the πτεροῦ δύναμις,* an element of refinement, of ascension, with the promise of an endless destiny. While the cult remains fixed, the æsthetic element, only accidentally connected with it, expands with the freedom and mobility of the things of the intellect. Always the fixed element is the religious observance; the fluid unfixed element is the myth, the religious conception. This religion is itself pagan, and has on a broad view of it the pagan sadness. It does not at once and for the majority become the higher Hellenic religion. That primeval pagan sentiment, as it is found in its most pronounced form in Christian countries where Christianity has been least adulterated by modern ideas, as in Catholic Bavaria, is discernible also in the common world of Greek religion, against which the higher Hellenic culture is in relief. In Greece, as in Catholic Bavaria, the beautiful artistic shrines, with their chastened taste, are far between. The wilder people have wilder gods; which, however, in Athens or Corinth, or Lacedæmon, changing ever with the worshippers in whom they live and move and have their being, borrow something of the lordliness and distinction of human nature there. The fiery, stupefying wine becomes in a happier region clear and exhilarating. In both, the country people cherish the unlovely idols of an earlier time, such as those which Pausanias found still devoutly preserved in Arcadia. Athenæus tells the story of one who, coming to a temple of Latona, had expected to see a worthy

image of the mother of Apollo, and who laughed on finding only a shapeless wooden figure. In both, the fixed element is not the myth or religious conception, but the cult with its unknown origin and meaning only half understood. Even the mysteries, the centres of Greek religious life at a later period, were not a doctrine but a ritual; and one can imagine the Catholic church retaining its hold through the 'sad mechanic exercise'* of its ritual, in spite of a diffused criticism or scepticism. Again, each adjusts but imperfectly its moral and theological conceptions; each has its mendicants, its purifications, its Antinomian mysticism, its garments offered to the gods, its statues worn with kissing,[1] its exaggerated superstitions for the vulgar only, its worship of sorrow, its addolorata,* its mournful mysteries. There is scarcely one wildness of the Catholic church that has not been anticipated by Greek polytheism. What should we have thought of the vertiginous prophetess at the very centre of Greek religion? The supreme Hellenic culture is a sharp edge of light across this gloom. The Dorian cult of Apollo, rational, chastened, debonair, with his unbroken daylight, always opposed to the sad Chthonian divinities,* is the aspiring element, by force and spring of which Greek religion sublimes itself.[2] Religions have sometimes, like mighty streams, been diverted to a higher service of humanity as political institutions. Out of Greek religion under happy conditions arises Greek art, *das Einzige, das Unerwartete*,* to minister to human culture. The claim of Greek religion is that it was able to transform itself into an artistic ideal. Unlike that Delphic Pythia,* old but clothed as a maiden, this new Pythia is a maiden, though in the old religious vesture.*

For the thoughts of the Greeks about themselves and their relation to the world were ever in the happiest readiness to be turned into an object for the senses. In this is the main distinction between Greek art and the mystical art of the Christian middle age, which is always struggling to express thoughts beyond itself.* Take, for instance, a characteristic work of the middle age, Angelico's 'Coronation of the Virgin,'* at San Marco, in Florence. In some strange halo of a moon sit the Virgin and our Lord, clad in mystical white raiment, half shroud, half priestly linen. Our Lord, with rosy nimbus and the long pale hair, *tanquam lana alba et tanquam nix*, of the figure in the

[1] Hermann's Gottesdienstliche Alterthümer der Griechen. *Th. ii. c. ii. § 21, 16.
[2] Hermann, Th. i. § 5.

Apocalypse,* sets, with slender finger tips, a crown of pearl on the head of his mother, who, corpse-like in her refinement, bends to receive it, the light lying like snow upon her forehead. Certainly it cannot be said of Angelico's fresco that it throws into a sensible form our highest thoughts about man and his relation to the world; but it did not do this adequately even for Angelico. For him all that is outward or sensible in his work—the hair like wool, the rosy nimbus, the crown of pearl—is only the symbol or type of an inexpressible world to which he wishes to direct the thoughts; he would have shrunk from the notion that what the eye apprehended was all. Such forms of art, then, are inadequate to the matter they clothe; they remain ever below its level. Something of this kind is true also of Oriental art. As in the middle age from an exaggerated inwardness, so in the East from a vagueness, a want of definition in thought, the matter presented to art is unmanageable: forms of sense struggle vainly with it. The many-headed gods of the East, the orientalised Ephesian Diana with its numerous breasts, like Angelico's fresco, are at best overcharged symbols, a means of hinting at an idea which art cannot adequately express, which still remains in the world of shadows.

But take a work of Greek art, the Venus of Melos.* That is in no sense a symbol, a suggestion of anything beyond its own victorious fairness. The mind begins and ends with the finite image, yet loses no part of the spiritual motive. That motive is not lightly and loosely attached to the sensuous form, as the meaning to the allegory, but saturates and is identical with it. The Greek mind had advanced to a particular stage of self-reflection, but was careful not to pass beyond it. In Oriental thought there is a vague conception of life everywhere, but no true appreciation of itself by the mind, no knowledge of the distinction of man's nature; in thought he still mingles himself with the fantastic indeterminate life of the animal and vegetable world. In Greek thought the 'lordship of the soul'* is recognised; that lordship gives authority and divinity to human eyes and hands and feet; nature is thrown into the background. But there Greek thought finds its happy limit; it has not yet become too inward; the mind has not begun to boast of its independence of the flesh; the spirit has not yet absorbed everything with its emotions, nor reflected its own colour everywhere. It has indeed committed itself to a train of reflection which must end in a defiance of form, of all that is outward, in an

exaggerated idealism. But that end is still distant; it has not yet plunged into the depths of Christian mysticism.

This ideal art, in which the thought does not outstrip or lie beyond its sensible embodiment, could not have arisen out of a phase of life that was uncomely or poor. That delicate pause in Greek reflection was joined by some supreme good luck to the perfect animal nature of the Greeks. Here are the two conditions of an artistic ideal. The influences which perfected the animal nature of the Greeks are part of the process by which the ideal was evolved. Those 'Mothers' who in the second part of 'Faust'* mould and remould the typical forms which appear in human history, preside at the beginning of Greek culture over such a concourse of happy physical conditions as ever generates by natural laws some rare type of intellectual or spiritual life. That delicate air, 'nimbly and sweetly recommending itself' to the senses,* the finer aspects of nature, the finer lime and clay of the human form, and modelling of the bones of the human countenance,—these are the good luck of the Greek when he enters into life. Beauty becomes a distinction like genius or noble place.

'By no people,' says Winckelmann, 'has beauty been so highly esteemed as by the Greeks. The priests of a youthful Jupiter at Ægæ, of the Ismenian Apollo, and the priest who at Tanagra led the procession of Mercury, bearing a lamb upon his shoulders, were always youths to whom the prize of beauty had been awarded. The citizens of Egesta, in Sicily, erected a monument to a certain Philip,* who was not their fellow-citizen, but of Croton, for his distinguished beauty; and the people made offerings at it. In an ancient song, ascribed to Simonides, or Epicharmus,* of four wishes, the first was health, the second beauty. And as beauty was so longed for and prized by the Greeks, every beautiful person sought to become known to the whole people by this distinction, and above all to approve himself to the artists, because they awarded the prize; and this was for the artists an opportunity of having supreme beauty ever before their eyes. Beauty even gave a right to fame; and we find in Greek histories the most beautiful people distinguished. Some were famous for the beauty of one single part of their form; as Demetrius Phalereus, for his beautiful eyebrows, was called χαριτοβλέφαρος.* It seems even to have been thought that the procreation of beautiful children might be promoted by prizes; this is shown by the existence of contests for beauty, which in ancient times were established by

Cypselus, King of Arcadia, by the river Alpheus; and at the feast of
Apollo of Philæ a prize was offered to the youths for the deftest kiss.
This was decided by an umpire; as also at Megara by the grave of
Diocles. At Sparta, and at Lesbos in the temple of Juno, and among
the Parrhasii, there were contests for beauty among women. The
general esteem for beauty went so far, that the Spartan women set up
in their bedchambers a Nireus, a Narcissus, or a Hyacinth, that they
might bear beautiful children.'[1]

So from a few stray antiquarianisms, from a few faces cast up
sharply from the waves, Winckelmann, as his manner is, divines the
temperament of the antique world, and that in which it had delight.
It has passed away with that distant age, and we may venture to dwell
upon it. What sharpness and reality it has, is the sharpness and real-
ity of suddenly arrested life. Gymnastic originated as part of a reli-
gious ritual. The worshipper was to recommend himself to the gods
by becoming fleet and serpentining, and white and red, like them.
The beauty of the palæstra and the beauty of the artist's studio
reacted on each other. The youth tried to rival his gods, and his
increased beauty passed back into them. "ὄμνυμι πάντας θεοὺς
μὴ ἑλέσθαι ἂν τὴν βασιλέως ἀρχὴν ἀντὶ τοῦ καλὸς εἶναι.* That is
the form in which one age of the world chose 'the better part'—a
perfect world, if our gods could have seemed for ever only fleet and
serpentining, and white and red—not white and red as in Francia's
'Golgotha.'* Let us not say, would that that unperplexed youth of
humanity, seeing itself and satisfied, had never passed into a mourn-
ful maturity; for already the deep joy was in store for the spirit of
finding the ideal of that youth still red with life in its grave.

It followed that the Greek ideal expressed itself pre-eminently in
sculpture. All art has a sensuous element, colour, form, sound—in
poetry a dexterous recalling of these together with the profound
joyful sensuousness of motion; each of these may be a medium for
the ideal; it is partly accident which in any individual case makes the
born artist, poet or painter rather than sculptor. But as the mind
itself has had an historical development, one form of art, by the very
limitations of its material, may be more adequate than another for the
expression of any one phase of its experience. Different attitudes of
the imagination have a native affinity with different types of sensuous

[1] 'Geschichte der Kunst des Alterthums,'* Th. i. Kap. iv.

form, so that they combine easily and entirely. The arts may thus be ranged in a series which corresponds to a series of developments in the human mind itself.[1] Architecture, which begins in a practical need, can only express by vague hint or symbol the spirit or mind of the artist. He closes his sadness over him, or wanders in the perplexed intricacies of things, or projects his purpose from him cleancut and sincere, or bares himself to the sunlight. But these spiritualities, felt rather than seen, can but lurk about architectural form as volatile effects, to be gathered from it by reflection; their expression is not really sensuous at all. As human form is not the subject with which it deals, architecture is the mode in which the artistic effort centres when the thoughts of man concerning himself are still indistinct, when he is still little preoccupied with those harmonies, storms, victories of the unseen intellectual world, which wrought out into the bodily form, give it an interest and significance communicable to it alone. The art of Egypt, with its supreme architectural effects, is, according to Hegel's beautiful comparison, a Memnon waiting for the day,* the day of the Greek spirit, the humanistic spirit, with its power of speech. Again, painting, music, poetry, with their endless power of complexity, are the special arts of the romantic and modern ages. Into these, with the utmost attenuation of detail, may be translated every delicacy of thought and feeling incidental to a consciousness brooding with delight over itself. Through their gradations of shade, their exquisite intervals, they project in an external form that which is most inward in humour, passion, sentiment. Between architecture and the romantic arts of painting, music, and poetry, is sculpture, which, unlike architecture, deals immediately with man, while it contrasts with the romantic arts, because it is not self-analytical. It deals more exclusively than any other art with the human form, itself one entire medium of spiritual expression, trembling, blushing, melting into dew with inward excitement. That spirituality which only lurks about architecture as a volatile effect, in sculpture takes up the whole given material and penetrates it with an imaginative motive; and at first sight sculpture, with its solidity of form, seems more real and full than the faint abstract manner of poetry or painting. Still the fact is the reverse. Discourse and action show man as he is more directly

[1] Hegel, Aesthetik, Theil. ii. Einleitung.*

than the springing of the muscles and the moulding of the flesh; and these poetry commands. Painting, by the flushing of colour in the face and dilatation of light in the eye, and music by its subtle range of tones, can refine most delicately upon a single moment of passion, unravelling its finest threads.

But why should sculpture thus limit itself to pure form? Because by this limitation it becomes a perfect medium of expression for one peculiar motive of the imaginative intellect. It therefore renounces all those attributes of its material which do not help that motive. It has had, indeed, from the beginning an unfixed claim to colour; but this colour has always been more or less conventional, with no melting or modulation of tones, never admitting more than a very limited realism. It was maintained chiefly as a religious tradition. In proportion as sculpture ceased to be merely decorative and subordinate to architecture it threw itself upon pure form. It renounces the power of expression by sinking or heightening tones. In it no member of the human form is more significant than the rest; the eye is wide, and without pupil; the lips and brow are not more precious than hands, and breasts, and feet. The very slightness of its material is part of its pride; it has no backgrounds, no sky or atmosphere, to suggest and interpret a train of feeling; a little of suggested motion, and much of pure light on its gleaming surfaces, with pure form—only these. And it gains more than it loses by this limitation to its own distinguishing motives; it unveils man in the repose of his unchanging characteristics. Its white light purged from the angry blood-like stains of action and passion, reveals not what is accidental in man, but the god, as opposed to man's restless movement. It records the first naive unperplexed recognition of man by himself; and it is a proof of the high artistic capacity of the Greeks that they apprehended and remained true to these exquisite limitations, yet in spite of them gave to their creations a vital, mobile individuality.

Heiterkeit, blitheness or repose, and *Allgemeinheit*,* generality or breadth, are, then, the supreme characteristics of the Hellenic ideal. But that generality or breadth has nothing in common with the lax observation, the unlearned thought, the flaccid execution which have sometimes claimed superiority in art on the plea of being 'broad' or 'general.' Hellenic breadth and generality come of a culture minute, severe, constantly renewed, rectifying and concentrating its impressions into certain pregnant types. The base of all

artistic genius is the power of conceiving humanity in a new, striking, rejoicing way, of putting a happy world of its own creation in place of the meaner world of common days, of generating around itself an atmosphere with a novel power of refraction, selecting, transforming, recombining the images it transmits, according to the choice of the imaginative intellect. In exercising this power, painting and poetry have a choice of subject almost unlimited. The range of characters or persons open to them is as various as life itself; no character, however trivial, misshapen, or unlovely, can resist their magic. This is because those arts can accomplish their function in the choice and development of some special situation, which lifts or glorifies a character in itself not poetical. To realise this situation, to define in a chill and empty atmosphere the focus where rays, in themselves pale and impotent, unite and begin to burn, the artist has to employ the most cunning detail, to complicate and refine upon thought and passion a thousand-fold. The poems of Robert Browning supply brilliant examples of this. His poetry is pre-eminently the poetry of situations. The characters themselves are always of secondary importance; often they are characters in themselves of little interest; they seem to come to him by strange accidents from the ends of the world. His gift is shown by the way in which he accepts such a character and throws it into some situation, apprehends it in some delicate pause of life, in which for a moment it becomes ideal. Take an instance from 'Dramatis Personæ.' In the poem entitled 'Le Byron de nos Jours'* we have a single moment of passion thrown into relief in this exquisite way. Those two jaded Parisians are not intrinsically interesting; they only begin to interest us when thrown into a choice situation. But to discriminate that moment, to make it appreciable by us, that we may 'find it,' what a cobweb of allusions, what double and treble reflections of the mind upon itself, what an artificial light is constructed and broken over the chosen situation—on how fine a needle's point that little world of passion is balanced! Yet, in spite of this intricacy, the poem has the clear ring of a central motive; we receive from it the impression of one imaginative tone, of a single creative act.

To produce such effects at all requires the resources of painting, with its power of indirect expression, of subordinate but significant detail, its atmosphere, its foregrounds and backgrounds. To produce them in a pre-eminent degree requires all the resources of poetry, language in its most purged form, its remote associations and suggestions,

its double and treble lights. These appliances sculpture cannot command. In it, therefore, not the special situation, but the type, the general character of the subject to be delineated, is all-important. In poetry and painting, the situation predominates over the character; in sculpture, the character over the situation. Excluded by the limitations of its material from the development of exquisite situations, it has to choose from a select number of types intrinsically interesting, interesting that is, independently of any special situation into which they may be thrown. Sculpture finds the secret of its power in presenting these types in their broad, central, incisive lines. This it effects not by accumulation of detail, but by abstracting from it. All that is accidental, that distracts the simple effect of the supreme types of humanity, all traces in them of the commonness of the world, it gradually purges away.

Works of art produced under this law, and only these, are really characterised by Hellenic generality or breadth. In every direction it is a law of limitation; it keeps passion always below that degree of intensity at which it is necessarily transitory, never winding up the features to one note of anger, or desire, or surprise. In the allegorical designs of the middle ages, we find isolated qualities portrayed as by so many masks; its religious art has familiarised us with faces fixed obdurately into blank types of religious sentiment; and men and women, in the hurry of life, often wear the sharp impress of one absorbing motive, from which it is said death sets their features free. All such instances may be ranged under the 'grotesque'; and the Hellenic ideal has nothing in common with the 'grotesque.' It lets passion play lightly over the surface of the individual form, which loses by it nothing of its central impassivity, its depth and repose. To all but the highest culture, the reserved faces of the gods will ever have something of insipidity. Again, in the best Greek sculpture, the archaic immobility has been thawed, its forms are in motion; but it is a motion ever kept in reserve, which is very seldom committed to any definite action. Endless as are the attitudes of Greek sculpture, exquisite as is the invention of the Greeks in this direction, the actions or situations it permits are simple and few. There is no Greek Madonna; the goddesses are always childless. The actions selected are those which would be without significance, except in a divine person, binding on a sandal or preparing for the bath. When a more complex and significant action is permitted, it is most often represented as just

finished, so that eager expectancy is excluded, as Apollo just after the slaughter of the Python,* or Venus with the apple of Paris already in her hand.* The Laocoon,* with all that patient science through which it has triumphed over an almost unmanageable subject, marks a period in which sculpture has begun to aim at effects legitimate only in painting. The hair, so rich a source of expression in painting, and, as we have lately seen, in poetry, because relatively to the eye or to the lip it is mere drapery, is withdrawn from attention; its texture, as well as its colour, is lost, its arrangement faintly and severely indicated, with no enmeshed or broken light. The eyes are wide and directionless, not fixing anything with their gaze, nor rivetting the brain to any special external object; the brows without hair. It deals almost exclusively with youth, where the moulding of the bodily organs is still as if suspended between growth and completion, indicated but not emphasised; where the transition from curve to curve is so delicate and elusive that Winckelmann compares it to a quiet sea, which, although we understand it to be in motion, we nevertheless regard as an image of repose; where, therefore, the exact degree of development is so hard to apprehend. If one had to choose a single product of Hellenic art, to save in the wreck of all the rest, one would choose from the 'beautiful multitude'* of the Panathenaic frieze* that line of youths on horses, with their level glances, their proud patient lips, their chastened reins, their whole bodies in exquisite service. This colourless unclassified purity of life, with its blending and interpenetration of intellectual, spiritual, and physical elements, still folded together, pregnant with the possibilities of a whole world closed within it, is the highest expression of that indifference which is beyond all that is relative or partial. Everywhere there is the effect of an awaking, of a child's sleep just disturbed. All these effects are united in a single instance—the Adorante of the museum of Berlin,* a youth who has gained the wrestler's prize, with hands lifted and open in praise for the victory. Naive, unperplexed, it is the image of man as he springs first from the sleep of nature; his white light taking no colour from any one-sided experience, characterless so far as character involves subjection to the accidental influences of life. In dealing with youth, Greek art betrays a tendency even to merge distinctions of sex. The Hermaphrodite was a favourite subject from early times. It was wrought out over and over again, with passionate care, from the mystic terminal Hermaphrodite of the British

Museum, to the perfect blending of male and female beauty in the Hermaphrodite of the Louvre.[1]*

'This sense,' says Hegel,* 'for the consummate modelling of divine and human forms was preeminently at home in Greece. In its poets and orators, its historians and philosophers, Greece cannot be conceived from a central point, unless one brings, as a key to the understanding of it, an insight into the ideal forms of sculpture, and regards the images of statesmen and philosophers as well as epic and dramatic heroes from the artistic point of view; for those who act, as well as those who create and think, have in those beautiful days of Greece this plastic character. They are great and free, and have grown up on the soil of their own individuality, creating themselves out of themselves, and moulding themselves to what they were and willed to be. The age of Pericles was rich in such characters: Pericles himself, Phidias, Plato, above all Sophocles, Thucydides also, Xenophon and Socrates, each in his own order, without the perfection of one being diminished by that of the others. They are ideal artists of themselves, cast each in one flawless mould—works of art which stand before us as an immortal presentment of the gods. Of this modelling also are those bodily works of art, the victors in the Olympic Games; yes, and even Phryne, who, as the most beautiful of women, ascended naked out of the water in the presence of assembled Greece.'

This key to the understanding of the Greek spirit, Winckelmann possessed in his own nature, itself like a relic of classical antiquity laid open by accident to our alien modern atmosphere.* To the criticism of that consummate Greek modelling he brought not only his culture but his temperament. We have seen how definite was the leading motive of his culture; how, like some central root-fibre, it maintained the well-rounded unity of his life through a thousand distractions. Interests not his, nor meant for him, political, moral, religious, never disturbed him. In morals, as in criticism, he followed the clue of an unerring instinct. Penetrating into the antique world by his passion, his temperament, he enunciates no formal principles, always hard and one-sided; it remained for Hegel to formulate what in Winckelmann is everywhere individualised and concrete. Minute and anxious as his culture was, he never became

[1] Hegel, Aesthetik, Th. iii. Absch. 2, Kap. 1.

one-sidedly self-analytical. Occupied ever with himself, perfecting himself and cultivating his genius, he was not content, as so often happens with such natures, that the atmosphere between him and other minds should be thick and clouded; he was ever jealously refining his meaning into a form, express, clear, objective. This temperament he nurtured and invigorated by friendships which kept him ever in direct contact with the spirit of youth. The beauty of the Greek statues was a sexless beauty; the statues of the gods had the least traces of sex. Here, there is a moral sexlessness, a kind of impotence, an ineffectual wholeness of nature, yet with a divine beauty and significance of its own.*

One result of this temperament is a serenity, a *Heiterkeit*, which characterises Winckelmann's handling of the sensuous side of Greek art. This serenity is, perhaps, in a great measure, a negative quality; it is the absence of any sense of want, or corruption, or shame. With the sensuous element in Greek art he deals in the pagan manner; and what is implied in that? It has been sometimes said that art is a means of escape from 'the tyranny of the senses.'* It may be so for the spectator; he may find that the spectacle of supreme works of art takes from the life of the senses something of its turbid fever. But this is possible for the spectator only because the artist in producing those works has gradually sunk his intellectual and spiritual ideas in sensuous form. He may live, as Keats lived, a pure life; but his soul, like that of Plato's false astronomer,* becomes more and more immersed in sense, until nothing else has any interest for him. How could such an one ever again endure the greyness of the ideal or spiritual world? The spiritualist is satisfied in seeing the sensuous elements escape from his conceptions; his interest grows, as the dyed garment bleaches in the keener air. But the artist steeps his thought again and again into the fire of colour. To the Greek this immersion in the sensuous was indifferent. Greek sensuousness, therefore, does not fever the blood; it is shameless and childlike. But Christianity, with its uncompromising idealism, discrediting the slightest touch of sense, has lighted up for the artistic life, with its inevitable sensuousness a background of flame. 'I did but taste a little honey with the end of the rod that was in mine hand, and lo, I must die.'* It is hard to pursue that life without something of conscious disavowal of a spiritual world; and this imparts to genuine artistic interests a kind of intoxication. From this intoxication Winckelmann

is free; he fingers those pagan marbles with unsinged hands, with no sense of shame or loss. That is to deal with the sensuous side of art in the pagan manner.

The longer we contemplate that Hellenic ideal in which man is at unity with himself, with his physical nature, with the outward world, the more we may be inclined to regret that he should ever have passed beyond it, to contend for a perfection that makes the blood turbid, and frets the flesh, and discredits the actual world about us. But if he was to be saved from the *ennui* which ever attaches itself to realisation, even the realisation of perfection, it was necessary that a conflict should come, that some sharper note should grieve the perfect harmony, in order that the spirit, chafed by it, might beat out at last a broader and profounder music. In Greek tragedy this conflict has begun; man finds himself face to face with rival claims. Greek tragedy shows how such a conflict may be treated with serenity, how the evolution of it may be a spectacle of the dignity, not of the impotence, of the human spirit. But it is not only in tragedy that the Greek spirit showed itself capable of thus winning joy out of matter in itself full of discouragements. Theocritus too, often strikes a note of romantic sadness. But what a blithe and steady poise above these discouragements in a clear and sunny stratum of the air!

Into this stage of Greek achievement Winckelmann did not enter. Supreme as he is where his true interest lay, his insight into the typical unity and repose of the sculpturesque seems to have involved limitation in another direction. His conception of art excludes that bolder type of it which deals confidently and serenely with life, conflict, evil. Living in a world of exquisite but abstract and colourless form, he could hardly have conceived of the subtle and penetrative, but somewhat grotesque art of the modern world. What would he have thought of Gilliatt, or of the bleeding mouth of Fantine in that first part of 'Les Miserables,'* penetrated as it is with a sense of beauty as lively and transparent as that of a Greek? There is even a sort of preparation for the romantic temper within the limits of the Greek ideal itself, which Winckelmann failed to see. For Greek religion has not merely its mournful mysteries of Adonis, of Hyacinthus, of Ceres,* but it is conscious also of the fall of earlier divine dynasties. Hyperion gives way to Apollo, Oceanus to Poseidon.* Around the feet of that tranquil Olympian family still crowd the weary shadows of an earlier, more formless, divine world. Even their still minds

are troubled with thoughts of a limit to duration, of inevitable decay, of dispossession. Again, the supreme and colourless abstraction of those divine forms, which is the secret of their repose, is also a pre-monition of the fleshless consumptive refinements of the pale medi-æval artists. That high indifference to the outward, that impassivity, has already a touch of the corpse in it; we see already Angelico and the 'Master of the Passion'* in the artistic future. The crushing of the sensuous, the shutting of the door upon it, the flesh-outstripping interest, is already traceable. Those abstracted gods, 'ready to melt out their essence fine into the winds,'* who can fold up their flesh as a garment, and remain themselves, seem already to feel that bleak air in which, like Helen of Troy herself, they wander as the spectres of the middle age.

Gradually as the world came into the church, as Christianity com-promised its earlier severities, the native artistic interest reasserted its claims.* But Christian art was still dependent on pagan examples, building the shafts of pagan temples into its churches, perpetuating the form of the basilica, in later times working the disused amphi-theatres as quarries. The sensuous expression of conceptions which unreservedly discredit the world of sense, was the delicate problem which Christian art had before it. If we think of mediæval painting as it ranges from the early German schools, still with the air of a char-nel-house about them, to the clear loveliness of Perugino, we shall see that the problem was met. Even in the worship of sorrow the native blitheness of art asserted itself; the religious spirit, as Hegel says, 'smiled through its tears.'* So perfectly did the young Raffaelle infuse that *Heiterkeit*, that pagan blitheness, into religious works, that his picture of Saint Agatha at Bologna* became to Goethe a step in the evolution of 'Iphigenie'.[1] But in proportion as this power of smiling was refound, there came also an aspiration towards that lost antique art, some relics of which Christian art had buried in itself, ready to work wonders when their day came.

The history of art has suffered as much as any history by trenchant and absolute divisions. Pagan and Christian art are sometimes harshly opposed, and the Renaissance is represented as a fashion which set in at a definite period. That is the superficial view; the

[1] *Italiänische Reise.* Bologna, 19 Oct. 1786.

deeper view is that which preserves the identity of European culture. The two are really continuous: and there is a sense in which it may be said that the Renaissance was an uninterrupted effort of the middle age, that it was ever taking place. When the actual relics of the antique were restored to the world, it was to Christian eyes as if an ancient plague-pit had been opened: all the world took the contagion of the life of nature and the senses. Christian art allying itself with that restored antiquity which it had ever emulated, soon ceased to exist. For a time art dealt with Christian subjects as its patrons required; but its true freedom was in the life of the senses and the blood—blood no longer dropping from the hands in sacrifice, as with Angelico, but, as with Titian, burning in the face for desire and love. And now it was seen that the mediæval spirit too had done something for the destiny of the antique. By hastening the decline of art, by withdrawing interest from it, and yet keeping the thread of its traditions, it had suffered the human mind to repose, that it might awake when day came, with eyes refreshed, to those antique forms.*

The aim of a right criticism is to place Winckelmann in an intellectual perspective, of which Goethe is the foreground. For, after all, he is infinitely less than Goethe; it is chiefly because at certain points he comes in contact with Goethe that criticism entertains consideration of him. His relation to modern culture is a peculiar one. He is not of the modern world; nor is he of the eighteenth century, although so much of his outer life is characteristic of it. But that note of revolt against the eighteenth century, which we detect in Goethe, was struck by Winckelmann. Goethe illustrates that union of the Romantic spirit, its adventure, its variety, its deep subjectivity, with Hellenism, its transparency, its rationality, its desire of beauty—that marriage of Faust and Helena, of which the art of the nineteenth century is the child, the beautiful lad Euphorion, as Goethe conceives him, on the crags in the 'splendour of battle,' 'in harness as for victory,' his brows bound with light.[1]* Goethe illustrates, too, the preponderance in this marriage of the Hellenic element; and that element, in its true essence, was made known to him by Winckelmann.

Breadth, centrality, with blitheness and repose, are the marks of Hellenic culture. Is that culture a lost art? The local, accidental

[1] Faust, Th. ii. Act 3.

colouring of its own age has passed from it; the greatness that is dead looks greater when every link with what is slight and vulgar has been severed; we can only see it at all in the reflected, refined light which a high education creates for us. Can we bring down that ideal into the gaudy, perplexed light of modern life?

Certainly for us of the modern world, with its conflicting claims, its entangled interests, distracted by so many sorrows, so many pre-occupations, so bewildering an experience, the problem of unity with ourselves in blitheness and repose, is far harder than it was for the Greek within the simple terms of antique life. Yet, not less than ever, the intellect demands completeness, centrality. It is this which Winckelmann prints on the imagination of Goethe, at the beginning of his culture, in its original and simplest form, as in a fragment of Greek art itself, stranded on that littered, indeterminate shore of Germany in the eighteenth century. In Winckelmann this type comes to him, not as in a book or a theory, but importunately, in a passionate life and personality. For Goethe, possessing all modern interests, ready to be lost in the perplexed currents of modern thought, he defines in clearest outline the problem of culture-balance, unity with oneself, consummate Greek modelling.

It could no longer be solved, as in Phryne ascending naked out of the water, by perfection of bodily form, or any joyful union with the world without; the shadows had grown too long, the light too solemn for that. It could hardly be solved as in Pericles or Phidias, by the direct exercise of any single talent; amid the manifold claims of modern culture that could only have ended in a thin, one-sided growth. Goethe's Hellenism was of another order, the *Allgemeinheit* and *Heiterkeit*, the completeness and serenity of a watchful, exigent intellectualism. *Im Ganzen, Guten, Wahren, resolut zu leben,** Goethe's description of his own higher life; and what is meant by life in the whole, *im Ganzen*? It means the life of one for whom, over and over again, what was once precious has become indifferent. Every one who aims at the life of culture is met by many forms of it, arising out of the intense, laborious, one-sided development of some special talent. They are the brightest enthusiasms the world has to show. They do not care to weigh the claims which this or that alien form of culture makes upon them. But the pure instinct of self-culture cares not so much to reap all that these forms of culture can give, as to find in them its own strength. The demand of the intellect is to

feel itself alive. It must see into the laws, the operation, the intellec-
tual reward of every divided form of culture; but only that it may
measure the relation between itself and them. It struggles with those
forms till its secret is won from each, and then lets each fall back into
its place in the supreme, artistic view of life. With a kind of passion-
ate coldness such natures rejoice to be away from and past their
former selves. Above all, they are jealous of that abandonment to one
special gift which really limits their capabilities. It would have been
easy for Goethe, with the gift of a sensuous nature, to let it overgrow
him. It is easy with the other-worldly gifts to be a *schöne Seele*;* but
to the large vision of Goethe that seemed to be a phase of life that a
man might feel all round and leave behind him. Again, it is easy to
indulge the commonplace metaphysical instinct. But a taste for
metaphysics may be one of those things which we must renounce if
we mean to mould our lives to artistic perfection. Philosophy serves
culture not by the fancied gift of absolute or transcendental knowl-
edge, but by suggesting questions which help one to detect the pas-
sion and strangeness and dramatic contrasts of life.

But Goethe's culture did not remain 'behind the veil';* it ever
abutted on the practical functions of art, on actual production. For
him the problem came to be—Can the *Allgemeinheit* and *Heiterkeit* of
the antique be communicated to artistic productions which contain
the fulness of the experience of the modern world? We have seen
that the development of the various forms of art has corresponded to
the development of the thoughts of man concerning himself, to the
growing relation of the mind to itself. Sculpture corresponds to the
unperplexed, emphatic outlines of Hellenic humanism; painting to
the mystic depth and intricacy of the middle age; music and poetry
have their fortune in the modern world. Let us understand by poetry
all literary production which attains the power of giving pleasure by
its form as distinct from its matter. Only in this varied literary form
can art command that width, variety, delicacy of resources, which
will enable it to deal with the conditions of modern life. What
modern art has to do in the service of culture is so to rearrange the
details of modern life, so to reflect it, that it may satisfy the spirit.
And what does the spirit need in the face of modern life? The sense
of freedom. That naive, rough sense of freedom, which supposes
man's will to be limited, if at all, only by a will stronger than his, he
can never have again. The attempt to represent it in art would have

so little verisimilitude that it would be flat and uninteresting. The chief factor in the thoughts of the modern mind concerning itself is the intricacy, the universality of natural law even in the moral order. For us necessity is not as of old an image without us, with whom we can do warfare; it is a magic web woven through and through us, like that magnetic system of which modern science speaks, penetrating us with a network subtler than our subtlest nerves, yet bearing in it the central forces of the world. Can art represent men and women in these bewildering toils so as to give the spirit at least an equivalent for the sense of freedom? Goethe's *Wahlverwandtschaften** is a high instance of modern art dealing thus with modern life; it regards that life as the modern mind must regard it, but reflects upon it blitheness and repose Natural laws we shall never modify, embarrass us as they may; but there is still something in the nobler or less noble attitude with which we watch their fatal combinations. In *Wahlverwandtschaften* this entanglement, this network of law, becomes a tragic situation, in which a group of noble men and women work out a supreme *dénouement*. Who, if he foresaw all, would fret against circumstances which endow one at the end with so high an experience?

CONCLUSION*

*Λέγει που Ἡράκλειτος ὅτι πάντα χωρεῖ καὶ οὐδὲν μένει.**

To regard all things and principles of things as inconstant modes or fashions has more and more become the tendency of modern thought. Let us begin with that which is without—our physical life. Fix upon it in one of its more exquisite intervals, the moment, for instance, of delicious recoil from the flood of water in summer heat. What is the whole physical life in that moment but a combination of natural elements to which science gives their names? But these elements, phosphorus and lime and delicate fibres, are present not in the human body alone: we detect them in places most remote from it. Our physical life is a perpetual motion of them—the passage of the blood, the wasting and repairing of the lenses of the eye, the modification of the tissues of the brain by every ray of light and sound—processes which science reduces to simpler and more elementary forces.* Like the elements of which we are composed, the action of these forces extends beyond us; it rusts iron and ripens corn. Far out on every side of us these elements are broadcast, driven by many forces; and birth and gesture and death and the springing of violets from the grave* are but a few out of ten thousand resulting combinations. That clear perpetual outline of face and limb is but an image of ours under which we group them—a design in a web, the actual threads of which pass out beyond it. This at least of flame-like our life has, that it is but the concurrence, renewed from moment to moment, of forces parting sooner or later on their ways.

Or if we begin with the inward world of thought and feeling, the whirlpool is still more rapid, the flame more eager and devouring. There it is no longer the gradual darkening of the eye and fading of colour from the wall,—the movement of the shore side, where the water flows down indeed, though in apparent rest,—but the race of the midstream, a drift of momentary acts of sight and passion and thought. At first sight experience seems to bury us under a flood of external objects, pressing upon us with a sharp importunate reality, calling us out of ourselves in a thousand forms of action. But when reflection begins to act upon those objects they are dissipated under

its influence; the cohesive force is suspended like a trick of magic; each object is loosed into a group of impressions,—colour, odour, texture,—in the mind of the observer. And if we continue to dwell on this world, not of objects in the solidity with which language invests them, but of impressions unstable, flickering, inconsistent, which burn and are extinguished with our consciousness of them, it contracts still further; the whole scope of observation is dwarfed to the narrow chamber of the individual mind. Experience, already reduced to a swarm of impressions, is ringed round for each one of us by that thick wall of personality through which no real voice has ever pierced on its way to us, or from us to that which we can only conjecture to be without. Every one of those impressions is the impression of the individual in his isolation, each mind keeping as a solitary prisoner its own dream of a world.

Analysis goes a step further still, and tells us that those impressions of the individual to which, for each one of us, experience dwindles down, are in perpetual flight; that each of them is limited by time, and that as time is infinitely divisible, each of them is infinitely divisible also; all that is actual in it being a single moment, gone while we try to apprehend it, of which it may ever be more truly said that it has ceased to be than that it is. To such a tremulous wisp constantly reforming itself on the stream, to a single sharp impression, with a sense in it, a relic more or less fleeting, of such moments gone by, what is *real* in our life fines itself down. It is with the movement, the passage and dissolution of impressions, images, sensations, that analysis leaves off,—that continual vanishing away, that strange perpetual weaving and unweaving of ourselves.*

Philosophiren, says Novalis, *ist dephlegmatisiren, vivificiren.* The service of philosophy, and of religion and culture as well, to the human spirit, is to startle it into a sharp and eager observation. Every moment some form grows perfect in hand or face; some tone on the hills or sea is choicer than the rest; some mood of passion or insight or intellectual excitement is irresistibly real and attractive for us,—for that moment only. Not the fruit of experience, but experience itself is the end. A counted number of pulses only is given to us of a variegated, dramatic life. How may we see in them all that is to be seen in them by the finest senses? How can we pass most swiftly from point to point, and be present always at the focus where the greatest number of vital forces unite in their purest energy?

To burn always with this hard gem-like flame,* to maintain this ecstasy, is success in life. Failure is to form habits; for habit is relative to a stereotyped world; meantime it is only the roughness of the eye that makes any two persons, things, situations, seem alike. While all melts under our feet, we may well catch at any exquisite passion, or any contribution to knowledge that seems, by a lifted horizon, to set the spirit free for a moment, or any stirring of the senses, strange dyes, strange flowers, and curious odours, or work of the artist's hands, or the face of one's friend. Not to discriminate every moment some passionate attitude in those about us, and in the brilliance of their gifts some tragic dividing of forces on their ways is, on this short day of frost and sun, to sleep before evening. With this sense of the splendour of our experience and of its awful brevity, gathering all we are into one desperate effort to see and touch, we shall hardly have time to make theories about the things we see and touch. What we have to do is to be for ever curiously testing new opinions and court- ing new impressions, never acquiescing in a facile orthodoxy of Comte or of Hegel, or of our own. Theories, religious or philosoph- ical ideas, as points of view, instruments of criticism, may help us to gather up what might otherwise pass unregarded by us. *La phil- osophie, c'est la microscope de la pensée.** The theory, or idea, or system, which requires of us the sacrifice of any part of this experi- ence, in consideration of some interest into which we cannot enter, or some abstract morality we have not identified with ourselves, or what is only conventional, has no real claim upon us.

One of the most beautiful places in the writings of Rousseau is that in the sixth book of the 'Confessions,'* where he describes the awak- ening in him of the literary sense. An undefinable taint of death had always clung about him, and now in early manhood he believed himself stricken by mortal disease. He asked himself how he might make as much as possible of the interval that remained; and he was not biassed by anything in his previous life when he decided that it must be by intellectual excitement, which he found in the clear, fresh writings of Voltaire. Well, we are all *condamnés*, as Victor Hugo says: *les hommes sont tous condamnés a morte avec des sursis indéfinis**: we have an interval, and then our place knows us no more. Some spend this interval in listlessness, some in high passions, the wisest in art and song. For our one chance is in expanding that interval, in getting as many pulsations as possible into the given time. High passions

give one this quickened sense of life, ecstasy and sorrow of love, political or religious enthusiasm, or the 'enthusiasm of humanity.'* Only, be sure it is passion, that it does yield you this fruit of a quickened, multiplied consciousness. Of this wisdom, the poetic passion, the desire of beauty, the love of art for art's sake* has most; for art comes to you professing frankly to give nothing but the highest quality to your moments as they pass, and simply for those moments' sake.

APPENDIX A

THE SCHOOL OF GIORGIONE

It is the mistake of much popular criticism to regard poetry, music, and painting—all the various products of art—as but translations into different languages of one and the same fixed quantity of imaginative thought, supplemented by certain technical qualities of colour, in painting; of sound, in music; of rhythmical words, in poetry. In this way, the sensuous element in art, and with it almost everything in art that is essentially artistic, is made a matter of indifference; and a clear apprehension of the opposite principle—that the sensuous material of each art brings with it a special phase or quality of beauty, untranslatable into the forms of any other, an order of impressions distinct in kind—is the beginning of all true æsthetic criticism. For, as art addresses not pure sense, still less the pure intellect, but the 'imaginative reason'* through the senses, there are differences of kind in æsthetic beauty, corresponding to the differences in kind of the gifts of sense themselves. Each art, therefore, having its own peculiar and untranslatable sensuous charm, has its own special mode of reaching the imagination, its own special responsibilities to its material. One of the functions of æsthetic criticism is to define these limitations; to estimate the degree in which a given work of art fulfils its responsibilities to its special material; to note in a picture that true pictorial charm, which is neither a mere poetical thought or sentiment, on the one hand, nor a mere result of communicable technical skill in colour or design, on the other; to define in a poem that true poetical quality, which is neither descriptive nor meditative merely, but comes of an inventive handling of rhythmical language, the element of song in the singing; to note in music the musical charm, that essential music, which presents no words, no matter of sentiment or thought, separable from the special form in which it is conveyed to us.

To such a philosophy of the variations of the beautiful, Lessing's analysis of the spheres of sculpture and poetry, in the *Laocoon*,* was an important contribution. But a true appreciation of these things is possible only in the light of a whole system of such art-casuistries. Now painting is the art in the criticism of which this truth most

needs enforcing, for it is in popular judgments on pictures that the false generalisation of all art into forms of poetry is most prevalent. To suppose that all is mere technical acquirement in delineation or touch, working through and addressing itself to the intelligence, on the one side, or a merely poetical, or what may be called literary interest, addressed also to the pure intelligence, on the other:—this is the way of most spectators, and of many critics, who have never caught sight all the time of that true pictorial quality which lies between, unique pledge, as it is, of the possession of the pictorial gift, that inventive or creative handling of pure line and colour,* which, as almost always in Dutch painting, as often also in the works of Titian or Veronese, is quite independent of anything definitely poetical in the subject it accompanies. It is the *drawing*—the design projected from that peculiar pictorial temperament or constitution, in which, while it may possibly be ignorant of true anatomical proportions, all things whatever, all poetry, all ideas however abstract or obscure, float up as visible scene or image: it is the *colouring*—that weaving of light, as of just perceptible gold threads, through the dress, the flesh, the atmosphere, in Titian's *Lace-girl*,* that staining of the whole fabric of the thing with a new, delightful physical quality. This *drawing*, then—the arabesque traced in the air by Tintoret's flying figures,* by Titian's forest branches; this colouring—the magic conditions of light and hue in the atmosphere of Titian's *Lace-girl*, or Rubens's *Descent from the Cross*:—these essential pictorial qualities must first of all delight the sense, delight it as directly and sensuously as a fragment of Venetian glass; and through this delight alone become the vehicle of whatever poetry or science may lie beyond them in the intention of the composer. In its primary aspect, a great picture has no more definite message for us than an accidental play of sunlight and shadow for a few moments on the wall or floor: is itself, in truth, a space of such fallen light, caught as the colours are in an Eastern carpet, but refined upon, and dealt with more subtly and exquisitely than by nature itself. And this primary and essential condition fulfilled, we may trace the coming of poetry into painting, by fine gradations upwards; from Japanese fan-painting, for instance, where we get, first, only abstract colour; then, just a little interfused sense of the poetry of flowers; then, sometimes, perfect flower-painting; and so, onwards, until in Titian we have, as his poetry in the *Ariadne*,* so actually a touch of true childlike

humour in the diminutive, quaint figure with its silk gown, which ascends the temple stairs, in his picture of the *Presentation of the Virgin*,* at Venice.

But although each art has thus its own specific order of impressions, and an untranslatable charm, while a just apprehension of the ultimate differences of the arts is the beginning of æsthetic criticism; yet it is noticeable that, in its special mode of handling its given material, each art may be observed to pass into the condition of some other art, by what German critics term an *Anders-streben**—a partial alienation from its own limitations, through which the arts are able, not indeed to supply the place of each other, but reciprocally to lend each other new forces.

Thus, some of the most delightful music seems to be always approaching to figure, to pictorial definition. Architecture, again, though it has its own laws—laws esoteric enough, as the true architect knows only too well—yet sometimes aims at fulfilling the conditions of a picture, as in the *Arena* chapel; or of sculpture, as in the flawless unity of Giotto's tower at Florence; and often finds a true poetry, as in those strangely twisted staircases of the *châteaux* of the country of the Loire, as if it were intended that among their odd turnings the actors in a theatrical mode of life might pass each other unseen; there being a poetry also of memory and of the mere effect of time, by which architecture often profits greatly. Thus, again, sculpture aspires out of the hard limitation of pure form towards colour, or its equivalent; poetry also, in many ways, finding guidance from the other arts, the analogy between a Greek tragedy and a work of Greek sculpture, between a sonnet and a relief, of French poetry generally with the art of engraving, being more than mere figures of speech; and all the arts in common aspiring towards the principle of music; music being the typical, or ideally consummate art, the object of the great *Anders-streben* of all art, of all that is artistic, or partakes of artistic qualities.

All art constantly aspires towards the condition of music.* For while in all other kinds of art it is possible to distinguish the matter from the form, and the understanding can always make this distinction, yet it is the constant effort of art to obliterate it. That the mere matter of a poem, for instance, its subject, namely, its given incidents or situation—that the mere matter of a picture, the actual circumstances of an event, the actual topography of a landscape—should be

nothing without the form, the spirit, of the handling, that this form, this mode of handling, should become an end in itself, should penetrate every part of the matter: this is what all art constantly strives after, and achieves in different degrees.

This abstract language becomes clear enough, if we think of actual examples. In an actual landscape we see a long white road, lost suddenly on the hill-verge. That is the matter of one of the etchings of M. Alphonse Legros:* only, in this etching, it is informed by an indwelling solemnity of expression, seen upon it or half-seen, within the limits of an exceptional moment, or caught from his own mood perhaps, but which he maintains as the very essence of the thing, throughout his work. Sometimes a momentary hint of stormy light may invest a homely or too familiar scene with a character which might well have been drawn from the deep places of the imagination. Then we might say that this particular effect of light, this sudden inweaving of gold thread through the texture of the haystack, and the poplars, and the grass, gives the scene artistic qualities, that it is like a picture. And such tricks of circumstance are commonest in landscape which has little salient character of its own; because, in such scenery, all the material details are so easily absorbed by that informing expression of passing light, and elevated, throughout their whole extent, to a new and delightful effect by it. And hence the superiority, for most conditions of the picturesque, of a river-side in France to a Swiss valley, because, on the French river-side, mere topography, the simple material, counts for so little, and, all being very pure, untouched, and tranquil in itself, mere light and shade have such easy work in modulating it to one dominant tone. The Venetian landscape, on the other hand, has in its material conditions much which is hard, or harshly definite; but the masters of the Venetian school have shown themselves little burdened by them. Of its Alpine background they retain certain abstracted elements only, of cool colour and tranquillising line; and they use its actual details, the brown windy turrets, the straw-coloured fields, the forest arabesques, but as the notes of a music which duly accompanies the presence of their men and women, presenting us with the spirit or essence only of a certain sort of landscape—a country of the pure reason or half-imaginative memory.

Poetry, again, works with words addressed in the first instance to the pure intelligence; and it deals, most often, with a definite subject

or situation. Sometimes it may find a noble and quite legitimate function in the conveyance of moral or political aspiration, as often in the poetry of Victor Hugo. In such instances it is easy enough for the understanding to distinguish between the matter and the form, however much the matter, the subject, the element which is addressed to the mere intelligence, has been penetrated by the informing, artistic spirit. But the ideal types of poetry are those in which this distinction is reduced to its *minimum*; so that lyrical poetry, precisely because in it we are least able to detach the matter from the form, without a deduction of something from that matter itself, is, at least artistically, the highest and most complete form of poetry. And the very perfection of such poetry often appears to depend, in part, on a certain suppression or vagueness of mere subject, so that the meaning reaches us through ways not distinctly traceable by the understanding, as in some of the most imaginative compositions of William Blake, and often in Shakespeare's songs, as preeminently in that song of Mariana's page in *Measure for Measure*,* in which the kindling force and poetry of the whole play seems to pass for a moment into an actual strain of music.

And this principle holds good of all things that partake in any degree of artistic qualities, of the furniture of our houses, and of dress, for instance, of life itself, of gesture and speech, and the details of daily intercourse; these also, for the wise, being susceptible of a suavity and charm, caught from the way in which they are done, which gives them a worth in themselves. Herein, again, lies what is valuable and justly attractive, in what is called the fashion of a time, which elevates the trivialities of speech, and manner, and dress, into 'ends in themselves,'* and gives them a mysterious grace and attractiveness in the doing of them.

Art, then, is thus always striving to be independent of the mere intelligence, to become a matter of pure perception, to get rid of its responsibilities to its subject or material; the ideal examples of poetry and painting being those in which the constituent elements of the composition are so welded together, that the material or subject no longer strikes the intellect only; nor the form, the eye or the ear only; but form and matter, in their union or identity, present one single effect to the 'imaginative reason, that complex faculty for which every thought and feeling is twin-born with its sensible analogue or symbol.

It is the art of music which most completely realises this artistic ideal, this perfect identification of matter and form. In its consummate moments, the end is not distinct from the means, the form from the matter, the subject from the expression; they inhere in and completely saturate each other; and to it, therefore, to the condition of its perfect moments, all the arts may be supposed constantly to tend and aspire. In music, then, rather than in poetry, is to be found the true type or measure of perfected art. Therefore, although each art has its incommunicable element, its untranslatable order of impressions, its unique mode of reaching the 'imaginative reason,' yet the arts may be represented as continually struggling after the law or principle of music, to a condition which music alone completely realises; and one of the chief functions of æsthetic criticism, dealing with the products of art, new or old, is to estimate the degree in which each of those products approaches, in this sense, to musical law.

By no school of painters have the necessary limitations of the art of painting been so unerringly though instinctively apprehended, and the essence of what is pictorial in a picture so justly conceived, as by the school of Venice; and the train of thought suggested in what has been now said is, perhaps, a not unfitting introduction to a few pages about Giorgione, who, though much has been taken by recent criticism from what was reputed to be his work, yet, more entirely than any other painter, sums up, in what we know of himself and his art, the spirit of the Venetian school.

The beginnings of Venetian painting link themselves to the last, stiff, half-barbaric splendours of Byzantine decoration, and are but the introduction into the crust of marble and gold on the walls of the *Duomo* of Murano, or of *Saint Mark's*, of a little more of human expression. And throughout the course of its later development, always subordinate to architectural effect, the work of the Venetian school never escaped from the influence of its beginnings. Unassisted, and therefore unperplexed, by naturalism, religious mysticism, philosophical theories, it had no Giotto, no Angelico, no Botticelli. Exempt from the stress of thought and sentiment, which taxed so severely the resources of the generations of Florentine artists, those earlier Venetian painters, down to Carpaccio and the Bellini, seem never for a moment to have been so much as tempted to lose sight of the scope of their art in its strictness, or to forget that painting must

be before all things decorative, a thing for the eye, a space of colour on the wall, only more dexterously blent than the marking of its precious stone or the chance interchange of sun and shade upon it:—this, to begin and end with; whatever higher matter of thought, or poetry, or religious reverie might play its part therein, between. At last, with final mastery of all the technical secrets of his art, and with somewhat more than 'a spark of the divine fire' to his share, comes Giorgione. He is the inventor of *genre*, of those easily movable pictures which serve neither for uses of devotion, nor of allegorical or historic teaching—little groups of real men and women, amid congruous furniture or landscape—morsels of actual life, conversation or music or play, but refined upon or idealised, till they come to seem like glimpses of life from afar. Those spaces of more cunningly blent colour, obediently filling their places, hitherto, in a mere architectural scheme, Giorgione detaches from the wall. He frames them by the hands of some skilful carver, so that people may move them readily and take with them where they go, as one might a poem in manuscript, or a musical instrument, to be used, at will, as a means of self-education, stimulus or solace, coming like an animated presence, into one's cabinet, to enrich the air as with some choice aroma, and, like persons, live with us, for a day or a lifetime. Of all art such as this, art which has played so large a part in men's culture since that time, Giorgione is the initiator. Yet in him too that old Venetian clearness or justice, in the apprehension of the essential limitations of the pictorial art, is still undisturbed. While he interfuses his painted work with a high-strung sort of poetry, caught directly from a singularly rich and high-strung sort of life, yet in his selection of subject, or phase of subject, in the subordination of mere subject to pictorial design, to the main purpose of a picture, he is typical of that aspiration of all the arts towards music, which I have endeavoured to explain,—towards the perfect identification of matter and form.

Born so near to Titian, though a little before him, that these two companion pupils of the aged Giovanni Bellini may almost be called contemporaries, Giorgione stands to Titian in something like the relationship of Sordello to Dante, in Browning's poem.* Titian, when he leaves Bellini, becomes, in turn, the pupil of Giorgione. He lives in constant labour more than sixty years after Giorgione is in his grave; and with such fruit, that hardly one of the greater towns of Europe is without some fragment of his work. But the slightly older

man, with his so limited actual product (what remains to us of it seeming, when narrowly explained, to reduce itself to almost one picture, like Sordello's one fragment of lovely verse*) yet expresses, in elementary motive and principle, that spirit—itself the final acquisition of all the long endeavours of Venetian art—which Titian spreads over his whole life's activity.

And, as we might expect, something fabulous and illusive has always mingled itself in the brilliancy of Giorgione's fame. The exact relationship to him of many works—drawings, portraits, painted idylls—often fascinating enough, which in various collections went by his name, was from the first uncertain. Still, six or eight famous pictures at Dresden, Florence and the Louvre, were with no doubt attributed to him, and in these, if anywhere, something of the splendour of the old Venetian humanity seemed to have been preserved. But of those six or eight famous pictures it is now known that only one is certainly from Giorgione's hand. The accomplished science of the subject has come at last, and, as in other instances, has not made the past more real for us, but assured us only that we possess less of it than we seemed to possess. Much of the work on which Giorgione's immediate fame depended, work done for instantaneous effect, in all probability passed away almost within his own age, like the frescoes on the façade of the *fondaco dei Tedeschi** at Venice, some crimson traces of which, however, still give a strange additional touch of splendour to the scene of the *Rialto*. And then there is a barrier or borderland, a period about the middle of the sixteenth century, in passing through which the tradition miscarries, and the true outlines of Giorgione's work and person are obscured. It became fashionable for wealthy lovers of art, with no critical standard of authenticity, to collect so-called works of Giorgione, and a multitude of imitations came into circulation. And now, in the 'new Vasari[1],' the great traditional reputation, woven with so profuse demand on men's admiration, has been scrutinised thread by thread; and what remains of the most vivid and stimulating of Venetian masters, a live flame, as it seemed, in those old shadowy times, has been reduced almost to a name by his most recent critics.

Yet enough remains to explain why the legend grew up above the name, why the name attached itself, in many instances, to the bravest

[1] Crowe and Cavalcaselle, *History of Painting in North Italy.**

work of other men. The *Concert* in the *Pitti* Palace,* in which a
monk, with cowl and tonsure, touches the keys of a harpsichord,
while a clerk, placed behind him, grasps the handle of a viol, and a
third, with cap and plume, seems to wait upon the true interval for
beginning to sing, is undoubtedly Giorgione's. The outline of the
lifted finger, the trace of the plume, the very threads of the fine linen,
which fasten themselves on the memory, in the moment before they
are lost altogether in that calm unearthly glow, the skill which has
caught the waves of wandering sound, and fixed them for ever on the
lips and hands—these are indeed the master's own; and the criticism
which, while dismissing so much hitherto believed to be Giorgione's,
has established the claims of this one picture, has left it among the
most precious things in the world of art.

It is noticeable that the 'distinction' of this *Concert*, its sustained
evenness of perfection, alike in design, in execution, and in choice of
personal type, becomes for the 'new Vasari' the standard of Giorgione's
genuine work. Finding here sufficient to explain his influence, and the
true seal of mastery, its authors assign to Pellegrino da San Daniele
the *Holy Family* in the Louvre, in consideration of certain points
where it comes short of this standard. Such shortcoming however
will hardly diminish the spectator's enjoyment of a singular charm
of liquid air, with which the whole picture seems instinct, filling the
eyes and lips, the very garments, of its sacred personages, with
some wind-searched brightness and energy; of which fine air the blue
peak, clearly defined in the distance, is, as it were, the visible pledge.
Similarly, another favourite picture in the Louvre, subject of a
delightful sonnet by a poet[1]* whose own painted work often comes to
mind as one ponders over these precious things—the *Fête Champêtre*,
is assigned to an imitator of Sebastian del Piombo; and the *Tempest*,
in the Academy at Venice, to Paris Bordone, or perhaps to 'some
advanced craftsman of the sixteenth century.' From the gallery at
Dresden, the *Knight embracing a Lady*, where the knight's broken
gauntlet seems to mark some well-known pause in a story we would
willingly hear the rest of, is conceded to 'a Brescian hand,' and *Jacob
meeting Rachel* to a pupil of Palma. And then, whatever their charm,
we are called on to give up the *Ordeal*, and the *Finding of Moses* with
its jewel-like pools of water, perhaps to Bellini.*

[1] Dante Gabriel Rossetti.

Nor has the criticism, which thus so freely diminishes the number of his authentic works, added anything important to the well-known outline of the life and personality of the man: only, it has fixed one or two dates, one or two circumstances, a little more exactly. Giorgione was born before the year 1477, and spent his childhood at Castelfranco, where the last crags of the Venetian Alps break down romantically, with something of park-like grace, to the plain. A natural child of the family of the Barbarelli by a peasant-girl of Vedelago, he finds his way early into the circle of notable persons—people of courtesy. He is initiated into those differences of personal type, manner, and even of dress, which are best understood there—that 'distinction' of the *Concert* of the *Pitti* Palace. Not far from his home lives Catherine of Cornara, formerly Queen of Cyprus; and, up in the towers which still remain, Tuzio Costanzo, the famous *condottiere*, a picturesque remnant of medieval manners, amid a civilisation rapidly changing. Giorgione paints their portraits; and when Tuzio's son, Matteo, dies in early youth, adorns in his memory a chapel in the church of Castelfranco, painting on this occasion, perhaps, the altarpiece, foremost among his authentic works, still to be seen there, with the figure of the warrior-saint, Liberale, of which the original little study in oil, with the delicately gleaming, silver-grey armour, is one of the greater treasures of the National Gallery. In that figure, as in some other knightly personages attributed to him, people have supposed the likeness of the painter's own presumably gracious presence. Thither, at last, he is himself brought home from Venice, early dead, but celebrated. It happened, about his thirty-fourth year, that in one of those parties at which he entertained his friends with music, he met a certain lady of whom he became greatly enamoured, and 'they rejoiced greatly,' says Vasari, 'the one and the other, in their loves.' And two quite different legends concerning it agree in this, that it was through this lady he came by his death; Ridolfi relating that, being robbed of her by one of his pupils, he died of grief at the double treason; Vasari, that she being secretly stricken of the plague, and he making his visits to her as usual, Giorgione took the sickness from her mortally, along with her kisses, and so briefly departed.

But, although the number of Giorgione's extant works has been thus limited by recent criticism, all is not done when the real and the traditional elements in what concerns him have been discriminated;

Appendix A

for, in what is connected with a great name, much that is not real is often very stimulating. For the æsthetic philosopher, therefore, over and above the real Giorgione and his authentic extant works, there remains the *Giorgionesque* also—an influence, a spirit or type in art, active in men so different as those to whom many of his supposed works are really assignable. A veritable school, in fact, grew together out of all those fascinating works rightly or wrongly attributed to him; out of many copies from, or variations on him, by unknown or uncertain workmen, whose drawings and designs were, for various reasons, prized as his; out of the immediate impression he made upon his contemporaries, and with which he continued in men's minds; out of many traditions of subject and treatment, which really descend from him to our own time, and by retracing which we fill out the original image. Giorgione thus becomes a sort of impersonation of Venice itself, its projected reflex or ideal, all that was intense or desirable in it crystallising about the memory of this wonderful young man.

And now, finally, let me illustrate some of the characteristics of this *School of Giorgione*, as we may call it, which, for most of us, notwithstanding all that negative criticism of the 'new Vasari,' will still identify itself with those famous pictures at Florence, at Dresden and Paris. A certain artistic ideal is there defined for us—the conception of a peculiar aim and procedure in art, which we may understand as the *Giorgionesque*, wherever we find it, whether in Venetian work generally, or in work of our own time. Of this the *Concert*, that undoubted work of Giorgione in the *Pitti* Palace, is the typical instance, and a pledge authenticating the connexion of the school, and the spirit of the school, with the master.

I have spoken of a certain interpretation of the matter or subject of a work of art with the form of it, a condition realised absolutely only in music, as the condition to which every form of art is perpetually aspiring. In the art of painting, the attainment of this ideal condition, this perfect interpenetration of the subject with the elements of colour and design, depends, of course, in great measure, on dexterous choice of that subject, or phase of subject; and such choice is one of the secrets of Giorgione's school. It is the school of *genre*, and employs itself mainly with 'painted idylls,'* but, in the production of this pictorial poetry, exercises a wonderful tact in the selecting of such matter as lends itself most readily and entirely to pictorial form,

to complete expression by drawing and colour. For although its pro-
ductions are painted poems, they belong to a sort of poetry which
tells itself without an articulated story. The master is pre-eminent
for the resolution, the ease and quickness, with which he reproduces
instantaneous motion—the lacing-on of armour, with the head bent
back so stately—the fainting lady—the embrace, rapid as the kiss,
caught with death itself from dying lips—some momentary conjunc-
tion of mirrors and polished armour and still water, by which all
the sides of a solid image are exhibited at once, solving that casuis-
tical question whether painting can present an object as completely
as sculpture. The sudden act, the rapid transition of thought, the
passing expression—these he arrests with that vivacity which Vasari
has attributed to him, *il fuoco Giorgionesco*,* as he terms it. Now it is
part of the ideality of the highest sort of dramatic poetry,* that it
presents us with a kind of profoundly significant and animated
instants, a mere gesture, a look, a smile, perhaps—some brief and
wholly concrete moment—into which, however, all the motives, all
the interests and effects of a long history, have condensed them-
selves, and which seem to absorb past and future in an intense con-
sciousness of the present. Such ideal instants the school of Giorgione
selects, with its admirable tact, from that feverish, tumultuously
coloured world of the old citizens of Venice—exquisite pauses in
time, in which, arrested thus, we seem to be spectators of all the ful-
ness of existence, and which are like some consummate extract or
quintessence of life.

It is to the law or condition of music, as I said, that all art like this
is really aspiring; and, in the school of Giorgione, the perfect
moments of music itself, the making or hearing of music, song or its
accompaniment, are themselves prominent as subjects. On that back-
ground of the silence of Venice, so impressive to the modern visitor,
the world of Italian music was then forming. In choice of subject, as
in all besides, the *Concert* of the *Pitti* Palace is typical of everything
that Giorgione, himself an admirable musician, touched with his
influence. In sketch or finished picture, in various collections, we
may follow it through many intricate variations—men fainting at
music; music at the pool-side while people fish, or mingled with the
sound of the pitcher in the well, or heard across running water, or
among the flocks; the tuning of instruments; people with intent faces,
as if listening, like those described by Plato in an ingenious passage

of the Republic,* to detect the smallest interval of musical sound, the smallest undulation in the air, or feeling for music in thought on a stringless instrument, ear and finger refining themselves infinitely, in the appetite for sweet sound; a momentary touch of an instrument in the twilight, as one passes through some unfamiliar room, in a chance company.

In these then, the favourite incidents of Giorgione's school, music or the musical intervals in our existence, life itself is conceived as a sort of listening—listening to music, to the reading of Bandello's novels,* to the sound of water, to time as it flies. Often such moments are really our moments of play, and we are surprised at the unexpected blessedness of what may seem our least important part of time; not merely because play is in many instances that to which people really apply their own best powers, but also because at such times, the stress of our servile, everyday attentiveness being relaxed, the happier powers in things without are permitted free passage, and have their way with us. And so, from music, the school of Giorgione passes often to the play which is like music; to those masques in which men avowedly do but play at real life, like children 'dressing-up,' disguised in the strange old Italian dresses, particoloured, or fantastic with embroidery and furs, of which the master was so curious a designer, and which, above all the spotless white linen at wrist and throat, he painted so dexterously.

But when people are happy in this thirsty land water will not be far off; and in the school of Giorgione, the presence of water—the well, or marble-rimmed pool, the drawing or pouring of water, as the woman pours it from a pitcher with her jewelled hand in the *Fête Champêter*, listening, perhaps, to the cool sound as it falls, blent with the music of the pipes—is as characteristic, and almost as suggestive, as that of music itself. And the landscape feels, and is glad of it also—a landscape full of clearness, of the effects of water, of fresh rain newly passed through the air, and collected into the grassy channels. The air, moreover, in the school of Giorgione, seems as vivid as the people who breathe it, and literally empyrean, all impurities being burnt out of it, and no taint, no floating particle of anything but its own proper elements allowed to subsist within it.

Its scenery is such as in England we call 'park scenery,' with some elusive refinement felt about the rustic buildings, the choice grass, the grouped trees, the undulations deftly economised for graceful effect.

Only, in Italy all natural things are as it were woven through and through with gold thread, even the cypress revealing it among the folds of its blackness. And it is with gold dust, or gold thread, that these Venetian painters seem to work, spinning its fine filaments, through the solemn human flesh, away into the white plastered walls of the thatched huts. The harsher details of the mountains recede to a harmonious distance, the one peak of rich blue above the horizon remaining but as the sensible warrant of that due coolness which is all we need ask here of the Alps, with their dark rains and streams. Yet what real, airy space, as the eye passes from level to level, through the long-drawn valley in which Jacob embraces Rachel among the flocks! Nowhere is there a truer instance of that balance, that modulated unison of landscape and persons—of the human image and its accessories—already noticed as characteristic of the Venetian school, so that, in it, neither personage nor scenery is ever a mere pretext for the other.

Something like this seems to me to be the *vraie vérité** about Giorgione, if I may adopt a serviceable expression, by which the French recognise those more liberal and durable impressions which, in respect of any really considerable person or subject, anything that has at all intricately occupied men's attention, lie beyond, and must supplement, the narrower range of the strictly ascertained facts about it. In this, Giorgione is but an illustration of a valuable general caution we may abide by in all criticism. As regards Giorgione himself, we have indeed to take note of all those negations and exceptions, by which, at first sight, a 'new Vasari' seems merely to have confused our apprehension of a delightful object, to have explained away in our inheritance from past time what seemed of high value there. Yet it is not with a full understanding even of those exceptions that one can leave off just at this point. Properly qualified, such exceptions are but a salt of genuineness in our knowledge; and beyond all those strictly ascertained facts, we must take note of that indirect influence by which one like Giorgione, for instance, enlarges his permanent efficacy and really makes himself felt in our culture. In a just impression of that, is the essential truth, the *vraie vérité*, concerning him.

1877.

APPENDIX B
DIAPHANEITÈ

THERE are some unworldly types of character which the world is able to estimate. It recognises certain moral types, or categories, and regards whatever falls within them as having a right to exist. The saint, the artist, even the speculative thinker, out of the world's order as they are, yet work, so far as they work at all, in and by means of the main current of the world's energy. Often it gives them late, or scanty, or mistaken acknowledgment; still it has room for them in its scheme of life, a place made ready for them in its affections. It is also patient of doctrinaires of every degree of littleness. As if dimly conscious of some great sickness and weariness of heart in itself, it turns readily to those who theorise about its unsoundness. To constitute one of these categories, or types, a breadth and generality of character is required. There is another type of character, which is not broad and general, rare, precious above all to the artist, a character which seems to have been the supreme moral charm in the Beatrice of the Commedia.* It does not take the eye by breadth of colour; rather it is that fine edge of light, where the elements of our moral nature refine themselves to the burning point. It crosses rather than follows the main current of the world's life. The world has no sense fine enough for those evanescent shades, which fill up the blanks between contrasted types of character—delicate provision in the organisation of the moral world for the transmission to every part of it of the life quickened at single points! For this nature there is no place ready in its affections. This colourless, unclassified purity of life it can neither use for its service, nor contemplate as an ideal.

'Sibi unitus et simplificatus esse,' that is the long struggle of the Imitatio Christi.* The spirit which it forms is the very opposite of that which regards life as a game of skill, and values things and persons as marks or counters of something to be gained, or achieved, beyond them. It seeks to value everything at its eternal worth, not adding to it, or taking from it, the amount of influence it may have for or against its own special scheme of life. It is the spirit that sees external circumstances as they are, its own power and tendencies as they are, and realises the given conditions of its life, not disquieted

by the desire for change, or the preference of one part in life rather than another, or passion, or opinion. The character we mean to indicate achieves this perfect life by a happy gift of nature, without any struggle at all. Not the saint only, the artist also, and the speculative thinker, confused, jarred, disintegrated in the world, as sometimes they inevitably are, aspire for this simplicity to the last. The struggle of this aspiration with a lower practical aim in the mind of Savonarola has been subtly traced by the author of Romola.* As language, expression, is the function of intellect, as art, the supreme expression, is the highest product of intellect, so this desire for simplicity is a kind of indirect self-assertion of the intellectual part of such natures. Simplicity in purpose and act is a kind of determinate expression in dexterous outline of one's personality. It is a kind of moral expressiveness; there is an intellectual triumph implied in it. Such a simplicity is characteristic of the repose of perfect intellectual culture. The artist and he who has treated life in the spirit of art desires only to be shown to the world as he really is; as he comes nearer and nearer to perfection, the veil of an outer life not simply expressive of the inward becomes thinner and thinner. This intellectual throne is rarely won. Like the religious life, it is a paradox in the world, denying the first conditions of man's ordinary existence, cutting obliquely the spontaneous order of things. But the character we have before us is a kind of prophecy of this repose and simplicity, coming as it were in the order of grace, not of nature, by some happy gift, or accident of birth or constitution, showing that it is indeed within the limits of man's destiny. Like all the higher forms of inward life this character is a subtle blending and interpenetration of intellectual, moral and spiritual elements. But it is as a phase of intellect, of culture, that it is most striking and forcible. It is a mind of taste lighted up by some spiritual ray within. What is meant by taste is an imperfect intellectual state; it is but a sterile kind of culture. It is the mental attitude, the intellectual manner of perfect culture, assumed by a happy instinct. Its beautiful way of handling everything that appeals to the senses and the intellect is really directed by the laws of the higher intellectual life, but while culture is able to trace those laws, mere taste is unaware of them. In the character before us, taste, without ceasing to be instructive, is far more than a mental attitude or manner. A magnificent intellectual force is latent within it. It is like the reminiscence of a forgotten culture that once

adorned the mind; as if the mind of one φιλοσοφήσας ποτε μετ' ἔρωτος,* fallen into a new cycle, were beginning its spiritual progress over again, but with a certain power of anticipating its stages. It has the freshness without the shallowness of taste, the range and seriousness of culture without its strain and over-consciousness. Such a habit may be described as wistfulness of mind, the feeling that there is 'so much to know,' rather as a longing after what is unattainable, than as a hope to apprehend. Its ethical result is an intellectual guilelessness, or integrity, that instinctively prefers what is direct and clear, lest one's own confusion and intransparency should hinder the transmission from without of light that is not yet inward. He who is ever looking for the breaking of a light he knows not whence about him, notes with a strange heedfulness the faintest paleness in the sky. That truthfulness of temper, that receptivity, which professors often strive in vain to form, is engendered here less by wisdom than by innocence. Such a character is like a relic from the classical age, laid open by accident to our alien modern atmosphere. It has something of the clear ring, the eternal outline of the antique. Perhaps it is nearly always found with a corresponding outward semblance. The veil or mask of such a nature would be the very opposite of the 'dim blackguardism' of Danton,* the type Carlyle has made too popular for the true interest of art. It is just this sort of entire transparency of nature that lets through unconsciously all that is really lifegiving in the established order of things; it detects without difficulty all sorts of affinities between its own elements, and the nobler elements in that order. But then its wistfulness and a confidence in perfection it has makes it love the lords of change. What makes revolutionists is either self-pity, or indignation for the sake of others, or a sympathetic perception of the dominant undercurrent of progress in things. The nature before us is revolutionist from the direct sense of personal worth, that χλιδή, that of pride of life, which to the Greek was a heavenly grace. How can he value what comes of accident, or usage, or convention, whose individual life nature itself has isolated and perfected? Revolution is often impious. They who prosecute revolution have to violate again and again the instinct of reverence. That is inevitable, since after all progress is a kind of violence. But in this nature revolutionism is softened, harmonised, subdued as by distance. It is the revolutionism of one who has slept a hundred years. Most of us are neutralised by the play of circumstances.

To most of us only one chance is given in the life of the spirit and the intellect, and circumstances prevent our dexterously seizing that one chance. The one happy spot in our nature has no room to burst into life. Our collective life, pressing equally on every part of every one of us, reduces nearly all of us to the level of a colourless uninteresting existence. Others are neutralised, not by suppression of gifts, but by just equipoise among them. In these no single gift, or virtue, or idea, has an unmusical predominance. The world easily confounds these two conditions. It sees in the character before us only indifferentism. Doubtless the chief vein of the life of humanity could hardly pass through it. Not by it could the progress of the world be achieved. It is not the guise of Luther or Spinoza; rather it is that of Raphael, who in the midst of the Reformation and the Renaissance, himself lighted up by them, yielded himself to neither, but stood still to live upon himself, even in outward form a youth, almost an infant, yet surprising all the world. The beauty of the Greek statues was a sexless beauty; the statues of the gods had the least traces of sex. Here there is a moral sexlessness, a kind of impotence, an ineffectual wholeness of nature, yet with a divine beauty and significance of its own.

Over and over again the world has been surprised by the heroism, the insight, the passion, of this clear crystal nature. Poetry and poetical history have dreamed of a crisis, where it must needs be that some human victim be sent down into the grave. These are they whom in its profound emotion humanity might choose to send. 'What,' says Carlyle, of Charlotte Corday, 'What if she had emerged from her secluded stillness, suddenly like a star; cruel-lovely, with half-angelic, half-dæmonic splendour; to gleam for a moment, and in a moment be extinguished; to be held in memory, so bright complete was she, through long centuries!'*

Often the presence of this nature is felt like a sweet aroma in early manhood. Afterwards, as the adulterated atmosphere of the world assimilates us to itself, the savour of it faints away. Perhaps there are flushes of it in all of us; recurring moments of it in every period of life. Certainly this is so with every man of genius. It is a thread of pure white light that one might disentwine from the tumultuary richness of Goethe's nature. It is a natural prophecy of what the next generation will appear, renerved, modified by the ideas of this. There is a violence, an impossibility about men who have ideas, which

makes one suspect that they could never be the type of any wide-spread life. Society could not be conformed to their image but by an unlovely straining from its true order. Well, in this nature the idea appears softened, harmonised as by distance, with an engaging naturalness, without the noise of axe or hammer.

People have often tried to find a type of life that might serve as a basement type. The philosopher, the saint, the artist, neither of them can be this type; the order of nature itself makes them exceptional. It cannot be the pedant, or the conservative, or anything rash and irreverent. Also the type must be one discontented with society as it is. The nature here indicated alone is worthy to be this type. A majority of such would be the regeneration of the world.

July, 1864.

EXPLANATORY NOTES

2 *To C.L.S.*: C.L.S. is Charles Lancelot Shadwell (1840–1919). Shadwell was a Fellow of Oriel College, Oxford, where he lectured in jurisprudence from 1865 to 1875. He had been a student of Pater's in Oxford, and both men became members of the Old Mortality Essay Society. In his youth, when he was famed for being handsome, he inspired Pater's essay 'Diaphaneitè' (1864). There, he stands behind the elusive diaphanous character evoked by Pater: 'a relic from the classical age, laid open by accident to our alien modern atmosphere'; one whose 'truthfulness of temper', it is gently insinuated, 'is nearly always found with a corresponding outward semblance'. The friends visited Italy together in 1865, and Pater's dedication is a testament to this experience. Subsequently, Pater contributed an introductory essay to Shadwell's translation of Dante's *Purgatorio*, published as *The Purgatory of Dante Alighieri* (1892). According to A. C. Benson, Shadwell was Pater's 'lifelong companion' and his 'closest friend', though they appear in fact to have become increasingly distant from one another. After Pater's death, Shadwell became his literary executor.

Note that in the fourth edition of *The Renaissance* Pater added an enigmatic epigraph, from Psalms 68: 13: '*Yet shall ye be as the wings of a dove.*'

PREFACE

Pater began composing his 'Preface'—which, from the third edition of *The Renaissance*, he dated '1873'—in the second half of 1872. Its text remained for the most part unaltered after its first appearance in *Studies in the History of the Renaissance*.

3 '*To see the object as in itself it really is*': Matthew Arnold used this formulation in 'On Translating Homer' (1862), and then cited it in 'The Function of Criticism at the Present Time' (1864): 'Of the literature of France and Germany, as of the intellect of Europe in general, the main effort, for now many years, has been a critical effort; the endeavour, in all branches of knowledge, theology, philosophy, history, art, science, to see the object as in itself it really is.'

4 '*De se borner . . . en humanistes accomplis*': this quotation comes from the French critic Charles Augustin Sainte-Beuve (1804–69) and is not in fact about him. Hence, in his edition, Hill amends 'a recent critic of Sainte-Beuve' to 'a recent critique of Sainte-Beuve', though he admits that this is conjectural. In an article on Joachim du Bellay, Sainte-Beuve discusses what it meant to be 'humanist' at the precise moment that the canonical books of Renaissance scholarship first appeared in print, thus making

ancient authors available for the first time. He imagines being a friend of Racine, for instance, or Fénelon, one of those who 'confined themselves to knowing beautiful things at close hand, and to nourishing themselves on these things as refined amateurs, as accomplished humanists.'

4 *'The ages are all equal . . . but genius is always above its age'*: this is taken from the annotations by William Blake (1757–1827) to the first volume of the second edition of *The Works of Sir Joshua Reynolds* (1798) which Pater probably encountered in the *Life of William Blake* (1863) by Alexander Gilchrist (1828–61).

5 *the function of the critic of Wordsworth*: Pater's article 'On Wordsworth' was to appear in the *Fortnightly Review* in April 1874; he announces there that the lesson that Wordsworth's poems convey most clearly is 'the supreme importance of contemplation in the conduct of life'.

ascesis: in 'Style', first published in the *Fortnightly Review* in December 1888, Pater wrote that 'self-restraint, a skilful economy of means, *ascêsis*, that too has a beauty of its own; and for the reader supposed there will be an aesthetic satisfaction in that frugal closenesss of style which makes the most of a word, in the exaction from every sentence of a precise relief, in the just spacing out of word to thought, in the logically filled space connected always with the delightful sense of difficulty overcome'. In *Marius the Epicurean* (1885) he had emphasized his eponymous hero's 'mystic enjoyment' of *ascêsis*.

AUCASSIN AND NICOLETTE

This chapter had not appeared in print before its publication in *Studies in the History of the Renaissance*. Hill points out that it must have been inspired by Swinburne's *William Blake* (1868), which celebrates 'the old Albigensian *Aucassin* and all its paganism'. In subsequent editions of *The Renaissance*, Pater renamed it 'Two Early French Stories'. As this implies, he also expanded the chapter, most importantly by adding two substantial sections. The first of these is an account of the tale of Amis and Amile, a twelfth-century *chanson de geste* that he translates extensively. The second, at the end of the chapter, is a discussion of the 'House Beautiful' which then revisits *Amis and Amile* in conclusion. In one of the additional paragraphs, Pater explains that he has 'illustrated the early strength of the Renaissance by the story of Amis and Amile', and that he will illustrate 'that other element, its early sweetness' by the story of Aucassin and Nicolette. 'For the Renaissance,' he emphasizes, 'has not only the sweetness which it derives from the classical world, but also that curious strength of which there are great resources in the true middle age.' Richard Dellamora has convincingly argued that in including an account of Amis and Amile to his discussion of love Pater adds a homoerotic emphasis not present in the previous version.

9 *Aucassin and Nicolette*: a thirteenth-century courtly love romance in northern French; at its conclusion, *Aucassin and Nicolette* identifies itself as a *chante fable*, a narrative that alternates between prose and verse.

Dante . . . the city of Paris: in Canto XI of his *Purgatorio*, Dante Alighieri (1265–1321) writes:

> 'Oh!' I said to him, 'are you not Oderisi,
> The pride of Gubbio, and the pride of that art
> Which in Paris is called "illuminating"?'

10 *the legend of Abelard*: Pierre Abelard (1079–1142) was a popular French philosopher, associated with nominalism, who fell in love with his student Héloïse, a brilliant classical scholar. Héloïse and Abelard had a child and secretly married, and, as a result, Héloïse's uncle punished Abelard by castrating him. Abelard became a monk and Héloïse a nun, but their relationship survived them in the form of their correspondence, which was found in a fifteenth-century manuscript and first published in 1616. Alexander Pope authored an influential poem entitled 'Eloisa to Abelard' (1717).

In a significant passage about Abelard added to subsequent editions, Pater described his importance thus:

> The opposition into which Abelard is thrown, which gives its colour to his career, which breaks his soul to pieces, is a no less subtle opposition than that between the merely professional, official, hireling ministers of that system, with their ignorant worship of system for its own sake, and the true child of light, the humanist, with reason and heart and sense quick, while theirs were almost dead. He reaches out towards, he attains, modes of ideal living, beyond the prescribed limits of that system, though in essential germ, it may be, contained within it. As always happens, the adherents of the poorer and narrower culture had no sympathy with, because no understanding of, a culture richer and more ample than their own.

10 *the legend of Tannhäuser*: Tannhäuser, who died some time after 1265, was a German love poet, or *Minnesinger*. In the fifteenth century, he became the protagonist of a legend in which, thanks to divine intervention, he is forgiven by the Pope for having lived with the goddess Venus in her caves, though only after he has been banished. Richard Wagner composed an opera about the legend, *Tannhäuser und der Sängerkrieg auf der Wartburg* (1845), which Charles Baudelaire discussed in 'Richard Wagner et Tannhäuser à Paris' (1861). A. C. Swinburne (1837–1909) used the Tannhäuser legend in 'Laus Veneris' (1866); and William Morris (1834–96) used it in 'The Hill of Venus', printed in *The Earthly Paradise* (1870). Subsequently, Aubrey Beardsley produced an erotic romance entitled *The Story of Venus and Tannhauser*, which appeared, in expurgated form, as *Under the Hill* (1896).

11 *'Love made himself of the party with them'*: not even Hill is able to identify this quotation, although he does allude to a line from *Lettres et épitres amoureuses d'Héloïse et de l'Abeilard* (1780), edited by A. E. Cailleau, that might have informed it: 'Learned conversations did not make up the whole occupation of these two happy lovers, love made up the greatest part of it.'

11 *'the Island'*: the Île de la Cité in Paris, one of the islands on the Seine, on which a cathedral was built in the tenth century.

the Trouvères: *trouvères* were troubadours.

the historian Michelet: Pater quotes from the 'Notes de l'introduction' to the seventh volume of *L'Histoire de France* (1855), though Michelet refers to 'la Révolution'—that is, the French Revolution—rather than 'the revolution', as Pater translates it.

finds an echo in Dante: it is at this point in subsequent editions of *The Renaissance* that Pater adds most of the material on Amis and Amile. The beginning of the passage is perhaps particularly significant, because of its emphasis on their homosocial and, implicitly, homosexual, relationship:

> In one of these thirteenth-century stories, *Li Amitiez de Ami et Amile*, that free play of human affection, of the claims of which Abelard's story is an assertion, makes itself felt in the incidents of a great friendship, a friendship pure and generous, pushed to a sort of passionate exaltation, and more than faithful unto death. Such comradeship, though instances of it are to be found everywhere, is still especially a classical motive; Chaucer expressing the sentiment of it so strongly in an antique take, that one knows not whether the love of both Palamon and Arcite for Emelya, or of those two for each other, is the chiefer subject of the *Knight's Tale*.

the Tenson and the Aubade, of Bernard de Ventadour and Pierre Vidal: the *tenson*, which originated in twelfth-century Provence, is a poem structured by a debate between speakers of opposing views; the *aubade*, or 'dawn song', is a poem about the parting of lovers at daybreak (Pater defines it as such in 'Poems by William Morris' (1868)). Bernard de Ventadour or Ventedorn (fl. 1150–95) and Pierre or Piere Vidal (fl. 1175–1215) were celebrated troubadours.

12 *Arabian Nights*: the *Arabian Nights Entertainments* or *The Thousand and One Nights* is a collection of narratives that was translated into French from a Syrian manuscript in the early eighteenth century. The first, anonymous English translation came out in 1708; a further, expurgated translation appeared from 1838 to 1840. From the third edition, Pater included a footnote at this point:

> Recently, *Aucassin and Nicolette* has been edited and translated into English, with much graceful scholarship, by Mr. F. W. Bourdillon. Still more recently we have had a translation—a poet's translation—from the ingenious and versatile pen of Mr. Andrew Lang. The reader should consult also the chapter on 'The Outdoor Poetry,' in Vernon Lee's most interesting *Euphrion, being Studies of the Antique and Mediaeval in the Renaissance*, a work abounding in knowledge and insight on the subjects of which it treats.

'Or se cante'—ici on chante; . . . 'Or dient et content et fabloient'—ici on conte: 'This part is sung'; . . . 'This part is spoken and narrated.'

13 'cortois,' . . . 'et bien assis': 'courtly', . . . 'and well phrased'.

15 'Lord of terrible aspect': a translation of 'uno segnore di pauroso aspetto', taken from section III of the edition of Dante's *Vita nuova* by Dante Gabriel Rossetti (1828–82). Pater also cites it in the opening sentences of the sixth chapter of *Marius the Epicurean*.

'Aucassin . . . amorous': 'Aucassin, the handsome, the blonde, | The noble, the amorous.'

dansellon: 'a very young man.'

16 *Pierre Vidal*: the poem to which Pater alludes, which he had probably encountered in *An Introduction to Dante* (1872) by John Addington Symonds (1840–93), is not in fact thought to have been composed by Vidal.

antinomianism: antinomianism signifies a doctrine, generally a religious one, that entails principled opposition to the prevailing moral laws.

'Notre Dame de Paris': a novel, first published in 1831, by the French Romantic author Victor Hugo (1802–85).

16 *The Albigensian movement*: a heretical sect, most often referred to as the Cathars, which was especially influential in the twelfth and thirteenth centuries. Hill emphasizes that the counts of Toulouse offered protection to the Albigensians and encouraged the troubadours. Note that, at his death, Pater left an unfinished, unpublished manuscript entitled 'Tibalt the Albigense'.

Joachim of Flora: Joachim of Flora or Fiore (*c.*1135–1202) was a mystic whose prophetic influence, especially among the Franciscans, was based on his apocalyptic interpretation of the Book of Revelation. Hill notes that Pater had read the account of Joachim by Michelet, and also speculates that he had read an article on him by Renan. Warwick Gould and Marjorie Reeves have commented that 'the epithet "flowery" seems to recall the "Flora" Pater (and others) habitually use for Fiore'.

17 *if he makes Nicolette his mistress*: the second substantial addition that Pater made to the chapter was inserted at this point. Perhaps the most significant passage is this one:

> But in the *House Beautiful* the saints too have their place; and the student of the Renaissance has this advantage over the student of the emancipation of the human mind in the Reformation, or the French Revolution, that in tracing the footsteps of humanity to higher levels, he is not beset at every turn by the inflexibilities and antagonisms of some well-recognised controversy, with rigidly defined opposites, exhausting the intelligence and limiting one's sympathies. The opposition of the professional defenders of a mere system to that more sincere and generous play of the forces of human mind and character, which I have noted as the secret of Abelard's struggle, is

indeed always powerful. But the incompatibility with one another of souls really 'fair' is not essential; and within the enchanted region of the Renaissance, one needs not be for ever on one's guard. Here there are no fixed parties, no exclusions: all breathes of that unity of culture in which 'whatsoever things are comely' are reconciled for the elevation and adorning of our spirits. And just in proportion as those who took part in the Renaissance become centrally representative of it, just so much the more is this condition realised in them. The wicked popes, and the loveless tyrants, who from time to time became its patrons, or mere speculators in its fortunes, lend themselves easily to disputations, and, from this side or that, the spirit of controversy lays just hold upon them. But the painter of the *Last Supper*, with his kindred, lives in a land where controversy has no breathing-place. They refuse to be classified.

17 '*En paradis qu'ai-je à faire? . . . ma très-douce mie*': in this edition, as the footnote indicates, Pater cites Fauriel's translation of Aucassin's speech into nineteenth-century French in full. In subsequent editions, he either excises this speech (1877) or edits it (1888, 1893). In the 1877 edition, he refers to it as 'a passage in which that note of rebellion is too strident for me to translate it here, though it has its more subdued echoes in our English Chaucer'. (Swinburne had invoked 'Chaucer's *Court of Love*, absolutely one in tone and handling as it is with the old Albigensian *Aucassin* and all its paganism' in his *William Blake* of 1868.) Jane Gilbert has kindly translated this passage for me:

'What would I do in paradise?' replied Aucassin. 'I'm not bothered about going there so long as I can have Nicolette my sweetheart, whom I love so. Who goes to paradise, other than such people as I shall tell you about? Old priests go there, and the sort of crippled and maimed decrepits who day and night cling to altars and chapels. And there too go ragged old monks, barefoot or in patched sandals, always dying of hunger or thirst or suffering. These are the types who go to paradise—and I don't care about such people. But I'll be happy to go to hell: for to hell go the good clerks and the handsome knights dead in battles and great wars, the fine sergeants at arms and the men of quality. And I want to go with all those. To hell go also the beautiful, courtly ladies who have two or three lovers as well as their husbands. The gold and silver go there, the fine furs, the vair and the gris. The harpers go there, the minstrels and the kings of the world. And I want to go with all these, so long as I can have with me Nicolette, my very sweet heart.'

PICO DELLA MIRANDOLA

This chapter, sent to Alexander Macmillan in June 1872, first appeared under the title 'Pico della Mirandola' in the *Fortnightly Review* of 1 October 1871 (see the Note on the Text). Pater did not significantly revise the essay for subsequent editions.

18 *Heine, in the 'Gods in Exile'*: 'Les Dieux en exil', by the German poet
Heinrich Heine (1797–1856), first appeared in the *Revue des deux mondes*
in 1853, although Pater's translation is from the abbreviated version
published in German in 1853 and 1854. Pater often alludes to Heine's
conception of these exiled divinities, as in 'Denys l'Auxerrois' (1886) and
'Apollo in Picardy' (1893).

19 *the éclaircissement of the eighteenth century*: the Enlightenment.

A modern scholar: the 'modern scholar' that Pater has in mind is a Hegelian
one. Pater set out this 'historic method', as opposed to a 'dogmatic' or an
'eclectic' one, in *Plato and Platonism* (1893):

> That ages have their genius as well as the individual; that in every age
> there is a peculiar *ensemble* of conditions which determines a common
> character in every product of that age, in business and art, in fashion
> and speculation, in religion and manners, in men's very faces; that
> nothing man has projected from himself is really intelligible except at
> its own date, and from its proper point of view in the never-resting
> 'secular process'; the solidarity of philosophy, of the intellectual life,
> with common or general history; that what it behoves the student
> of philosophic systems to cultivate is the 'historic sense': by force of
> these convictions many a normal, or at first sight abnormal, phase of
> speculation has found a reasonable meaning for us.

20 *the gradual education of the human race*: this formulation, which echoes
that of 'the gradual education of the human mind' in the same paragraph,
is a reference to the German critic and dramatist Gotthold Ephraim
Lessing (1729–81), whose essay 'Die Erziehung der Menschengeschlechts'
(1780) had been translated into English, by F. W. Robertson, as 'The
Education of the Human Race' (1858).

'madhouse-cell': under the title 'Madhouse Cells', Robert Browning
(1812–89) published the companion poems 'Johannes Agricola in
Meditation' and 'Porphyria's Lover' in the *Monthly Repository* of January
1836 (they were reprinted in *Dramatic Lyrics* in 1842).

21 *as M. Renan has pointed out*: a reference to *Averroès et l'averroïsme* (1852)
by Ernest Renan (1823–92), the French archaeologist, Hebraist, and
historian (who published his controversial *Vie de Jésus* in 1863).

22 *Tobit*: in the Book of Tobit, one of the so-called 'Apocrypha' from the
Old Testament, the archangel Raphael accompanies Tobit's son Tobias
on his travels to Media. This scene was depicted by Verrocchio in *Tobias
and the Angel* (*c*.1473), a painting to which both Leonardo and Perugino
probably contributed.

23 *The oration . . . still remains*: this is the *Oratio Iannis Pici Mirandulani
concordiae comitis* (1486), known as the 'Oration on the Dignity of Man'.

the 'interpreter of nature': Francis Bacon (1561–1626) uses the formulation
'Homo, naturae minister et interpres' ('Man, the minister and interpreter
of nature') in his *Aphorismi de interpretatione naturae, et regno hominis,*

from the *Instauratio magna* (1620). In the third and fourth editions of *The Renaissance*, Pater uses the phrase 'Homo minister et interpres naturae' as an epigraph to the chapter on Leonardo da Vinci.

24 *like that map . . . in one of the earlier frescoes of the Campo Santo at Pisa*: Pater is no doubt referring to *Theological Cosmography* by the fourteenth-century painter Piero di Puccio, which was situated in the north corridor of the Camposanto (before being destroyed by artillery fire in 1944). He probably visited the Camposanto when he travelled to Pisa in 1865. Symonds, in his review of *Studies in the History of the Renaissance* in the *Academy* (15 March 1875), insisted that Pater had 'forgotten that the point of this old picture lies in the fact that it is *not* the creative Demeurgus, but Christ, in the prime of manhood, who supports the disc of the universe, with its concentric rings of created beings'. Note that when the Pre-Raphaelites constituted themselves as such in 1848 they were partly inspired by the engravings of the fourteenth-century frescos in the Camposanto by Carlo Lasinio (1759–1838).

a mote in the beam: a 'mote' is a particle of dust; see Matthew 7: 3: 'And why beholdest thou the mote that is in thy brother's eye, but considerest not the beam that is in thine own eye?'

Le silence éternel de ces espaces infinis m'effraie: this sentence is from the *Pensées*, by Blaise Pascal (1623–62), an uncompleted book in defence of Christianity, which was posthumously published in 1670 and probably first translated into English by Joseph Walker in 1688. In 'Pascal', posthumously published in the *Contemporary Review* of February 1895, Pater proposed that the *Pensées* seem 'essentially the utterance of a soul *malade*—a soul of great genius, whose malady became a new quality of that genius, perfecting it thus, by its very defect, as a type of the intellectual stage, and thereby guiding, reassuring sympathetically, manning by a sense of good company that large class of persons who are *malade* in the same way'.

Savonarola's famous 'bonfire of vanities': the 'bonfire of vanities' refers to the events of 7 February 1497, when supporters of Savonarola publicly burned innumerable objects that they deemed emblematic of religious corruption, including various books and paintings. (Botticelli, who had attended Savonarola's sermons, sacrificed several of his paintings on this occasion.) George Eliot describes this spectacle, and the 'collection of marketable abominations' that were burned, in chapter XLIX of *Romola* (1862–3). Pater must have read this novel by 1864, for he comments on it in his celebration of a 'colourless, unclassified purity of life' in 'Diaphaneitè':

> Not the saint only, the artist also, and the speculative thinker, confused, jarred, disintegrated in the world, as sometimes they inevitably are, aspire for this simplicity to the last. The struggle of this aspiration with a lower practical aim in the mind of Savonarola has been subtly traced by the author of Romola.

the Cabala: the Cabbala or Kabbala is a tradition of Jewish mysticism that originated as such in the twelfth century.

25 *those thoughts on the religious life . . . the 'Imitation'*: More translated the *Duodecim regulae* as the *Twelve Rules of John Picus Earl of Mirandula, Partly Exciting, Partly Directing a Man in Spiritual Battle*; he also translated the *Duodecim arma spiritualis pugnae* as *The Twelve Weapons of Spiritual Battle, Which Every Man Should Have at Hand when the Pleasure of a Sinful Temptation Cometh to Mind*; and the *Duodecim conditiones amantis* as *The Twelve Properties or Conditions of a Lover*. Richard Whitford (1495–1555?), an Augustinian, added them to his influential translation, dated 1530, of the *Imitatio Christi* by Thomas à Kempis (*c*.1380–1471).

Joubert's: *Recueil des pensées de M. Joubert*, by Joseph Joubert (1754–1824), appeared posthumously in 1838. Matthew Arnold published an article on him in *Essays in Criticism* (1864).

26 *'bind the ages each to each by natural piety'*: Pater paraphrases the final lines of Wordsworth's poem 'My Heart Leaps Up When I Behold' (1807): 'And I could wish my days to be | Bound each to each by natural piety.'

'Heptaplus, or Discourse on the Seven Days of the Creation': this is the *Heptaplus de septiformi sex dierum Geneseos enarratione* (1489), which Pico composed in the villa in Fiesole that Lorenzo de' Medici had lent him.

the 'Timaeus' of Plato: a Socratic dialogue by Plato, written in approximately 360 BCE.

27 *the Maremma*: this is the area of marshland on the western coast of Italy, at the centre of which is Grosseto.

the Doni Madonna in the Tribune of the Uffizii: a circular painting (or *tondo*) of the Holy Family by Michelangelo, probably commissioned by the cloth merchant Agnolo Doni and executed some time between 1506 and 1508; it is preserved in the Uffizi Gallery in Florence, in a frame thought to have been designed by Michelangelo.

28 *caesiis et vigilibus oculis*: 'his eyes bluish grey and watchful.'

decenti rubore interspersa: 'intermixed with respectable reds.'

SANDRO BOTTICELLI

This chapter first appeared as 'A Fragment on Sandro Botticelli' in the *Fortnightly Review* of August 1870. It was not substantially revised thereafter.

29 *the legend of Lippo and Lucrezia*: Vasari reports that Fra Filippo Lippi (*c*.1406–69), the Florentine painter, abducted Lucrezia Buti (b. 1435) from the convent in which she was a nun:

Then, the nuns of Santa Margherita gave him the project of painting
the panel from the main altar, and one day while he was at work on it,
he caught sight of the younger daughter of Francesco Buti, a Florentine
citizen, who was living there either as a ward or as a nun. Once Fra
Filippo cast his eye on Lucrezia (for that was the girl's name), who
had the most beautiful grace and bearing, he was so persistent with
the nuns that they allowed him to paint her portrait in order to use it
in a figure of the Madonna for the work he was completing for them.
The opportunity caused him to fall even more deeply in love, and he
then made arrangements, using various means, to steal her away from
the convent.

See too Browning's poem 'Fra Lippo Lippi', published in *Men and
Women* (1855), which is also based on Vasari's chapter.

29 *Andrea del Castagno*: Vasari alleges, falsely, that Andrea del Castagno (1419/
21–57), another influential Florentine painter, murdered a contemporary
of whom he was desperately envious, the painter Domenico Veneziano
(who died, in fact, in approximately 1461):

One summer night, as he usually did, Domenico took his lute, and
left Santa Maria Novella, where Andrea was still drawing in his
room, having declined Domenico's invitation to go out for a stroll
on the pretext he had certain important drawings to complete. After
Domenico had gone out by himself to pursue his pleasures, Andrea
secretly went to wait for him around a corner, and when Domenico
was returning home and reached the spot, Andrea smashed both his
lute and his stomach in the same blow with some pieces of lead, and
still not feeling he had settled the matter as he would have liked, he
struck Domenico forcefully on the head with the same pieces of lead
and then, leaving him lying upon the ground, he went back to his room
in Santa Maria Novella and closed the door, returning to his drawing
just as he had done when Domenico left him.

30 *the illustrator of Dante*: Botticelli's extensive illustrations to the *Divine
Comedy*, meticulously drafted on parchment, were commissioned by
Lorenzo de' Medici and executed some time between 1480 and 1495.

those who 'go down quick into hell': see Canto XIX of Dante's *Inferno*,
where Simon Magus and his 'wretched followers' are plunged upside
down into holes in the rock:

From each of these mouths there stuck out in the air
The feet, and the legs up to the calves, of a sinner,
The rest remaining out of sight inside.

the Centaurs themselves . . . mignon forms, drawing tiny bows: see the *Inferno*,
Canto XII:

I saw a wide ditch bent like a bow,

Like that which held the whole plain in its embrace,
Just as my guide had indicated;

And between it and the foot of the bank, on a track,
Ran centaurs one behind the other, armed with arrows,
As they used, in the world, to go hunting.

The adjective 'mignon' refers to delicate or prettily petite forms.

31 *'La Città Divina'*: the Florentine humanist Matteo Palmieri (1406–75), a prominent civil servant and historian, wrote *La città di vita*, a three-volume poem in imitation of the *Divine Comedy*, composed in *terza rima*, in 1465 (though it remained unpublished at his death, and was thereafter condemned by the Church as heretical). Note that Pater erroneously transcribes its title as 'La Città Divina'. Note too that the painting that he ascribes to Botticelli, *The Assumption of the Virgin* (c.1475–6), is in fact by Francesco Botticini (c.1446–1497).

31 *Alexandrian philosophy*: a diverse Neoplatonist movement, centred on Alexandria, Egypt, in the first centuries of the common era, and associated in particular with Plotinus (204–70 CE); it was syncretistic in approach, and attempted to synthesize Platonic, Aristotelian, and various Eastern philosophies. Note that from the second edition of *The Renaissance* Pater altered the previous clause to read 'were neither for Jehovah nor for His enemies' in order not to upset Christian readers.

like that in which Giotto painted the portrait of Dante: the portrait of Dante to which Pater refers, in a fresco of Paradise in the Bargello in Florence, was probably painted at least partly by Giotto's pupils.

32 *Orcagna's 'Inferno'*: Andrea di Cione (c.1308–1368), called Orcagna, a Florentine painter, sculptor, and architect who partially rejected the example of Giotto, was influential in the late fourteenth century. Note however that the 'Inferno' to which Pater refers, at the Strozzi Chapel, where he painted the altarpiece, is not in fact by Orcagna, although it might be by one of his brothers, Nardo di Cione (active 1343/6), who was also influential at this time.

the Sistine Madonna: painted by Raffaello Sanzio (1483–1520), known as Raphael, one of the most important artists of the High Renaissance, in approximately 1513. Pater published a lecture on Raphael in the *Fortnightly Review* of October 1892; there he declares that, in Raphael, a 'synoptic intellectual power worked in perfect identity with the pictorial imagination and a magic hand'.

the 'Desire of all nations': see Haggai 2: 7: 'And I will shake all nations, and the desire of all nations shall come: and I will fill this house with glory, saith the LORD of hosts.'

33 *Once, indeed, he guides her hand . . . to hold the inkhorn and support the book*: Pater is describing the *Madonna of the Magnificat* (c.1481) in the Uffizi.

enfants du chœur: 'children of the choir.'

the faultless nude studies of Ingres: see for example *The Source* (1856) by
Jean-Auguste-Dominique Ingres (1780–1867), perhaps the most import-
ant French neoclassical painter of the nineteenth century, who lived in
Italy for much of his adult life and who was influenced above all by
Raphael. Pater is describing Botticelli's allegorical painting of the *Birth of
Venus* (*c*.1485).

34 *Judith . . . Justice . . . Veritas*: these refer to *The Return of Judith* (*c*.1469);
Fortitude (1470); and *The Calumny of Apelles* (1495).

LUCA DELLA ROBBIA

This chapter, which from the third edition of *The Renaissance* Pater dated
'1872', had not appeared in print before the publication of *Studies in the
History of the Renaissance*. Pater made relatively minor revisions to it after the
first edition.

38 *the Venus of Melos*: this famously beautiful ancient Greek sculpture,
thought to portray Aphrodite, was discovered on the island of Melos
in 1820, before being presented to the Louvre. Note that Oscar Wilde
(1854–1900) used the phrase 'little Melian farm' in his poem 'The Burden
of Itys' (1890): 'O for one midnight and as paramour | The Venus of the
little Melian farm!'

39 *the tomb of Conte Ugo . . . the tomb of the youthful Medea Colleoni*:
Count Hugo von Andersburg's tomb, designed by the Florentine
sculptor Mino di Giovanni (1429–84), known as Mino da Fiesole, was
completed in 1481; Medea Colleoni's tomb, by Giovanni Antonio
Amadeo (*c*.1447–1522), was completed in approximately 1475.

THE POETRY OF MICHELANGELO

This chapter, sent to Macmillan in June 1872, had been published in the
Fortnightly Review in November 1871. Pater added three of Michelangelo's
sonnets, translated by Symonds in the *Contemporary Review* of September
1872, when it first appeared in book form, though he left them out of subse-
quent editions.

41 *the blossoming of the aloe*: the aloe is a genus of plant, indigenous to Africa,
with 'erect spikes of flowers' (*OED*). Hill compares Pater's insistence on
the 'strangeness' of 'all true works of art' to Baudelaire's claim, in
'Exposition universelle 1855' (1855), that 'the beautiful is always bizarre'.
See also this sentence on the diaphanous state from Pater's 'Poems
by William Morris', subsequently republished as 'Aesthetic Poetry' in
the first edition of *Appreciations, with an Essay on Style* (1889): 'Here,
under this strange complex of conditions, as in some medicated air,
exotic flowers of sentiment expand, among people of a remote and
unaccustomed beauty, somnambulistic, frail, androgynous, the light
almost shining through them.'

ex forti dulcedo: see Judges 14: 14: 'And he said unto them, Out of the eater came forth meat, and out of the strong came sweetness.' Pater also uses the phrase in his essay on 'Raphael':

> It was as if he [Raphael] desired to add to the strength of Michelangelo that sweetness which at first sight seems to be wanting there. *Ex forti dulcedo*: and in the study of Michelangelo certainly it is enjoyable to detect, if we may, sweet savours amid the wonderful strength, the strangeness and potency of what he pours forth for us: with Raphael, conversely, something of a relief to find in the suavity of that so softly moving, tuneful existence, an assertion of strength.

the butterfly . . . in 'Les Misérables': see the description of the barricade of the Faubourg du Temple in Hugo's *Les Misérables* (1862), part 5, book 1, chapter 1: 'There were corpses here and there and pools of blood. I remember seeing a butterfly flutter up and down that street. Summer does not abdicate.'

those sea-birds . . . in 'Les Travailleurs de la Mer': see the description of Gilliatt in Hugo's *Les Travailleurs de la mer* (1866), part 2, book 2, chapter 4: 'The birds and Gilliatt were now good friends. Suffering poverty and hardship together, they helped one another.'

Grimm: *Leben Michelangelo's*, by Herman Grimm (1828–1901), appeared in two volumes from 1860 to 1863; it was translated into English as *The Life of Michelangelo* (1865) by Fanny Elizabeth Bunnett (1832/3–75).

42 *the Elgin marbles*: the Greek sculptures appropriated from the Parthenon and other buildings on the Acropolis by Thomas Bruce, Earl of Elgin (1766–1841), had been sold to the British government, which displayed them in the British Museum, in 1816.

the tomb of Julius, the tombs of the Medici: the tomb of Pope Julius II (1443–1513) is in San Pietro in Vincoli, Rome; the tombs of Giuliano and Lorenzo de' Medici are in San Lorenzo, Florence.

the legend of Leda: in Greek mythology, Zeus seduced Leda, the Queen of Sparta, in the form of a swan, and she conceived Helen and Polydeuces as a consequence. Michelangelo's painting of this myth, from 1530, is lost.

43 *master of live stone*: Hill cites Michelet's discussion of the medieval cathedrals in *L'Histoire de France*: 'The artist makes life spring out of [stone]. He was very well named in the middle ages: "The master of living stone," *Magister de vivis lapidibus*.'

'simple persons, who wore no gold on their garments': according to Vasari, Michelangelo insisted that they were 'simple' in the sense of being ascetic:

> Since the pope saw Michelangelo often, he used to say to him: 'Let the chapel be embellished with colours of gold, for it looks too plain.' And Michelangelo replied in a familiar tone: 'Holy Father, in those days men did not wear gold, and those who are painted there never were rich, for they were holy men who despised wealth.'

44 *that unique conception of Bacchus*: Pater also discussed this statue, the *Drunken Bacchus* (1496–7), in 'A Study of Dionysus: The Spiritual Form of Fire and Dew', published in the *Fortnightly Review* in December 1876 and subsequently collected in *Greek Studies: A Series of Essays* (1895). There, Pater writes:

> The artists of the Renaissance occupied themselves much with the person and the story of Dionysus; and Michelangelo, in a work still remaining in Florence, in which he essayed with success to produce a thing which should pass with the critics for a piece of ancient scuplture, has represented him in the fulness, as it seems, of this enthusiasm, an image of delighted, entire surrender to transporting dreams.

45 *Raffaelle says of him*: according to Hill, this anecdote, which Grimm repeats, originates in *Idea del tempio della pittura* (1590) by the painter Giovanni Paolo Lomazzo (1538–1600).

wilfully lived in sadness: see Canto VII of the *Inferno*:

> 'Stuck in the slime, they say: "We chose to be sad
> In the sweet air enlivened by the sun,
> And our hearts smouldered with a sullen smoke:
>
> Now we are sad instead in this black filth."'

Beneath the Platonic calm . . . a deep delight in carnal form and colour: as Hill points out, 'Pater was well aware that Michelangelo had addressed songs and sonnets of passionate love to Tommaso Cavalieri and to other young men.' Michelangelo met Cavalieri (*c.*1509–1587), a young Roman nobleman, in 1532.

par che amaro ogni mio dolce io senta: see Michelangelo's madrigal, 'Amor, la morte a forza': 'I seem to feel as bitter every sweet.' Hill points out that Pater quotes the spurious text rather than the autograph text.

46 *Michelangelo Buonarroti the younger*: Michelangelo Buonarrotti the Younger (1568–1646), a poet and playwright, was the editor of *Rime di Michelagnolo Buonarroti: Raccolte da Michelagnolo suo nipote* (1623), a drastically doctored text that replaced the poems' male pronouns with female pronouns in order to conceal his great-uncle's homosexuality.

Sa reputation . . . le lit guère: this is taken from 'Le Dante' (1765), in the *Dictionnaire philosophique*, by Voltaire, the pseudonym of François-Marie Arouet (1694–1778). From the third edition of *The Renaissance*, Pater substituted a translation of this quotation: 'His reputation will ever be on the increase, because he is so little read.'

A learned Italian, Signor Cesare Guasti . . . with dissertations and a paraphrase: in this edition, *Le rime di Michelangelo Buonarroti: Pittore, scultore e architetto* (1863), by the philologist Cesare Guasti (1822–89), Michelangelo's epigrams, madrigals, and sonnets were 'taken from his own manuscripts' (Guasti added a prose paraphrase of each of them). From the third edition of *The Renaissance*, Pater added this

footnote: 'The sonnets have been translated into English, with much skill, and poetic taste, by Mr. J. A. Symonds.' See *The Sonnets of Michael Angelo Buonarroti and Tommaso Camapanella* (1878); Symonds published *The Life of Michelangelo Buonarroti* in 1893.

47 *un dolce amaro, un si e no mi muovi*: 'a bitter sweet, a yes and no moves me.'

del suo prestino stato . . . il raggio ardente: 'the ardent light of the soul's former state.'

We know how Goethe . . . making a book about them: this refers to *Die Leiden des jungen Werthers* (1774), by Johann Wolfgang von Goethe (1749–1832).

'La vita . . . è senza core': 'What gives my love its life is not my heart, | The love by which I love you has no heart.'

48 *chalybeate salt*: salt flavoured with iron (from the Latin *chalybs*, meaning 'steel').

49 *il bel del fuor che agli occhi piace . . . trascenda nella forma universale*: 'the outward beauty which pleases the eyes . . . it goes beyond to universal form.'

la dove io t'amai prima: 'there where I first loved you.' Note once more that the footnote appended at this point, quoting the three sonnets taken from the translations by Symonds in the *Contemporary Review* of September 1872, is excised from the third and fourth editions of *The Renaissance*. In his article, Symonds observes that he does not intend to criticize Michelangelo's poetry, for 'that has recently been done by Mr. W. H. Pater, whose essay in a late number of the *Fortnightly Review* reveals the purest and most delicate sympathy with the poet's mind'. Instead, he offers his translations as a 'supplement' to Pater's piece. He pointed out the mistakes that Pater had made in transcribing these poems in a letter to Horatio Forbes Brown (1854–1926) from 1873: 'In the first sonnet, line 7 *our* should be *one*, and in the second sonnet line 7 *those* should be *these*. It would also be well to print *knight* in the last line of the second sonnet with a large *K*, since Michael Angelo designed a pun upon the young man's name.'

50 *ove gran desir gran copia affrena*: 'wherever an abundance of great desire is restrained.'

d'angelica forma: 'in the form of an angel.'

Some of those whom the gods love die young: in Canto IV of *Don Juan* (1819–24), George Gordon, Lord Byron (1788–1824), echoes the Greek historian Herodotus (*c*.480–*c*.425 BC): ' "Whom the gods love die young" was said of yore.'

51 *the Oratory*: the Oratory of Divine Love was a religious confraternity founded in about 1517 by Giovanni Pietro Caraffa (1476–1559) and Gaetano da Thiene (1480–1547). It sought reform of the Roman Catholic Church through an insistence on spiritual exercises, and sponsored movements (like that of the Theatines) that promised to stem the advance of Protestantism.

52 *Outre-tombe!*: 'Beyond the grave.' *Mémoires d'outre-tombe*, famously, is the title of a multi-volume autobiography by François-René de Chateaubriand (1768–1848), published posthumously in 1849 and 1850.

53 *The young Cardinal of Portugal . . . Rossellino carved his tomb in the church of San Miniato*: the young cardinal is Jacopo di Lusitania, nephew of King Alfonso of Portugal (1109–85), who died in Florence, aged 25, in 1459. Antonio Gamberelli (1427–*c*.1479), nicknamed Rossellino, a sculptor who had studied under Donatello, constructed this monument to him, at San Miniato al Monte, Florence, from 1461 to 1466. The tomb's epitaph reads: 'I was distinguished for my comeliness and wonderful modesty.' Luca della Robbia painted the ceiling of the chapel in which it was placed.

the Pazzi conspirators: the Pazzis and the Salviatis, families that were desperate to end the dominance of the Medicis in Florence, mounted a spectacular *coup d'état* in the Duomo on 26 April 1478. The conspirators succeeded in assassinating Giuliano de' Medici and wounding Lorenzo de' Medici, but most of them were subsequently apprehended and executed.

Danse Macabre: the *danse macabre*, which generally depicted Death leading peasants and aristocrats alike in a gruesome dance to the grave, was a popular allegorical form from the fourteenth century.

a drawing of his at Oxford: Pater is thinking of a black chalk *piéta* that Michelangelo made for Vittoria Colonna, but this drawing was not in fact part of the University of Oxford's collection. Hill wonders 'why, having made an error of which he must soon have become aware, he let it stand (though he made other revisions) in all four republications of the essay in his lifetime'.

LEONARDO DA VINCI

This essay was first published in the *Fortnightly Review* in November 1869, where it was entitled 'Notes on Leonardo da Vinci'. Subsequently, Pater made a number of relatively minor amendations. It should be noted that from the third edition of *The Renaissance* (as I pointed out in the annotations to p. 23 above) Pater inserted an epigraph taken from Francis Bacon at the beginning of this chapter: *Homo minister et interpres naturae* ('Man, the minister and interpreter of nature').

56 *In Vasari's life . . . some variations from the first edition*: in the second, enlarged edition of his *Lives*, published in 1568, Vasari implicitly christianized Leonardo; he omitted this sentence, for instance, as Hill indicates: 'His cast of mind was so heretical that he did not adhere to any religion, deeming perhaps that it was better to be a philosopher than a Christian.'

as to Michelet and others to have anticipated modern ideas: in his *Histoire de France*, as Hill notes, Michelet embodies 'the great Italian, the complete man, balanced, all-powerful in all things, who summed up the whole past and anticipated the future; who, above and beyond the universality of the Florentine, had that of the North, uniting the chemical and mechanical arts to those of design'.

M. Arsène Houssaye: Arsène Houssaye (1815–96), the novelist and poet, published his *Histoire de Léonard de Vinci* in 1869. This reference to Houssaye, like a number of others, was removed from subsequent editions—perhaps because, in her review of *Studies in the History of the Renaissance* in the *Westminster Review*, Mrs Mark Pattison had declared that 'M. Houssaye's book is a mere romance of no scientific pretensions whatever'.

57 *Passavant . . . for Raffaelle*: see *Raffael von Urbino und sein Vater Giovanni Santi*, by the artist and curator Johann David Passavant (1787–1861), published in three volumes from 1839 to 1858.

58 *the 'Modesty and Vanity'*: this painting is in fact by Bernardino Luini (*c.*1481/2–1532), a Milanese painter popular because he successfully vulgarized Leonardo's style. Note that, in her discussion of Leonardo in *Memoirs of the Early Italian Painters* (1845), Anna Jameson (1794–1860) had concluded thus: 'We have mentioned a few of the genuine works of Lionardo da Vinci; they are exceedingly rare. It appears certain that not one-third of the pictures attributed to him and bearing his name were the production of his own hand.'

the 'Virgin of the Balances': this painting remains unattributed; in 'The Myth of Demeter and Persephone', printed in the *Fortnightly Review* in February 1876, Pater described it as 'a work by one of his [i.e. Leonardo's] scholars'.

59 *Nature was 'the true mistress of higher intelligences'*: this sentence, from Leonardo's manuscripts, was translated by the physicist Giovanni Batista Venturi (1746–1822) in his *Essai sur les ouvrages physico-mathématiques de Léonard de Vinci* (1797), and then reproduced in a number of nineteenth-century publications that discussed Leonardo.

natural magic: pre-Baconian science.

60 *the 'Medusa' of the Uffizii*: in his edition of *The Renaissance*, Kenneth Clark notes that 'the *Medusa* is a seventeenth century picture showing the influence of Carravaggio; but it may be based on a lost original by Leonardo'. In *Marius the Epicurean*, Pater refers at the end of chapter 21 to 'the malignant beauty of pagan Medusa'.

Vasari's story of an earlier Medusa: see *The Lives of the Artists*:

> One day when Leonardo picked up the shield and saw that it was crooked, badly worked, and crude, he straightened it over the fire and gave it—as rough and crude as it was—to a turner who

made it smoother and even. And after he had covered it with gesso and prepared it in his own manner, he began to think about what he could paint on it that would terrify anyone who encountered it and produce the same effect as the head of the Medusa. Thus, for this purpose, Leonardo carried into a room of his own, which no one but he himself entered, crawling reptiles, green lizards, crickets, snakes, butterflies, locusts, bats, and other strange species of this kind, and by adapting various parts of this multitude, he created a most horrible and frightening monster with poisonous breath that set the air on fire. And he depicted the monster emerging from a dark and broken rock, spewing forth poison from its open mouth, fire from its eyes, and smoke from its nostrils so strangely that it seemed a monstrous and dreadful thing indeed.

60 *the beautiful verses of Shelley*: see 'On the Medusa of Leonardo da Vinci in the Florentine Gallery', by Percy Bysshe Shelley (1792–1822), composed in 1819 and first published in Mary Shelley's edition of his *Posthumous Poems* (1824):

> It lieth, gazing on the midnight sky,
> Upon the cloudy mountain-peak supine;
> Below, far lands are seen tremblingly;
> Its horror and its beauty are divine.
> Upon its lips and eyelids seems to lie
> Loveliness like a shadow, from which shine,
> Fiery and lurid, struggling underneath,
> The agonies of anguish and of death.
>
> Yet it is less the horror than the grace
> Which turns the gazer's spirit into stone,
> Whereon the lineaments of that dead face
> Are graven, till the characters be grown
> Into itself, and thought no more can trace;
> 'Tis the melodious hue of beauty thrown
> Athwart the darkness and the glare of pain,
> Which humanize and harmonize the strain.
>
> And from its head as from one body grow,
> As [] grass out of a watery rock,
> Hairs which are vipers, and they curl and flow
> And their long tangles in each other lock,
> And with unending involutions show
> Their mailèd radiance, as it were to mock
> The torture and the death within, and saw
> The solid air with many a raggèd jaw.
>
> And from a stone beside, a poisonous eft
> Peeps idly into those Gorgonian eyes;
> Whilst in the air a ghastly bat, bereft

Of sense, has flitted with a mad surprise
Out of the cave this hideous light had cleft,
 And he comes hastening like a moth that hies
After a taper; and the midnight sky
Flares, a light more dread than obscurity.

'Tis the tempestuous loveliness of terror;
 For from the serpents gleams a brazen glare
Kindled by that inextricable error,
 Which makes a thrilling vapour of the air
Become a [] and ever-shifting mirror
 Of all the beauty and the terror there—
A woman's countenance, with serpent-locks,
Gazing in death on Heaven from those wet rocks.

Raffaelle du Fresne: Pater is referring to the *Trattato della pittura di Leonardo da Vinci* (1651), edited by Räphael Trichet du Fresne (1611–61), and illustrated by Nicolas Poussin (1594–1665); it was first translated into English in 1721.

62 *Curiosity and the desire of beauty*: as Hill points out, this paragraph antici-pates Pater's argument in his article on 'Romanticism', printed in *Macmillan's Magazine* in November 1876: 'It is the addition of strange-ness to beauty that constitutes the romantic character in art; and the desire of beauty being a fixed element in every artistic organization, it is the addition of curiosity to this desire of beauty that constitutes the romantic temper.'

that subtilitas naturæ which Bacon notices: see the tenth aphorism of book 1 of Bacon's *Novum organum* (1620): 'Subtilitas naturae subtilitatem sensus et intellectus multis partibus superat' ('The subtlety of nature is many times greater than the subtlety of the senses and understanding').

Clement . . . Rio: see Charles Clément, *Michel-Ange, Léonard de Vinci, Raphael* (1861); and Alexis-François Rio, *De l'art chrétien* (1861–7). Pater borrowed these volumes from the Taylor Instition, Oxford, in 1869.

63 *Ludovico's mistresses . . . the Duchess Beatrice*: the identities of the sitters of all four of the portraits referred to in this paragraph are doubtful; and none of the paintings can confidently be attributed to Leonardo.

64 *thought itself weary*: this is taken from Goethe's essay 'Antik und Modern' (1818).

Elective Affinities and the first part of 'Faust': Goethe's novel *Elective Affinities* appeared in 1809; the first part of his drama *Faust* appeared in 1808, the second part in 1832.

bien-être: 'well-being.'

Quanto più . . . tanto più è vile!: 'the more physical effort an art entails, the more contemptible it is!'

65 *Let us take some of these drawings*: as Clark notes in his edition, 'unfortunately none of the drawings mentioned in the next two paragraphs is by Leonardo himself.'

Daughters of Herodias: Salome, the daughter of Herodias, danced for Herod, her stepfather, on his birthday, and in exchange he promised to give her anything she asked for; she demanded the head of John the Baptist, on her mother's advice, and Herod reluctantly executed him.

66 *Salaino*: from the second edition, Pater refers to 'Andrea Salaino', although Clark points out in his edition of *The Renaissance* that 'there was no such painter as Andrea Salaino'. Pater is no doubt referring to Gian Giacomo Caprotti da Oreno (1480–1524), nicknamed 'Il Salaino' ('little devil'), a painter apprenticed to Leonardo (who appears to have adored him in spite of his satanic reputation) in 1490.

67 *the so-called Saint John the Baptist of the Louvre*: this painting, a 'Bacchus' based on a drawing by Leonardo, is by one of his followers, possibly Francesco Melzi.

which set Gautier thinking of Heine's notion of decayed gods: Pater is referring to 'Léonard da Vinci', by the French critic, poet, and novelist Théophile Gautier (1811–72), in Théophile Gautier, Arsène Houssaye, and Paul de Saint-Victor, *Les Dieux et les demi-dieux de la peinture* (1864). On Heine's 'notion of decayed gods' see the note to p. 18.

Goethe's pensive sketch: see 'Giuseppe Bossi: Über Leonardo da Vincis Abendmahl zu Mailand', written in 1817.

68 *one drawing of the central head at the Brera*: this drawing, in the Brera Museum in Milan, is thought to be a copy by one of Leonardo's followers.

the French entered Milan: French soldiers entered Milan in October 1499, when Louis XII, supported by the Milanese themselves, at least initially, claimed the city. The massive wax model of the horse on which Leonardo intended to monumentalize Lodovico's father Francesco was effectively destroyed by the French archers.

M. Arsène Houssaye comes to save the credit of his countrymen: this footnote only appeared in the first and second editions.

69 *Cimabue's triumph*: Cenni di Pepo (Giovanni) Cimabue (*c*.1240–1302?), an influential mosaicist and painter, was Giotto's teacher. Vasari falsely attributed the Madonna in the Rucellai Chapel to him, and reported that, because it approached 'the lines and style of modern times', 'this work so astonished the people of the day . . . that they carried it with great rejoicing and with the sounding of trumpets from Cimabue's home to the church in a solemn procession'. In the fourth edition of *The Renaissance*, Pater altered 'Cimabue's triumph' to 'the "triumph" of Cimabue'.

Ginevra di Benci: Leonardo's portrait of Ginevra di Amerigo de' Benci (1457–1521), a Florentine aristocrat of considerable intellectual attainment, was probably painted in (or shortly after) 1474, the year in which she married Luigi Niccolini.

the Melancholia of Dürer: Dürer's 'Melencolia' is an allegorical engraving on copper produced in 1514.

70 *'the ends of the world are come'*: see 1 Corinthians 10: 11: 'Now all these things happened unto them for ensamples: and they are written for our admonition, upon whom the ends of the world are come.'

71 *the embodiment of the old fancy, the symbol of the modern idea*: Hill helpfully glosses this sentence thus: 'The "old fancy" of the transmigration and reincarnation of souls and of reminiscence of the experience of former lives; the "modern idea" of evolution.'

the battle of Anghiari: this battle was fought in Tuscany between Milanese and Florentine forces on 29 June 1440.

a fragment of Rubens: this refers to *The Battle of the Standard* (1603) by the Flemish painter Peter Paul Rubens (1577–1640), the most important exponent of the Baroque in northern Europe, who travelled in Italy between 1604 and 1608; it is thought to have been copied from a copy of Leonardo's lost cartoon. Note that shortly before his death Pater started to prepare a lecture on Rubens.

72 *to 'fly before the storm'*: the phrase 'Flee from storms' was inscribed on the top of one of Leonardo's manuscripts.

the anti-Gallican society at Rome: in the article that had appeared in the *Fortnightly Review*, Pater referred to 'the anti-Gallican, Medicean society at Rome'; and from the second edition, he wrote that Leonardo was suspected of French sympathies 'in the political society of Rome'; so it is apparent that he intended to evoke the anti-Gallic atmosphere in Rome in general, rather than some specific organization (such as the Anti-Gallican Society, subsequently founded in England in about 1745).

JOACHIM DU BELLAY

This chapter, dated '1872' from the third edition of *The Renaissance*, had not appeared before its publication in book form. Pater made minor amendations and corrections to it in subsequent editions.

73 *Maître Roux and the masters of the school of Fontainebleau*: Giovanni Battista di Jacopo (1494–1540), variously known as Rosso Fiorentino, Il Rosso, and Maître Roux, was an Italian painter of the Mannerist school appointed to the court of Francis I from 1530. The First School of Fontainebleau, comprising Francesco Primaticcio (1504/5–70) and Niccolò dell' Abbate (c.1512–1571), in addition to Rosso himself, is the name ascribed to the decoration, influenced by Mannerism, that was commissioned by Francis I for the Royal Palace of Fontainebleau and executed from 1530 to approximately 1560.

Saint Martin's summer: before the term 'Indian summer' (an Americanism) became colloquial, this phrase referred to the temperate, balmy autumn that, in northern Europe, sometimes preceded St Martin's Day (11 November).

73 *the house of Jacques Cœur at Bourges or the 'Maison de Justice' at Rouen*:
Jacques Cœur (1395–1456), the most successful French merchant of his
time, at least until the campaign against him that commenced in 1451, built
'la Grant'Maison' in Bourges from 1443 to 1450. The Palais de Justice in
Rouen was built by Roulland le Roux (c.1479–1527) in 1508 and 1509.

une netteté remarquable d'exécution: 'a remarkable neatness of execution.'

74 *of Villon's poetry, and of the 'Hours of Anne of Brittany'*: François Villon
(1431–after 1463), some of whose poems were translated by Rossetti and
Swinburne, among others, was the most important French lyric poet of
the medieval period. Anne of Brittany (1477–1514), who was married to
both Charles VII (1491–8) and Louis XII (1499–1514), commissioned a
'Book of Hours', illuminated by Jean Bourdichon (1457–1521), in approxi-
mately 1508.

chansons de geste: un chanson de geste (literally, 'a song of deeds'), popular
from the eleventh to the fourteenth centuries, was an epic poem, in Old
French, which narrated the heroic adventures of Carolingian aristocrats.

Archbishop Turpin in the song of Roland: La Chanson de Roland, which
probably dates from at least the second half of the eleventh century, is the
most famous example of the *chanson de geste*. In the passage to which Pater
refers, Roland arranges the dead body of the Archbishop of Rheims. See
for instance the translation by C. K. Scott Moncrieff (1889–1930), first
published in 1919:

> The count Rollant sees the Archbishop lie dead,
> Sees the bowels out of his body shed,
> And sees the brains that surge from his forehead;
> Between his two arm-pits, upon his breast,
> Crossways he folds those hands so white and fair.

Hill notes that Pater had recently read a reference to this scene in the
manuscript of an article for the *Westminster Review* by his friend Andrew
Lang (1844–1912).

mere Gothic strength or heaviness: from the third edition, Pater added a
footnote at this point: 'The purely artistic aspects of this subject have
been interpreted, in a work of great taste and learning, by Mrs. Mark
Pattison.—*The Renaissance of Art in France*.'

75 *Pindaric ode*: an ode, composed for a public occasion, in the tradition of
Pindar (522–442 BCE).

'Avril, la grace . . . Du printemps les messageres': these are the sixth and
seventh stanzas of 'Avril', from *La Bergerie* (1565), by Remy Belleau
(1528–77). Hill reproduces Lang's translation:

> April, with thy gracious wiles,
> Like the smiles,
> Smiles of Venus; and thy breath
> Like her breath, the Gods' delight,

(From their height
They take the happy air beneath;)

It is thou that, of thy grace
From their place
In the far-off isles dost bring
Swallows over earth and sea,
Glad to be
Messengers of thee, and Spring.

Remy Belleau . . . Joachim du Bellay: Ronsard and the six poets listed by Pater collectively formed La Pléiade, named in 1556 after the Pleiades, a scattering of hundreds of stars in the constellation Taurus, only seven of which can be seen by the naked eye. (In the third century BCE, Alexandrian critics had ascribed this name to a group of seven prominent poets.) Influenced by classical and neoclassical literature, La Pléiade promoted French as a medium of poetic expression that might inherit this tradition. As Pater goes on to explain, du Bellay effectively provided its manifesto in his *Deffence et illustration de la langue françoyse* (1549).

76 *La prose . . . sur notre poésie*: from the third edition of *The Renaissance*, Pater replaced this sentence (which misprints 'en' for 'eu') with a translation: '"It is a remarkable fact," says M. Sainte-Beuve, "and an inversion of what is true of other languages, that, in French, prose has always had the precedence over poetry."' It is taken from Sainte-Beuve's essay 'Anciens poètes français: Joachim du Bellay' (1840).

77 *the Æneid*: du Bellay's translation of the fourth book of the *Aeneid*, the epic poem by Virgil (70–19 BCE), appeared in 1552.

nous favorisons toujours les étrangers: from the third edition, Pater provided a translation of this line: 'strangers are ever favourites with us.'

cette dernière main que nous désirons: from the third edition, Pater provided a translation of this line: 'that last, so desirable, touch.'

péris et mises en reliquaires de livres: from the third edition, Pater provided a translation: 'shut up in books as in reliquaries.'

poor plante et vergette: from the third edition, this sentence reads: 'this starveling stock—*pauvre plante et vergette . . .*'

le discours fatal des choses mondaines: from the third edition, Pater provided a translation: 'that discourse about affairs which decides men's fates.'

parfait en toute élégance et venuste de paroles: from the third edition, Pater translated this as 'perfect in all elegance and beauty of words'.

78 *ce petit Lyrè*: this echoes the phrase 'mon petit Lyré', a reference to du Bellay's birthplace, in the thirty-first sonnet of the sequence of sonnets entitled *Les Regrets* (1558).

79 *the Romanticists*: a generation of French writers dominant in the second quarter of the nineteenth century, including Victor Hugo, Alphonse de Lamartine (1790–1869), and Alfred de Musset (1810–57), who

resolutely rejected classicism and revived the reputations of Ronsard and his associates.

79 *rococo*: perhaps both 'old-fashioned, antiquated' (*OED* sense 1) and, as in the decorative style characteristic of both Louis XIV (1638–1715) and Louis XV (1710–74), 'excessively or tastelessly florid or ornate' (*OED* sense 2a). In a retrospective comment made in the 1890s Pater reportedly said that he had recently come to admire certain art forms that hitherto he had not admired, 'especially in the case of some forms of rococo'.

80 *la petite pucelle Angevine*: this reference to 'the little maid of Anjou' echoes a line from 'Le Second Livre des Amours' (1578). In *Gaston de Latour*, published in *Macmillan's Magazine* in five parts in 1888, Pater alludes to Ronsard's 'Angevine maiden—*La petite pucelle Angevine*—who had vexed his young soul by her inability to yield him more than a faint Platonic affection'.

the restoration of the i voyelle en sa première liberté: from the third edition, this reads: 'the restoration of the letter *i* to its primitive liberty—*del' i voyelle en sa première liberté*.'

Goudimel: Claude Goudimel (*c*.1514–1572) was a French composer chiefly famous for his settings of the Psalms, though he also composed chansons. In *Gaston de Latour*, Gaston hears a setting of Goudimel's when he visits Ronsard: 'And then, in nasal voice, well-trained to Latin intonation, giving a quite mediaeval amplitude to the poet's sonorities of rhythm and vocabulary, the Sub-prior was bidden to sing, after the notation of Goudimel, the "Elegy of the Rose": the author girding cheerily at the clerkly man's assumed ignorance of such compositions.'

That 'lord of terrible aspect'. . . the petit enfant Amour: the 'lord of terrible aspect' is taken from the third section of Dante Gabriel Rossetti's translation of Dante's *Vita nuova* (see note to p. 15); Ronsard refers to the 'petit enfant Amour' in *Le Quatriesme Livre des odes*.

ondelette, fondelette, doucelette, Cassandrette: these diminutives are taken from Ronsard; Hill notes that ' "Cassandre" is Ronsard's name for his mistress in the "Amours" and "la Cassandrette" the name he confers in her honor on "la gantelée", one of the campanula or bell-flowers.'

81 *le beau sejour du commun jour*: from the third edition, Pater translated this as 'this fair abode of our common daylight'.

82 *'D'amour, de grace . . . Son nom des Dieux prist l'immortalité'*: this sonnet is the second in du Bellay's sequence of Petrarchan sonnets entitled *L'Olive* (1549). Adam Phillips offered this 'rough prose translation' in the 'Explanatory Notes' to his edition of *The Renaissance*:

> With love, with grace, and with high valour were the divine fires surrounded; and the heavens clothed themselves in a precious mantle of burning rays of various colours; everything was filled with beauty, with happiness, the sea tranquil and the wind filled with grace when she was born in these lowly places, she who has plundered the

world of all honour. She took her colour from the blanching lily, her head-dress from gold, her two lips from the rose, and from the sun her eyes blazing with light: the sky showering her with his wealth left, enclosed in her soul, his seeds, and her name took immortality from the gods.

In an article on 'English Indifference to du Bellay's "Regrets"' (1951), W. D. Elcock commented that 'reading and re-reading, rubbing one's eyes, one cannot refrain from wondering whether a paragraph of Pater has not somewhere slipped out'; and added that 'it is most difficult to associate this, the second sonnet of the *Olive*, with the characteristics of which it is alleged to be "a perfectly crystallized specimen"'.

the 'Antiquités de Rome' and the 'Regrets': the *Antiquités de Rome* (1558), a sonnet sequence translated as *The Ruins of Rome* (1591) by Edmund Spenser (*c*.1552–1599); and *Regrets* (1558), another sonnet sequence mostly composed in Rome.

82 *poésie intime*: this concept appears in a biographical notice about du Bellay included in an edition of the poet's *Œuvres françoises* published from 1866 to 1867 by Charles Marty-Laveaux (1823–99). Sainte-Beuve reviewed the first volume of this edition in the *Journal des savants* in August 1867.

83 *Montaigne's Essays*: the *Essais* of Michel Eyquem de Montaigne (1533–92) appeared from 1580. In *Plato and Platonism*, Pater describes Montaigne as the 'representative essayist because the representative doubter, inventor of the name as, in essence, of the thing'. Note too that, in his essay 'The Character of the Humourist: Charles Lamb', published in the *Fortnightly Review* in October 1878, Pater compares Lamb to Montaigne, and emphasizes that, for both of them, 'the desire of self-portraiture is, below all more superficial tendencies, the real motive in writing at all—a desire closely connected with that intimacy, that modern subjectivity, which may be called the *Montaignesque* element in literature'.

le grand tout: from the third edition, Pater translates this as 'the great whole'.

84 *as Gray's on the 'Elegy in a Country Churchyard'*: Thomas Gray (1716–71) published his *Elegy Written in a Country Church-Yard* in 1751.

Ronsard's . . . one famous ode: the so-called *Ode à Cassandre*, originally published in the 1553 edition of *Les Amours* and then included in his *Odes* of 1555.

À vous trouppe legère . . . À la chaleur du jour: Lang translated this song, 'From a Winnower of Corn to the Winds', taken from du Bellay's *Divers Jeux rustiques* (1558), as follows (note that 'œlliets' should read 'œillets'):

> To you, troop so fleet.
> That with winged wandering feet,
> Through the wide world pass,
> And with soft murmuring
> Toss the green shades of spring

In woods and grass,
Lily and violet
I give, and blossoms wet,
Roses and dew;
This branch of blushing roses,
Whose fresh bud uncloses,
Wind-flowers too.
Ah, winnow with sweet breath,
Winnow the holt and heath,
Round this retreat;
Where all the golden morn
We fan the gold o' the corn,
In the sun's heat.

WINCKELMANN

This chapter first appeared in the *Westminster Review* of January 1867, where it purported at least to be a review of both G. H. Lodge's translation of Winckelmann's *The History of Ancient Arts among the Greeks* (1850) and Otto Jahn's *Biographische Aufsätze* (1866). Pater made relatively substantial revisions to this chapter when it was republished; as Hill has explained, most of these were attempts to improve the style of the piece, but some of them were 'milder restatements' or excisions of 'remarks that might be considered disparaging to the Roman Catholic church or to Christianity itself'. Note that from the third edition Pater incorporated an epigraph to this chapter: '*Et ego in Arcadia fui*' ('I too have been in Arcadia'). 'Et in Arcadia Ego', which served as the title of both versions of a pastoral painting by Poussin, is generally understood to denote the presence of death in even the most perfect places (in Virgil's *Eclogues*, Arcadia is the idyllic homeland of the god Pan).

86 *Goethe's fragments . . . on the character of Winckelmann*: Goethe's 'Winckelmann' was originally published as his contribution to a co-authored book called *Winckelmann und sein Jahrhundert* (1805).

Hegel, in his Lectures on the Philosophy of Art: Georg Wilhelm Friedrich Hegel (1770–1831) delivered his lectures on aesthetics in Berlin in the 1820s. Pater translates selectively from the introduction to the second edition of Hegel's *Aesthetik* (1842).

famulus: 'an attendant; *esp.* on a scholar or magician' (*OED*).

87 *'vowelled' Greek*: this echoes lines from 'Lamia' (1820) by John Keats (1795–1821): 'Soft went the music the soft air along, | While fluent Greek a vowelled undersong | Kept up among the guests . . .'

'Il se sentit . . . l'amour de la patrie': from the third edition of *The Renaissance*, Pater translated these sentences, taken from *De l'Allemagne* (1810) by Madame de Staël (1766–1817): ' "He felt in himself," says Madame de Staël, "an ardent attraction towards the south. In German imaginations even now traces are often to be found of that love of the sun, that weariness of the north (*cette fatigue du nord*) which carried the

northern peoples away into the countries of the south. A fine sky brings to birth sentiments not unlike the love of one's Fatherland." '

a house not made with hands: see 2 Corinthians 5: 1: 'For we know that if our earthly house of *this* tabernacle were dissolved, we have a building of God, an house not made with hands, eternal in the heavens.'

'*Homo vagus et inconstans*': 'an aimless and inconstant man.'

Schiller: according to Hill, Pater is probably recalling the description, in 'Schiller' (1831), by Thomas Carlyle (1795–1881), of Schiller's unhappy experiences at school in Stuttgart.

88 '*Iphigenie*': Goethe's play *Iphigenia auf Tauris* (1787), which was based on a play of the same name by Euripides (485–406 BCE).

89 *the Lysis*: a short Socratic dialogue on friendship by Plato.

89 *Count Bünau*: Heinrich Graf von Bünau (1697–1762), a German historian and statesman, owned a library of some 42,000 books located at Nöthnitz, in which Winckelmann worked from 1748 to 1754. Note that it was in 1748, and not in 1784, that Winckelmann wrote to Bünau, although this error remained uncorrected in all the editions of *The Renaissance* published in Pater's lifetime.

90 *this life of the senses and the understanding*: as Hill points out, in 'Pagan and Mediaeval Religious Sentiment', published in the *Cornhill Magazine* in April 1864, Arnold had described the Renaissance, in its paganism, as 'a return towards the life of the senses and the understanding'.

Hermione melts from her stony posture: see *The Winter's Tale*, v. iii., 99–103:

> 'Tis time: descend; be stone no more; approach;
> Strike all that look upon with marvel. Come,
> I'll fill your grave up. Stir; nay, come away.
> Bequeath to death your numbness, for from him
> Dear life redeems you. You perceive she stirs.
> *Hermione descends.*

Lessing, in the Laocoon: Lessing's *Laokoon oder über die Grenzen der Malerei und Poesie* (1766) was in part prompted by Winckelmann's assessment of the ancient sculpture known as the Laocoön in *Gedanken über die Nachahmung der griechischen Werke in der Malerei und Bildhauerkunst* (1755).

the tumultuous richness of Goethe's culture: in 'Diaphaneitè' (1864), Pater refers to 'the tumultuary richness of Goethe's nature'.

91 *He speaks of the doubtful charm . . . Andeutung von Fäulniss*: Pater removed this sentence from subsequent editions of *The Renaissance*. The expression in German can be roughly translated as 'meat with a little touch of rottenness'.

92 ὀψιμαθείς: this signifies someone who is wise or knowledgeable only belatedly. Hill points out that 'nowhere in all his writings does Winckelmann

cry out in French', and that these sentences are taken from a letter, in German, to Johann Hermann Riedesel (1740–85), in which he reluctantly declined his young friend's suggestion that they travel to Sicily and Greece together.

93 *'On exécute mal ce qu'on n'a pas conçu soi-même'*: from the third edition, Pater translated this as: 'One is always a poor executant of conceptions not one's own.' Marie-Anne Charlotte Corday d'Armont (1768–93), who murdered Jean-Paul Marat (1743–93), and who was subsequently executed by the French revolutionary tribunal, had been asked who advised her.

the 'Phædrus': this is one of Plato's major dialogues from his middle period. Pater discussed 'enthusiasm' in the seventh chapter of *Plato and Platonism*:

> He is in truth, in the power, in the hands, of another, of another will—this lover of the Ideas—attracted, corrected, guided, rewarded, satiated, in a long discipline, that 'ascent of the soul into the intelligible world,' of which the ways of earthly love (τα ἐρωτικά) are a true parallel. His enthusiasm of knowledge is literally an *enthusiasm*: has about it that character of possession of one person by another, by which those 'animistic' old Greeks explained natural madness. That philosophic enthusiasm, that impassioned desire for true knowledge, is a kind of madness (μανία) the madness to which some have declared great wit, all great gifts, to be always allied—the fourth species of mania, as Plato himself explains in the *Phaedrus*. To natural madness, to poetry and the other gifts allied to it, to prophecy like that of the Delphic pythoness, he has to add, fourthly, the 'enthusiasm of the ideas'.

94 *Guido's archangel*: a reference to *The Archangel Michael* (*c*.1635), an altarpiece in Santa Maria della Concezione dei Cappuccini, Rome, painted by Guido Reni (1575–1642).

the words of Pindar: taken from Pindar's Tenth Olympian Ode, the words that Pater cites in the succeeding sentence were used by Winckelmann as an epigraph: 'beautiful of form and showered with grace.'

95 *A German biographer . . . Columbus*: Hill thinks that the biographer to whom Pater refers is Otto Jahn (1813–69); he points out, however, that the comparison to Christopher Columbus (1451–1506) is in fact taken from one of Goethe's conversations with Eckermann, in which he stated that Winckelmann is 'like Columbus when he had not yet discovered the New World, but bore it in mind as a presentiment'.

M. Edgar Quinet: a reference to *Les Révolutions d'Italie* (1848) by the French republican historian Edgar Quinet (1803–75).

as if the mind of one . . . a certain power of anticipating its results: from the third edition, Pater explicated the phrase in Greek, which literally means 'seeking knowledge alongside love', as 'lover and philosopher at once in some phase of pre-existence'. This passage is adapted from

'Diaphaneitè': 'It is like the reminiscence of a forgotten culture that once adorned the mind; as if the mind of one φιλοσοφήσασ ποτε μέτ ἔρωτος, fallen into a new cycle, were beginning its spiritual progress over again, but with a certain power of anticipating its stages.'

they are . . . ein Leben selbst: from the third edition, Pater includes a translation: 'they are a life, a living thing, designed for those who are alive.'

96 *palæstra*: a colonnaded, rectangular court in which ancient Greeks were schooled in wrestling.

97 *one of the frescoes of the Vatican*: The Disputation concerning the Blessed Sacrament (1509–10), painted by Raphael for the Stanza della Segnatura in the Apostolic Palace of the Vatican.

97 *The companion fresco*: The Parnassus (1510–11), painted by Raphael for the same Stanza.

a river making glad this other city of God: see Psalm 46: 4: '*There is* a river, the streams whereof shall make glad the city of God, the holy *place* of the tabernacles of the most High.'

98 *Scyles in the beautiful story of Herodotus*: Herodotus narrates the exploits of the Scythian king Scyles, the half-Greek son of Ariapithes, in the fourth book of *The Histories*. There he records that 'Scyles ruled over the Scythians, but he was not happy with the Scythian way of life; as a result of his upbringing, he was far more inclined towards things Greek'. According to Herodotus, whenever the opportunity presented itself he secretly dressed in Greek clothes and performed Bacchic rites.

the Olympian Zeus and the Athena Polias: a reference to Phidias's chryselephantine statues of Zeus and Athena, built in the mid-fifth century, in Olympia and Athens respectively.

'the classical polytheism . . . in a civilised age': from *An Essay on the Development of Christian Doctrine* (1845) by John Henry Newman (1801–90), who joined the Church of Rome in the year that it was published.

99 *He makes wilful Gods in his own image*: see Genesis 1: 27: 'So God created man in his *own* image, in the image of God created he him; male and female created he them.'

'rise up with wings as eagles': see Isaiah 40: 31: 'But they that wait upon the LORD shall renew *their* strength; they shall mount up with wings as eagles; they shall run, and not be weary; *and* they shall walk, and not faint.'

100 πτεροῦ δύναμις: in subsequent editions, Pater translated this phrase, from Plato's *Phaedrus*, as 'the power of the wing'.

101 *'sad mechanic exercise'*: from the fifth section of *In Memoriam* (1850), by Alfred Tennyson (1809–92):

> But, for the unquiet heart and brain,
> A use in measured language lies;

The sad mechanic exercise,
Like dull narcotics, numbing pain.

101 *addolorata*: this refers to Our Lady of Sorrows. In the second version of his essay on 'The Myth of Demeter and Persephone' (1895), Pater wrote that Demeter is 'our Lady of Sorrows, the *mater dolorosa* of the ancient world'.

Chthonian divinities: gods of the underworld, from the Greek word meaning 'of the earth'.

das Einzige, das Unerwartete: this phrase, meaning 'the unique, the unexpected', was removed from the third and all subsequent editions.

that Delphic Pythia: Pythia was the generic name for the priestess who presided over the Oracle of Apollo at Delphi and there delivered prophecies.

More definite religious conceptions . . . the old religious vesture: much of this long paragraph was excised from the third edition.

For the thoughts . . . thoughts beyond itself: the first two sentences of this paragraph replaced a far longer passage in the *Westminster Review*:

> Under what conditions does Greek religion thus transform itself into an artistic ideal? 'Ideal' is one of those terms which through a pretended culture have become tarnished and edgeless. How great, then, is the charm when in Hegel's writings we find it attached to a fresh, clear-cut conception! With him the ideal is a *Versinnlichen* of the idea—the idea turned into an object of sense. By the idea, stripped of its technical phraseology, he means man's knowledge about himself and his relation to the world, in its most rectified and concentrated form. This, then, is what we have to ask about a work of art—Did it at the age in which it was produced express in terms of sense, did it present to the eye or ear, man's knowledge about himself and his relation to the world in its most rectified and concentrated form?

Angelico's 'Coronation of the Virgin': the fresco of the *Coronation* was painted in approximately 1441.

Hermann's Gottesdienstliche Alterthümer der Griechen: a reference to the second part of *Lehrbuch der griechischen Antiquitäten* (1858) by the German archaeologist and philologist Karl Friedrich Hermann (1804–55).

102 *tanquam lana alba . . . the figure in the Apocalypse*: see Revelation 1: 14: 'His head and *his* hairs *were* white like wool, as white as snow; and his eyes *were* as a flame of fire.'

the Venus of Melos: see the note to p. 38.

'lordship of the soul': see Swinburne's *Atalanta in Calydon* (1865), lines 1197–1200:

> For silence after grievous things is good,
> And reverence, and the fear that makes men whole,

> And shame, and righteous governance of blood,
> And lordship of the soul.

103 *Those 'Mothers' who in the second part of 'Faust'*: a reference to Goethe's *Faust*, part 2, I. vii; in particular, see this speech of Faust's:

> In your name, oh great Mothers, you whose throne
> Is boundlessness: eternally alone
> You dwell, and yet in company! Round the head
> Of each of you, life's forms float, live yet dead;
> What once has been, what once shone gloriously,
> Still stirs there, seeking evermore to be.
> Your mighty power divides it; day's bright tent
> Receives it, or the night's dark firmament.
> Some images are merged with life's sweet flow,
> And some the bold magician captures: so
> With prodigal confidence he satisfies
> Our wish, and brings wonders before our eyes.

103 *That delicate air, 'nimbly and sweetly recommending itself' to the senses*: see Shakespeare's *Macbeth*, I. vi. 1–3:

> This castle hath a pleasant seat; the air
> Nimbly and sweetly recommends itself
> Unto our gentle senses.

a certain Philip: Philip of Croton was a heroic athlete famed for being beautiful. In the fifth book of *The Histories*, Herodotus writes:

> This Phillipus was an olympic victor and the best-looking man of his day; and because of his good looks he received from the people of Egesta the unparalleled honour of a hero's shrine erected on his tomb, at which religious ceremonies are still held to win his favour.

an ancient song, ascribed to Simonides, or Epicharmus: this song is mentioned by Plato in *Gorgias*, though he does not ascribe it to an author. Simonides of Ceos (*c*.556–467 BCE) was a Greek lyric poet; Epicharmus of Kos, born in the mid-sixth century BCE, was a Greek comic dramatist and philosopher.

Demetrius Phalereus . . . χαριτοβλέφαρος: Demetrius Phalereus (*c*.350–280 BCE) was an Athenian statesman and Peripatetic philosopher (although, as Hill emphasizes, Winckelmann himself refers to the Athenian general Demetrius Polyorcetes (337–283 BCE)); the phrase in Greek signifies that he had the eyes of the Graces.

104 *ὄμνυμι . . . εἶναι*: from the third edition, Pater included a translation of this sentence, taken from the *Symposium* by Xenophon

(*c*.430–352 BCE): 'I take the gods to witness, I had rather have a fair body than a king's crown.'

104 *Francia's 'Golgotha'*: Franceso Raibolini (*c*.1450–1517/18), called Francia, was a goldsmith and painter from Bologna; his *Crucifixion*, originally in Bologna, was bought by the Louvre in 1864.

'Geschichte der Kunst des Alterthums': Winckelmann's *History of Ancient Art among the Greeks* (1764).

105 *a Memnon waiting for the day*: in Greek mythology, Memnon was the son of Tithonus and Eos. See the relevant passage from the first part of Hegel's *Aesthetics* (in T. M. Knox's translation):

> Especially remarkable are those colossal statues of Memnon which, resting in themselves, motionless, the arms glued to the body, the feet firmly fixed together, numb, stiff, and lifeless, are set up facing the sun in order to await its ray to touch them and give them soul and sound. Herodotus at least relates that statues of Memnon gave a sound automatically at sunrise.

Hegel, Aesthetik . . . Einleitung: a reference to the introduction to the second part of the *Aesthetics*: *Lectures on Fine Art*. Hegel's influence on Pater is perceptible throughout this section of the chapter on Winckelmann.

106 *Heiterkeit . . . Allgemeinheit*: these terms are taken from Hegel's *Aesthetics*.

107 *'Le Byron de nos Jours'*: 'Dîs Aliter Visum; or, Le Byron de Nos Jours', from Browning's *Dramatis Personae* (1864). Arthur Symons (1865–1945) cited these comments on Browning in his *Introduction to the Study of Browning* (1886), a copy of which he sent to Pater in the year of its publication.

109 *Apollo just after the slaughter of the Python*: according to the third Homeric Hymn, the hymn devoted to Apollo, Apollo killed a dragon in Pytho, took the name Pythias, and then built a temple. Hill points out that Winckelmann deeply admired the *Apollo Belvedere*, a Roman sculpture from the fourth century BCE, though based on a Greek original, which is housed in the Vatican Museums.

Venus with the apple of Paris already in her hand: in the Greek myth of the Judgement of Paris, alluded to in the *Iliad*, Paris elects to give the golden apple, inscribed 'to the fairest', to Aphrodite (as opposed to Athena or Hera), because she has offered him the love of Helen of Sparta (later, Helen of Troy).

The Laocoon: the celebrated scuplture of Laocoön and his sons attempting to escape the serpents that killed them. It was discovered in 1506, bought by Pope Julius II, and housed in the Vatican Museums. See also the note to p. 90.

the 'beautiful multitude': see Keats's *Endymion* (1818), book III, lines 818–21:

> Thus went that beautiful multitude, nor far,
> Ere from among some rocks of glittering spar,
> Just within ken, they saw descending thick
> Another multitude.

Panathenaic frieze: the panathenaic procession, an annual ritual in honour of Athene, depicted on the frieze of the Parthenon.

the Adorante of the museum of Berlin: the so-called 'Praying Boy', an ancient sculpture created in approximately 300 BCE and housed in the Altes Museum, Berlin, since 1830. In 'The Age of Athletic Prizemen: A Chapter in Greek Art', published in the *Contemporary Review* in 1893, Pater makes further reference to this sculpture: 'the *Adorante* of Berlin, Winckelmann's antique favourite, who with uplifted face and hands seems to be indeed in prayer, looks immaculate enough to be interceding for others.'

110 *Hermaphrodite of the British Museum . . . Hermaphrodite of the Louvre*: presumably the 'mystic terminal Hermaphrodite' is the second-century Parian marble of a hermaphrodite feeding a bird, acquired by the British Museum in 1805 (it was photographed by Roger Fenton (1819–69) in the mid-1850s). The *Sleeping Hermaphrodite* in the Louvre is a marble copy, also dating from the second century, of a Greek sculpture (it inspired Swinburne's poem 'Hermaphroditus', published in *Poems and Ballads* (1866)). From the third edition of *The Renaissance*, Pater's reference to these hermaphrodites is cut.

says Hegel: Pater's translation is from the second book of the *Aesthetik*.

his own nature . . . alien modern atmosphere: see 'Diaphaneitè': 'Such a character is like a relic from the classical age, laid open by accident to our alien modern atmosphere.'

111 *The beauty of the Greek statues . . . significance of its own*: these sentences are taken directly from 'Diaphaneitè'.

'the tyranny of the senses': Hill notes that this idea (if not the phrase itself) is to be found in both Schiller's *Briefe über die ästhetische Erziehung des Menschen* (1795) and Hegel's *Aesthetik*. In 'The English Renaissance of Art', a lecture delivered in New York in 1882, Wilde wrote that 'while art has been defined as an escape from the tyranny of the senses, it is an escape rather from the tyranny of the soul' (a formulation that reappeared in *Lady Windermere's Fan* (1892)).

Plato's false astronomer: see *The Republic*, book VII, as translated by Benjamin Jowett (1817–93):

> And now, Socrates, as you rebuked the vulgar manner in which I praised astronomy before, my praise shall be given in your own spirit.

For every one, as I think, must see that astronomy compels the soul to look upwards and leads us from this world to another.

Every one but myself, I said; to every one else this may be clear, but not to me.

And what then would you say?

I should rather say that those who elevate astronomy into philosophy appear to me to make us look downwards and not upwards.

What do you mean? he asked.

You, I replied, have in your mind a truly sublime conception of our knowledge of the things above. And I dare say that if a person were to throw his head back and study the fretted ceiling, you would still think that his mind was the percipient, and not his eyes. And you are very likely right, and I may be a simpleton: but, in my opinion, that knowledge only which is of being and of the unseen can make the soul look upwards, and whether a man gapes at the heavens or blinks on the ground, seeking to learn some particular of sense, I would deny that he can learn, for nothing of that sort is matter of science; his soul is looking downwards, not upwards, whether his way to knowledge is by water or by land, whether he floats, or only lies on his back.

111 *'I did but taste . . . I must die'*: see 1 Samuel 14: 43: 'Then Saul said to Jonathan, Tell me what thou hast done. And Jonathan told him, and said, I did but taste a little honey with the end of the rod that *was* in mine hand, *and*, lo, I must die.'

112 *Gilliatt . . . 'Les Miserables'*: for Gilliatt, see the notes to p. 41; for the description of Fantine's mouth after she has sold her teeth to an itinerant dentist, see *Les Misérables*, part 1, book 5, chapter 10: 'It was a blood-stained smile. There were flecks of blood at the corners of her mouth and a wide gap beneath her upper lip.'

of Adonis, of Hyacinthus, of Ceres: Adonis was a young man with whom Aphrodite fell in love, and from whose blood the anemone was created. Hyacinthus was a young man with whom Apollo fell in love, and from whose blood the hyacinth was created. Ceres is the Roman name for Demeter, a Greek goddess of grain and fertility (from the second edition of *The Renaissance*, Pater more properly referred to her as Demeter).

Hyperion gives way to Apollo, Oceanus to Poseidon: Hyperion was a Titan, the father of Helios, the sun; Apollo an Olympian god of the sun (among other things). Oceanus was a Titan, too, the god of the sea; Poseidon the Olympian god of the sea.

113 *the 'Master of the Passion'*: this Dutch or German engraver is known as the 'Master of the Berlin Passion' because of a cycle of nine engravings of the Passion found glued into a late fifteenth-century manuscript.

'*ready to melt out their essence fine into the winds*': see Keats, *Endymion*, book I, lines 95–100:

> For 'twas the morn: Apollo's upward fire
> Made every eastern cloud a silvery pyre
> Of brightness so unsullied, that therein
> A melancholy spirit well might win
> Oblivion, and melt out his essence fine
> Into the winds.

Gradually . . . its claims: in the *Westminster Review*, another long paragraph preceded this one. There, Pater discussed the decline of the 'Hellenic ideal' (as its second half adequately indicates):

> In Roman hands, in the early days of Christianity, it was already falling to pieces through the loose eclecticism which characterised the age, not only in religion and philosophy, but also in literature and art. It was the age of imitators, mechanically putting together the limbs, but unable to unite them by the breath of life. Did Christianity quicken that decline? The worship of sorrow, the crucifixion of the senses, the expectation of the end of the world, are not in themselves principles of artistic rejuvenescence. Christianity in the first instance did quicken that decay. That in it which welcomed art was what was pagan in it, a fetichistic veneration for particular spots and material objects. Such materialism is capable of a thin artistic varnish, but has no natural connection with art of a higher kind. So from the first we see Christianity taking up a few fragments of art, but not the best that the age afforded, careless of their merits; thus aiding the decline of art by consecrating it in its poorest forms.

'*smiled through its tears*': see the first part of Hegel's *Aesthetics* (in Knox's translation):

> Even in romantic art, however, although suffering and grief affect the heart and subjective inner feeling more deeply there than is the case with the ancients, there do come into view a spiritual inwardness, a joy in submission, a bliss in grief and rapture in suffering, even a delight in agony. Even in the solemnly religious music of Italy this pleasure and transfiguration of grief resounds through the expression of lament. This expression in romantic art generally is 'smiling through tears'.

Saint Agatha at Bologna: this painting, in the Palazzo Ranuzzi in Bologna, was erroneously attributed to Raphael. For 'Iphigenie', see the note to p. 88.

114 *to those antique forms*: Pater excised a paragraph at this point when he reprinted the article on Winckelmann in book form. Its principal thesis is contained in its first half:

> But even after the advance of the sixteenth century the Renaissance still remained in part an unfulfilled intellectual aspiration. An artificial

classicism, as far as possible from the naturalism of the antique, was ready to set in if ever the Renaissance was accepted as an accomplished fact; and this was what happened. The long pilgrimage came to an end with many congratulations; only the shrine was not the genuine one. A classicism arose, based on no critical knowledge of the products of the classical spirit, unable to estimate the conditions either of its own or the classical age, regarding the adoption of the classical spirit as something facile. And yet the first condition of an historical revival is an appreciation of the differences between one age and another. The service of Winckelmann to modern culture lay in the appeal he made from the substituted text to the original.

114 *that marriage of Faust and Helena . . . his brows bound with light*: Goethe chooses to identify Euphorion, the son of Helen and Achilles, as the son of Helen and Faust. In *Faust*, part 2, II. xiii, Euphorion makes a dramatic ascent of the Arcadian rocks, a sight described by the Chorus:

> Look, how high he has ascended,
> Yet majestic still he seems,
> Like a conqueror: see, with splendid
> Bronze and steel his armour gleams.

Euphorion then dies in a spectacular suicidal flight from the rocks: '[*He hurls himself into the air, his garments bear him up for a moment, his head shines, a trail of light follows him.*]'

115 *Im Ganzen, Guten, Wahren, resolut zu leben*: Hill points out that Pater follows Carlyle in his essay on Schiller and misquotes Goethe's poem 'Generalbeichte' (1804). It should read: 'Im Ganzen, Guten, Schönen | Resolut zu leben' ('In wholeness, good, beauty | Resolute to live').

116 *schöne Seele*: 'beautiful soul', a quotation from Goethe's *Wilhelm Meister's Apprenticeship* (1795–6). Incidentally, Pater excised the following sentence from the article in the *Westminster Review*, where it preceded this one: 'But the utmost a sensuous gift can produce are the poems of Keats, or the paintings of Giorgione; and often in some stray line of Shakespeare, some fleeting tone of Raphael, the whole power of Keats or Giorgione strikes on one from its due place in a complete composite nature.'

'behind the veil': Hill is surely correct to claim that this is taken from section 55 of Tennyson's *In Memoriam*:

> O life as futile, then, as frail!
> O for thy voice to soothe and bless!
> What hope of answer, or redress?
> Behind the veil, behind the veil.

It was also the title poem of a recent collection by Roden Noel (1834–94) called *Behind the Veil; and Other Poems* (1863). Pater himself uses the

phrase again—in a reference to 'varieties of facts, of truths, just "behind the veil"'—in the final paragraph of chapter 20 of *Marius the Epicurean*.

117 *Goethe's Wahlverwandtschaften*: Goethe's *Elective Affinities* (see the note to p. 64). From the second edition of *The Renaissance*, Pater wrote instead that 'in Goethe's romances, and even more in the romances of Victor Hugo, we have high examples of modern art dealing thus with modern life'.

CONCLUSION

Pater's 'Conclusion' is adapted from the final paragraphs of 'Poems by William Morris', a review of *The Defence of Guenevere* (1858), *The Life and Death of Jason* (1867), and *The Earthly Paradise* (1868) which appeared unsigned in the *Westminster Review* of October 1868. In reprinting them, Pater did not include the paragraph from 'Poems by William Morris' that precedes the one that opens the 'Conclusion', though it effectively motivates it:

> One characteristic of the pagan spirit these new poems have which is on their surface—the continual suggestion, pensive or passionate, of the shortness of life; this is contrasted with the bloom of the world and gives new seduction to it; the sense of death and the desire of beauty; the desire of beauty quickened by the sense of death. '*Arrière!*' you say, 'here in a tangible form we have the defect of all poetry like this. The modern world is in possession of truths; what but a passing smile can it have for a kind of poetry which, assuming artistic beauty of form to be an end in itself, passes by those truths and the living interests which are connected with them, to spend a thousand cares in telling once more these pagan fables as if it had but to choose between a more and a less beautiful shadow?' It is a strange transition from the earthly paradise to the sad-coloured world of abstract philosophy. But let us accept the challenge; let us see what modern philosophy, when it is sincere, really does say about human life and the truth we can attain in it, and the relation of this to the desire of beauty.

118 *CONCLUSION*: from the third edition, when the 'Conclusion' was restored to *The Renaissance*, Pater appended this footnote:

> This brief 'Conclusion' was omitted in the second edition of this book, as I conceived it might possibly mislead some of those young men into whose hands it might fall. On the whole, I have thought it best to reprint it here, with some slight changes which bring it closer to my original meaning. I have dealt more fully in *Marius the Epicurean* with the thoughts suggested by it.

Λέγει που Ἡράκλειτος. . . μένει: in the translation by Jowett, this dictum, which is cited by Socrates in Plato's *Cratylus*, reads: 'Heraclitus

says "All things are in motion and nothing at rest."' In *Plato and Platonism*, where he identifies 'Heracliteanism' with both Hegelianism and Darwinism, Pater translates it as 'All things give way: nothing remaineth'. On Heracliteanism, see also chapter 8 of *Marius the Epicurean*. This epigraph, incidentally, is an addition to the paragraphs taken from 'Poems by William Morris'.

118 *Our physical life . . . more elementary forces*: Hill proposes that this passage is indebted to 'Waste and Repair' (1864) by Herbert Spencer (1820–1903).

the springing of violets from the grave: compare Laertes' speech at Ophelia's grave, in *Hamlet*, v. i. 232–4: 'Lay her i' th' earth; | And from her fair and unpolluted flesh | May violets spring!'

119 *weaving and unweaving of ourselves*: Pater deleted a paragraph included in 'Poems by William Morris' at this point:

> Such thoughts seem desolate at first; at times all the bitterness of life seems concentrated in them. They bring the image of one washed out beyond the bar in a sea at ebb, losing even his personality, as the elements of which he is composed pass into new combinations. Struggling, as he must, to save himself, it is himself that he loses at every moment.

120 *this hard gem-like flame*: according to Billie Andrew Inman, this image is derived from an article by John Tyndall, 'On the Relations of Radiant Heat to Chemical Constitution, Colour, Texture', which appeared in the *Fortnightly Review* in February 1866.

La philosophie, c'est la microscope de la pensée: from the second edition, Pater replaced this sentence (which should read 'le microscope') with its translation: 'Philosophy is the microscope of thought.' The quotation is taken from Hugo's *Les Misérables*, part 5, book 2, chapter 2:

> Philosophy is the microscope of thought, from which everything seeks to fly but nothing escapes. To compromise is useless: what side of oneself does one show by compromise; except what is shameful? Philosophy pursues evil with its unflinching gaze and does not allow it to escape into nothingness.

the sixth book of the 'Confessions': Rousseau does not actually mention Voltaire in this context, though Pater implies that he does; as Gerald Monsman has pointed out, Pater 'confused Rousseau's pleasure in a work by Bernard Lamy with an earlier mention of Voltaire in the *Confessions*'. *Entretiens sur les sciences* (1683), by the mathematician and philosopher Bernard Lamy (1640–1715), had a significant impact on Rousseau.

Well, we are all condamnés . . . des sursis indéfinis: from the second edition, Pater includes a translation: 'we are all under sentence of death

Explanatory Notes

179

but with a sort of indefinite reprieve.' The quotation is taken from Hugo's *Le Dernier Jour d'un condamné* (1832). Compare the final paragraph of *Marius the Epicurean*, which contains this sentence: 'He had often dreamt he was condemned to die, that the hour, with wild thoughts of escape, had arrived; and waking, with the sun all around him, in complete liberty of life, had been full of gratitude for his place there, alive still, in the land of the living.'

121 *the 'enthusiasm of humanity'*: a Comtean formulation, possibly taken from *Système de politique positive* (1851–4). It is also the title of one of the chapters of *Ecce Homo* (1866), a recent book on Christ's humanity by John Robert Seeley (1834–95).

the love of art for art's sake: in the fourth edition of *The Renaissance*, Pater altered this to 'the love of art for its own sake'. The concept of 'art for art's sake' is in part derived from the preface to Gautier's *Mademoiselle de Maupin* (1835):

> The only things that are really beautiful are those which have no use; everything that is useful is ugly, for it is the expression of some need, and the needs of men are ignoble and disgusting, like his poor and infirm nature. The most useful place in the house is the lavatory.
> Whether these gentlemen like it or not, I belong to those for whom the superfluous is necessary. And I prefer things and people in inverse proportion to the services they render me.

It should also be recalled that, in *William Blake: A Critical Essay* (1868), Swinburne had announced: 'Art for art's sake first of all, and afterwards we may suppose all the rest shall be added to her.'

APPENDIX A: THE SCHOOL OF GIORGIONE

It is generally assumed by scholars that the unnamed essay sent to Macmillan in June 1872 and then cancelled by Pater in October 1872 was the preliminary draft of 'The School of Giorgione'. It was eventually published in the *Fortnightly Review* in October 1877, and was incorporated, in a slightly abridged form, in the third edition of *The Renaissance* in 1888. The version of this chapter printed here is taken from the fourth edition of 1893.

122 *'imaginative reason'*: see Arnold's 'Pagan and Mediaeval Religious Sentiment':

> The poetry of later paganism lived by the senses and understanding; the poetry of mediaeval Christianity lived by the heart and imagination. But the main element of the modern spirit's life is neither the senses and understanding, nor the heart and imagination; it is the imaginative reason.

the Laocoon: see the note to p. 109.

123 *pure line and colour*: Hill usefully compares this paragraph to Baudelaire's comments in 'L'Œuvre et la vie d'Eugène Delacroix' (1863):

> To speak exactly, there is in nature neither line nor colour. It is man who creates line and colour. . . . Both line and colour makes us think and dream; the pleasures which derive from them are of a different but perfectly equal nature, and they are absolutely independent of the subject of the picture.

Titian's Lace-girl: this has since been attributed to Sofonisba Anguissola (*c*.1532–1625), the first female Italian painter to acquire an international reputation.

Tintoret's flying figures: the important Venetian painter Jacopo Tintoretto (1518–94), who was influenced by Michelangelo and Titian, made dramatic use of foreshortening in his compositions.

the Ariadne: Titian's *Bacchus and Ariadne* (1518–23) in the National Gallery, London.

124 *the Presentation of the Virgin*: Titian's *Presentation of the Virgin* (1534–8), in the Accademia, Venice.

Anders-streben: literally, a 'striving after otherness'; Hill observes that 'neither Goethe nor Hegel uses the term', and that he has been 'unable to find it in the vocabulary of any other German writers'.

All art constantly aspires towards the condition of music: compare the essay on 'Style': 'If music be the ideal of all art whatever, precisely because in music it is impossible to distinguish the form from the substance or matter, the subject from the expression, then, literature, by finding its specific excellence in the absolute correspondence of the term to its import, will be but fulfilling the condition of all artistic quality in things everywhere, of all good art.' See also chapter 9 of *Marius the Epicurean*.

125 *M. Alphonse Legros*: Alphonse Legros (1837–1911), the French draughtsman and painter, moved to London in 1863 and was a professor at the Slade from 1876 to 1892. Hill proposes that the etching mentioned by Pater is *Le Coup de Vent* (1875).

126 *Measure for Measure*: see Shakespeare's *Measure for Measure*, IV. i:

> Take, O take those lips away
> That so sweetly were forsworn;
> And those eyes, the break of day,
> Lights that do mislead the morn:
> But my kisses bring again, bring again;
> Seals of love, but sealed in vain, sealed in vain.

'ends in themselves': from Kant's *Grundlegung zur Metaphysik der Sitten* (1785), where he argues that rational beings are ends in themselves.

128 *Browning's poem*: Browning's *Sordello* was published in 1840; the poem's eponymous hero, based on the thirteenth-century Italian troubadour called Sordello, is described in book 1 as Dante's 'forerunner' and a 'herald-star'.

129 *Sordello's one fragment of lovely verse*: see Browning, *Sordello*, book 2, lines 151–5:

> 'Take Elys, there,
> —"Her head that's sharp and perfect like a pear,
> So close and smooth are laid the few fine locks
> Coloured like honey oozed from topmost rocks
> Sun-blanched the livelong summer" . . .'

the fondaco dei Tedeschi: the warehouse from which German trade was conducted in Venice, built between 1505 and 1508.

History of Painting in North Italy: *History of Painting in North Italy* (1871), by Joseph Arthur Crowe (1825–96) and Giovanni Battista Cavalcaselle (1820–97).

130 *The Concert in the Pitti Palace*: the *Concert* has since been attributed to Titian.

a delightful sonnet by a poet: this is Dante Gabriel Rossetti's 'For a Venetian Pastoral by Giorgione (in the Louvre)':

> Water, for anguish of the solstice:—nay,
> But dip the vessel slowly,—nay, but lean
> And hark how at its verge the wave sighs in
> Reluctant. Hush! Beyond all depth away
> The heat lies silent at the brink of day:
> Now the hand trails upon the viol-string
> That sobs, and the brown faces cease to sing,
> Sad with the whole of pleasure. Whither stray
> Her eyes now, from whose mouth the slim pipes creep
> And leave it pouting, while the shadowed grass
> Is cool against her naked side? Let be:—
> Say nothing now unto her lest she weep,
> Nor name this ever. Be it as it was,—
> Life touching lips with Immortality.

the Fête Champêtre . . . perhaps to Bellini: the *Fête Champêtre* is in fact probably by Giorgione, though possibly Titian; the *Tempest* is thought to be by Giorgione, and to have been completed by Palma Vecchio and Bordone; the *Knight Embracing a Lady* is thought to be by Girolamo Romanino (1484/7–*c*.1560), who worked in both Venice and Brescia; *The Meeting of Jacob and Rachel* (*c*.1515) is regarded as the work of Palma Vecchio himself; finally, the *Ordeal* is in fact thought to be by the school of Giorgione, and the *Finding of Moses* by Giorgione himself.

132 *'painted idylls'*: the so-called *poesie* often associated with Titian.

133 *il fuoco Giorgionesco*: 'the Giorgionesque fire.'

 the highest sort of dramatic poetry: as Pater's comments in the chapter on
 Winckelmann imply, he is probably thinking of Browning's poems.

134 *an ingenious passage of the Republic*: see Jowett's translation of the *Republic*,
 book VII:

> The error which pervades astronomy also pervades harmonics.
> The musicians put their ears in the place of their minds.
> 'Yes,' replied Glaucon, 'I like to see them laying their ears alongside
> of their neighbours' faces—some saying, "That's a new note,"
> others declaring that the two notes are the same.' Yes, I said; but you
> mean the empirics who are always twisting and torturing the strings of
> the lyre, and quarrelling about the tempers of the strings; I am referring
> rather to the Pythagorean harmonists, who are almost equally in
> error. For they investigate only the numbers of the consonances
> which are heard, and ascend no higher,—of the true numerical
> harmony which is unheard, and is only to be found in problems, they
> have not even a conception. 'That last,' he said, 'must be a marvellous
> thing.' A thing, I replied, which is only useful if pursued with a view
> to the good.

 Bandello's novels: Matteo Bandello (*c.*1480–1562) published the four
 volumes of his *Novelle*, tales that are deeply indebted to the example of
 Boccaccio, from 1554 to 1573.

135 *the vraie vérité*: 'the essential truth.'

APPENDIX B: DIAPHANEITÈ

Pater read this essay to the Old Mortality Society in July 1864, though it did
not appear in print until 1895, the year after he died, when it was included in
Miscellaneous Studies, a collection edited by C. L. Shadwell, the friend who
had originally inspired its youthful effusions. The title is a distinctly eccentric
rendition of 'diaphaneity', derived from the French *diaphanéité*, meaning 'the
quality of being freely pervious to light; transparency' (*OED*). It is the first,
and the most abstract, of Pater's 'Imaginary Portraits'.

136 *the Beatrice of the Commedia*: Beatrice Portinari (1266–90), a Florentine
 with whom Dante fell in love, is his guide through the celestial spheres of
 Paradiso in the *Divine Comedy*.

 'Sibi unitus . . . the Imitatio Christi: 'to be at one and open with oneself'
 (on the *Imitatio Christi*, by Thomas à Kempis, see the note to p. 25).

137 *the author of Romola*: this refers to George Eliot (see the notes to p. 24).

138 φιλοσοφήσας . . . ἔρωτος: 'having once philosophized with love.'

the 'dim blackguardism' of Danton: this misquotes a description of Camille Desmoulins (1760–94)—rather than Georges Danton (1759–94)—from the first volume of Thomas Carlyle's *The French Revolution: A History* (1837): 'Then that other, his [Danton's] slight-built comrade and craft-brother; he with the long curling locks; with the face of dingy black-guardism, wondrously irradiated with genius, as if a naphtha-lamp burnt within it: that Figure is Camille Desmoulins.'

139 *'What . . . through long centuries'*: this is adapted from the third volume of *The French Revolution*: 'What if she, this fair young Charlotte, had emerged from her secluded stillness, suddenly like a Star; cruel-lovely, with half-angelic, half-demonic splendour; to gleam for a moment, and in a moment be extinguished: to be held in memory, so bright complete was she, through long centuries!'

GLOSSARY OF NAMES

Albani Alessandro Albani (1692–1779), an influential antiquarian, had from 1745 built the Villa Albani to house his vast, evolving collection.

Alexander the Sixth Roderic Llançol (1431–1503), who from 1455 assumed his mother's name—which in its Italian form, Borgia, became notorious for its association with corruption—was Pope Alexander VI from 1492 to 1503.

Amoretti Carlo Amoretti (1741–1816), an encyclopedist and the conservator of the Biblioteca Ambrosiana in Milan, published *Memorie storiche su la vita gli studi e le opere di Leonardo da Vinci* in 1804.

Angelico Fra Giovanni da Fiesole (c.1400–1455), known as Fra Angelico, was an important didactic painter of religious topics, whose style was more conservative than that of contemporaries like Fra Filippo Lippi (c.1406–1469).

Arcangeli Francesco Arcangeli (1737–68), an unemployed cook who had become a petty thief, murdered Winckelmann on 8 June 1768.

Archinto Alberico Archinto (1698–1758) was the papal nuncio in Poland from 1746 to 1754.

Arnold of Brescia Arnold of Brescia (1090–1155), who studied under Abelard in Paris, acquired an incendiary reputation for attacking the corruption of the clergy and preaching the benefits of apostolic poverty; a leading proponent of the short-lived Commune of Rome, he drove Pope Eugene III into exile in 1846, and was consequently executed as a rebel.

Arnolfo Arnolfo di Cambio (c.1240–c.1300/1310), an architect and sculptor, supervised the construction of Florence Cathedral, and supplied the statues that decorated the façade destroyed in the late sixteenth century.

Athenæus a Greek grammarian of the early third century CE, Athenæus was the author of the *Deipnosophistae*, a compendious account, in fifteen books, of an encyclopedic 'banquet of the philosophers'.

Beatrice Beatrice d'Este (1475–97), who married Ludovico Sforza in 1491, became an influential patron of the arts, and an effective political ambassador to her husband, before her premature death.

Bellini the Bellinis included Jacopo (c.1400–1470/71) and his sons Gentile (c.1429–1507) and Giovanni (c.1430–1516); Giovanni's pupils included Giorgione and Titian.

Beniveni Girolamo or Hieronymo Beniveni (1453–1542) was a Florentine poet, important partly because his poems popularized Platonism

(he mediated its doctrines to Edmund Spenser, for example); 'De lo amore celeste' ('Of Heavenly Love'), a canzone which inspired the commentary by Pico to which Pater refers in the chapter on Mirandola, had itself summarized Ficino's commentary on the *Symposium*; a close friend of Pico, Beniveni later became a supporter, and translator, of Savonarola.

Berg Winckelmann met Baron Friedrich Reinhold von Berg (1736–1809) in Rome in 1762 and quickly fell in love with him; he dedicated an important epistolary essay to him, *Abhandlung von der Fähigkeit der Empfindung des Schönen in der Kunst, und dem Unterrichte in derselben* (1763).

Boccaccio Giovanni Boccaccio (1313–75), an Italian humanist, was the author, most famously, of the *Decameron* (1353), a collection of one hundred stories; from 1360 he compiled his *Geneaologia deorum gentilium*, an encyclopedic treatise on the pagan gods.

Bordone Paris Bordone (1500–71), a Trevisan painter who lived most of his life in Venice, was an imitator of Giorgione.

Borgia Cesare Borgia (1475–1507), the son of Pope Alexander VI and brother of Lucrezia Borgia (1480–1519), commanded the papal armies, and commissioned Leonardo to act as his military architect from 1502 to 1503.

Brunelleschi Filippo Brunelleschi (1377–1446), perhaps the most important architect of the Florentine Renaissance, designed a number of churches, in addition to the famous dome of Florence Cathedral (1420–36).

Canossa Michelangelo appears to have believed his family's implausible claim that it was descended from Matilda of Canossa (1046–1115), 'La Gran Contessa', a military campaigner who supported Pope Gregory VII, in opposition to the Holy Roman Emperor Henry IV, in the so-called 'investiture controversy'.

Cardan Girolamo Cardano (1501–76) was an astrologer, mathematician, and physician; his father Fazio Cardano (1444–1524), a professor at the University of Pavia, and himself a student of the occult, had been a friend of Leonardo.

Carpaccio Vittore Carpaccio (*c.*1460–1523/6), a pupil probably of Gentile Bellini, and an assistant to Giovanni Bellini, painted (most famously) the *Legend of St Ursula* (from 1490).

Catherine Catherine de' Medici (1519–89) was the wife of Henry II (1519–59) who acceded to the French throne in 1547.

Catherine of Cornara the Venetian Caterina Cornaro (1454–1510) married James II of Cyprus in 1468 and, as a result of both his death and that of their infant son, became Queen of Cyprus in 1474; she was

forced to abdicate in 1489, when the island was annexed to Venice, and thereafter held court at Asolo.

Cavaceppi Bartolomeo Cavaceppi (*c.*1716–1799), a friend of Winckelmann, was an Italian sculptor who restored sculptures for Alessandro Albani.

Clouet François Clouet (*c.*1510–1572), a portraitist and miniaturist, succeeded his father Jean Clouet (*c.*1480–1541) as French court painter in 1541.

Colonna Vittoria Colonna (1490–1547), who had been married to the *condottiero* Fernando Francesco d'Ávalos, Marquess of Pescara (1489–1525), and who published her poems from 1538, became a friend of Michelangelo's in 1536.

Comte the French positivist philosopher Auguste Comte (1798–1857) published his *Cours de philosophie positive* in six volumes from 1830 to 1842; it was 'freely translated and condensed' by Harriet Martineau (1802–76) as *The Positive Philsosophy of August Comte* (1853).

Constantine Flavius Valerius Aurelius Constantine (*c.*272–337), the first Roman emperor to be Christian, ruled the united empire from 324 to 337.

Corday Marie-Anne Charlotte de Corday d'Armont (1768–93), known as Charlotte Corday, assassinated Jean-Paul Marat (1743–93) during the Terror and was consequently executed by guillotine.

Cosimo Piero di Cosimo (*c.*1462–1521), a distinguished pupil of the Florentine painter Cosimo Rosselli (1439–1507), who apparently worked on his master's frescos in the Sistine Chapel, was deeply influenced by Leonardo da Vinci.

Costanzo the *condottiere* Tuzio Costanzo commissioned Giorgione's so-called *Castelfranco Madonna* (*c.*1504), an alterpiece for the Cathedral of Castelfranco Veneto, to commemorate the death of his son Matteo.

Cousin Jean Cousin the Elder (*c.*1490–1560) was an engraver, painter, and designer of stained glass; his son Jean Cousin the Younger (*c.*1522–1595) was a book illustrator and glass painter.

Cypselus Cypselus ruled Corinth in the seventh century BCE.

Daniele Pellegrino de San Daniele (1467–1547) was a painter also known as Martino da Udine.

Dante Dante Alighieri (1265–1321), the greatest Italian medieval poet, composed the *Vita nuova* in the early 1290s, and the *Divina commedia*, his masterpiece, in the 1310s.

Diana Diana (or Artemis) of Ephesus, in ancient Ionia, was a goddess of fertility closely related to Egyptian deities; in iconic images of the Ephesian Diana her torso was adorned with numerous breasts or eggs.

Dionysius Dionysius the Areopagite is mentioned in the Bible as someone converted by St Paul at Athens, but his name subsequently became associated, in about 500, with a number of influential treatises on Neoplatonism and Christianity by the so-called Pseudo-Dionysius.

Donatello Donato di Niccolò di Betto Bardi (*c.*1385/6–1466), known as Donatello, the most important Florentine sculptor before Michelangelo, had an immense influence on Renaissance art, in Padua and Venice as well as Florence.

du Bellay, Jean Cardinal Jean du Bellay (*c.*1492–1560), Joachim's first cousin and a friend of Rabelais, was an influential diplomat during the reign of Francis I, and a poet himself.

Dürer Albrecht Dürer (1471–1528), the prolific German engraver, painter, and printer, an important humanist influenced in particular by Leonardo, mediated and transmuted the ideas of the Italian Renaissance in northern Europe.

Eckermann the poet Johann Peter Eckermann (1792–1854), who edited Goethe's complete works (1839–40), was also the author of *Conversations with Goethe* (1836).

Fauriel Claude Charles Fauriel (1772–1844), a French historian, was professor of foreign literature at the Sorbonne from 1830; his *Histoire de la littérature provençale*, based on lectures he had given there, was published posthumously in 1846.

Ficino Marsilio Ficino (1433–99) was an influential Neoplatonist philosopher who produced Latin translations of all of Plato's dialogues; he met Pico della Mirandola, who became his pupil, in 1486.

Francis I Francis I (1494–1547), who patronized a number of Italian artists, and in 1516 persuaded Leonardo to move to France, ruled the country from 1515 to 1547.

Ghirlandaio Domenico Ghirlandaio (1449–94), who specialized in frescos, ran an important studio in which Michelangelo was apprenticed; in 1481–2 he worked in the Sistine Chapel, in a style deeply indebted to Masaccio, alongside the rather more inspired Botticelli (note that in the chapter on Michelangelo Pater refers to him as 'Ghirlandajo').

Giocondo Francesco di Bartolomeo di Zanobi del Giocondo (1460–1528/39), a cloth merchant, married Lisa Gherardini (1479–1542) in 1495.

Giotto the Florentine painter and architect Giotto di Bondone (1266/67–1337), known as Giotto, is of seminal importance to the history of European painting; his naturalistic frescos, as in the Scrovegni Chapel in Padua, freed the human form from the stereotypical representations characteristic of Italo-Byzantine art and infused the faces that he painted with emotional drama.

Kant Immanuel Kant (1724–1804), author most importantly of the *Critique of Pure Reason* (1781), was perhaps the most influential philosopher of the European Enlightenment.

Lavater Johann Caspar Lavater (1741–1801), a Swiss physiognomist and poet, and a friend of Goethe, published his famous *Physiognomische Fragmente zur Beförderung der Menschenkenntnis und Menschenliebe*, in four volumes, from 1775 to 1778.

Lessing Gotthold Ephraim Lessing (1729–81), the German dramatist and philosopher, published *Laocoon: On the Limits of Painting and Poetry*, which opposed the classical aesthetics of Winckelmann, in 1766.

Liberale this is the fourth-century saint St Liberalis of Treviso, who might be the knight that flanks the Madonna in Giorgione's *Castelfranco Madonna* (standing opposite St Francis).

Lorenzo Lorenzo de' Medici (1449–92), known as Lorenzo il Magnifico, was head of the Florentine Republic during the so-called 'Golden Age' of Florence.

Luther Martin Luther (1483–1546) was the German priest whose theological and political challenge to the authority of the papacy was in part responsible for the Protestant Reformation.

Maecenas Gaius Cilnius Maecenas (70–8 BCE) was a munificent patron of the arts, and in particular of poets such as Horace and Virgil.

Malherbe François de Malherbe (1555–1628), a critic, poet and translator, was the architect of French classicism in literature, and an upholder of linguistic propriety and purity.

Masaccio Tommaso di Ser Giovanni di Mone (1401–*c*.1428), nicknamed 'Masaccio', inherited Giotto's mantle as a pioneer of modern painting, and proved equally influential; he evolved a realist style of painting, heroic and sculptural in its form, in opposition to the International Gothic style popular in Florence in the early fifteenth century.

Medici, Alessandro de Alessandro de' Medici (1510–37), nicknamed 'Il Moro', who was the illegitimate son of Giulio di Giuliano de' Medici (1478–1534), ruled Florence despotically from 1532 to 1537.

Medici, Cosmo de' Cosmo (1389–1464) was the first of the Medicis to rule Florence; he appointed Marsilio Ficino as the head of his Platonic Academy and commissioned him to produce a complete translation of Plato.

Medici, Giuliano de' Giuliano de' Medici (1453–78), the younger son of Piero de' Medici (1416–69), ruled Florence alongside his brother Lorenzo; he was assassinated in the Duomo in the course of the Pazzi Conspiracy.

Medici, Piero de' Piero de' Medici (1472–1503), Lorenzo de' Medici's oldest son, became ruler of Florence on his father's death in 1492;

Vasari states that he was 'among the first to have Luca [della Robbia] create works in coloured clay'.

Melzi Francesco Melzi (*c*.1491–1570), son of a Milanese nobleman, was apprenticed to Leonardo in 1506 and assisted him faithfully until his master died; after Leonardo's death, Melzi inherited his books, drawings, and manuscripts.

Memling Hans Memlinc or Memling (*c*.1430–1494), a pupil of Roger van der Weyden (1399/1400–64), was a Netherlandish painter who produced portraits and devotional pictures.

Mengs Anton Raffael Mengs (1728–79), the court painter at Dresden from 1745 and an early exponent of neoclassicism, met Winckelmann, with whom he became close friends, in 1755.

Michelet Jules Michelet (1798–1874), the French historian, was an outspoken republican whose *L'Histoire de France* appeared in seventeen volumes from 1833 to 1867.

More Thomas More (*c*.1477–1535), the great English humanist and the author of *Utopia* (1516), published his *Lyfe of John Picus Erle of Mirandula*, translated from the Latin of Pico's biographer, his nephew Giovanni Francesco Pico, in approximately 1510.

Naugerius Andrea Navagero (1483–1529), keeper of the library of San Marco in Venice from 1516 to 1526, wrote pastoral poems in Latin which were posthumously published as *Lusus* (1530).

Novalis Friedrich Leopold von Hardenberg (1772–1801), called Novalis, was a German Romantic novelist and poet, and the author of philosophical fragments (note that Thomas Carlyle (1795–1881) had published an article on him in the *Foreign Review* in 1829).

Oeser Adam Friedrich Oeser (1717–99), an etcher, painter, and sculptor, taught Goethe drawing at the Kunstakademie in Leipzig in 1764.

Ollanda Francesco d'Ollanda (1517–84), or Francisco de Hollanda, an architect and painter of miniatures, was sent by the King of Portugal to study art in Italy in the 1530s; he recorded his experiences, including the conversation between Michelangelo and Vittoria Colonna at San Silvestro al Quirinale, in a manuscript of 1549.

Paccioli the Franciscan monk Fra Luca Bartolomeo de Pacioli (1446/7–1517), author of *Summa de arithmetica, geometria, proportioni et proportionalita* (1494), moved to Milan at the invitation of Ludovico Sforza; in Milan, he taught mathematics to Leonardo, who illustrated his *De divina proportione* (1509) in the late 1490s.

Palma Jacopo Palma (*c*.1480–1528), the Venetian painter called Palma Vecchio, was a pupil of Giovanni Bellini whose paintings were also influenced by Giorgione and Titian.

Paracelsus Theophrastus von Hohenheim (1493–1541), who adopted the name Paracelsus, was an influential Swiss alchemist, occultist philosopher, and physician.

Passionei Domenico Silvio Passionei (1682–1761), pro-librarian of the Vatican Library from 1741, became its librarian in 1755.

Pausanias the author of a painstaking *Description of Greece* in ten books, Pausanias lived in the second century CE.

Pericles Pericles (c.495–429 BCE) was the Athenian statesman who came to prominence in the middle decades of the fifth century BCE, between the Persian and Peloponnesian wars.

Perugino Pietro Vannucci (c.1445/50–1523), known as Perugino, worked in Verrocchio's shop at the same time as Leonardo and contributed to the frescos in the Sistine Chapel.

Phidias Phidias (c.490–430 BCE), or Pheidias, an Athenian architect and sculptor, supervised Pericles' building projects, according to Plutarch, and was probably responsible for the sculptures on the Parthenon.

Phryne a famously beautiful Greek courtesan of the fourth century BCE, who on one occasion bathed naked in the sea during a festival for Poseidon at Eleusis; she makes an appearance in the poem 'Lesbos', by Charles Baudelaire (1821–67), in *Les Fleurs du mal* (1857).

Pilon Germain Pilon (c.1537–1590) was a French sculptor influenced in particular by Michelangelo.

Piombo Sebastiano del Piombo (c.1485–1547) was a Venetian painter deeply influenced by Giorgione, at least until he came under Michelangelo's influence after moving to Rome in 1511.

Pisa Giovanni Pisano (c.1245/50–c.1315), son of Nicola Pisano (c.1220/25–c.1284), was an architect and (like his father) an influential sculptor, whose most important pieces were commissioned for the cathedrals at Pisa and Siena.

Plotinus Plotinus (204/5–70 CE) was a Platonist philosopher who effectively founded Neoplatonism; after his death, his pupil Porphyry (c.232–304 CE) edited his philosophical essays into a collection called the *Enneads* (in 1486, Pico severely criticized Ficino's translation of the *Enneads*).

Politian Angelo Ambrogini (1454–94), known as Poliziano, was a Florentine classicist and poet.

Pomona the Roman goddess of fruit trees (who had no counterpart in Greek mythology).

Pythagoras Pythagoras of Samos, the Ionian Greek philosopher and mathematician, was born between 580 and 572 BCE and died between 500 and 490 BCE; Pythagoreans observed an initiatory rule of silence, called *echemythia*.

Queen of Scots Mary Stuart (1542–87), Queen of Scots, was brought up in the French court from 1548 to 1558.

Quercia Jacopo della Quercia (1374/5–1438), the greatest Sienese sculptor, made the stone reliefs for San Petronio in Bologna that Michelangelo much admired.

Rabelais François Rabelais (*c.*1494–1553), the French humanist and satirist, published his most famous books, exuberant celebrations of the giants Gargantua and Pantagruel, from the early 1530s.

Rémusat Charles François Marie, Comte de Rémusat (1797–1875), a French politician, was the author of *Pierre Abélard* (1845) and a number of other books, including *Histoire de la philosophie en Angleterre depuis Bacon jusqu'à Locke* (1875).

Ridolfi Carlo Ridolfi (1594–1658), a biographer and painter, was the author of *Le maraviglie dell'arte, ovvero le vite degli illustri pittori Veneti e dello stato* (1648).

Ronsard Pierre de Ronsard (1524–85), the influential French poet, is perhaps most famous for his sequences of love poems, published from the 1550s, but he also wrote poems on political, philosophical, and religious themes.

Rousseau Jean-Jacques Rousseau (1712–78), political philosopher whose *Les Confessions* (1781–8) and *Les Rêveries du promeneur solitaire* (1782) appeared posthumously.

Rucellai Camilla Rucellai (1455–1520) was a Florentine noblewoman who, after coming under the influence of Savonarola, separated from her husband and became a Dominican nun famed as a prophetess.

Savonarola Girolamo Savonarola (1452–98) was a Dominican priest who preached against the corruption of the Church, and in particular the decadent climate cultivated by Lorenzo de' Medici in Florence and Alexander VI in Rome.

Schiller Johann Christoph Friedrich von Schiller (1759–1805), the dramatist, historian, and poet, was a protagonist of the *Sturm und Drang* movement, like Goethe, in late eighteenth-century Germany.

Sforza Ludovico Sforza (1452–1508), Duke of Milan from 1494, was known as Ludovico Il Moro, a nickname probably derived from his chivalric device, the mulberry tree (*mora* in Italian), though posssibly also from his dark complexion; Francesco Sforza (1401–66), Ludovico's father, to whom Pater also refers in the chapter on Leonardo, was duke from 1450.

Signorelli Luca Signorelli (*c.*1441/50–1523), a pupil of Piero della Francesca (1410/20–92), probably contributed to the frescos in the Sistine Chapel, like Botticelli; his masterpiece is the cycle of frescos in Orvieto Cathedral, shaped by the apocalypticism of Savonarola, which influenced Michelangelo.

Silvestre Israel Silvestre (1621–91), a French draughtsman and engraver who specialized in architectural and topographical views, was *dessina-teuer et graveur du roi* from 1662.

Simonetta Simonetta Cattaneo (*c*.1453–1476), known as 'La Bella Simonetta', who married into the Vespucci family at the age of 15 or 16, was a famously beautiful Florentine who appears in paintings by both Botticelli and Piero di Cosimo; Botticelli, no doubt besotted with her, was interred at her feet, at his request, in the Church of Ognissanti, Florence.

Spinoza Baruch Spinoza (1632–77), a Dutchman of Jewish origin, is one of the most influential philosophers in European history; his *Ethics*, a critique of Cartesian thought, was published posthumously in 1677.

Theocritus Theocritus (*c*.308–*c*.240 BCE), who wrote in the Doric dialect, was the bucolic poet responsible for the pastoral form.

Titian Tiziano Vecelli (*c*.1487–1576), called Titian, who is generally considered the most important of the Venetian painters of the Renaissance, transformed the practice of painting through his application of colour.

Torre Marc Antonio della Torre (1478/81–1511), who set up a school of anatomy at the University of Pavia, probably met Leonardo in 1510 (though it is not necessarily the case, as Vasari insists, that they collaborated with one another).

Van Eyck Hubert (*c*.1366–1426) and Jan (*c*.1395–1441) Van Eyck, who were once credited with the invention of oil painting, were the most prominent and technically brilliant artists of the Flemish School.

Vasari the painter and architect Giorgio Vasari (1511–74) was in effect the first Italian art historian; his *Lives of the Most Excellent Painters, Sculptors, and Architects* (1550, revised 1668), a comprehensive selection of artists' biographies that was laced both with anecdotes and stylistic assessments, helped to codify the idea of an Italian renaissance (*rinascita*).

Veronese Paolo Veronese (*c*.1528–1588), who was profoundly influenced by Titian, worked in Venice from approximately 1553, and specialized in large pageantic paintings on biblical, historical, and allegorical themes.

Verrocchio Andrea del Verrocchio (*c*.1435–1488), a Florentine gold-smith, painter, and sculptor, was Leonardo's master; as Pater points out, Leonardo probably painted one of the angels in Verrocchio's *Baptism of Christ* (*c*.1475), which had been commissioned by the Vallombrosan monks at San Salvi.

Vidal Pierre Vidal, who died in 1229, came to be known as the 'Don Quixote of the Troubadours', according to Edgar Taylor's *Lays of the Minnesingers* (1825).

Wolf Christian Wolff (1679–1754) was a Leibnizian philosopher whose encyclopedic teachings dominated German intellectual life until the ascendancy of Kantianism.

American Literature

British and Irish Literature

Children's Literature

Classics and Ancient Literature

Colonial Literature

Eastern Literature

European Literature

Gothic Literature

History

Medieval Literature

Oxford English Drama

Poetry

Philosophy

Politics

Religion

The Oxford Shakespeare

A complete list of Oxford World's Classics, including Authors in Context, Oxford English Drama, and the Oxford Shakespeare, is available in the UK from the Marketing Services Department, Oxford University Press, Great Clarendon Street, Oxford OX2 6DP, or visit the website at www.oup.com/uk/worldsclassics.

In the USA, visit www.oup.com/us/owc for a complete title list.

Oxford World's Classics are available from all good bookshops. In case of difficulty, customers in the UK should contact Oxford University Press Bookshop, 116 High Street, Oxford OX1 4BR.

Late Victorian Gothic Tales

JANE AUSTEN
Emma
Mansfield Park
Persuasion
Pride and Prejudice
Selected Letters
Sense and Sensibility

MRS BEETON
Book of Household Management

MARY ELIZABETH
BRADDON
Lady Audley's Secret

ANNE BRONTË
The Tenant of Wildfell Hall

CHARLOTTE BRONTË
Jane Eyre
Shirley
Villette

EMILY BRONTË
Wuthering Heights

ROBERT BROWNING
The Major Works

JOHN CLARE
The Major Works

SAMUEL TAYLOR
COLERIDGE
The Major Works

WILKIE COLLINS
The Moonstone
No Name
The Woman in White

CHARLES DARWIN
The Origin of Species

THOMAS DE QUINCEY
The Confessions of an English
 Opium-Eater
On Murder

CHARLES DICKENS
The Adventures of Oliver Twist
Barnaby Rudge
Bleak House
David Copperfield
Great Expectations
Nicholas Nickleby
The Old Curiosity Shop
Our Mutual Friend
The Pickwick Papers

	Six French Poets of the Nineteenth Century
HONORÉ DE BALZAC	Cousin Bette Eugénie Grandet Père Goriot
CHARLES BAUDELAIRE	The Flowers of Evil The Prose Poems and Fanfarlo
BENJAMIN CONSTANT	Adolphe
DENIS DIDEROT	Jacques the Fatalist The Nun
ALEXANDRE DUMAS (PÈRE)	The Black Tulip The Count of Monte Cristo Louise de la Vallière The Man in the Iron Mask La Reine Margot The Three Musketeers Twenty Years After The Vicomte de Bragelonne
ALEXANDRE DUMAS (FILS)	La Dame aux Camélias
GUSTAVE FLAUBERT	Madame Bovary A Sentimental Education Three Tales
VICTOR HUGO	The Essential Victor Hugo Notre-Dame de Paris
J.-K. HUYSMANS	Against Nature
PIERRE CHODERLOS DE LACLOS	Les Liaisons dangereuses
MME DE LAFAYETTE	The Princesse de Clèves
GUILLAUME DU LORRIS and JEAN DE MEUN	The Romance of the Rose